Drawings by

Rembrandt and His Pupils

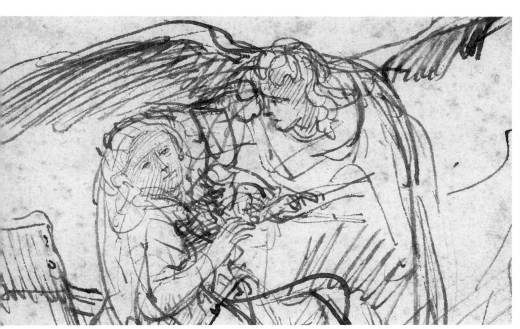

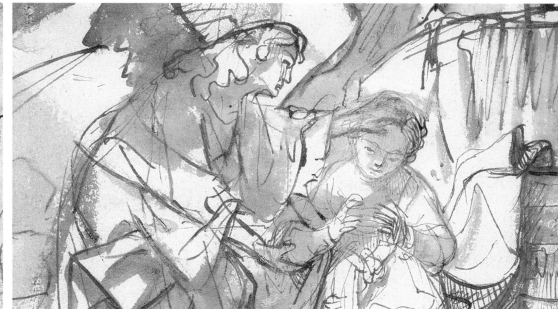

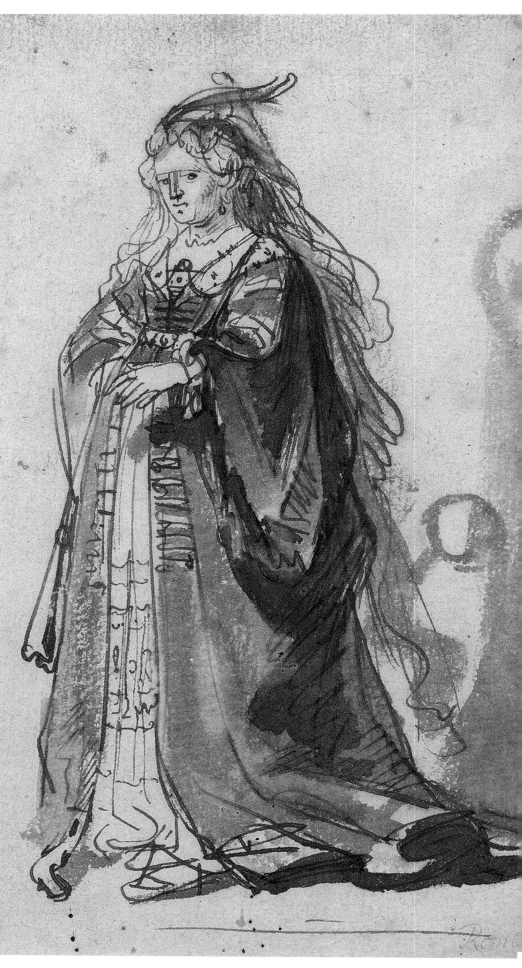

Holm Bevers

Lee Hendrix

William W. Robinson

Peter Schatborn

Ferdinand Bol

Willem Drost

Gerbrand van den Eeckhout

Carel Fabritius

Govert Flinck

Abraham Furnerius

Arent de Gelder

Samuel van Hoogstraten

Jan Lievens

Nicolaes Maes

Johannes Raven

Constantijn Daniel van Renesse

Jan Victors

Pieter de With

Rembrandt pupil

Drawings by Rembrandt and His Pupils

Telling the Difference

The J. Paul Getty Museum, Los Angeles

Contents

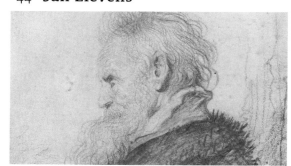

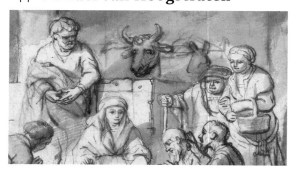

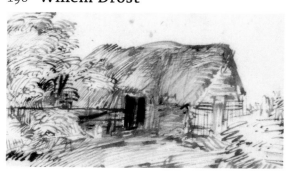

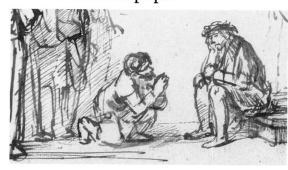

80 Ferdinand Bol

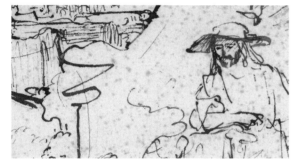

102 Gerbrand van den Eeckhout

124 Jan Victors

158 Abraham Furnerius

164 Nicolaes Maes

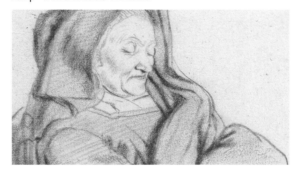

182 Constantijn Daniel van Renesse

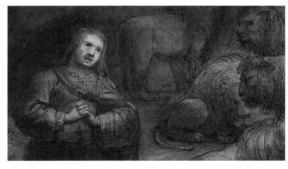

216 Pieter de With

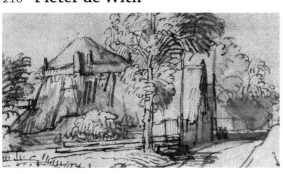

226 Arent de Gelder

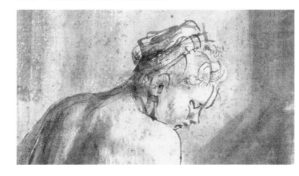

240 Johannes Raven

Foreword

MICHAEL BRAND
Director
The J. Paul Getty Museum

Among the many great projects that have grown out of the guest scholar program at the Getty Museum, *Drawings by Rembrandt and His Pupils: Telling the Difference* is among the most stunning and momentous. The idea for this unique exhibition came about when Peter Schatborn was a guest scholar in our Drawings Department in 2004. During his stay in Los Angeles, he and the Getty's Senior Curator of Drawings, Lee Hendrix, began to discuss the possibility of an exhibition that would summarize and clearly present over thirty years of scholarship on the drawings of Rembrandt and his most important pupils during the nearly forty-year span of his studio. This idea became a reality when they formed a working team with Holm Bevers, Curator of Netherlandish Drawings and Prints at the Berlin Kupferstichkabinett and himself a former Getty guest scholar, and William W. Robinson, George and Maida Abrams Curator of Drawings at the Harvard Art Museum/Fogg Museum. We are immensely grateful to this marvelous team of scholars, who have brought such depth of expertise to the project and who have given their time and effort so unstintingly in bringing this exhibition and catalogue to fruition.

We would also like to offer our thanks to our lenders, who have responded so generously to our loan requests. These loans include many of Rembrandt's greatest and most famous drawings, as well as numerous masterpieces by his compatriots and students, including Jan Lievens, Govert Flinck, Gerbrand van den Eeckhout, Samuel van Hoogstraten, and Nicolaes Maes. Indeed, it is fair to say that the exhibition presents, both qualitatively and quantitatively, the most comprehensive display of drawings by Rembrandt and his studio ever mounted. Many institutions granted multiple loans, including extraordinary groups of drawings from the Berlin Kupferstichkabinett; the British Museum, London; the Rijksmuseum, Amsterdam; and the Musée du Louvre, Paris.

Because of the fragility of drawings and the difficulty of obtaining the loans for multiple venues, it was decided to hold the exhibition at the Getty Museum only. *Drawings by Rembrandt and His Pupils: Telling the Difference* takes its place within a tradition of exhibitions that the Getty is both proud of and fortunate enough to be able to undertake. These are exhibitions that really make a difference, bringing transformative scholarship to bear on art of the utmost profundity. During these difficult economic times, we are more than ever grateful to be able to continue this level of excellence and to enrich our local and worldwide audience with these moving and beautiful drawings from the Dutch Golden Age.

Acknowledgments

LEE HENDRIX
Senior Curator, Department of Drawings
The J. Paul Getty Museum

The genesis of this exhibition and accompanying catalogue came about five years ago, when Peter Schatborn was a guest scholar at the Getty Museum. During his stay, he gave a presentation on how to tell the difference between Rembrandt's drawings and those of his pupils, bringing to bear his decades of research in this difficult field. The lecture hall was packed with art historians of every stripe, and they reacted with overwhelming enthusiasm—even those who might normally lose interest when confronted with questions of connoisseurship. It was as if a lightbulb had switched on in the audience as people realized that they could actually perceive these differences and that the process of describing them was both engrossing and meaningful. The richness of the material itself—the drawings of Rembrandt and his many pupils—generously rewards the effort: the more one looks, the more one sees. After this positive reception, Peter and I began to talk about presenting this material and this method to a wider audience in the form of an exhibition. Then, in 2006, at the Rembrandt symposium in Berlin, we shared the idea with Bill Robinson and Holm Bevers (who had been a guest scholar at the Getty in 2003, working on his catalogue of the Rembrandt drawings in the Berlin Kupferstichkabinett), and, to our delight, they decided to join our team.

We all felt that the time was ripe for this project thanks to the massive scholarship on distinguishing the drawings of Rembrandt from those of his pupils that has taken place over the past thirty or so years. The picture of Rembrandt's drawn oeuvre embodied in Otto Benesch's six-volume catalogue raisonné, first published in 1954–57 and enlarged and revised in 1973, has since changed dramatically through the milestone publications of the collection catalogues of major Rembrandt holdings, including those of the Rijksmuseum, the British Museum, and the Berlin Kupferstichkabinett, and Werner Sumowski's ten-volume *Drawings of the Rembrandt School*, which began to appear in 1979. Our team decided that we would attempt to distill this enormous and far-flung scholarship into carefully selected pairs of drawings by Rembrandt and a given pupil, in which the visuals would tell most of the story, accompanied by precise and comprehensible prose that would lay out the scholarly method. In using the catalogue, the reader will note that the entries concentrate on the stylistic differences and that additional information, including selected bibliography on each drawing, is found in the checklist at the back. We spent many months collectively making the list of pairs for Rembrandt and fifteen of his pupils. This involved numerous refinements until we arrived at the current, finely honed pairings. An exhibition so highly structured meant that we had to obtain both drawings in each pair or the pairing would have to be dropped entirely. This made the securing of loan objects unusually critical. Because the loans were so all-important, we decided to hold the exhibition at the Getty only.

The overwhelmingly positive response to the loan requests was heartening, and our thanks go out to the many individuals who acceded to our loan requests and helped to further the exhibition and catalogue in so many ways. These include George Abrams, Mària van Berge-Gerbaud, Marian Bisanz-Prakken, Szilvia Bodnár, Emanuelle Brugerolles, Stephanie Buck, S. A. C. Dudok van Heel, Chr. P. van Eeghen, Rhoda Eitel-Porter, Albert Elen, Chris Fischer, Thera Folmer-von Oven, David Franklin, Carina Fryklund, Jeroen Giltaij, Mechthild Haas, Laurel Hanif, Matthew Hirst, Richard Hüttel, Thomas Ketelsen, Katarzyna Kenc-Lechowska, Hanne Kolind Poulsen, Dagmar Korbacher, Werner H. Kramarsky, Diana Kunkel, Ad Leerintveld, Jan Leja, Ger Luijten and the staff of the Rijksmuseum Print Room and Study Room, Volker Manuth, Suzanne McCullagh, Norbert Middelkoop, Hermann Mildenberger, Charles Noble, Michiel Plomp, Achim Riether, the staff of the Rijks-bureau voor Kunsthistorische Documentatie, Andrew Robison, Martin Royalton-Kisch, Gregory Rubinstein, Inge Schoone, Ursula Sdunnus, Carel van Tuyll van Serooskerken, Françoise Souliér-François, Miriam Stewart, Andreas Stolzenburg, Dominique Surh, Carol Togneri, Ed van der Vlist, Margreet Wafelbakker, Arthur Wheelock, and Marieke de Winkel. We are especially grateful for the particularly generous loans from the Berlin Kupferstichkabinett, the British Museum, the Rijksmuseum, and the Louvre, which includes the Rothschild collection. We also thank the private lenders for their generosity.

At the Getty we are grateful for the efforts of Susan Amorde, Jeffrey Cohen, Mark Greenberg, John Harris, Elizabeth Burke Kahn, and the other members of Getty Publications, along with our able copy editor, Cynthia Newman Bohn, and our translators, Russell Stockman and Diane Webb; Merrit Price and Robert Checchi in Exhibition Design; Quincy Houghton and Susan McGinty in Exhibitions; Sally Hibbard and Kanoko Sasao in the Registrar's Office; Bruce Metro and the Preparators; Nancy Yocco, Lynne Kaneshiro, Stephen Heer, and Ron Stroud in Paper Conservation; and Gene Karraker in Paintings Conservation. I want especially to thank the fine staff in the Drawings Department. This catalogue would not have been possible without the thoroughness of Laura Patrizi, Senior Staff Assistant, and Victoria Sancho Lobis, Drawings Intern, who checked factual information, bibliography, and notes. Laura coordinated and input the authors' edits, and we owe her a huge debt of gratitude for this demanding task. Stephanie Schrader, Associate Curator of Drawings, was instrumental with the labels and interpretive components of the exhibition. I would like to thank Michael Brand, Director of the Getty Museum, and David Bomford, Associate Director for Collections, for supporting this ambitious exhibition and seeing its enormous value, despite this period of financial constraint.

Finally, we owe a debt of gratitude to Holm Bevers, Bill Robinson, and Peter Schatborn, whose scholarship, generosity, and good cheer have brought this great project to fruition.

Lenders to the Exhibition

Amsterdam, Historisch Museum

Amsterdam, Rijksmuseum

Berlin, Staatliche Museen, Kupferstichkabinett

Besançon, Musée des Beaux-Arts et d'Archéologie

Boston, The Maida and George Abrams Collection

Bremen, Kunsthalle

Budapest, Szépmüvészeti Múzeum

Cambridge, Harvard Art Museum / Fogg Museum

Chatsworth, The Duke of Devonshire and the Trustees
 of the Chatsworth Settlement

Chicago, The Art Institute of Chicago

Copenhagen, Statens Museum for Kunst

Darmstadt, Hessisches Landesmuseum

Dresden, Staatliche Kunstsammlungen, Kupferstich-Kabinett

Haarlem, Teylers Museum

The Hague, Koninklijke Bibliotheek

Hamburg, Kunsthalle

Leipzig, Museum der Bildenden Künste

London, The British Museum

London, The Samuel Courtauld Trust, The Courtauld Gallery

Los Angeles, The J. Paul Getty Museum

Munich, Staatliche Graphische Sammlung

New York, Sarah-Ann and Werner H. Kramarsky

New York, The Pierpont Morgan Library and Museum

Oslo, Nasjonalmuseet for kunst, arkitektur og design

Ottawa, National Gallery of Canada

Paris, École nationale supérieure des Beaux-Arts

Paris, Frits Lugt Collection, Institut Néerlandais

Paris, Musée du Louvre

Pasadena, Norton Simon Art Foundation

Rotterdam, Museum Boijmans Van Beuningen

Stockholm, Nationalmuseum

Vienna, Albertina

Washington, D.C., National Gallery of Art

Weimar, Klassik Stiftung, Graphische Sammlungen

Wroclaw, The Ossoliński National Institute

A number of generous private lenders

Rembrandt and His Pupils: A Timeline

S.A.C. Dudok van Heel

1600s

1606

Rembrandt is born on July 15 in Leiden to the miller Harmen Gerritsz van Rijn and the baker's daughter Neeltgen Willemsdr van Zuytbrouck. He is the youngest son in a family with at least ten children.

1610s

1613

Rembrandt attends the Latin school in Leiden.

1620s

1620

Rembrandt enrolls in Leiden University on May 29, presumably to study theology.

1621–24

Rembrandt is apprenticed in Leiden to the history painter Jacob Isaacsz van Swanenburg (1571–1638), from whom he learns the basic principles of painting.

1625

Rembrandt spends six months in Amsterdam as an apprentice of Pieter Lastman (1583–1633). A celebrated history painter, Lastman teaches Rembrandt the techniques of narrative painting, focusing especially on themes from the New and Old Testament and from ancient history.

1625–ca. 1633

Rembrandt sets up his first studio in his parents' house in Leiden. He and his fellow townsman Jan Lievens (1607–1674), who also apprenticed with Lastman for several years, encourage each other. Rembrandt teaches himself the art of etching and develops into a master printmaker.

1628–31

Gerard Dou (1613–1675) of Leiden becomes one of Rembrandt's first pupils.

The youthful work of Rembrandt and Lievens catches the eye of Constantijn Huygens (1596–1687), erudite secretary to Prince Frederik Hendrik. He praises Rembrandt's *Repentant Judas Returning the Pieces of Silver* of 1629 (England, private collection).

Isaack Jouderville (1612–1645/48) spends two years as Rembrandt's pupil and pays him 100 guilders a year—enough to support a laborer's family for months.

1631–35

In Amsterdam, Rembrandt paints his first commissioned portraits in the workshop of the painter and art dealer Hendrick Uylenburgh. These include the large group portrait *The Anatomy Lesson of Dr. Nicolaes Tulp*, commissioned by the surgeons' guild (The Hague, Mauritshuis).

1634

In the summer Rembrandt and Saskia Uylenburgh (1614–1642), a mayor's daughter from Leeuwarden, are married in Friesland. In the same year Rembrandt becomes a citizen of Amsterdam and enters the painters' guild, the Guild of St. Luke.

1635

On May 1, Rembrandt and Saskia Uylenburgh, who have been living with her first cousin Hendrick Uylenburgh, move into a rented house on the Nieuwe Doelenstraat (New Shooting Gallery Street). Their first child, Rombartus, is born here but does not live long. After leaving Uylenburgh's workshop and becoming an independent master, Rembrandt stops painting mainly portraits and concentrates on history subjects.

1635–36

Govert Flinck (1615–1660) spends a year as Rembrandt's pupil, probably after working for a while with Uylenburgh. Flinck presumably returned to Uylenburgh's workshop, where he took over Rembrandt's position as portrait painter.

1630s

1636

Ferdinand Bol (1616–1680) comes to work for several years in Rembrandt's studio.

On the basis of his early Rembrandtesque drawings it is assumed that Jan Victors (1619/20–after 1676) becomes a pupil of Rembrandt. According to the art theorist and biographer Arnold Houbraken, Gerbrand van den Eeckhout was also Rembrandt's pupil during the second half of the thirties.

1637

As of May 1, Rembrandt rents living and working space in a former sugar refinery by the Amstel River. In 1638 his daughter Cornelia is born there but does not live long.

1639

In January, Rembrandt purchases a house on the Sint Antoniesbreestraat (Saint Anthony's Broad Street) for the then vast sum of 13,000 guilders. He agrees to pay for it in installments. In order to make the first payment, he asks Prince Frederik Hendrik to pay for two of the seven paintings from the Passion series that the prince had commissioned in the 1630s (Munich, Alte Pinakothek). Centuries later, Rembrandt's splendid dwelling will become the Museum Het Rembrandthuis (Rembrandt House Museum).

1640

A second daughter, also named Cornelia, dies shortly after birth.

1641

In September, Rembrandt's only surviving son, Titus van Rijn (1641–1668), is born in the house on the Sint Antoniesbreestraat.

Samuel van Hoogstraten (1627–1678), who trained with his father in Dordrecht, comes to work in Rembrandt's studio after October 1641. In his 1678 book on the art of painting, he writes that Abraham Furnerius (ca. 1628–1654) and Carel Fabritius (1622–1654) were fellow pupils in Rembrandt's studio.

1642

Rembrandt completes his masterpiece *The Night Watch,* a group portrait of the civic militia company led by Captain Frans Banninck Cocq (1605–1655) (Amsterdam, Rijksmuseum). Not long after this, Saskia Uylenburgh dies (on June 14) and is buried in Amsterdam's Oude Kerk (Old Church). Geertje Dircks (1590/1610–ca. 1656), the childless widow of a trumpeter, assumes the task of caring for Titus. She also becomes Rembrandt's mistress.

1640s

ca. 1648

Willem Drost (1633–1659) becomes Rembrandt's pupil during the second half of the 1640s. This talented pupil leaves for Italy in about 1655, a trip that Rembrandt himself never makes. According to Houbraken, Nicolaes Maes (1634–1693) of Dordrecht "learned the art of painting from Rembrandt." The precise dates of his training in Amsterdam remains undocumented, but he probably entered the workshop in the late 1640s.

1649

After eight years in Rembrandt's employ, Geertje Dircks leaves his service in June. She lodges a complaint against Rembrandt for breaking his promise to marry her, whereupon the court orders him to pay her an annual allowance of 200 guilders. Hendrickje Stoffels (1626–1663), a sergeant's daughter from Bredevoort, takes Geertje's place as Rembrandt's domestic servant. She soon becomes his mistress.

The erudite Constantijn Daniel van Renesse (1626–1680), according to an inscription on the back of a drawing (see fig. 30a), was in Rembrandt's studio for the second time on October 1, 1649. It appears that he, as an amateur artist, took occasional drawing lessons from Rembrandt from 1649 to around 1652/53, and perhaps even later.

1652

Pieter de With (active second half of the seventeenth century) is connected to Rembrandt on the basis of the style of his drawings and etchings. The same motifs occur in the landscape drawings of both artists.

1654

In the summer, the church council bars Hendrickje Stoffels from observance of the Lord's Supper because of her extramarital relationship with Rembrandt. In October she gives birth to a daughter, Cornelia, who is baptized on October 30 in the Oude Kerk (Old Church). Rembrandt is registered as the child's father.

1650s

1656

After several years of financial difficulties, Rembrandt applies to the court in The Hague for *cessio bonorum* (surrender of goods), a form of insolvency that prevents creditors from negotiating the amount of repayment of his debt. This makes it necessary to draw up an inventory of his paintings and art collections, which must now be sold.

1658

After the sale of his house and collections, the painter and his family move to rented accommodations on the Rozengracht (Rose Canal) in a working-class district of Amsterdam. Hendrickje Stoffels and Rembrandt's son Titus take over the running of Rembrandt's art business.

ca. 1661–62

Johannes Raven (1634–1662) is thought to have been one of Rembrandt's pupils because they both drew the same model in the early 1660s.

ca. 1661–63

According to Houbraken, Arent de Gelder spends two years as Rembrandt's pupil in this period, having been apprenticed around 1660 to Samuel van Hoogstraten in Dordrecht.

1662

Rembrandt is given the opportunity to paint *The Conspiracy of Claudius Civilis* for the new town hall (now the Royal Palace) of Amsterdam. The painting is deemed unsatisfactory for reasons that remain unclear. Rembrandt never receives another government commission. He crops the canvas of *Claudius Civilis* (Nationalmuseum, Stockholm).

In this same period Rembrandt paints the group portrait *The Syndics of the Clothmakers' Guild* (Amsterdam, Rijksmuseum).

1660s

1663

Hendrickje Stoffels dies during a plague epidemic and is buried on July 24 in the Westerkerk (West Church) in Amsterdam.

1668

Titus van Rijn, trained since childhood in his father's studio, marries Magdalena van Loo (1641–1669) on February 28 in the Nieuwe Kerk (New Church) in Amsterdam. He dies several months later during a visit to Leiden and is buried on September 7 in the Westerkerk (West Church) in Amsterdam.

1669

Rembrandt's granddaughter Titia van Rijn (1669–1725) is born after the death of her father and baptized on March 22.

Rembrandt dies on October 4 and is buried on October 8 in the Westerkerk (West Church).

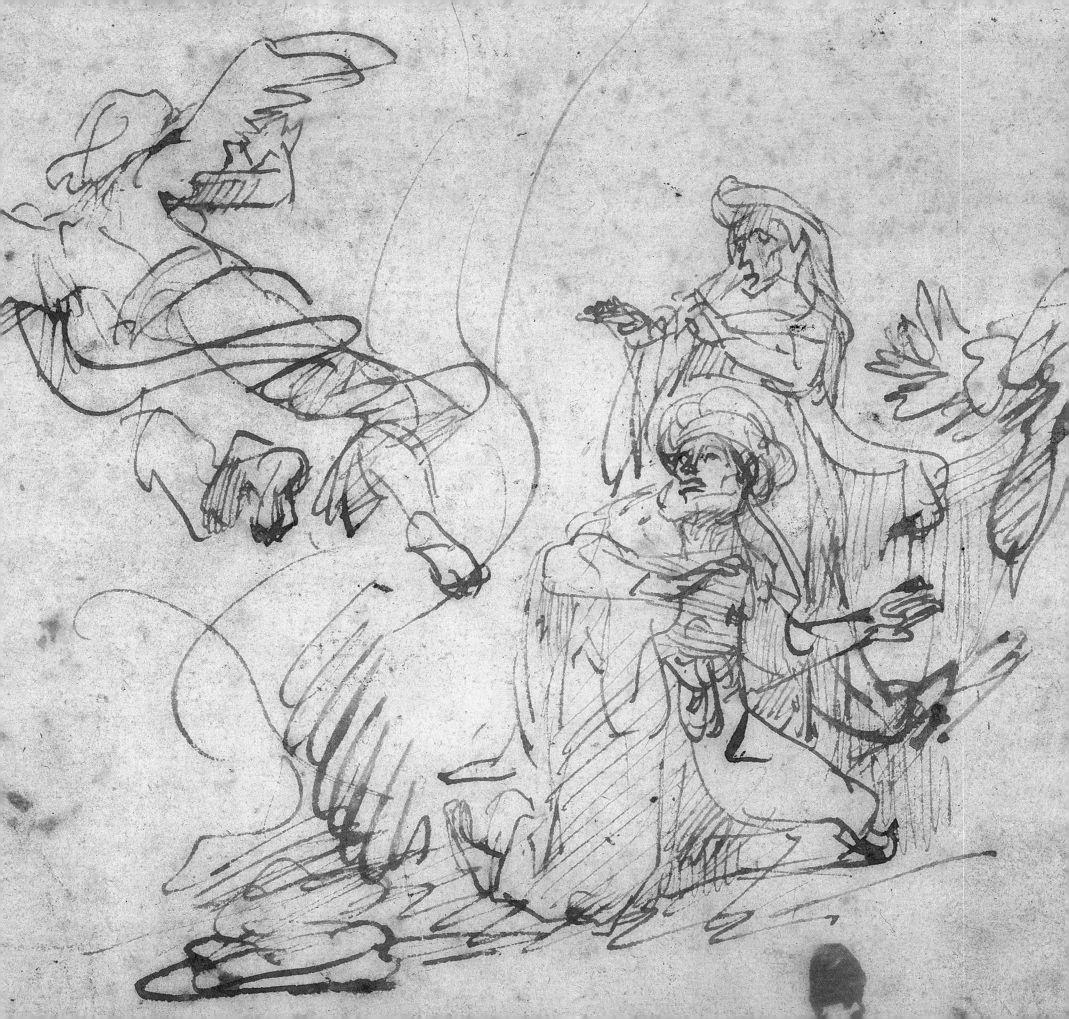

HOLM BEVERS

Drawing in Rembrandt's Workshop

The source for the great stylistic similarity between drawings by Rembrandt and those of his pupils lies in the method of teaching within the master's workshop.[1] His assistants sought to imitate their master's style as precisely as possible, and moreover favored the same drawing techniques and subject matter. Since they executed their own drawings in his spirit, they frequently look similar to works by Rembrandt himself, so that now it is often very difficult to distinguish among their hands. None of Rembrandt's pupils was able to fully free himself from his master's formative influence. Their attempts to imitate him generally prevented them from developing drawing styles of their own until later, after they had left Rembrandt's workshop, and in many cases they continued to follow his example even after that point. The same can be said, mutatis mutandis, of the paintings of Rembrandt's pupils. In Dutch workshops it was customary for pupils and assistants to work in the style of the master, and they were not permitted to sign their own names to their work.[2] In a typical example, the Dutch artist-biographer Arnold Houbraken relates that the early paintings of Govert Flinck were so similar to Rembrandt's that many of them were taken to be works by his teacher and sold as such, and that he only later turned away from Rembrandt's style.[3] One can also apply this to Flinck's early drawings, wholly in the style of Rembrandt, that have only recently been attributed to Flinck (cat. nos. 4–6).

During the roughly forty years of his artistic career, Rembrandt had numerous pupils, and thus his own artistic output went hand in hand with his teaching. His pupils came not only from Holland but also from Germany, Flanders, and Denmark. Very little is known about his teaching methods, and there are virtually no documents directly relating to them. There are a few hints in the

1 For drawing instruction in Rembrandt's workshop, see Hofstede de Groot 1915; Haverkamp-Begemann in Chicago, Minneapolis, and Detroit 1969–70; Haverkamp-Begemann 1972; Sumowski 1983; Schatborn in Amsterdam 1984–85; Ketelsen 2006; Blanc 2006; Döring 2007. For drawing instruction in Holland generally, see Walsh 1996.
2 Van de Wetering 1986, pp. 49–50, 57.
3 "He was advised to study with Rembrandt for a year. Ultimately he became accustomed to handling pigments and painting technique, which he soon managed to imitate so well that many of his works were taken to be genuine products of Rembrandt's brush and sold as such. But later it was only with the greatest difficulty and effort that he managed to put aside this way of painting" (vond hy zig geraden een Jaar by Rembrant te gaan leeren; ten einde hy zig die behandeling der verwen en wyze van schilderen gewendde, welke hy in dien korten tyd zoodanig heeft weten na te bootzen dat verscheiden van zyne stukken voor echte penceelwerken van Rembrant wierden aangezien en verkocht. Doch hy heeft die wyze van schilderen naderhant met veele moeite en arbeid weer afgewent). Houbraken 1718–21, vol. 2, p. 21.

writings of his pupil Samuel van Hoogstraten (1627–1678; see cat. nos. 22–24), and there are second-hand comments by Hoogstraten's own pupil Arnold Houbraken (1660–1719), but these must be treated with a certain skepticism, inasmuch as they reflect their authors' personal views. In addition, there are a few pictorial documents that provide glimpses of Rembrandt's atelier and the master's teaching. Far more can be deduced from the surviving drawings by the master and his pupils.

We do not know precisely how many pupils and assistants passed through Rembrandt's workshop. Some twenty names are mentioned in old documents or reliable sources, and roughly another thirty artists are either named in other sources or are identifiable thanks to their stylistic similarity to Rembrandt.[4] For example, there are no documents confirming that Jan Victors apprenticed under Rembrandt, yet this appears to be highly likely owing to the distinctly Rembrandtesque style of his early drawings (cat. nos. 18–19). The German painter Joachim von Sandrart, who lived in Amsterdam from 1637 to 1645 and most likely knew Rembrandt, speaks of the countless apprentices who sought instruction in Rembrandt's workshop.[5] Sandrart's comment refers to the master's Amsterdam years. It was apparently only after he left the workshop of Hendrick Uylenburgh in May 1635 and moved into his new house in the Nieuwe Doelenstraat that Rembrandt accepted pupils of his own. This is suggested by the sudden rise in the numbers of both his own drawings and drawings by pupils after the mid-1630s. Govert Flinck appears to have been one of the first, after having presumably worked alongside Rembrandt in Uylenburgh's workshop (cat. nos. 3–7). Also among the early pupils from the second half of the 1630s were three artists included in this exhibition and its catalogue: Ferdinand Bol (cat. nos. 8–12), Gerbrand van den Eeckhout (cat. nos. 13–17), and Jan Victors (cat. nos. 18–19). Rembrandt continued to teach after moving to his imposing house and atelier on the Sint Antoniesbreestraat in 1639. Numerous pupils are known from the 1640s, for example, Abraham Furnerius (cat. no. 25), Carel Fabritius (cat. nos. 20–21), and Samuel van Hoogstraten (cat. nos. 22–24), all of whom entered his workshop in the first half of the decade, and Willem Drost (cat. nos. 33–35), Nicolaes Maes (cat. nos. 26–29), and Constantijn Daniel van Renesse (cat. nos. 30–32), who arrived somewhat later and stayed with Rembrandt into the early 1650s. Fewer apprentices are known from the late 1650s, and two of his apparently rare pupils from the 1660s were Johannes Raven (cat. nos. 42–43) and Arent de Gelder (cat. nos. 39–41).

Yet even in his Leiden years, between roughly 1626 and 1633, it is possible that Rembrandt had other apprentices beyond the two whose names are documented, Gerard Dou and Isaak Jouderville. We also know that during Rembrandt's stay in the Uylenburgh workshop between roughly 1631 and 1635, when he was mainly executing portrait commissions, other artists assisted him in this work.[6] These were not pupils in the true sense. One can thus assume that in addition to the roughly fifty pupils whose names we know, there were numerous anonymous pupils, whose names have been forgotten. Taking into account Sandrart's assertion that each year some twenty to twenty-five pupils trained under Gerard van Honthorst in The Hague and in Utrecht,[7] the number of Rembrandt's apprentices could also have been quite considerable. Their parents were required to pay him tuition, as was the case with other artists, but for Rembrandt the fee was quite high. Sandrart reports the figure of 100 guilders a year.[8] Documents attesting to this fee survive for one of his pupils; in six receipts, Rembrandt confirmed that he received a total of 200 guilders for instructing Isaak Jouderville in the period between November 1629 and November 19, 1631.[9] Presumably this sum covered only tuition and the cost of materials, not room and board.

4 Broos 1983, p. 44; Sumowski 1983, p. 10; Van de Wetering 1986, p. 45; Van de Wetering in Kassel and Amsterdam 2001–02, p. 60; Liedtke 2004, p. 68.

5 "and fills his dwelling in Amsterdam with innumerable well-to-do children there for instruction and teaching" (und seine Behausung in Amsterdam mit fast unzahlbaren fuernehmen Kindern zur Instruction und Lehre erfuellet). Sandrart 1675 and 1679, part 2, book 3, p. 326.

6 Van der Veen in London and Amsterdam 2006, pp. 136–37.

7 Sandrart 1675 and 1679, part 2, book 3, p. 303.

8 "each of which pays him as much as 100 guilders a year" (deren jeder ihme jaehrlich in die 100. Gulden bezahlt). Sandrart 1675 and 1679, part 2, book 3, p. 326.

9 Strauss and Van der Meulen 1979, nos. 1630/2, 1630/2, 1630/4, 1631/3, 1631/7, 1631/9, 1631/10; Van de Wetering 1983, pp. 59–69.

Gerard van Honthorst and Gerard Dou in Leiden charged a similar amount. Teaching was thus highly lucrative for painters. Sandrart recounts that Rembrandt earned between 2,000 and 2,500 guilders a year from sales of his pupils' works alone,[10] though this amount appears to be exaggerated. Moreover, one must take into account the fact that fully trained assistants involved in workshop production were doubtless no longer required to pay any tuition fees.

Rembrandt provided training to individuals at various stages of their artistic development. Young beginners, who customarily entered a workshop at around the age of twelve to serve a proper apprenticeship, which in Holland usually lasted three years, barely appear in his studio. This small group includes Dou and Jouderville. Most of his pupils had already completed an apprenticeship elsewhere and came to him later, often at around the age of twenty. This corresponded to Rembrandt's own training; he first apprenticed under the Leiden painter Jacob Isaacsz van Swanenburg from roughly 1621 to 1624, and then for six months in 1625 he received further training in narrative painting from the Amsterdam painter Pieter Lastman. Gerbrand van den Eeckhout, for example, had received his first artistic training from his father, a goldsmith. Willem Drost most probably came to study with Rembrandt from Samuel van Hoogstraten, Rembrandt's former pupil, as did Arent de Gelder. These "pupils" were thus not young apprentices but as a rule were fully schooled journeymen or assistants who received further training in Rembrandt's workshop. They were given final polish, as it were, becoming qualified in their teacher's particular field while employed with Rembrandt as assistants before setting out on their own.

Working under a second master after preliminary training was altogether common in Holland. Rembrandt's pupils appropriated the master's style and assisted him; one of their tasks in the early years of the studio, between roughly 1628 and the end of the 1630s, was producing copies of his paintings for the market.[11] Another group of pupils comprised interested laymen, so-called *dilettanti*, who went to Rembrandt for instruction in drawing. Since the Renaissance, drawing had been considered an essential component of a prince's or well-to-do burgher's humanistic education, and cultivated Dutchmen, many of them jurists, dabbled in it. Constantijn Daniel van Renesse, for example, who is known to have studied drawing with Rembrandt in the late 1640s and early 1650s, was by profession the town clerk in Eindhoven. The fact that so many young artists and dilettanti chose Rembrandt as a teacher surely reflects the major reputation that he had acquired quite early in his career. People obviously went to Rembrandt to learn the new way of painting, or working method (*handeling*). In addition, it was surely known that Rembrandt owned a large and important art collection, and that these engravings, drawings, and sculptures by other masters served as important instructional aids. We do not know just how long a pupil normally stayed in Rembrandt's workshop. Apparently a few of his apprentices remained only a short time, while others served the customary term of three years. And some, like Van Renesse, appear to have visited the master's atelier sporadically. It also seems that some of his pupils remained in contact with Rembrandt even after leaving his workshop (see p. 102).

Rembrandt's workshop seems to have functioned more like an informal private academy, which sought to set itself apart from the rigid apprentice system of Holland's predominant painting guilds.[12] The master may have deliberately patterned it after the academy of the Carracci in Bologna, established in 1582 and active until roughly 1610.[13] A distinguishing feature in this respect was its acceptance of pupils and assistants of various ages and backgrounds, especially assistants who had already been trained elsewhere. The involvement of cultivated laymen in drawing

10 "that also amount to from 2,000 to 2,500 guilders in cash" (der sich auch in die 2 bis 2500 Gulden baares Gelds belauffen). Sandrart 1675 and 1679, part 2, book 3, p. 326.

11 Franken in Amsterdam and Berlin 2006, pp. 159–67.

12 Haverkamp-Begemann 1972, pp. 105–6.

13 See Dempsey 1986–87; Feigenbaum 1993; Pfisterer in Berlin 2007–08, nos. 20–21.

instruction also links Rembrandt's atelier with the Carracci academy. And, finally, the emphasis on life drawing (nudes) and drawing in nature—to be discussed below—seems to confirm the connection. We can assume that within the atelier there was discussion of theoretical questions in addition to practical instruction. We know that Rembrandt's workshop was visited by art lovers and connoisseurs, and on those occasions they would have had debates about art and about how pictures were conceived and composed.[14] His pupils could well have overheard these conversations and even participated in them. Finally, it must be noted that in his instruction Rembrandt not only made his pupils strive for mastery in drawing but also expected his apprentices to work on large canvases, to which his pupils' painted copies and the variations on his own works attest. This is another feature that links his atelier with the Carracci academy.[15] In one pupil's drawing (fig. i), attributed to Samuel van Hoogstraten,[16] a young artist is depicted seated at a large easel, painting a double portrait of a married couple. The husband has just stood up to check the artist's progress. A second young artist is seated on the left working on a drawing, and in the background on the right, an apprentice is busy grinding pigments.

Since most of his pupils had already completed an apprenticeship elsewhere, Rembrandt had no need to teach such fundamental tasks as preparing the master's palette and grinding colors. His pupils' chief activities were copying other works of art—engravings or etchings, drawings, paintings, and three-dimensional sculptures, including his own works as models. One was supposed to learn through imitation, just as recommended by both Willem Goeree in his drawing manual *Inleydinge tot de Alghemeene Teycken-Konst* (*Introduction to the General Art of Drawing*) of 1668 and Rembrandt's pupil Samuel van Hoogstraten in his treatise *Inleyding tot de Hooge Schoole der Schilderkonst* (*Introduction to the Illustrious School of the Art of Painting*), published in 1678.[17] Basically, one can say that Rembrandt's teaching emphasized specific kinds of workshop activities at certain times and at other times pursued these less intensively.[18] The dramatic increase in the number of pupils' drawings of biblical subjects in the early 1650s doubtless is connected to the fact that in this period Rembrandt produced a group of narrative drawings, homogenous in style and concept—among them cat. nos. 31 and 34—that obviously served as models for drawing instruction.[19]

The drawing *Christ Disputing with the Scribes* by an unknown pupil from the first half of the 1650s in the Museum voor Stad en Lande, Groningen,[20] which is reminiscent of Willem Drost in style, was based on Rembrandt's two etchings of the same subject from 1652 and 1654.[21] The group of scribes around Christ derives from the earlier of the two compositions, while the men listening behind the balustrade on the right are borrowed from the etching made two years later. This example makes it clear that Rembrandt gave his pupils a great deal of freedom when "copying" his works. This is also encountered in his pupils' copies, or variations after his own paintings, exemplified by *The Sacrifice of Isaac* from 1636 in the Alte Pinakothek, Munich, most likely the work of Govert Flinck, which was based on Rembrandt's autograph version of the subject from 1635, now in St. Petersburg.[22] This practice recalls Van Hoogstraten's recommendation to would-be artists not to copy other artists' engravings slavishly but to freely select from them, adopting perhaps only single elements such as heads, nude figures, or specific details of movement, in order to inspire inventions of their own: "When you are looking at a fine engraving, it is not always necessary that you copy it completely, but rather learn early on to distinguish what is best in art . . . do not follow unquestioningly the things that lie before you, but determine for yourself what makes them

14 Van de Wetering in Kassel and Amsterdam 2001–02, pp. 27–32.
15 Pfisterer in Berlin 2007–08, nos. 20–21.
16 Paris, Musée du Louvre, RF 690; Sumowski, *Drawings*, 1167a.
17 Goeree 1668, pp. 13ff.; Van Hoogstraten 1678, pp. 26–27.
18 Bruyn in Berlin, Amsterdam, and London 1991–92, vol. 1, p. 72.
19 See also Bruyn 1983, pp. 54–55; Robinson 1987, pp. 249–52.
20 Benesch A 87; Amsterdam 1984–85, nos. 59–60.
21 B. 64 and 65.
22 *Corpus*, III, no. A 108 and copy 2; Francken in Amsterdam and Berlin 2006, p. 161; Dekiert 2004.

Figure i. Samuel van Hoogstraten
Artist in His Studio Painting a Double Portrait, ca. 1640–45
Pen and brown ink, brush and brown wash,
17.5 × 23.4 cm (6⅞ × 9³⁄₁₆ in.)
Paris, Musée du Louvre, Département des Arts graphiques, RF 690

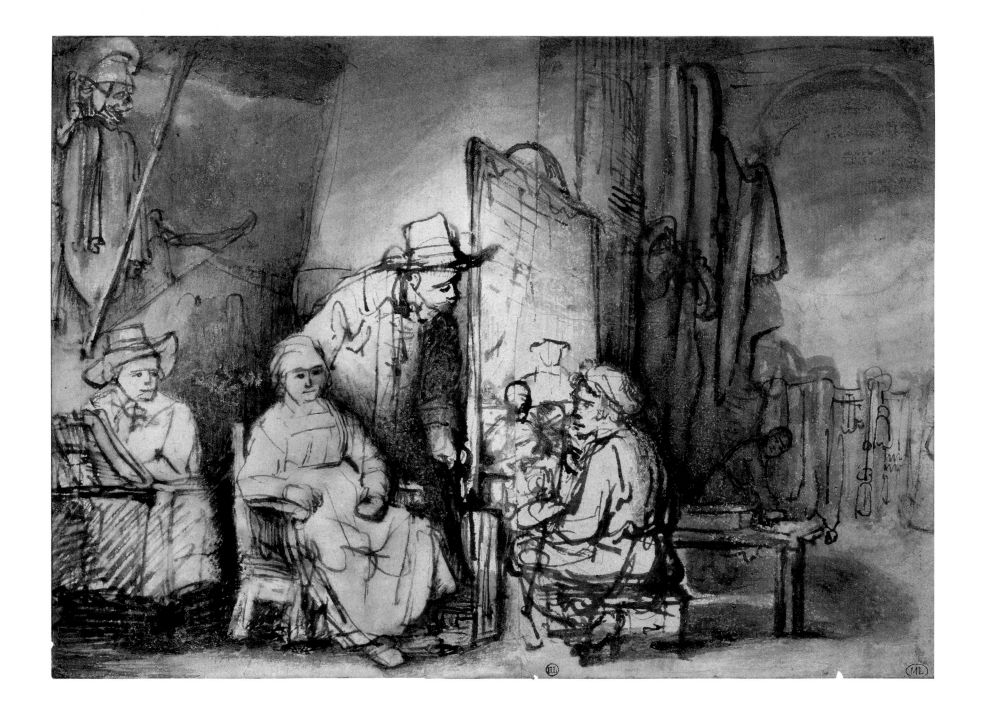

Figure ii. **Rembrandt**
An Artist in His Studio, ca. 1630
Pen and brown ink, 20.5 × 17 cm (8¹/₁₆ × 6¹¹/₁₆ in.)
Los Angeles, The J. Paul Getty Museum, 86.GA.675

23 "Komt u een goede prent voor, 't en
zal niet altijts noodich zijn, dat gy
dezelve in al haer deelen nateykent,
maer leer al vroegh de deuchden
der konst onderscheyden. . . . Volch
de dingen, niet alleen, zoo als gy
die voor u ziet, maer onderzoekt zelf,
waer in derzelver deucht bestaet."
Van Hoogstraten 1678, p. 26.

24 Sumowski, *Drawings*, 273ˣ; Amsterdam
1984–85, nos. 49–50.

25 B. 35. A number of counterproofs
survive.

26 New York, The Metropolitan Museum
of Art, Walter C. Baker Bequest,
1972.118.285; Benesch A 105a. It has
been proposed that this could be a
pupil's copy after Mantegna's prelimi-
nary drawing for the engraving,
which was once owned by Rembrandt;
Royalton-Kisch and Ekserdjian 2000.

27 Berlin, Staatliche Museen, Kupfer-
stichkabinett, KdZ 13733; Bock and
Rosenberg 1930, vol. 1, p. 243.

28 "Maer boven al zoo onderzoek de
deucht van een goede ordinantie. 't Is
een groot geluk zeer goede teykenin-
gen, om een goede handeling te leeren,
al vroech na te teykenen; want zoo
vint men in korten tijt 't gunt andere
lang zochten. Anders vervalt men
licht in een quaede manier, die men
namaels bezwaerlijk kan verlaten."
Van Hoogstraten 1678, p. 27.

29 Benesch 390.

30 Van de Wetering in Leiden 1976–77,
pp. 26–29.

31 Hendrix in Goldner and Hendrix 1992,
no. 103.

praiseworthy."[23] Another example is a drawing exhibited here, Gerbrand van den Eeckhout's *Cruci-fixion* (cat. no. 13.2), which was based on two Rembrandt etchings from circa 1636 and 1640. While this particular drawing was produced while Van den Eeckhout was still working in Rembrandt's workshop, Rembrandt's etchings also occasionally provided models for his pupils even after they had left the master's atelier. Ferdinand Bol's sketch *The Sacrifice of Isaac* in a private collection in Amsterdam, dating from the second half of the 1650s,[24] corresponds in its essential features to Rembrandt's etching of the same subject from 1655, although in reverse. Bol could have based his drawing on a counterproof of the print that also presented the composition in mirror image.[25]

Just like Rembrandt himself, his pupils also found models in the graphic works by past masters. Rembrandt's wide-ranging art collection encompassed engravings and woodcuts by Albrecht Dürer and Lucas van Leyden, for example, and prints after famous Italian Renaissance masters. Thus there are drawings by his pupils after Andrea Mantegna's engraving *The Entomb-ment of Christ*[26] and after a reproduction of Raphael's fresco *The Repulse of Attila*.[27]

Examples of his pupils' variations after engravings of older masters and after Rembrandt's etchings are nevertheless rather rare. Far more common are their renderings after Rembrandt's drawings, some of which are discussed in the present catalogue. Samuel van Hoogstraten also addresses this, a practice with which he was familiar from his own years as a Rembrandt appren-tice. Only in so doing could one most effectively discover the *ordinantie* (composition) or the *handeling* (working method), that is, the proper way of constructing a picture and making it tell a story: "Above all, strive to acquire the virtue of a good *ordinantie*. It is of great benefit to copy very good drawings early on, in order to learn a good style of drawing. For in this way one quickly dis-covers that which others search for at length." At the same time, the correct way of drawing, which is to say "style," should be learned by imitation: "Otherwise one falls into an unfortunate habit that one can only unlearn with great effort."[28] Before discussing this central feature of Rem-brandt's instruction in greater detail, let us first mention other stages in his method of instructing pupils in the art of drawing.

It appears that Rembrandt studied the rules of perspective in his early years, and his teach-ing certainly included the fundamentals of geometry and perspective, tools that always figured in an artist's initial training. A Rembrandt drawing in the Getty Museum depicts a painter holding a maulstick, palette, and brushes and leaning against the back of a chair as he studies a painting resting on an easel (fig. ii).[29] Next to the easel is a large stone for grinding pigments, and in the background other pictures appear to be stacked against the wall. The painter has been identified as Rembrandt's friend and colleague Jan Lievens (cat. nos. 1–2), as his features recall those in portraits of the artist. The drawing, executed around 1630, can be understood as encapsulating the artist's formation of an idea when contemplating his first rough sketch.[30] Of interest are the perspective lines radiating from an invisible point outside the space of the picture to the right and connecting to various parts of the composition—the painting, the feet of the easel, etc.—to indicate the perspective foreshortenings.[31] These lines were drawn by Rembrandt himself and were added only after the objects in the image had been sketched. Accordingly, he did not use them to construct his composition but rather added them after the fact to demonstrate pictorial construction by means of auxiliary perspective lines. Indeed, this suggests that Rembrandt drew them to illustrate a point to his pupils.

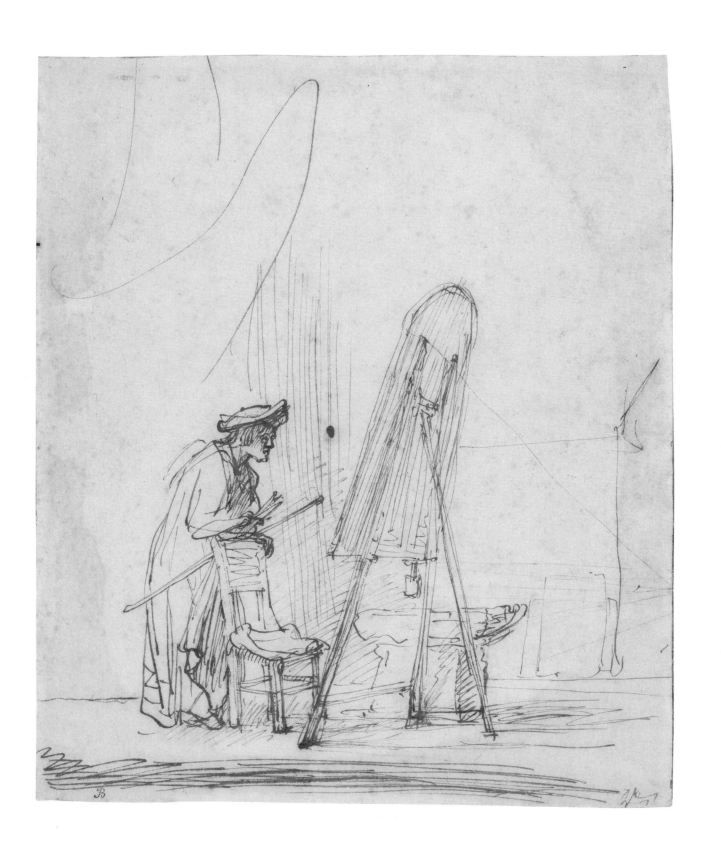

Figure iii. Constantijn Daniel van Renesse
Rembrandt and His Pupils Drawing from a Nude Model, ca. 1650
Black chalk, brush and brown wash, heightened with white,
18 × 26.6 cm (7⅛ × 10½ in.)
Darmstadt, Hessisches Landesmuseum, AE 665

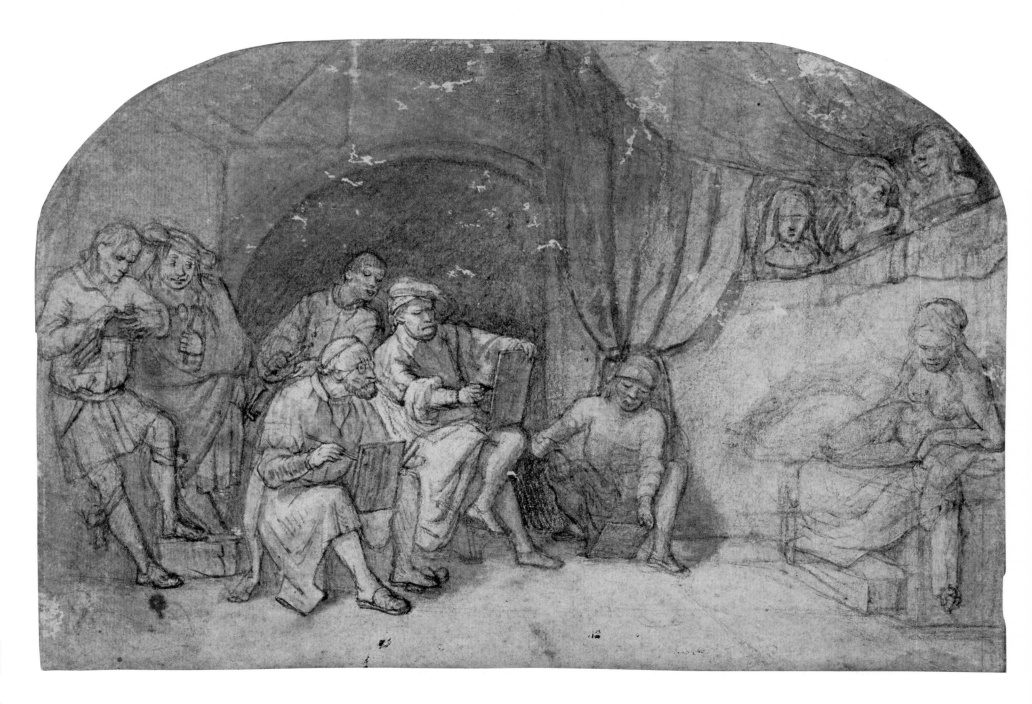

A third stage involved copying "multicolored paintings" in "monochrome drawings," as Samuel van Hoogstraten put it.[32] In doing so, one first made a crude sketch of the subject before proceeding to the details. This sort of sketch in thin lines preparatory to developing the composition in detail is a typical feature of Rembrandt's drawings. Drawings after paintings are extremely rare, and they do not appear to have played any significant role in Rembrandt's teaching. They are mainly found in the work of Ferdinand Bol, between roughly 1636 and 1640/41, the period in which he was active in Rembrandt's workshop, and then again during the mid-1640s.[33] For example, Bol copied Rembrandt's 1635 painting *Saskia as Flora*, in the National Gallery, London,[34] in a painterly brush drawing in the British Museum, London.[35] It is not impossible that Bol produced the drawing as a record of a copy that he had made of Rembrandt's painting. On the verso of the drawing *Susanna at Her Bath* in the Berlin Kupferstichkabinett from circa 1636, one encounters notes in Rembrandt's hand referring to the sale of paintings by his pupils. Among them there is mention of two versions of the *Flora*, one executed by Leendert Cornelisz van Beyeren, the other presumably by Bol.[36] This could also explain Bols's other drawings after Rembrandt paintings, works that record painted copies by him and other pupils. The drawings are then not so much student exercises as documentation of painted copies. This brings up an important feature of Rembrandt's workshop regimen: his pupils were expected to produce full-scale copies of his own paintings. Not only did they learn how to paint in the process, but the finished works could be sold—as noted on the Berlin drawing—at a considerable profit to their master.[37] One well-known example is the aforementioned *Sacrifice of Isaac* from 1636.[38] The 1637 inventory drawn up by the painter and art dealer Lambert Jacobsz, who worked with Hendrick Uylenburgh, lists various painted copies after Rembrandt. These were presumably paintings that had been produced in Uylenburgh's atelier.[39]

After executing copies after paintings, the next step in learning to draw was sketching three-dimensional sculptures, commonly plaster casts of classical works, as Willem Goeree, for one, relates.[40] Van Hoogstraten has little to say about this, and judging from surviving drawings after sculptures, his teacher Rembrandt had little interest in this as well. Nevertheless, Rembrandt is known to have owned twelve busts of Roman emperors; at least three drawings after them still survive.[41] It is quite possible that these served as instructional and study material in his workshop, although there are no known pupil drawings after them.[42] One could, however, point to a drawing by Constantijn Daniel van Renesse in Darmstadt (fig. iii) that depicts several artists, among them one with Rembrandt's features, drawing a nude female model.[43] Standing on a railing behind the model are a few portrait busts, which in the context of this depiction of drawing from life may allude to the previous exercise of drawing sculptures. There is also a diminutive Rembrandt etching from 1641 that depicts a young man making a pen drawing of a bust (probably a plaster copy) by candlelight (fig. iv).[44] Concentrated study by candlelight was regarded as proof of dedication and perseverance, indicating that this sheet may symbolize the kind of industry extolled in the ancient saying *nulla dies sine linea*—let no day pass without drawing a line. Simultaneously, Rembrandt's etching portrays *disegno* as a glimmer of creativity and perception in the darkness of uncertainty.[45] This small etching underscores how important it was to master the representation of the human figure. Goeree remarks that drawing after plaster casts is a necessary "preparation for drawing from life."[46] Casts of ancient and Italian Renaissance sculptures were employed in the teaching of drawing, along with casts of body parts like hands, arms, and heads,

32 Van Hoogstraten 1678, p. 27: "om veelwerwige Schilderyen in eenverwige teykeningen na te klaren."

33 One example is Barend Fabritius's colored drawing *Susanna at Her Bath* from circa 1646 in Budapest, which reproduces an intermediate state of Rembrandt's 1647 painting *Susanna at Her Bath* in Berlin's Gemäldegalerie; Sumowski, *Drawings*, 823ˣ.

34 Oo,10.133, Sumowski, *Drawings*, 127ˣ. Other Bol copies after paintings by Rembrandt are his *Minerva in the Studio* in the Rijksprentenkabinet, Amsterdam, 1975:85 (Sumowski, *Drawings*, 126ˣ), *The Standard Bearer* in the British Museum, London, Oo,10.132 (Sumowski, *Drawings*, 128ˣ), and *Portrait of Rembrandt* in the National Gallery of Art, Washington, D.C., 1943.3.1503 (Sumowski, *Drawings*, 142ˣ).

35 *Corpus*, III, no. 112.

36 Benesch 448; Bevers 2006, no. 18. For the text, see also Strauss and Van der Meulen 1979, pp. 594–95.

37 Broos 1983, p. 41; Van de Wetering 1986, pp. 60ff.; Franken in Amsterdam and Berlin 2006, pp. 159ff.

38 See p. 4 and note 22.

39 Strauss and Van der Meulen 1979, no. 1637/4.

40 Goeree 1668, pp. 15–16.

41 Benesch 452, 770, and 770a. The bankruptcy inventory of 1656 also lists two portfolios of drawings after ancient sculptures: "A portfolio containing antique drawings by Rembrandt. / Another [book] with statues drawn from life by Rembrandt." (Een paquet vol antickse teeckeninge van Rembrant. / Een dito [boeck] vol Statuen van Rembrant nae 't leven geteeckent). Strauss and Van der Meulen 1979, no. 1656/12, nos. 251 and 261.

42 Bevers 2006, no. 26.

43 Amsterdam 1984–85, no. 7; Märker and Bergsträsser 1998, no. 32.

44 B. 130.

45 Pfisterer in Berlin 2007–08, p. 110.

46 "een inleydinge is tot het leven." Goeree 1668, p. 15; discussed by Kwakkelstein in Goeree 1668, pp. 96–97.

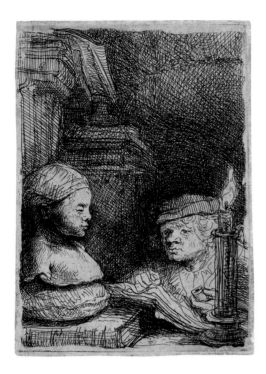

Figure iv. Rembrandt
A Pupil Drawing from a Plaster Cast, ca. 1641
Etching, state 1, 9.2 × 6.3 cm (3⅝ × 2½ in.)
Paris, Frits Lugt Collection, Institut Néerlandais, 727

47 Walsh 1996, pp. 51–52, 65–67.

48 "A studie of a head made from gypsum; two naked children made from gypsum; some hands and heads made from life; 17 hands and arms, made from life."(Een tronie van pleijster; Twee naeckte Kinderkens van Pleijster; Een groote pertije handen en tronien op 't leven afgegooten; 17 handen en armen, op 't leven afgegoten). Strauss and Van der Meulen 1979, no. 1656/12, nos. 1, 7, 316 1, and 317.

49 "Zit steyl overeyndt, en beur u papier of teykenboek met de linkerhandt ook steylachtich, op dat gy uw oog en hooft in het opzien niet de veel hebt op te staen." Van Hoogstraten 1678, p. 26.

50 One thinks especially of the two engravings depicting drawing lessons in the "academy" of Baccio Bandinelli by Agostino Musi, called Veneziano, and Enea Vico from 1531 and circa 1561; B. 418 and 49; Pfisterer in Berlin 2007–08, nos. 24–25.

51 "mans- of vrouwe-naekten nae 't leven in de warme stooven te teykenen." Van Hoogstraten 1678, p. 294.

52 Benesch 1129; Koblenz, Göttingen, and Oldenburg 2000, no. 52.

53 Benesch 1161; Berlin, Amsterdam, and London 1991–92, vol. 2, p. 116, no. 33.

which are frequently seen as props in depictions of artists' ateliers.[47] Rembrandt's bankruptcy inventory mentions a number of casts of body parts and entire figures for use in his workshop.[48]

The previously mentioned Van Renesse drawing in Darmstadt illustrates the next step in drawing instruction: drawing from a live model. It also provides one of the few glimpses of Rembrandt's atelier and the artistic practices within it. Here we see several men gathered around a master with Rembrandt's features, all of them drawing a nude female model. The master braces his vertical drawing board on his knee, just as Van Hoogstraten recommends: "Sit erect and hold up your paper or sketchbook with your left hand, so that you do not need to lift up your eyes or head too much."[49] His head tilted slightly back, he is gazing at the motion of his hand in respect to the lines he has just drawn. One young man is looking over his shoulder, and next to him sits an older man who appears to have paused for a moment to study the model. A man leaning against the wall on the left is drawing in a sketchbook, and the assistant next to him is looking to see how Rembrandt is working. Still another apprentice seated on the right is contemplating the sheet lying in front of him. One wonders to what degree this drawing represents an eyewitness account of everyday workshop practice or whether it is simply an idealized scene in an academy, for which there are numerous precedents in Italian art.[50] Even if this is not a totally accurate record, reality could not have looked so very different. The drawing also confirms that the assistants in Rembrandt's atelier were of different ages. Another drawing from the Rembrandt circle in Weimar depicts a quite similar atelier scene, but there the female model is standing up (fig. 43a). This could be an old copy after a pupil's drawing produced during the same lesson, with the model recumbent in the one and standing in the other.

Two studies of a seated female nude by Rembrandt and Arent de Gelder (cat. no. 41) were apparently produced in the same sitting. They depict the same model, one from the back and the other seen from a different angle. In the background of the pupil's drawing there is a suggestion of the stove that provided the necessary warmth for the model. In his 1678 treatise on art, Samuel van Hoogstraten speaks of apprentices who enter drawing schools and academies "in order to draw male or female nude models from life by warm stoves."[51] Another Arent de Gelder drawing shows a female nude seated on an elevated stool with three draftsmen visible sitting at her feet.[52] These drawings were made in the early 1660s, when De Gelder was serving a second apprenticeship under Rembrandt. At that same time the virtually unknown Johannes Raven was also working in Rembrandt's workshop, and he also drew female nude models together with his teacher (cat. nos. 42–43). But one can see that Raven studied not only the model seated before him but also Rembrandt's drawing, which he used as a guide for his own, as clearly indicated by his rendering of the woman's right hand. In Van Renesse's drawing in Darmstadt (fig. iii) there is also a young artist peering inquisitively over his master's shoulder to see how he should proceed.

To judge from the surviving drawings, notably the examples just discussed, during the mid-1640s and at the beginning of the 1660s, Rembrandt and his pupils devoted particular attention to the study of nudes. Yet there is also evidence of such activity from the early 1650s. Besides the aforementioned drawing by Van Renesse, there is a surviving Rembrandt drawing showing his atelier with a nude female model, possibly his second wife, Hendrickje Stoffels (fig. v).[53] It probably depicts the *Groote Schildercaemer* (Large Painting Studio) in Rembrandt's house on Sint Antoniesbreestraat, which he was forced to leave in 1658. The lower window shutters are closed, and curtains are affixed to the ceiling. Bright light falls from the upper windows onto the figure

Figure v. Rembrandt
Rembrandt's Studio with a Model, ca. 1654–55
Pen and brown ink, brush and brown wash, heightened with white,
20.5 × 19 cm (8⅛ × 7½ in.)
Oxford, Ashmolean Museum, P.I.192 (WA1855.8)

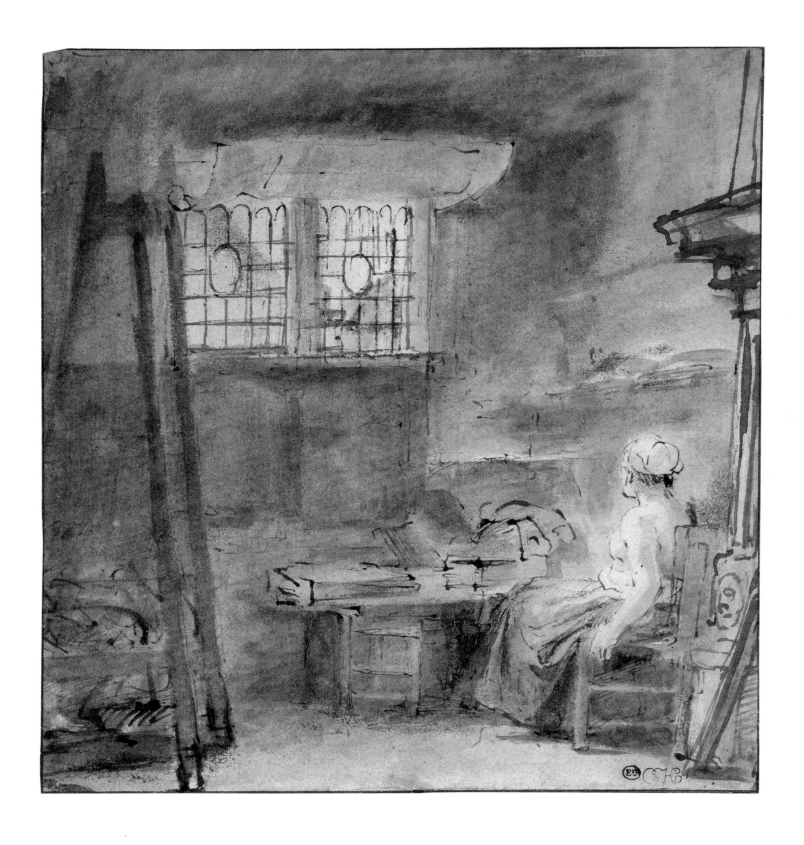

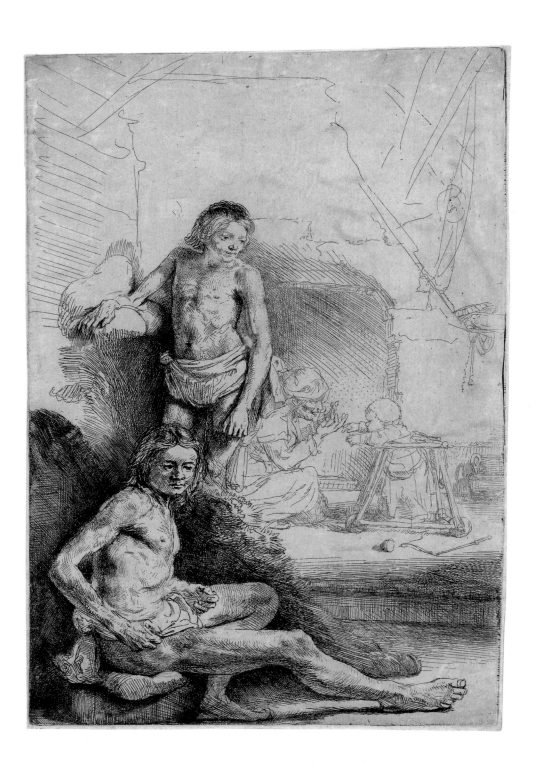

of a woman seated next to a fireplace with her back to the viewer. On the left stands an easel on which a canvas has been placed, and behind it there is the suggestion of a chair with what may be a painter's smock lying across it. In front of the window stands a table with a lectern of the sort that Rembrandt used when making drawings and etchings. To the right of the table is a cradle, probably belonging to Rembrandt and Hendrickje's infant daughter Cornelia, born in 1654.

Most of the pictorial documentation of the method of instruction carried out in Rembrandt's workshop depicts drawing from life, as in the atelier scene in Darmstadt (fig. iii). In the mid-1640s, Rembrandt produced three etchings of male nudes that were executed in direct connection with drawing instruction in his atelier. Two of them depict a young man wearing a loincloth; in one he is seated on a stool and seen from the front, in the other he sits on the floor and is viewed from the side.[54] The third sheet, for centuries known as *Het Rolwagentje ("The Walking Trainer")* (fig. vi),[55] depicts in the foreground two young men dressed only in loincloths. Both figures represent the same model; apparently Rembrandt drew him twice on the same plate. He first worked out the seated figure, then added the standing one.[56] In the background, rendered with more delicate lines, a woman teaches a child to walk in a wheeled trainer. The print represents the theoretical maxim that admonishes young artists to be unflaggingly conscious of the necessity of study. Just as the tiny child in the wheeled trainer has to learn to walk, the aspiring artist must constantly practice and thereby perfect his craft through drawing. The comparison is frequently encountered in seventeenth-century texts. For example, the poet Joost van den Vondel explains that "Those who wish to learn something must not be discouraged by initial difficulty. Small children learn to walk by holding onto chairs and benches. Later, having become bolder and stronger, they venture to let go of them and no longer require any support. If one were not to proceed in just this way, one would allow himself to be too blinded by his own illusions, and would commit gross errors, thinking himself cleverer than his teacher."[57]

It is revealing that there are four surviving drawings from Rembrandt's workshop that depict the same model as in the etching. One shows the seated young man from the front, and three show the same slender youth standing. When studying the sheets and comparing them to the print *Het Rolwagentje*, one has to bear in mind that the figures appear in mirror-image reversal to those in the etching. The standing model in the drawing in the Albertina, Vienna (fig. vii), attributed to Carel Fabritius,[58] is depicted from almost the same vantage point as is the youth in the print; also identical are the twist of his head and the position of his arms, one of which rests on a cushion. A drawing in the Louvre, Paris (fig. viii), shows the young man in the same pose, only from a slightly different vantage point farther to the right. This drawing, attributed to Samuel van Hoogstraten,[59] confirms that Van Hoogstraten and Carel Fabritius worked with Rembrandt at the same time, as Van Hoogstraten himself relates.[60] In a sheet by an unknown pupil in the British Museum, London (fig. ix), the model is depicted from a vantage point still farther to the right; here he is shown frontally and his head is turned more to the left.[61] The unsigned etching *Het Rolwagentje* can be dated to the year 1646, on the basis of two further etchings by Rembrandt, which are thematically and stylistically closely related—both with depictions of single nude male models—and which bear this date.[62]

Obviously, the pupils' three studies of the standing nude were produced during the same sitting, for they all show the same model seen from slightly different vantage points, suggesting that the three artists were seated next to each other. Simultaneously, Rembrandt was no doubt

Figure vi. Rembrandt
Male Nudes Seated and Standing ("The Walking Trainer"), ca. 1646
Etching, state 1, on Japanese paper, lightly retouched by a later hand in grayish brown ink, 18.9 × 12.8 cm (7⅝ × 5¹⁄₁₆ in.)
Paris, Frits Lugt Collection, Institut Néerlandais, 2486

54 B. 193 and 196.

55 B. 194.

56 Hinterding in Amsterdam and London 2000–01, no. 51.

57 "Wie leerzaam is, late zich de beginsels, die altijt moeielijck vallen, niet verdrieten. De kleenen leeren zoo aen stoelen en bancken gaen; daer na, stouter en steviger geworden, durvenze afsteecken, en behoeven geene ondersteunsels meer: anders vergaept men zich te verwaent aen eige inbeeldingen, en vervalt in grove misslagen, terwijl men wijzer dan zijn leitsman will geacht zijn." Quoted from Emmens 1968, p. 156. See also Franken in Amsterdam and Berlin 2006, p. 176.

58 Benesch 709; Schatborn 2006, pp. 136–37; see cat. no. 21.

59 Benesch A 55; Sumowski, *Drawings*, 1253ˣ.

60 Van Hoogstraten 1678, p. 11.

61 Benesch 710; Royalton-Kisch 1992, no. 87; Royalton-Kisch 2008–9, no. 71.

62 B. 193 and 196.

Figure vii. Carel Fabritius
Standing Male Nude, ca. 1646
Pen and brown ink, brush and brown wash, white gouache
heightening, 19.8 × 13.3 cm (7¹³⁄₁₆ × 5¼ in.)
Vienna, Albertina, 8827

OPPOSITE
Figure viii. Samuel van Hoogstraten
Standing Male Nude, ca. 1646
Pen and brown ink, brush and brown wash, white gouache
heightening, 24.7 × 15.5 cm (9¾ × 6⅛ in.)
Paris, Musée du Louvre, Département des Arts graphiques, RF 4713

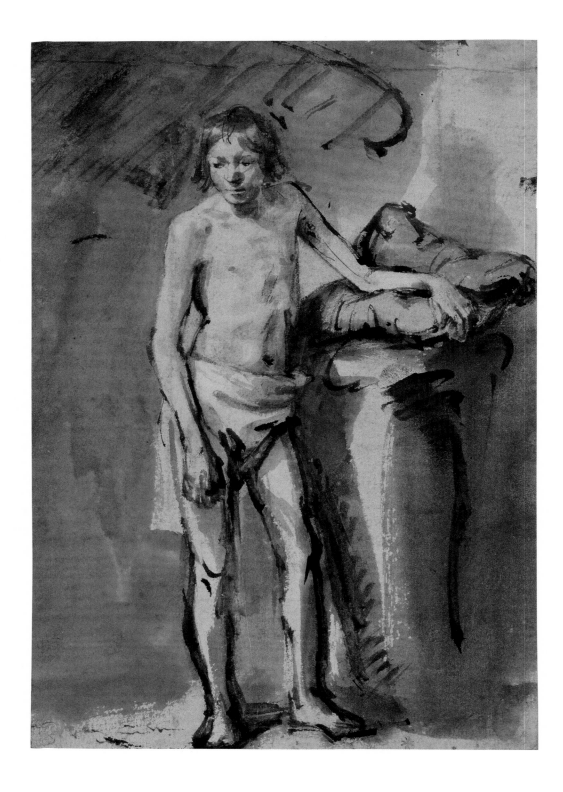

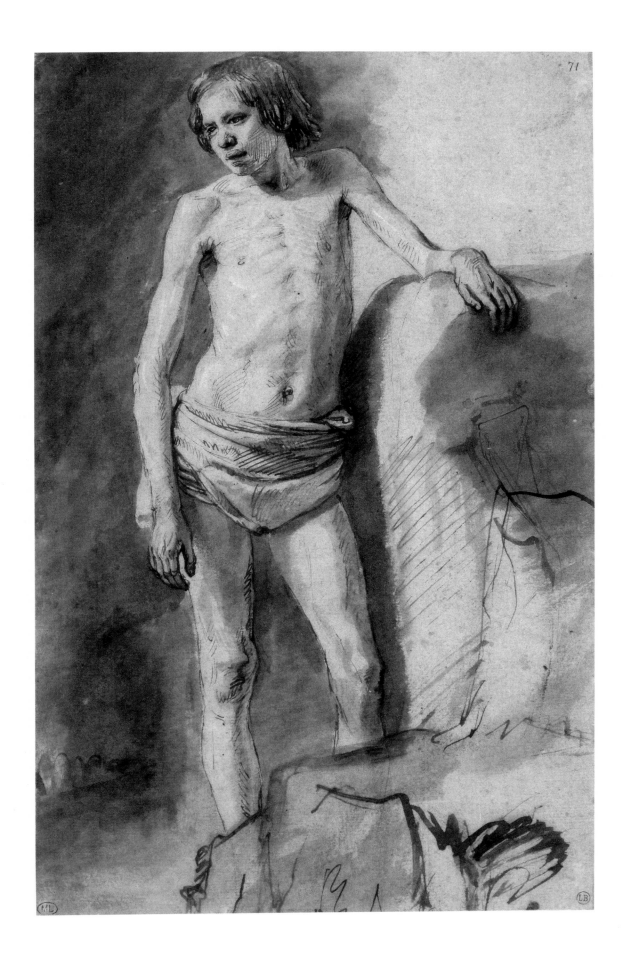

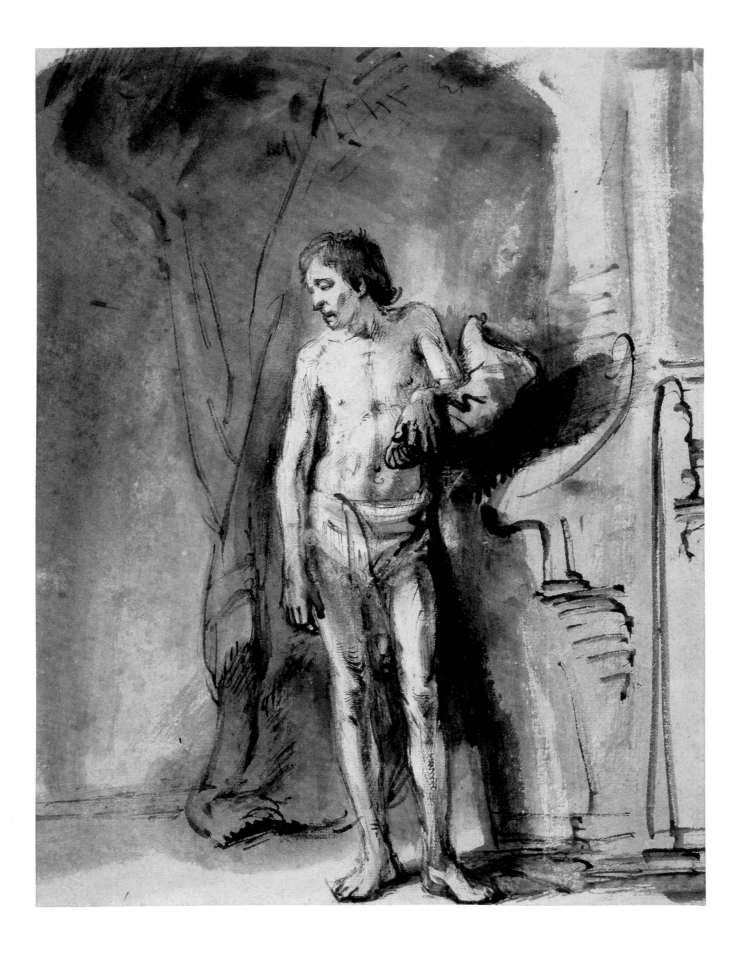

drawing from the model directly into the layer of varnish on his copper plate, intending to further develop his composition at a later date. While so doing, he was seated a bit to the right of Carel Fabritius, as indicated by a comparison of the model's poses. Samuel van Hoogstraten was seated to Rembrandt's right. There is yet another Samuel van Hoogstraten drawing in a Dutch private collection that depicts a young seated man much like the one in Rembrandt's etching.[63] In the case of the seated model as well as the standing one, we can assume that Rembrandt drew on his copper plate while his pupil sketched the model with his pen. Presumably the model in both the drawings and the etching was one of Rembrandt's apprentices. This is entirely in accordance with the traditional practice in the Italian academies, where apprentices and assistants also served as nude models.[64]

Arnold Houbraken recounts that Rembrandt rented a separate building divided into compartments in which his pupils could devote themselves to the study of models: "For his host of apprentices he rented a warehouse on the Bloemgracht, where each of them was given a small cubicle marked off by paper or canvas, so that they could paint from life without disturbing each other."[65] This report is confirmed by a document concerning the sale of Rembrandt's house on the Sint Antoniesbreestraat in 1658. There we read that in Rembrandt's atelier there were small teaching spaces separated by curtains or movable walls.[66]

Rembrandt's three etchings of nude young men also served as model studies to be used as sources by the pupils. A drawing by a pupil in the British Museum, London, depicting a flute player seated on the floor, is based on the seated model in the etching *Het Rolwagentje*.[67] In 1745, Antoine-Joseph Dezallier d'Argenville, the French writer on art, reports that Rembrandt assembled a small primer: "son livre à dessiner est de dix à douze feuilles" (His drawing book has ten to twelve sheets).[68] Although no copy survives, it is nevertheless entirely plausible that Rembrandt created a little instructional book on drawing, with etched illustrations for internal use in his workshop. It would have included the etchings of nude models, the small print *A Pupil Drawing from a Plaster Cast* (fig. iv), and possibly some of his sketches of heads.[69] This is suggested by the similarity between the academic poses of the nude models in Rembrandt's etchings and corresponding illustrations in contemporary drawing manuals, such as that of Crispijn van de Passe the Younger.[70]

Another etching might also have been a part of this drawing manual (fig. x). In it an artist whose face is reminiscent of that of Rembrandt is seated and draws a female nude model, who probably represents an allegory of fame and truth.[71] Behind him a bare, unpainted canvas rests on an easel, and hanging on the wall next to it are standard atelier props such as a shield, a sword, a quiver, a drinking bottle, and a feather hat. The art of painting is suggested by both the canvas and the shield (Dutch *schild* = shield; *schilder* = painter; *schilderkunst* = painting). The wider subject is the glorification of drawing as the basis of painting, i.e., its soul, as Goeree put it in 1668.[72] The unfinished part of the composition, executed only in lines, alludes to line itself as the essence of drawing. Simultaneously, this section refers to the manner and method whereby the draftsman should proceed, first loosely outlining his composition and then going on to develop the composition more fully, beginning with the background and working toward the front.[73]

In a later example Rembrandt again drew a female nude model directly on the copper plate while another pupil, Johannes Raven, sketched the same woman from a different vantage point (cat. no. 42). In considering the nude studies by Rembrandt and his pupils, one notes that the

63 Sumowski, *Drawings*, 1250ˣ.
64 Meder 1919, pp. 214, 382–83.
65 "Daar zynde vloeide hem het werk van alle kanten toe; gelyk ook menigte van Leerlingen, tot welken einde hy een Pakhuis huurde op de Bloemgraft, daar zyne leerlingen elk voor zig een vertrek (of van papier of zeildoek afschoten) om zonder elkander te storen naar 't leven te konnen schilderen." Houbraken 1718–21, vol. 1, p. 256.
66 There we read "of various cubicles that had been set up there in the attic for his pupils" (van diversche afschutsels, op de solder voor sijn leerlingen aldaer gestelt). Strauss and Van der Meulen 1979, no. 1658/3.
67 Benesch 710a; Royalton-Kisch 1992, no. 98.
68 After Emmens 1968, p. 157.
69 B. 363, 365–70.
70 Van de Passe 1643. See Berlin, Amsterdam, and London 1991–92, pp. 224–26, no. 21.
71 B. 192.
72 "Teyckenkonst is de ziel van de Schilderkonst." Goeree 1668, p. 3.
73 Van Hoogstraten 1678, p. 27.

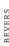

emphasis was placed less on the precise rendering of anatomy than on the three-dimensional modeling of the body through light and shadow. Samuel van Hoogstraten lamented that Rembrandt unfortunately cared little about capturing the beauty of his models' bodies and poses when drawing nudes: "To be sure, when I look at my old academy drawings I regret that we were so poorly taught in our youth. For it is no more work to capture a graceful pose than an unpleasant and offensive one."[74]

Judging from the works that survive, Rembrandt's main emphasis in his teaching was on copying and producing variations of his own drawings, especially narrative compositions. Nevertheless, one must not conclude that this aspect of his training methods functioned in an overly inflexible or didactic way. His pupils did not always base their drawings on Rembrandt's work, but rather only occasionally, and they also made different kinds of imitations. Sometimes they copied Rembrandt's entire composition, but never slavishly; they tended to introduce variations of their own. At other times they borrowed only specific motifs or figures from his drawings, employing them in new contexts. Finally, Rembrandt's compositional style, specifically the way he grouped figures, could become the starting point for a pupil's drawing of an entirely different subject. Consistently, however, they attempted to imitate Rembrandt's drawing technique and style, hence the frequent mistaken attributions of his pupils' works to Rembrandt himself.

There are virtually no direct, slavish copies of his works from Rembrandt's immediate circle. As a rule, those that do survive are the work of later artists imitating drawings that came on the market after the sale of Rembrandt's possessions in 1658 and after his death in 1669. The collection of copies after Rembrandt in the Herzog Anton Ulrich-Museum in Braunschweig (see later discussion in this essay and note 100) appears to comprise just such works. Rembrandt and his pupils often depicted the same themes, primarily biblical subjects, with the master's paintings, etchings, and drawings inspiring his pupils' derivative variants. The Old Testament stories of Tobias and Hagar were especially popular. They portrayed all of the episodes from the story of Tobias, one of the books of the Apocrypha, especially Tobias's journey with the angel, the healing of his father's blindness, and the departure of the angel.[75] Most of the drawings on these subjects were formerly thought to be by Rembrandt himself, but recent scholarship has determined that only a very few are by him. The majority should be attributed to his pupils, known or unknown. Rembrandt's strong impact on his pupils' compositions is evident, for example, in Willem Drost's drawing *The Angel Departing from the Family of Tobit* (cat. no. 33.2), which was mostly based on Rembrandt's etching of the same subject of roughly ten years earlier. Other drawings of scenes from the Tobias legend by Rembrandt's pupils also borrow from his compositions.

There are more than one hundred surviving drawings from the Rembrandt circle that treat the story of Hagar, and the same can be said of these. The poignant scenes in which Hagar is dismissed by Abraham and she becomes lost in the wilderness are the ones most frequently illustrated.[76] Rembrandt's psychologically penetrating 1637 etching of Hagar's dismissal[77]—particularly the figure of the weeping Hagar and that of the boy Ishmael seen from the rear—clearly made a great impression on his pupils and inspired numerous variations.

The proliferation of compositions on a particular subject occurs in other examples as well. We do not know precisely how drawing *uyt de geest* (from the imagination) was handled in Rembrant's atelier, specifically as it concerned the depiction of historical subjects. It is possible that he allowed his pupils to study his own drawn examples or those by other artists, however briefly,

Figure x. Rembrandt
Artist Drawing from the Model, ca. 1639
Etching, drypoint and burin, 23.4 × 18.3 cm (9¼ × 7¼ in.)
Washington, D.C., National Gallery of Art,
Print Purchase Fund (Rosenwald Collection), 1968.4.1

74 "Zeker, ik beklaeg my, wanneer ik mijn oude Academiteykeningen overzie, dat men ons daer van in onze jonkheyd zoo spaerich heeft onderrecht; daer het niet meer arbeyt is een graesselijk postuur, dan een onaengenaem en walgelijk na te volgen." Van Hoogstraten 1678, p. 294.

75 Rotermund ca. 1960; Held 1964 and Held 1991; Tümpel and Schatborn 1987.

76 Hamann 1936.

77 B. 30.

before repeating them from memory. Or perhaps he permitted them to work directly from those examples. It is also conceivable that Rembrandt at times even held actual competitions in which his pupils were asked to produce drawings on a given theme; we know that this was the practice in the Carracci academy in Bologna.[78] One can assume, albeit without concrete proof, that on such occasions they were required to interpret the assigned subject by using only their imaginations. Six similar sheets from the beginning of the 1650s, dealing with the story of Adam and Eve and their sons Cain and Abel, suggest that Rembrandt and various pupils all treated this subject, possibly at the same time, and perhaps as a group exercise. Rembrandt's *Cain Slaying Abel* and Willem Drost's *Lamentation on the Death of Abel* depict successive events in the same story (cat. no. 34), and the pupil's drawing exhibits close parallels in composition and style to that of his master. This could indicate that both were produced at the same sitting, and that the younger man looked over the master's shoulder. Of course it is equally possible that he consulted his teacher's drawing at some later date and from it developed the idea to depict a different moment from the same story.

Numerous drawings demonstrate how biblical stories were illustrated in groups and series in Rembrandt's workshop based on his own examples. Additionally, it is important to distinguish between those sheets produced in the workshop itself, when their authors were active members and were to some extent working under Rembrandt's direction and oversight, and those produced by pupils who had left his atelier. Indeed, a number of them maintained contact with Rembrandt and apparently still had access to their teacher's drawings, as is indicated by their continued imitation of him and regard for his work as a model. And it is possible that, even after their apprenticeship had ended, they continued to join him in life drawing sessions or sketching trips in the landscape. In order to explain the influence of later Rembrandt drawings on former apprentices who were already independent, one must assume that they still occasionally drew with him and had access to the drawings in his atelier. Obviously, after Rembrandt's estate sale in 1658, his drawings became publicly available.

Govert Flinck's *Joseph in Prison Interpreting the Dreams of Pharaoh's Baker and Butler* is a free variation on the drawing of the same subject by Rembrandt (cat. no. 7), and in it he closely followed the style of his model. The pupil's drawing was doubtless executed at the same time as that of Rembrandt. Ferdinand Bol's *Christ as a Gardener Appearing to Mary Magdalene* is strongly indebted to his teacher's drawing in composition and style (cat. no. 12). The two sheets can be dated to circa 1640, around the time Bol left Rembrandt's workshop. It is uncertain whether he produced his version while he was still there or shortly thereafter. In any case, even as an independent painter Bol continued to imitate Rembrandt until roughly 1650, which could indicate that he had recourse to his teacher's drawings after his departure from Rembrandt's atelier. Gerbrand van den Eeckhout's *A Quack and His Public* shows how significantly one of his pupils could rework an original Rembrandt drawing. Yet despite all Van den Eeckhout's changes and reorganization, close analysis reveals its basis in the original by Rembrandt (cat. no. 15).

Samuel van Hoogstraten, who worked for Rembrandt as an assistant in the 1640s, imitated him for a long time thereafter. *Peter's Vision of the Unclean Beasts* from circa 1646–47 closely follows Rembrandt's version of the same subject (cat. no. 23), especially in its constituent parts, while its painterly, colorful execution displays considerable differences in technique and style. The style of his *Baptism of the Eunuch* is more like that of Rembrandt (cat. no. 24), though this drawing was obviously executed some years after his departure from Rembrandt's workshop and after his

78 Dempsey 1986–87, pp. 36–37;
 Feigenbaum 1993, p. 62.

travels to central Europe and Vienna (1651–56). Rembrandt's *Simeon and the Christ Child* and the drawing of the same subject by Arent de Gelder (cat. no. 40) display such stylistic similarities that it seems virtually certain that the younger man, who studied under Rembrandt in the early 1660s, saw his teacher's drawing in the atelier.

It is possible that Rembrandt's teaching, as discussed above, emphasized that the students make variants on their master's versions. Yet one also notes that sometimes a specific iconography was employed for a different subject but with a related motif. For example, it appears that Gerbrand van den Eeckhout knew the subject of Saint Paul Preaching in Athens—rarely depicted in the art of Northern Europe—from Marcantonio Raimondi's engraving after Raphael. Yet he based his interpretation of the subject on Rembrandt's painting *Saint John the Baptist Preaching* (cat. no. 14), which also depicts a speaker standing before an audience. And Drost's *Angel Departing from the Family of Tobit* borrows compositional elements not only from Rembrandt's aforementioned 1637 etching but also from one of his teacher's drawings on a related theme, *Manoah's Offering* (cat. no. 33), in which another divine messenger takes flight.

Rembrandt's pupils certainly copied from engravings by earlier masters, and at times also borrowed from drawings by foreign artists in Rembrandt's collection. An unknown pupil from the early 1650s executed *The Sermon of Saint Mark*,[79] a quite faithful imitation of a drawing by an early-sixteenth-century northern Italian artist.[80] This latter sheet, now at Chatsworth, comes from the collection of Nicolaes Anthoni Flinck (1646–1723), the son of Rembrandt's pupil Govert Flinck. It can be assumed with some certainty that it was originally in Rembrandt's collection —as part of the large number of landscape drawings in the Duke of Devonshire's collection at Chatsworth that belonged to Rembrandt before they came into Flinck's possession.[81] Another of Rembrandt's pupils, possibly Pieter de With, copied a Titian landscape drawing that is also now at Chatsworth.[82] Copying drawings not only served as a useful exercise but also was the only way to make duplicates of originals. Rembrandt himself drew copies and variations of designs by his teacher Pieter Lastman and by Italian masters such as Leonardo (*The Last Supper*, which he knew from engravings); he even drew copies of Indian miniatures. This material was available to his pupils as well.

As a major part of their instruction in drawing, Rembrandt's pupils were clearly encouraged to develop their own compositional ideas. As a result, the sources of multiple renderings of a single subject, such as the story of Cain and Abel, are somewhat unclear. Many drawings by pupils that Benesch (see the following essay in this volume) still catalogued as works by Rembrandt cannot be traced back to prototypes by the master, and it is altogether possible that these have been lost. Carel Fabritius, one of Rembrandt's most gifted and independent pupils, depicted two subjects (cat. nos. 20 and 21) that—to the best of our knowledge—were never treated by Rembrandt or only taken up by other pupils. In such instances, Rembrandt's pupils were obviously indebted to him not for their subject matter but only for their drawing style. Still, working up their own inventions did not preclude their consultation of prototypes by other masters. *Imitatio* was not considered a sign of insufficient imagination but was rather seen as proof of an artist's comprehensive knowledge and acculturation. Artists were expected to compete with famous predecessors and to attempt to surpass them. This was the prevailing notion of the time, and Rembrandt doubtless imparted this idea to his pupils. Jan Victors based his *Lot and His Family Departing from Sodom* on an engraving after Rubens's composition of the same theme, yet, for his depiction

79 New York, Pierpont Morgan Library and Museum, I, 206; Benesch A 104; Turner 2006, p. 165, no. 245. Here attributed to Lattanzio da Rimini.
80 Jaffé 1994, vol. 2, no. 809.
81 Jaffé 2002, vol. 3, nos. 1472–1500.
82 Bevers 2006, pp. 205–6.

of the two major figures, he borrowed from a design by his teacher in which there are also two figures departing on a sojourn (cat. no. 19). Another Victors drawing shows that sometimes his teacher's compositional style—the way he arranged figures in space and developed their movements and gestures, his rhetorical organization of the subject, as it were—could serve as the starting point for the depiction of a wholly different subject (cat. no. 18). These examples demonstrate how numerous the variations among Rembrandt's pupils' drawings could be, and how differently they went about devising new pictorial solutions.

Narrative drawings *uyt de geest* (from the imagination) posed varying degrees of difficulty. Achieving successful results required constant practice and correction, adherence to the rules of composition, especially a balanced distribution of figural groupings, and drawing from one's observations *naar het leven* (from life). As Samuel van Hoogstraten put it: "In order to arrange compositions skillfully and properly, I recommend making numerous sketches and drawing any number of narrative scenes on paper, for theory will be of little use to you if you have not acquired it through practice. It will be most helpful to the pupil to turn to drawing narrative scenes '*uyt de geest*' in the evening, when tired of painting. In doing so, one should sometimes refer to and make use of what one has produced '*nae 't leven*'."[83]

Rembrandt and some of his pupils not only drew nude models together but also seem to have gone walking together on occasion in the immediate environs of Amsterdam in order to draw from nature. Rembrandt's etching *Cottage and Farm Buildings with a Man Sketching* (fig. xi) from roughly 1641[84] provides a glimpse of the process. A draftsman wearing a hat is seated in the right-hand corner on the ground. He gazes at the half-ruined farmstead as he records it in a drawing. His point of view is nearly the same as the viewer's, which heightens the scene's sense of immediacy. It is possible that Rembrandt drew on the copper plate directly in front of the motif, capturing one of his colleagues or pupils who was drawing to his left—here seen on his right as a result of the reversal in printing the plate. The appearance of the same landscape motifs from slightly different vantage points in numerous drawings by Rembrandt and his pupils (cat. nos. 25, 35, 37, 38) confirms that they often went outside to capture impressions from nature. If these were in fact made on location, the teacher and his pupil would have been seated next to each other. But the slight differences in motif between their drawings could also suggest that such works were not executed at precisely the same moment (cat. no. 37). It is altogether possible that in some cases a pupil took one of his teacher's landscape drawings as a model in the workshop and produced a slightly altered variation of his own—a practice, as described above, common enough in the imitation of narrative scenes (cat. no. 38).

One difficult problem, and one that is still debated, concerns Rembrandt's corrections to his pupils' drawings, visible especially on certain works from the early 1650s. The corrections are obvious from their heavier and broader lines made with a reed pen. They tend to give clearer structure to individual figures and pictorial details, accenting and thereby emphasizing the action in a biblical event and in turn underscoring its content. Rembrandt occasionally corrected his pupils' paintings as well; one example is the above-mentioned *Sacrifice of Isaac*. The Munich version bears the inscription: *Rembrandt. verandert. En overgeschildert 1636* (Rembrandt changed and overpainted 1636), which could refer to minor corrections that he made on his pupil's picture, even though these are difficult to identify. The inscription might also be explained through the example of a chalk and wash drawing by Rembrandt in the British Museum, which was apparently

83 "Den wegh, om zeker en gewis in het ordineeren te worden, is, dat men zich gewenne veel Schetssen te maken, en veel Historyen op 't papier te teykenen; want de wetenschap zal u weynich dienen, zoo gyze door geen oeffening vast krijgt. Het zal een leerling zeer vorderlijk zijn, als hy vermoeit is van't penseel, des avonts zich tot het teykenen van Historien uyt de geest te begeven, daer in somtijts te passe brengende 't geene hy nae 't leven heeft opgegaert." Van Hoogstraten 1678, p. 191.

84 B. 219.

Figure xi. Rembrandt
Cottage and Farm Buildings with a Man Sketching, ca. 1641
Etching, 13.5 × 21 cm (5⁵⁄₁₆ × 8¼ in.)
Pasadena, Norton Simon Art Foundation, M.1977.32.069G

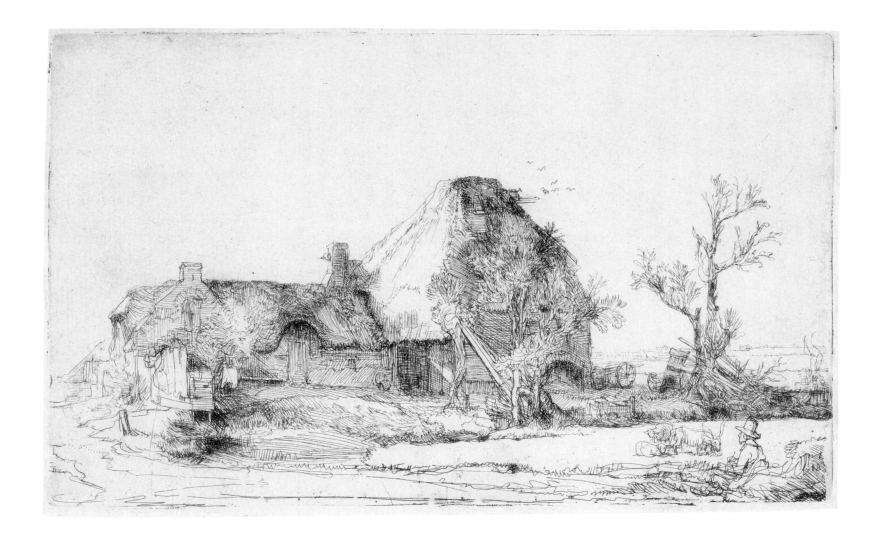

Figure xii. Constantijn Daniel van Renesse and Rembrandt
The Annunciation, ca. 1650–52
Black and red chalk, pen and brown ink, brush and brown wash,
heightened with white, 17.4 × 23.1 cm (6 13/16 × 9 1/8 in.)
Berlin, Staatliche Museen, Kupferstichkabinett, KdZ 2313

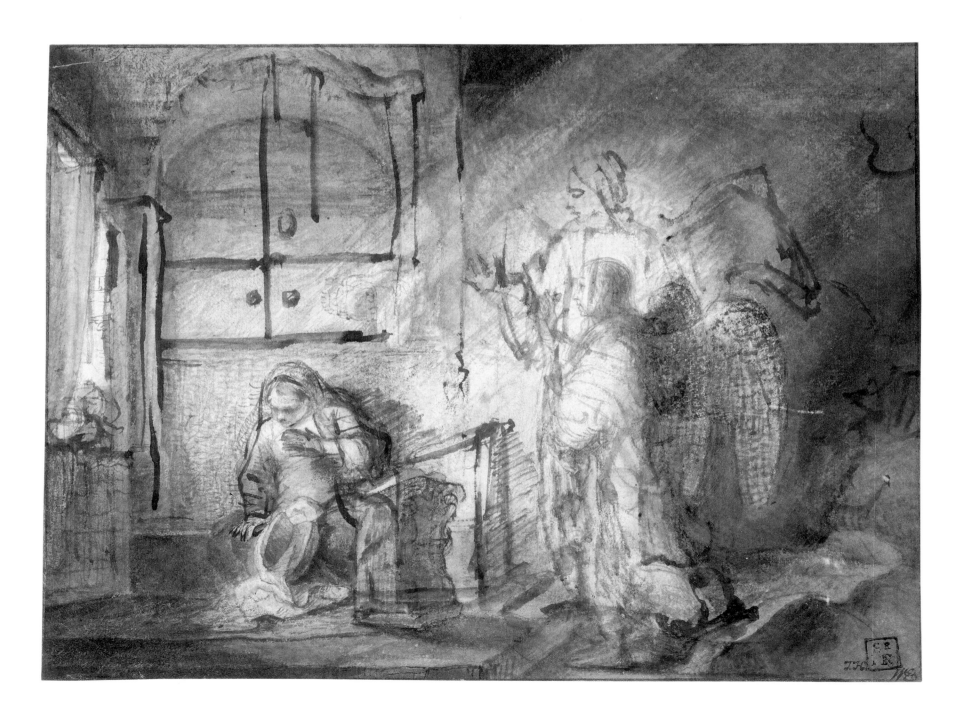

produced between the execution of the two paintings. One assumes that in this drawing Rembrandt "changed" the version of his painting now in St. Petersburg, and that this drawing in turn then served within the workshop as the model for his pupil's painting of 1636.[85]

Rembrandt's pupil Samuel van Hoogstraten expressly mentions that correcting a pupil's drawings is a useful teaching tool: "I advise masters that when they look over the drawings of their pupils they make corrections to these on the work itself."[86] In another passage he also relates how tedious he found it as an apprentice to have to correct his own works that had been so criticized: "At times I felt so disheartened by my master's comments that I went to work with tears in my eyes and without eating or drinking, and did not rest until I had repaired the mistakes I had been accused of."[87] In fact, almost all of the student drawings on which Rembrandt made corrections are by Constantijn Daniel van Renesse. This suggests that Van Renesse, who refers to his drawing lessons with Rembrandt in inscriptions on some of his drawings (cat. no. 30), expressly requested that his teacher correct his work. The best-known example is *The Annunciation* in the Kupferstichkabinett, Berlin (fig. xii).[88] It is obvious that two different hands were involved in the drawing. The first version was executed in a pictorial manner with a brush and with black and red chalk. The somewhat fussy treatment of the squat, doll-like figures is typical of Van Renesse. The drawing was then attacked with a reed pen in broad, heavy lines primarily redrawing the figure of the angel. The small, childlike angel in the original was transformed into a large, supernatural figure. He is turned so as to face the viewer, his wings spread wide, and his hand is brought farther forward, emphasizing his gesture of greeting. Additional corrections appear on the back wall and on the window to the left; also the prie-dieu between Mary and the angel was enlarged, giving Mary more space and at the same time creating greater distance between her and the divine messenger. These corrections are generally attributed to Rembrandt. Their style indicates his hand, but of even greater significance is the radical improvement, even re-creation, of the scene, which is now far more convincingly presented.[89] In principle, however, one has to distinguish among the teacher's corrections—as in the case just described—corrections by fellow pupils, and corrections made by the artist himself. These have not been clearly separated heretofore. A few of Van Renesse's drawings may have been corrected by his fellow pupil Samuel van Hoogstraten, whose hand is revealed in the broad outlines, added after the drawing had been made.[90] We know that in Italian Renaissance ateliers, it was incumbent on the more advanced pupils to supervise the younger apprentices and correct their work.[91] Also it would appear that the young artists made corrections themselves; Sumowski assumes that this was the case in Van Renesse drawings with correction lines that cannot be ascribed to either Rembrandt or Van Hoogstraten.[92]

A rare example of the master's practice of correcting is found in a chalk drawing, *Standing Female Nude* (fig. xiii), in Budapest, which dates from around 1637.[93] Executed in soft outlines and flaccid internal drawing, it also exhibits strong, decisive chalk strokes in several places, which to judge from their style are most probably by Rembrandt. The corrections correspond to the dark lines accenting the head, especially the outline of the face. The outlines of both feet that make them steadier and the vigorous lines along the calves and thighs were made at the same time, as were the strokes indicating folds in the draped fabric near the woman's arm. It is also possible that Rembrandt further developed the drawing with parallel hatching in the area of the table and farther into the background, which adds considerably to the three-dimensionality of the standing figure.

85 Benesch 90; Royalton-Kisch 1992, no. 13; Dekiert 2004, pp. 55–57; Royalton-Kisch 2008–09, no. 10.

86 "De meesters raed ik, alsze de Teykeningen haerer discipelen overzien, datze de zelve, met schetssen op 't zelve voorwerp te maeken, verbeeteren." Van Hoogstraten 1678, p. 192.

87 "toen ik somtijts, door meesters onderwijs verdrietich, my zelven zonder eeten of drinken met traenen laefde, en niet eer van mijn werk ging, voor ik de aengeweeze misslach te booven was." Van Hoogstraten 1678, p. 12.

88 Benesch 1372; Bevers 2006, no. 47.

89 Most recently in Bevers 2006, no. 47. However Royalton-Kisch has interpreted the corrections as improvements made by Van Renesse himself (Royalton-Kisch 2000, pp. 163–64).

90 First proposed in Henkel 1942, p. 101, no. 6; Sumowski, *Drawings*, 2159ˣ, 2160ˣ, and 2193ˣˣ [according to Sumowski, corrections by Rembrandt].

91 Meder 1919, p. 214.

92 Sumowski, *Drawings*, 2200ˣˣ, 2203ˣˣ, and 2204ˣˣ.

93 Benesch 713. These details are based on verbal observations of Peter Schatborn and Marijn Schapelhouman; Bisanz-Prakken in Vienna 2004, no. 59; Gerszi 2005, no. 208.

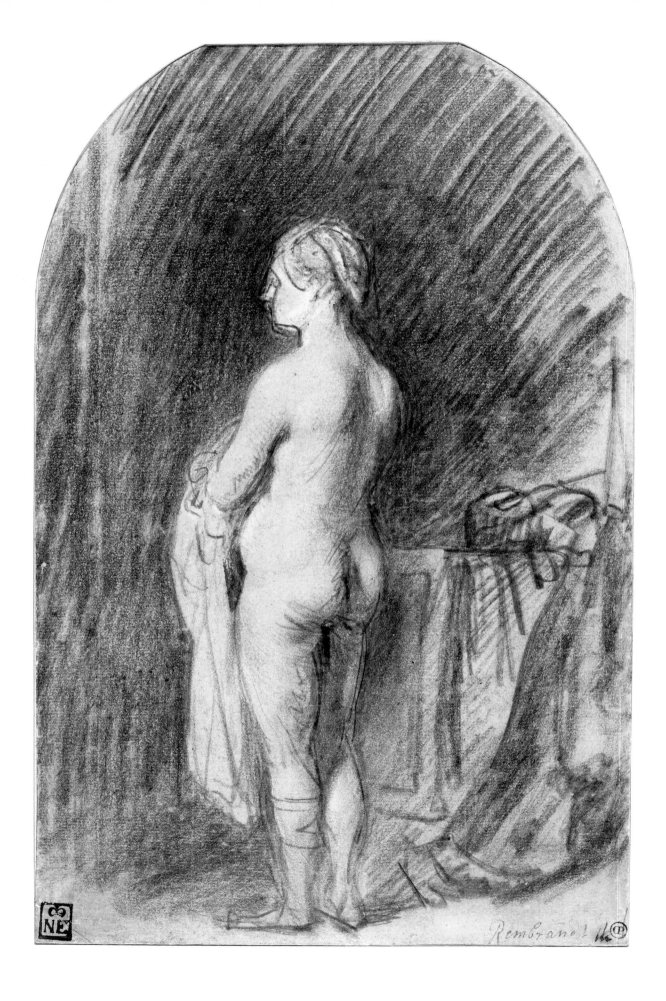

Figure xiii. Anonymous Rembrandt pupil and Rembrandt
Standing Female Nude, ca. 1637
Black chalk, pen and brown ink, heightened with white,
25.3 × 16.2 cm (9 $^{15}/_{16}$ × 6 $^{3}/_{8}$ in.)
Budapest, Szépművészeti Múzeum, 1575

Altogether, only a few pupil drawings corrected by Rembrandt are known. Equally rare are handwritten comments, though the two surviving examples shed an interesting light on Rembrandt's notions regarding the pictorial structure of narrative subjects. On the verso of Van Renesse's drawing *The Return from Egypt* (cat. no. 31.2) there is an inscription by either the draftsman himself or by one of his fellow pupils. One assumes that it records an opinion expressed by Rembrandt in the atelier. It indicates that the figures' heads should be smaller, their gestures less extreme. In addition, the position of the donkey looking out of the picture should be reversed, so that it faces into the picture space. Given this critique, the closely related drawing by the master appears to represent a correction of his pupil's version (cat. no. 31.1).

Another example is the drawing *The Departure of Rebecca from Her Parents' Home* in the Staatsgalerie, Stuttgart (fig. xiv).[94] Below the composition, set off by a line, there is an inscription in Rembrandt's hand: "dit behoorde vervoucht te weesen met veel gebueren die deesen hoge brujit sien vertrekken" (this should be augmented with the figures of a number of neighbors watching the bride's departure).[95] For a long time this drawing was attributed to Rembrandt himself; however, the pen lines and figures present close similarities to a group of drawings ascribed to Gerbrand van den Eeckhout (cat. nos. 13–17), and this drawing can be ascribed to Van den Eeckhout as well.[96] Further substantiating the attribution is the implausibility of Rembrandt adding a critical comment to one of his own compositions. Sumowski, however, supports Rembrandt's authorship of the Stuttgart sheet and believes that with this inscription Rembrandt was criticizing a drawing by a different pupil, and that in making the Stuttgart sheet, he meant to show how the picture should have been composed.[97] He assumes that a drawing by Van den Eeckhout, known from a faithful copy in the Museum Boijmans Van Beuningen, Rotterdam,[98] was what led Rembrandt to make the Stuttgart drawing and to inscribe it. All in all, however, it seems more likely that the Stuttgart version is also the work of a pupil,[99] probably Van den Eeckhout.

Rembrandt's criticism addresses the formal and iconographic articulation of the subject. It therefore brings up a perennial problem of art theory: whether narrative subjects should be represented with only a few figures or with many. The only characters mentioned in the Bible passage are the bride's family, her nurse, her maids, and the men accompanying Isaac's servant, who will later accompany Rebecca on her journey. The caravan with her escort is depicted to the left, and on the right Rebecca takes leave of her mother. Behind her we apparently see both her father, in a turban adorned with a feather, and her brother Laban. While these already comprise a significant number of people, Rembrandt appears to have imagined a more elaborate departure scene in which the bride's neighbors are depicted as well, reacting with a variety of emotions to her impending departure. Moreover, the focal grouping is placed close to the margin of the image. Additional figures would obviously have shifted Rebecca closer to the center of the composition. It is certainly possible that Rembrandt wrote his comment on the sheet before it was finished. The onlookers in the doorway and window are probably later additions, as their outlines overlap the previously established architectural elements. In any case, this is a rare instance of Rembrandt commenting on the pictorial composition. One can assume that such drawings were discussed in Rembrandt's drawing classes as a way of establishing criteria for creating effective and well-structured compositions.

One can assume that most of his pupils' drawings remained with Rembrandt when the apprentices left his workshop, and that these, together with drawings by Rembrandt himself,

94 Benesch 147.
95 Strauss and Van der Meulen 1979, p. 592, no. 1.
96 As, for example, Schatborn in Amsterdam 1987–88, no. 46; Bevers 2006, p. 196.
97 Sumowski, *Drawings*, under 806ˣˣ.
98 Sumowski, *Drawings*, 806ˣ; Giltaij 1988, no. 68.
99 As proposed, for example, by Hofstede de Groot 1915, pp. 88–89.

Figure xiv. Gerbrand van den Eeckhout
The Departure of Rebecca from Her Parents' Home, ca. 1637–40
Pen and brown ink, brush and brown wash, 18.5 × 30.6 cm
(7⁵⁄₁₆ × 12¹⁄₁₆ in.)
Stuttgart, Staatsgalerie, Graphische Sammlung, GL 936

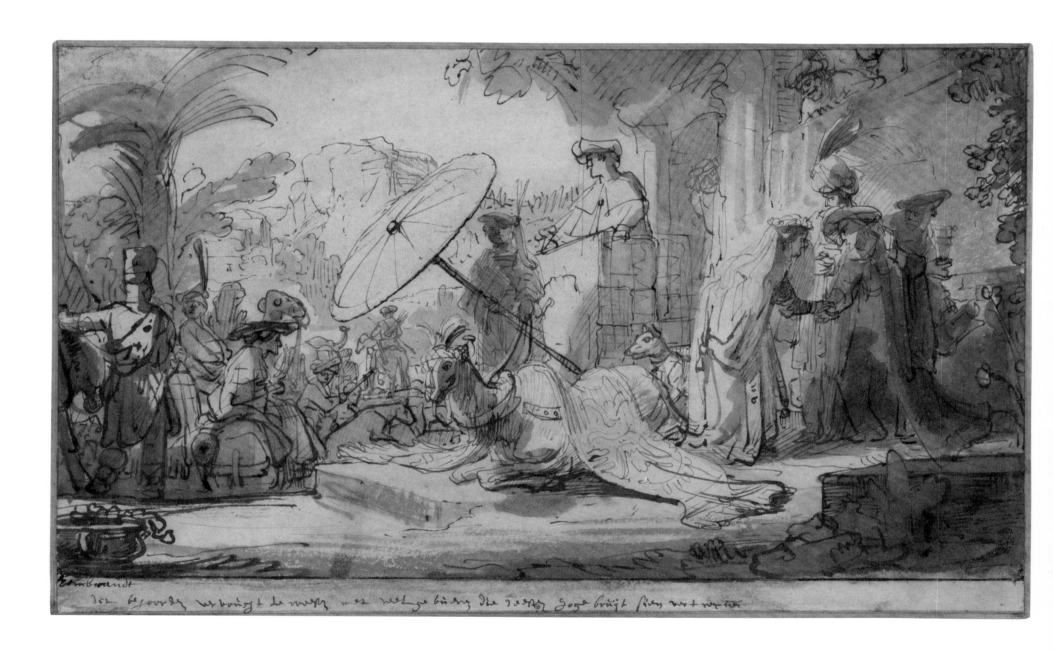

were kept in folders and albums and used as instructional material. This is certainly suggested by early collections of drawings like the one in Stockholm (see the following essay) and by the collection of copies in Braunschweig. The drawings in Braunschweig appear to be the work of a single artist.[100] Two features indicate that they were not produced in Rembrandt's atelier: first, the prevailing preliminary drawing in chalk, and second, the slavish imitation of (known) models. Neither is typical of pupils' copies from Rembrandt's workshop. Therefore, these copies must have been produced after 1658, more probably even after 1669, apparently by a collector or a dealer. The majority of the originals on which they were based were compositional studies depicting biblical themes that can be dated to the late 1640s and especially the 1650s. Among them are two Rembrandt originals, but the majority are drawings by his pupils—Constantijn Daniel van Renesse, Willem Drost, and unknown pupils from the 1650s; there are also sheets by Gerbrand van den Eeckhout from the late 1630s and by Arent de Gelder from the 1660s. This would indicate that the originals of the Braunschweig copies all came from a single source: Rembrandt's workshop. All of this suggests that the confusion surrounding the authenticity of Rembrandt's drawings and those of his pupils resulted from Rembrandt's manner of teaching his pupils to draw. The complex issues of the attribution of Rembrandt school drawings and the history of the related scholarship are taken up in the following essay.

100 Braunschweig 2006, pp. 16–20, 136–68, nos. A 1–A 62.

HOLM BEVERS is the Curator of Netherlandish Drawings and Prints at the Berlin Kupferstichkabinett.

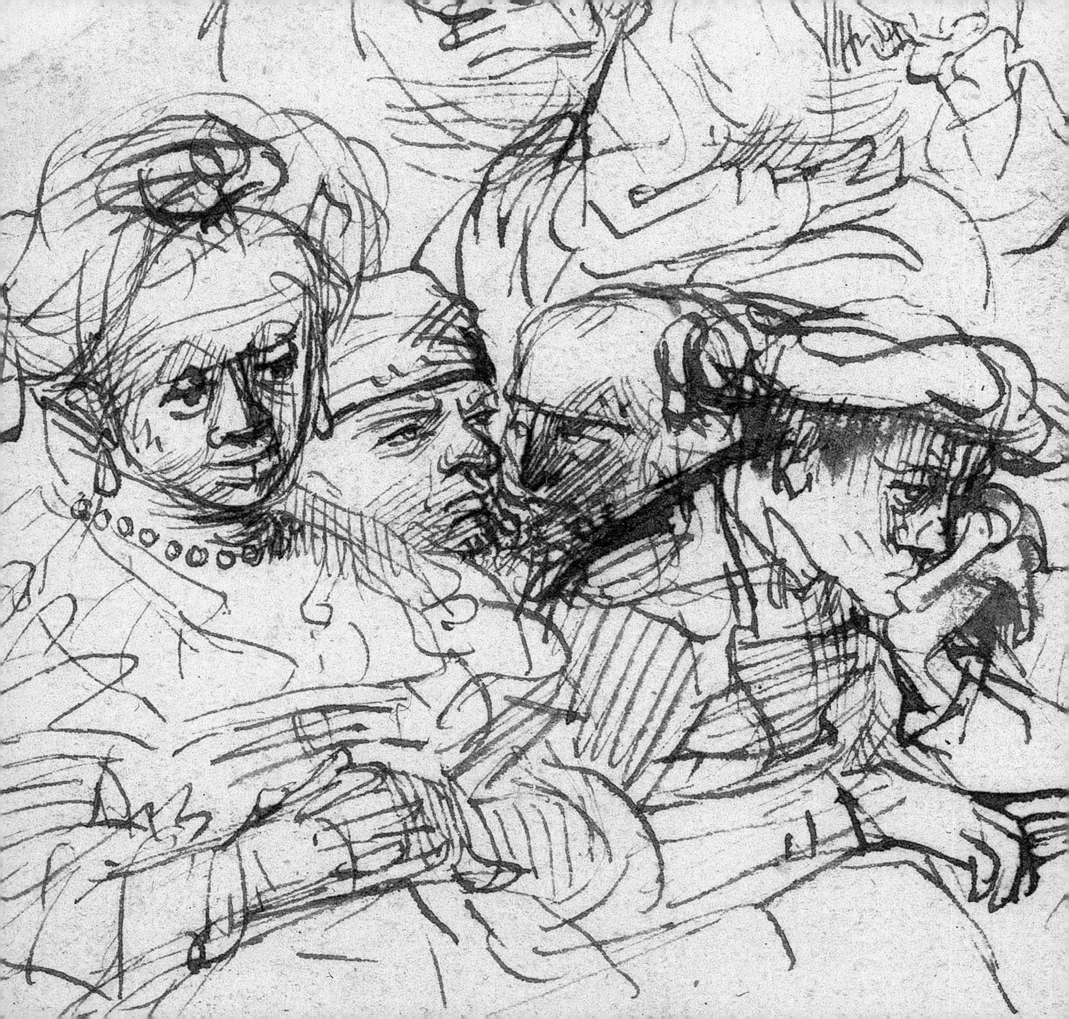

PETER SCHATBORN
WILLIAM W. ROBINSON

The History of the Attribution of Drawings by Rembrandt and His Pupils

The French diplomat and art theorist Roger de Piles (1663–1709) ranks among the earliest critics who singled out Rembrandt's drawings for their originality and expressive power. In his *Abrégé de la vie des peintres* of 1699, De Piles wrote that Rembrandt "drew an infinite number of sketches, which are no less pungent and pointed than the productions of the best painters. The large quantity of his drawings that I have in my hands is convincing proof of it, to those who are willing to do them justice."[1] De Piles presumably acquired his collection in the Netherlands. Arrested as a French agent during the Nine Years War, he spent about four years (1693–97) in a Dutch prison.[2] The claim that he owned a "large quantity" of drawings by Rembrandt was no empty boast. Of the 351 sheets attributed to the Dutch master in the 1741 sale of the collection of Pierre Crozat, "la plus grande partie" had belonged to De Piles.[3] A Swedish nobleman purchased ninety-two of the works sold in the Crozat auction under Rembrandt's name; barely one in five is attributed to Rembrandt today.[4] To the extent that this cache represents a reliable sample of Roger de Piles's holdings, the body of work he cited as "convincing proof" of Rembrandt's incisive draftsmanship is mostly by his pupils and followers.

The vicissitudes in the status of the De Piles–Stockholm group poignantly attest to the longevity of the problem of attribution—the focus of this essay and of the exhibition *Drawings by Rembrandt and His Pupils: Telling the Difference*. Barely a generation after Rembrandt's death, works by his students and imitators already passed for originals by his hand. Three centuries later, the task of distinguishing autograph drawings by Rembrandt from Rembrandtesque studies by draftsmen trained or inspired by him remains a work in progress, sometimes a controversial

1 "Rembrandt..., quoiqu'il ait dessiné une infinité de pensées qui n'ont pas moins de sel & de piquant que les productions des Meilleurs Peintres. Le grand nombre de ses desseins que j'ai entre mes mains en est une preuve convaincante à qui voudra leur rendre justice." De Piles 1699, p. 436. Slive 1953, p. 128.

2 De Piles had likely purchased his drawings from the most prominent art dealer of his time, Jan Pietersz Zomer (1641–1724). De Piles had been sent to Holland as a diplomatic agent for Louis XIV to begin secret peace negotiations in connection with the war with France. During his imprisonment, he would have worked on his *Abrégé*, which was published in 1699; Roscam Abbing 1999, pp. 97ff.

3 Auction P. Crozat, Paris, April 10–May 13, 1741, auction catalogue by Pierre-Jean Mariette; Schatborn 1981, pp. 41–46; Starcky 1993, p. 197; Stockholm 1992–93, nos. 131–60.

4 About eighty-three of ninety-two are in the Nationalmuseum in Stockholm. Schatborn 1981, pp. 41–46.

one. Why is it so difficult to determine the size and shape of Rembrandt's oeuvre and to discriminate between his works and those by artists in his circle?

First of all, there is the sheer number of works that merit consideration. Several thousand Rembrandtesque drawings survive from the seventeenth century. An inventory of Rembrandt's possessions, taken in 1656, records 1,500 to 2,000 drawings under his name.[5] The more productive draftsmen among his pupils must have executed as many as those recorded in Rembrandt's inventory. By a happy accident, large numbers of school drawings, even slight scribbles, have been preserved, because for centuries dealers and collectors regarded them as works by the master. In his catalogue raisonné of Rembrandt's drawings, Otto Benesch listed some 1,400 drawings by Rembrandt, and Werner Sumowski's *Drawings of the Rembrandt School* contains about 2,500 entries but does not include the numerous sheets he regarded as unattributable.[6] The Dutch scholar and collector Frits Lugt maintained a card file on every Rembrandt and Rembrandtesque drawing he examined. It runs to about 5,000 items.[7] Now dispersed in public and private collections from St. Petersburg to Los Angeles, this prodigious legacy of drawings cannot be studied in isolation but must be considered in relation to the thousands of paintings and prints by Rembrandt and his school.

The role of drawing in Rembrandt's creative process and teaching practice further complicates the problem of attribution (see Holm Bevers's essay in this catalogue). His drawings served several purposes, but the great majority consists of biblical compositions, figure studies, scenes of daily life, and landscapes, which he made to hone his skill, record a motif, test compositional ideas and the means of expressing emotion, and provide models for the instruction of his pupils. Intended for workshop use, such sheets are rarely signed. In fact, fewer than twenty drawings bear his autograph signature. A handful of others are annotated in the artist's hand, although this in itself does not always guarantee that he made the drawing. Additionally, Rembrandt did not use drawings consistently to aid in the design and execution of finished works of art. Only about fifty studies are securely attributable to him because they relate directly to a painting or print. Finally, when one encounters two drawings in Rembrandt's manner that represent the identical motif or closely related compositions, they may not necessarily be by the same artist. As several pairs of studies in the exhibition attest, Rembrandt and his pupils sat together to draw landscapes and studio models (cat. nos. 35, 37, 41–43), and he challenged his students to illustrate biblical themes, for which they might take one of his sketches as their point of departure (cat. nos. 8, 12, 23).

To some extent, the problem of distinguishing Rembrandt's drawings from those by his pupils is also a consequence of seventeenth-century workshop organization: students strove to emulate their master's style so that they could assist in the shop's production. A popular teacher, Rembrandt had dozens of pupils, and most of them, having learned his manner of drawing in their youth, continued to practice it for the rest of their lives. Whenever one of the pupils died and drawings from his estate came on the market, they could be taken for works by Rembrandt and sold as such. Another possible source of confusion lies in the albums in which Rembrandt organized his drawings for use in his workshop. He probably filed sketches by pupils alongside his own studies in these volumes. If so, following the sale of Rembrandt's "paper art" in 1658, all the works in the albums were probably assumed to be by the master himself.

In addition to the albums from his workshop, "mixed" groups of drawings and albums—comprising a few sheets by the master and a great many more by pupils—circulated on the art

5 Schatborn 1981, p. 7.
6 Benesch and Sumowski, *Drawings*.
7 Frits Lugt, file of Rembrandt drawings, preserved in the Rijksbureau voor Kunsthistorische Documentatie, The Hague.

market. Various sources attest that in early-eighteenth-century collections, all Rembrandtesque drawings were regarded as autograph.[8] As we have seen, most of the works auctioned under Rembrandt's name in the 1741 Crozat sale are probably by his pupils and followers.[9] Other eighteenth-century collections included drawings described as by Rembrandt that we now ascribe to his pupils. For example, some of the drawings—a few bearing old annotations of Rembrandt's name—that the Duke of Devonshire acquired in 1723 from the collection of Nicolaes Flinck are no longer regarded as autograph.[10] The same holds true for drawings that bear the collector's mark of the art dealer Jan Pietersz Zomer and those recorded in the inventory of the Delft patrician Valerius Röver.[11] Only in the middle of the eighteenth century do we come across references to drawings from the "Rembrandt School," an early example being in the sale catalogue of the collection of Chevalier de La Roque, written by E. F. Gersaint in 1745, where we read under no. 571: "Quarante-deux Desseins, tant de Rimbrant que de son Ecole" (forty-two drawings, both by Rembrandt and his school).[12] In the later eighteenth century, auction catalogues begin to distinguish between drawings by Rembrandt, in the manner of Rembrandt, and after Rembrandt, for example in the Verschuring sale of January 18, 1771.[13]

We have scant information about how seventeenth-century connoisseurs evaluated attributions of drawings. A letter from Constantijn Huygens to his brother Christiaan reveals that, during a visit in 1667 to the great collector Everard Jabach, they strongly disagreed with their host as to whether certain drawings were by Raphael or Giulio Romano, but Huygens does not disclose the criteria invoked in the discussion.[14] De Piles addressed the connoisseurship of drawings—that is, the ability to recognize the hand of the artist—in his *Abrégé* of 1699. He wrote that the determination of the author of a drawing and the judgment of its quality demand a profound knowledge of the artist's oeuvre, along with a refined sensibility and insight into the art of drawing, even to the extent that only someone practiced in the art of drawing is qualified to judge.[15] In fact, familiarity with an artist's entire oeuvre is still an absolute requirement.

Between 1745 and 1752, Antoine-Joseph Dezallier d'Argenville (1680–1765) published his *Abrégé de la vie des plus fameux peintres*, preceded by a *Discours sur la connaissance des desseins et des tableaux*.[16] He wrote extensively about drawing, including the manner and style of drawing, which he described as a kind of writing. Every draftsman has his distinctive characteristics, which can be imitated: "These are practices of the hand that can be counterfeited, as we learn all the time from the drawings of Guercino and Rembrandt."[17] D'Argenville goes on to discuss at length the differences between an original and a copy. Originals are so spirited that copies always lack something, because they show a certain blending of different manners: "This is what one observes in drawings supposedly by Guercino & Rembrandt."[18] While d'Argenville refers to Rembrandt in the original edition of his treatise, Rembrandt's biography—along with those of various other artists—first appears in the 1762 edition. There d'Argenville relates that Rembrandt's drawings are frequently copied, but the copies are betrayed by their "stiffness" (*contrainte*) and "dependence" (*servitude*) and are never the same as the original.[19] For d'Argenville, provenance has no bearing on the question of authenticity. "It is to the thing itself, to the intrinsic value of the work, that one must attach oneself."[20] Chronology must be taken into account, because a painter has an early, middle, and late period. D'Argenville also brings up the elaboration or correction of students' drawings by the master.

8 Mixed albums were made up by dealers, for example, the one that has been preserved in Braunschweig; Braunschweig 2006, pp. 12–13.
9 See note 3.
10 Schatborn 1981, pp. 16–21; Schatborn 2008.
11 Schatborn 1981, pp. 21–24 and 37–41.
12 Starcky 1993, p. 203.
13 Sale Verschuring, Amsterdam, January 18, 1771: There were drawings by Rembrandt (no. 186), in the manner of Rembrandt (no. 428), and after Rembrandt (no. 429).
14 Plomp 2001, p. 105.
15 "Pour connoître si un Dessein est d'un tel Maître, il faut en avoir vû beaucoup d'autres de la même main avec attention, & avoir dans l'Esprit une Idée juste de la Caractère de son Génie, & de la Caractère de sa practique.... Mais pour connoître si un Dessein est beau, & s'il est Original ou Copie, il faut avec le grand usage beaucoup de délicatesse & de pénétration; je ne croy pas même qu'on le puisse faire sans avoir outre cela quelque Pratique manuelle du Dessein." De Piles 1699, pp. 72–73.
16 d'Argenville 1745–52, vol. 1, pp. xv–xliv.
17 "ce sont des pratiques de la main qu'on peut souvent contrefaire, comme nous l'éprouvons tous les jours dans les desseins du Guerchin & de Rembrandt." d'Argenville 1745–52, vol. 1, pp. xxvii–xxvii.
18 "c'est qu'on observe dans les desseins supposés de Guerchin & de Rembrandt." d'Argenville 1745–52, vol. 1, p. xxx.
19 "On trouve dans ses desseins copiés, quand on les examine bien, de la contrainte & de la servitude; quand même on y employeroit une touche aisée, elle ne seroit jamais le même de celle de Rembrant." d'Argenville 1745–52, vol. 3, pp. 117–18.
20 "c'est la chose même, à la VALEUR INTRINSEQUE, de l'ouvrage qu'il faut s'attacher." d'Argenville 1745–52, vol. 1, p. xxxi.

In 1751, the first catalogue raisonné of Rembrandt's work appeared, albeit of his prints, not his drawings. The author, Edme-François Gersaint (1694–1750), was one of the most important art dealers in Paris during the first half of the eighteenth century.[21] From 1733 on, he compiled catalogues of auction sales, including those of the collections of Quentin de Lorengère (March 2, 1744),[22] Antoine de la Roque (April 27, 1745),[23] and Angran, Vicomte de Fonspertuis (December 17, 1747).[24] In some cases his catalogues include the entire oeuvre of a printmaker. To the catalogue itself, with its extensive descriptions, he added artists' biographies, commentary, and articles that summarized specific subjects, thus establishing his reputation as a dealer in the eyes of collectors. In so doing, Gersaint created the first detailed, rationally argued catalogue raisonné.

Gersaint died in 1750, and his catalogue raisonné of Rembrandt's etchings was published posthumously by Helle and Glomy. It addresses the problem of attribution, because some of Rembrandt's pupils made etchings in his manner. Remarks by Gersaint in the catalogue confirm that the question of authenticity was a real one, particularly for a dealer. In fact, this is the first instance of a fairly detailed discussion of connoisseurship with reference to the work of a single artist. In Gersaint's catalogue, a chapter titled "Doubtful Prints and Prints Mistakenly Attributed to Rembrandt" follows the section on original prints. The texts in the chapter on questionable works suggest that Gersaint did not believe any of those works were by Rembrandt, even if he does not say so explicitly. When arguing whether a work was by Rembrandt or a pupil or follower, Gersaint invoked various criteria. The most important was the tradition of the attribution: if a print was recorded in an old collection as a Rembrandt, he agreed that it very well must be by Rembrandt. Gersaint also referred to the authority of others as a criterion. Commenting on his catalogue number 367, which fell under the heading of doubtful or misattributed works, he wrote: "Since most of the connoisseurs in Holland include this print in Rembrandt's oeuvre, I shall not take upon myself the responsibility of rejecting it."[25] Provenance can also contribute to the judgment of authenticity. For example, Gersaint writes about *The Rest on the Flight into Egypt* (his cat. no. 59): "Apart from the distinctive features that form the basis for the attribution of the print, it is confirmed by the fact that it belonged to the collection of the famous Burgomaster Jan Six, which originated in Rembrandt's lifetime or, to put it better, was assembled by Rembrandt himself."[26] He further relates that the artist and biographer Arnold Houbraken acquired the etching at the burgomaster's sale, "which is sufficient evidence in favor of this print."[27] It is beside the point that Gersaint erred because the auction where Houbraken bought the print was not that of Jan Six but of Willem Six. The putative provenance from Rembrandt's friend removed any doubt.[28] As a condition of accepting the print, Gersaint insisted that it must be a work of the artist's youth, a solution also resorted to later on in the history of attributions.[29]

Comparison served as another important criterion for Gersaint. The most basic form of comparison is a simple one: a print is not by Rembrandt because it does not resemble Rembrandt's work. Gersaint pronounced his judgments on the basis of his firsthand knowledge of the entire oeuvre. The degree of conformity with his mental image of Rembrandt's work was indicated by different kinds of comparisons, and the terminology used to express it can vary. With the "doubtful prints" Gersaint renders his judgment in a couple of sentences. He addresses the technique ("engraved with a fine and light line, but a little dry, cold and without much effect"[30]), occasionally elaborating further ("badly engraved and failed biting in almost all the plate"[31]). He also discusses execution, "tone" (*ton*), and "touch" (*touche*). Regarding the representation, he refers

21 Gersaint 1751. On Gersaint, see, first and foremost, Glorieux 2002. See also Schatborn 2008. Our thanks to Cécile Tainturier and Hans Buijs for their help in the translation of the French texts.

22 Lugt 1938, no. 590; for the history of Gersaint's sales and sale catalogues, see Glorieux 2002, pp. 347–420.

23 Lugt 1938, no. 619.

24 Lugt 1938, no. 677.

25 "mais comme la plûpart des Curieux de la Hollande le mettent dans son Oeuvre, je n'ai pas voulu prendre sur moi de le rejetter." Gersaint 1751, p. 286.

26 "Indépendamment des apparences qui la lui font attribuer, ce qui détermine encore à n'en point douter, est qu'elle foit partie de l'Oeuvre du fameux Bourguemestre Six, qui a été formé du temps même de Rembrandt, ou pour mieux dire, que Rembrandt a formé lui-même." Gersaint 1751, p. 49.

27 "ce qui fait une preuve assez convaincante enfaveur de ce Morceau." Gersaint 1751, p. 49.

28 The Willem Six sale took place in Amsterdam on May 12, 1734, and Gersaint was in fact in Amsterdam at that time; Glorieux 2002, p. 311.

29 The print (B. 59) is now generally accepted as an early work by Rembrandt, although it has also been attributed recently to Jan Lievens; Van Straten 2005, pp. 37–38, fig. 25.

30 "gravé d'une taille fine & légere, mais un peu séche, froide & sans beaucoup d'effet." Gersaint 1751, p. 266.

31 "mal gravé & dont l'eau forte a manqué dans presque toute la panche." Gersaint 1751, p. 279.

to the composition, the figures and heads, the background, and the effect of light and shadow. In evaluating these elements he applies terms such as "intelligence," "spirit" (*esprit*), or "expression and character," sometimes appraising a print more generally by its "effect," meaning the overall impression it makes, and "taste" (*goût*). Other adjectives invoked include "brilliant," "mediocre," "agreeable," and "unintelligible." Finally, he also cites rarity ("rare," "extremely rare," "much sought after") and "highly esteemed."

Gersaint was the first to address the questions of attribution posed by Rembrandt's work. His experience as a dealer, including constant engagement with works of art and collectors, enabled him to understand and formulate the nature of the problem. When comparing etchings to secure an attribution, Gersaint did not begin by referring to signed prints, even though a fairly large number bear Rembrandt's autograph signature and are thus incontrovertibly by his hand. Rembrandt also dated many etchings, but Gersaint did not consider chronology a useful criterion, except in those few cases where he suggested the artist's youth or inexperience might account for weaknesses in the work. Only later did Rembrandt's signature and chronology emerge as significant factors in the determination of authenticity.

Chronology figured prominently in a noteworthy contribution to the development of Rembrandt connoisseurship produced in the middle of the nineteenth century by E. J. T. Thoré, who wrote under the pseudonym Wilhelm Bürger (1807–1869). Following a visit to the British Museum, he wrote a short article in the 1858 *Revue Germanique*,[32] in which he recorded his views on the drawings. Bürger listed about 150 sheets by Rembrandt, and the accompanying descriptions constitute the first catalogue of the master's drawings in a public collection. By 1857, Bürger had already realized what was required to determine authenticity: "What we need in the case of Rembrandt . . . is a chronological study of his works, which has never been done."[33] Because Rembrandt's drawings incorporate all kinds of stylistic variations, a chronology would provide a framework for comparing dated and undated works to determine whether the undated works fit into his oeuvre. Antoine-Chrysostome Quatremère de Quincy had compiled the first chronological catalogue of an artist's work ever published, which was devoted to the paintings of Raphael.[34] It appeared in 1824 and must have been known to Bürger.[35]

In the practice of connoisseurship, the establishment of a chronology is one of the means that can help to determine authenticity. In his book on Rembrandt, which came out in 1868, the Dutch art historian Carel Vosmaer published the first chronological catalogue of the artist's paintings, prints, and drawings.[36] Vosmaer regularly expressed doubts about drawings, but he did not pursue the question of authenticity any further.

By far the most significant nineteenth-century contribution toward a resolution of the problem of authenticity appeared in a review by the German museum official Woldemar von Seidlitz of the series of facsimiles of Rembrandt's drawings initiated in 1888 by Friedrich Lippmann and continued through 1911 by Cornelis Hofstede de Groot.[37] This series, which reproduced 550 works attributed to Rembrandt in various public and private collections, opened the way to the knowledge and critical study of his oeuvre of drawings. In his 1894 review, Von Seidlitz addressed the matter of authenticity and, for the first time, attempted to formulate a method.[38] More than a century later, his criteria still constitute the basis for the critical study of Rembrandt attributions. The following is a summary of Von Seidlitz's method:

32 Bürger 1858, pp. 393–403.
33 "Ce qu'il faudrait sur Rembrandt . . . , c'est une étude chronologique des ses oeuvres, qui n'a jamais été faite." Bürger 1857, p. 246.
34 Quatremère de Quincy 1824.
35 See also Passavant 1839–58.
36 Vosmaer 1868.
37 Lippmann–Hofstede de Groot 1888–1911.
38 Von Seidlitz 1894, pp. 116–17.

1. Assemble a group of signed and dated drawings that must serve as the point of departure for further attributions. The signatures must be authenticated by comparison with those on paintings and etchings.
2. Assemble a group of drawings made in connection with paintings and prints, distinguishing genuine preliminary studies from copies, which may correspond too closely to the related picture or etching.

 By ordering the drawings in these two groups chronologically, one can establish the development of the artist's style.
3. Now drawings of uncertain status can be evaluated on the basis of their stylistic similarity to works in groups 1 and 2. For Von Seidlitz, the ability to perceive the resemblance is a matter of the connoisseur's "artistic, judicious sensibility and trained eye" (*des künstlerischen, richtigen Gefühls und des geschulten Auges*).
4. Finally, drawings may also be attributed by comparison with paintings and etchings, even if they did not, like those in group 2, serve as preliminary studies.

Von Seidlitz divided the drawings reproduced in the Lippmann facsimiles into four groups: A. autograph; B. possibly autograph; C. evidently not autograph; D. not autograph. The method described under 1, 2, and 3 remains the point of departure for determining the authenticity of Rembrandt's drawings, but Von Seidlitz did not elaborate on the criteria for comparing drawings in group 3 with those in the first two categories.

Connoisseurship played a major role in the catalogue of Rembrandt's drawings published in 1906 by Cornelis Hofstede de Groot (fig. xv).[39] In his introduction, Hofstede de Groot addressed the problem of authenticity more thoroughly than did Von Seidlitz, but his method clearly depends on that of the German scholar.

The first category cited by Hofstede de Groot as a reliable starting point for further attributions consists of sheets that bear an autograph signature or other inscription in Rembrandt's hand—an extension of Von Seidlitz's group 1, which comprised only signed drawings.[40] For Hofstede de Groot, the second group, the preliminary studies for paintings and etchings, was more problematic. He refers to pupils' drawings based on Rembrandt models, as well as copies after the master's works. Like Gersaint, Hofstede de Groot admitted the possible significance of the history of the attribution. If a drawing was considered autograph through several generations, perhaps the original owner had access to objective information, now lost, that affirmed its authenticity.[41] Nevertheless, for him the most important means for resolving the problem of authenticity is comparison, with the drawings in groups 1 and 2 as the point of departure. He refers to the style, modeling, effects of light and shadow, anatomy, expression, and all other characteristics of a drawing: "Neither minor nor incidental elements should be overlooked; nothing is without significance."[42] As far as chronology is concerned, one should begin with the development of the paintings and etchings. Finally, Hofstede de Groot includes a chapter on media and techniques, which provide objective information for the study of drawings.

Hofstede de Groot expanded the method articulated by Von Seidlitz, defined the criteria more thoroughly, and introduced copies and provenance into the discussion. For Hofstede de Groot, comparison was far and away the most valuable tool. He also addressed the subjective element in the art historian's judgment. In his short book *Kunstkennis* (*Knowledge of Art*) of 1927, he distin-

39 Hofstede de Groot 1906.
40 Hofstede de Groot 1906, pp. xiv–xv, lists drawings known to him with inscriptions in Rembrandt's hand, but which are not signed with his name.
41 Hofstede de Groot 1906, pp. xxv–xxvi.
42 "Keine Kleinigkeit, keine Zufälligkeit darf dabei vernachlässigt werden; nichts ist ohne Belang." Hofstede de Groot 1906, p. xxx.

Figure xv. Max Liebermann (German, 1847–1935)
Cornelis Hofstede de Groot, 1929
Etching, 28.8 × 22.8 cm (11⅜ × 9 in.)
Amsterdam, Rijksmuseum, Rijksprentenkabinet, RP-P-1929-156

guished between concrete and immaterial information: on the one hand, the external, "objective" characteristics, such as media and technique, and, on the other, the subjective elements of artistic and aesthetic quality.[43] He held that quality is only partially a subjective criterion, because it is expressed through tangible means that can be evaluated. In fact, aspects of the technique, especially the working process, can reveal Rembrandt's hand.

The methods formulated by the authors we have considered thus far constituted a starting point, a framework for establishing authenticity. For the most part, scholars did not disclose how they arrived at an attribution. For example, when making a comparison, they rarely identified explicitly the elements compared or the criteria applied in making a judgment. Even Hofstede de Groot, who insisted that the comparison of one drawing with another offered the best approach to determining authenticity, often expressed his opinion in the most summary terms.

During the years following Hofstede de Groot's 1906 publication, scholars continued to grapple with the attribution of Rembrandt's drawings in articles and catalogues of exhibitions and museum collections. In 1925, Wilhelm Valentiner issued volume one of a projected three-volume catalogue organized by subject—the second came out in 1934, but the third never appeared—that would have been the first fully illustrated corpus of the master's drawings. Important here are the two introductions, in which he made numerous attributions to the pupils, which in many cases were accepted and formed the starting point for assembling their respective oeuvres.[44]

Prior to the publication of Otto Benesch's catalogue raisonné in the 1950s, scholars approached the problem in various ways. Generally speaking, they fall into two different camps: on the one hand were those who tried to resolve the problem following an explicit method, and,

43 Hofstede de Groot 1927, pp. 16, 21.
44 Valentiner 1925 and 1934, vol. 1, pp. xii–xxix, vol. 2, pp. viii–xliii.

Figure xvi. Egon Schiele (Austrian, 1890–1918)
Central Inspector Benesch and His Son Otto, 1913
Verso: *Kneeling Female Nude*
Graphite on off-white wove paper, 47 × 30.8 cm (18½ × 12⅛ in.)
Cambridge, Harvard Art Museum / Fogg Museum, Gifts for Special
Uses Fund: Shelter Rock Foundation and an Anonymous Donor,
1964.170

on the other, those who attempted to define the oeuvre by relying on a personal-critical relationship to the works. None, however, expressly took Von Seidlitz's criteria as their point of departure, and, for example, they did not always substantiate an attribution by citing drawings that belong to Von Seidlitz's groups 1 and 2, i.e., works attributed with certainty to Rembrandt.

For connoisseurs like Max Friedländer and Frits Lugt,[45] the critic's personal relationship to the work of art—dismissed as a "subjective" criterion by Hofstede de Groot—played a significant role. In Friedländer's view, the first impression is more important than an analysis of the work, although he noted that "for every drawing one must ask oneself about its purpose, intention, or goal" (*Zweck, Absicht oder Bestimmung*)—what we call its function.[46]

After that of Hofstede de Groot of 1906, various catalogues on the drawings of Rembrandt and his pupils in public collections came out: those of Hind in 1915 (London, British Museum), Bock and Rosenberg in 1930 (Berlin, Kupferstichkabinett), Lugt in 1933 (Paris, Louvre), and Henkel in 1942 (Amsterdam, Rijksmuseum). The individual drawings were described extensively, and above all in the latter two, attention was directed toward their authenticity, relation to other works, and dating.

In 1935 the Viennese art historian Otto Benesch (fig. xvi), who had already begun his study in the 1920s, published an overview of the drawings of Rembrandt in *Rembrandt: Werk und Forschung (Rembrandt: Work and Research)*, in which he roughly employed the method of Von Seidlitz: he described groups of drawings according to chronology, using signed drawings as a starting point as well as drawings that he deemed to be studies for paintings and etchings.[47] Before he published his catalogue raisonné, Benesch wrote the introduction to a book of plates in 1947, in which he summarized the problems of authenticity.[48] Following the starting point provided

45 Lugt 1933, p. x.
46 Friedländer 1915, p. 213.
47 Benesch 1935.
48 Benesch 1947, pp. 29–30.

by Von Seidlitz, Benesch also mentioned the possibility of using chronology as a criterion for authenticity and maintained that objective standards should be used as much as possible in the assessment of quality. In the six-volume, chronologically ordered catalogue raisonné, which was published from 1954 to 1957 and in an enlarged edition released in 1973 by Benesch's widow, Eva Benesch, he applied a different method than that used in *Werk und Forschung*, perhaps because he did not want to be too hemmed in by methodology. Alongside the drawings that Benesch regarded as authentic (1,369 catalogue numbers plus some additional sheets to which he gave "a" numbers), he created a category of copies, with "C" numbers (103 numbers) and a category of attributions to which he gave "A" numbers (117 numbers). Furthermore, he added a group of drawings by pupils, which he thought were corrected by Rembrandt (18 numbers).[49] The publication was extensively reviewed by Rosenberg in 1956 and 1959, Haverkamp-Begemann in 1961, and Sumowski in 1956/57 and 1961. Not only was Benesch's work thereby generally discussed and enhanced by many new findings, but the authors of these reviews also presented their own opinions about individual drawings. The explanations and reasoning for their remarks about attributions, however, remained very brief.

Just as in *Werk und Forschung*, Benesch viewed chronology as an important tool in making attributions: "Anything that can be fitted into a meaningful, historically organic sequence has a claim to authenticity, anything that does not can be rejected without further ado."[50] The importance of chronology stipulated by Bürger one hundred years earlier was elevated by Benesch to a crucial criterion. The catalogue is thus also divided chronologically into four periods and within these, organized according to subject matter. A chronological organization allowed Benesch to justify the authenticity of drawings with similar compositions and subjects—but with different styles—because of their different dating. These stylistic differences, however, could also be clarified through the possibility that a compositionally similar drawing could have been made in imitation of the master, as was done in a number of cases discussed in the present catalogue. In the end, the method of Von Seidlitz also formed an important starting point for Benesch, but in his entries it seems that the relationships of particular drawings with Rembrandt's etchings, paintings, and other drawings were in many cases not clearly formulated or were based on drawings that were not securely attributed to him. The comparisons that Benesch made are thus often not very clear, and in many cases he failed to present adequate argumentation. Naturally, Benesch also considered style and technique in making attributions, but the more formal, stylistic aspects were for him of less import than the quality and expressiveness of the drawings; Benesch regularly resorts to superlatives to support his attributions, often in cases that have not received general approval. It is interesting that in his category "Attributions" the comparisons are more concrete and make reference to both style and technique. He is more cautious and speaks less categorically in this section, above all in its later parts.

The importance of Benesch's catalogue raisonné lies in its bringing together so much material, including many unknown drawings and numerous new connections. With respect to the development of Rembrandt's draftsmanship, he is not always convincing in his quest for precise dating, but nevertheless his chronology forms an important framework. As the later development of the study of Rembrandt's drawings and their attribution makes clear, Benesch's work did not achieve the definitive character for which he strove, as the reviews mentioned above pointed out.

49 Schatborn 1975–76.
50 Benesch 1970, p. 39.

Figure xvii. Friederich Stabenau (German, 1900–1980)
Werner Sumowski at Seventeen, 1948
Reed pen and black ink, 56 × 39 cm (22¹⁄₁₆ × 15⅜ in.)
Stuttgart, Private Collection

A great service was rendered by Werner Sumowski in the publication of his ten-part *Drawings of the Rembrandt School*, which began to appear in 1979 (an eleventh volume will soon complete the series) (fig. xvii).[51] The drawings of the pupils had naturally attracted attention, but an overview of the oeuvres of all of the known pupils was lacking. The importance of this publication cannot be overstated. Earlier in his review of Benesch's catalogue raisonné, Sumowski had set out a number of rules that would establish when a drawing could not be by Rembrandt: drawings that correspond precisely to a work by Rembrandt; drawings that combine substitute, reverse, or misinterpret elements from various works by Rembrandt; and drawings that contain elements from works by pupils.[52] The 2,453 drawings are divided into three categories: 1) authentic drawings, signed works and preparatory drawings, self-portraits; 2) substantiated drawings, drawings of unquestionable authenticity based on stylistic criteria (which are given a number with an *x*); and 3) attributed drawings and hypothetical attributions (which are given numbers with two *x*'s). For Sumowski, stylistic observations play an important role in making attributions of drawings to pupils, some of which were earlier given to Rembrandt by Benesch. The division of drawings in groups 1 and 2 corresponds to Von Seidlitz's groups 1, 2, and 3, while Sumowski's third group consists of attributions about which he is less secure. This nuanced categorization has its value because it is realistic about the challenges of attribution, and the reader can understand Sumowski's position. Not only does

51 Sumowski, *Drawings*.
52 Sumowski 1956–57, p. 256.

40

Sumowski catalogue the work of many pupils for the first time—although there is no claim to exhaustiveness—but the ten volumes also offer important comparative material to drawings in Benesch's catalogue that were not accepted as by Rembrandt.

The attributions of Sumowski are generally short and to the point, and extensive stylistic comparisons are rare. The underlying relationships between drawings, based on the extensive material that he brings together, and the relationships with the work of Rembrandt, play an important role in his entries, while the opinions of others are always briefly commented upon. Due to his years of involvement with the subject, it is inevitable that he sometimes reverses his earlier opinions.

The catalogues of Benesch and Sumowski have formed the starting point for the research that followed. The results thereof chiefly take the form of collection catalogues of the drawings by Rembrandt and his pupils,[53] and a number of exhibition catalogues.[54] These publications discuss a considerable number of drawings and new attributions. In general the authors strive to apply the method of Von Seidlitz: when making attributions, to connect them as much as possible to drawings that belong to the substantiated core of the oeuvre of either Rembrandt or a pupil or to drawings to which they can be directly related. What was lacking in many earlier catalogues now forms an essential part of the argumentation, namely, the critical stylistic analysis by which authenticity can be accepted or rejected. The study of the working method—that is, the process by which the drawing comes about—also plays a role here. These catalogues have led to an oeuvre sharply diminished from what Benesch compiled and have defined some groups that can be attributed to different, known pupils.

The catalogue *Drawings by Rembrandt and His Pupils: Telling the Difference* takes as its starting point the work done by Benesch, Sumowski, and their successors. The method for considering authenticity is as follows.[55] First, assemble all of the relevant material, including drawings attributed to Rembrandt's pupils as well as to Rembrandt himself. Next, identify a core group for Rembrandt and for each of the pupils that consists of signed drawings and studies for autograph paintings and etchings. (Sheets with inscriptions in Rembrandt's hand also belong to this group, although these are less secure in certain cases.) Then, using explicit arguments and a rigorous process of comparison, introduce to the oeuvre drawings whose style and technique are consistent with those in the core group. Attributions proposed by this method are hypothetical, and it is important to consider openly the cons as well as the pros in each case. The more technical and stylistic traits the attributed work shares with those in the core group, the more secure the attribution. This method corresponds to that applied in many other areas of research: material and facts (core group); hypothesis (attribution); arguments laid out. The attributions in *Drawings by Rembrandt and His Pupils: Telling the Difference* are the result of this carefully applied process.

53 For Amsterdam, Historisch Museum, coll. Fodor, see Broos 1981; for Amsterdam, Rijksmuseum, see Schatborn 1985A; for Rotterdam, Museum Boijmans Van Beuningen, see Giltaij 1988; for London, British Museum, see Royalton-Kisch 1992; for Berlin, Kupferstichkabinett, see Bevers 2006.

54 Paris 1988–89; Berlin, Amsterdam, and London 1991–92; Stockholm 1992–93; Copenhagen 1996; Paris and Haarlem 1997–98; Bremen 2000–01; Munich and Amsterdam 2001–02; Dresden 2004; Vienna 2004; Paris 2006–07.

55 See also Schatborn 1993.

PETER SCHATBORN is Emeritus Head of the Rijksprentenkabinet, Rijksmuseum, Amsterdam.
WILLIAM W. ROBINSON is the Maida and George Abrams Curator of Drawings at the Harvard Art Museum/Fogg Museum.

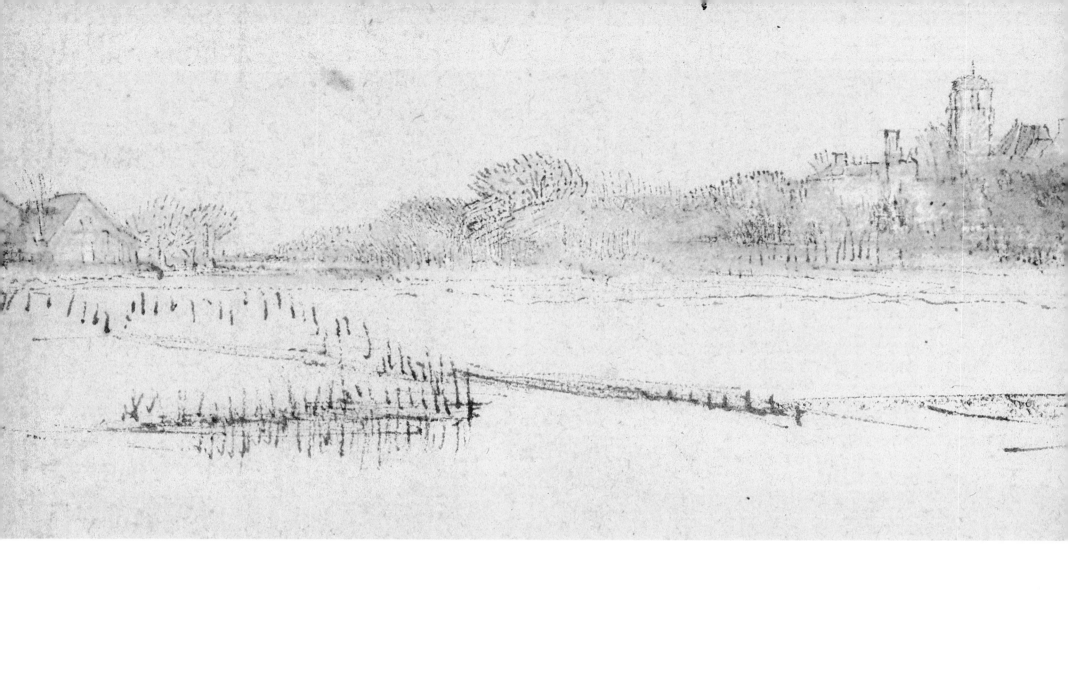

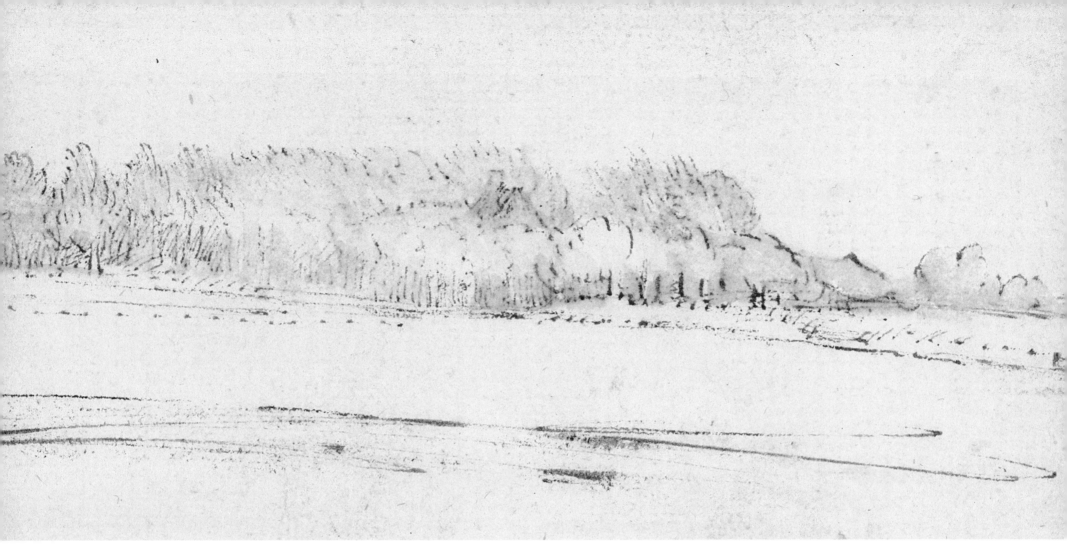

Catalogue

The entries in the catalogue are arranged chronologically according to the approximate period in which a particular student was in Rembrandt's studio. In the dimensions provided, height precedes width. Most of the drawings in the catalogue section are reproduced at actual size. The authors of the individual entries are identified by these initials:

HB Holm Bevers
LH Lee Hendrix
WWR William W. Robinson
PS Peter Schatborn

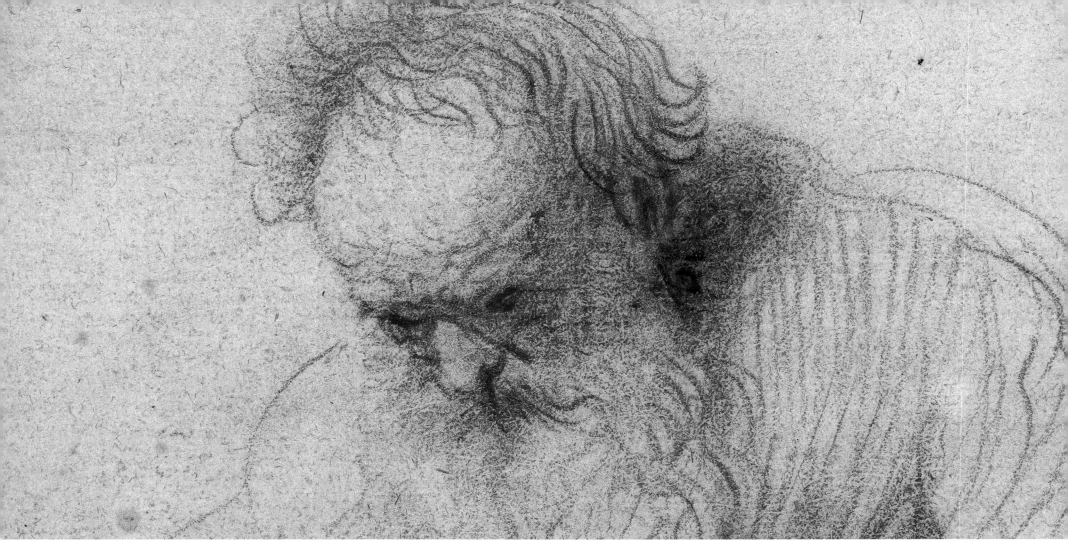

Rembrandt

Lievens was born in Leiden to an embroiderer from Ghent.[1] Jan Orlers, an early patron of Lievens, reports that at the age of eight the precocious boy was a pupil of Joris van Schooten in Leiden; at ten he went to Amsterdam to train with the famous history painter Pieter Lastman. He stayed there for several years (ca. 1617/18 to ca. 1619/20), establishing himself as an independent master back in Leiden in 1621. Around 1625, Lievens came into contact with the slightly older, Leiden-born Rembrandt, also a recent pupil of Lastman. The two became close artistic associates, drawing and painting similar subjects, clearly feeding off each other's youthful creativity. Recording a visit to them in Leiden in his autobiography, Constantijn Huygens

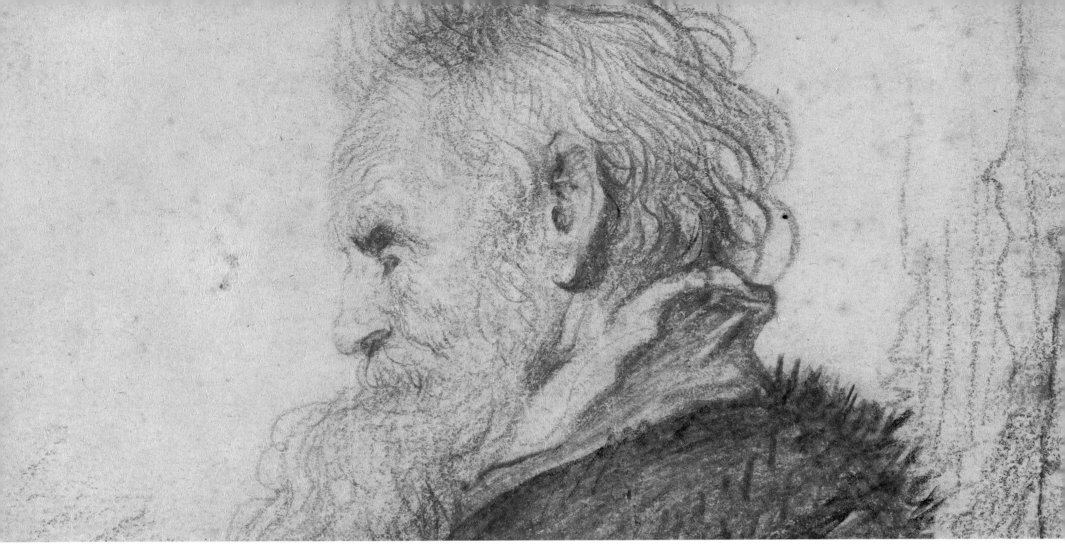

Jan Lievens

Leiden, October 24, 1607–Amsterdam, June 4, 1674

recognized them as rising young stars as well as essentially different artistic temperaments. Their lives and careers diverged when Rembrandt left for Amsterdam in 1631 and Lievens for London in 1632.

Gaining entrance to the court, Lievens painted portraits of the English royalty (now lost) and came under the influence of Van Dyck, then court painter to King Charles I. Lievens moved to Antwerp in 1635, where he remained until 1644.

Lievens moved back to Amsterdam in 1644, where his elegant Flemish style of painting attracted important commissions. This success led to employment with the Elector of Brandenburg in Berlin in 1653/54. Lievens moved to The Hague the same year and soon received

commissions for prestigious history paintings. His final years were plagued with financial problems, and he moved variously to The Hague, Leiden, and Amsterdam, dying there in 1674.

1 Key publications include Schneider 1932, reprinted with a supplement by Schneider and Ekkart in 1973; Braunschweig 1979; Sumowski, *Drawings*, vol. 7; Sumowski, *Paintings*, vols. 3 and 6; Amsterdam 1988–89; and Washington, Milwaukee, and Amsterdam 2008–09.

1.1

Rembrandt

Study of an Old Man with an Open Book

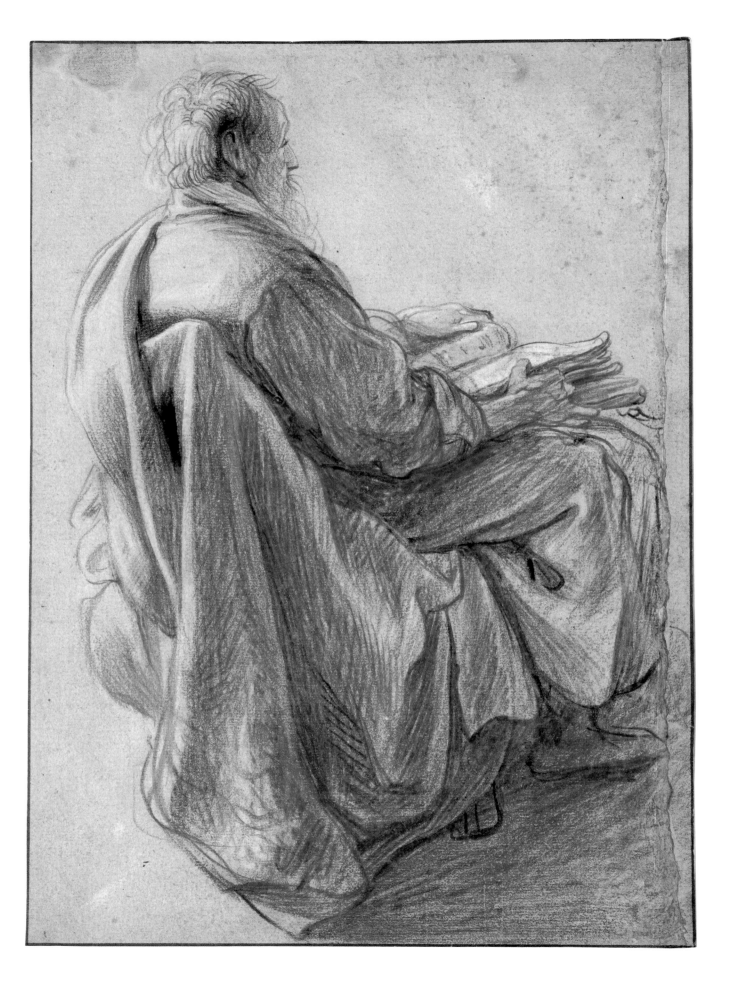

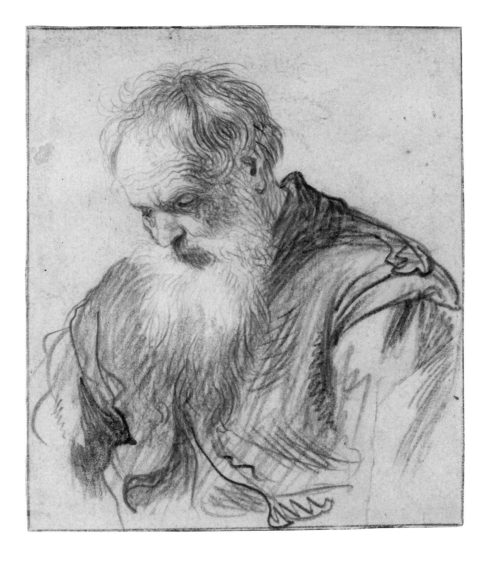

1.2

**Rembrandt, also attributed
to Jan Lievens**

Bust of an Old Man Looking Left

1.3

Jan Lievens

Bust of an Old Woman

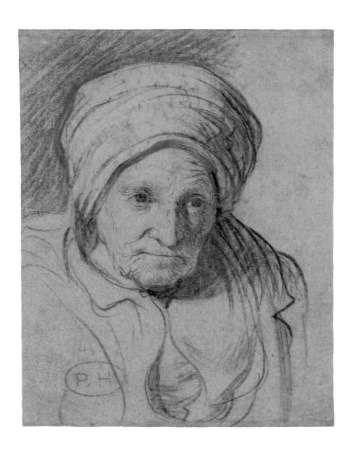

1.1 Rembrandt

Study of an Old Man with an Open Book, ca. 1627–28

Red and black chalk, white chalk heightening, pale yellow prepared paper;
vertical strip at right a later addition, 29.6 × 21.1 cm (11¹¹⁄₁₆ × 8⁵⁄₁₆ in.)
Berlin, Staatliche Museen, Kupferstichkabinett, KdZ 5284

1.2 Rembrandt, also attributed to Jan Lievens

Bust of an Old Man Looking Left, ca. 1629–30

Red and black chalk; piece at bottom right a later addition,
13.7 × 11.6 cm (5³⁄₈ × 4⁹⁄₁₆ in.)
The Hague, Private Collection

1.3 Jan Lievens

Bust of an Old Woman, ca. 1628–30

Red and black chalk on pale yellow prepared paper, 10.8 × 8.3 cm (4¼ × 3¼ in.)
New York, Private Collection

Although not a pupil of Rembrandt, Lievens is included here because of the strong cross-influences among their early drawings. Between 1625 and 1631, Rembrandt and Lievens both worked in Leiden, and their styles and subject matter were sometimes extraordinarily close. They may have occasionally shared the same studio and certainly used the same models. Lievens, the younger by one year, seems to have been the leader initially and must have had a studio before Rembrandt returned to Leiden, but Rembrandt's strong artistic personality quickly emerged. Their mutual teacher, Pieter Lastman, drew figures in a vivid, rich manner combining red chalk and white heightening on pale yellow prepared paper, and this might have influenced their initial attraction to the colorful combination of mixed chalks seen in Rembrandt's *Study of an Old Man with an Open Book* (cat. no. 1.1) and Lievens's *Bust of an Old Man Looking Left* (cat. no. 1.2). Remarkably for two young men in their early twenties, they were deeply attracted to themes involving the elderly. They even used the same model—the bearded, sagelike soul depicted in *Bust of an Old Man Looking Left, Bust of an Old Man with Folded Arms* (cat. no. 2.2), and *Bust of an Old Man Looking Right* (cat. no. 2.1).

Lievens's *Bust of an Old Man Looking Left* in The Hague is here catalogued as "Rembrandt, also attributed to Jan Lievens" based on the acceptance of it by Bauch and Royalton-Kisch, who currently thinks that it may be by Rembrandt.[1] The authors of this catalogue, however, strongly believe that it is by Jan Lievens and that it is a starting point for analyzing the relationship between the styles of the two artists and the possible impact of Lievens's style on the young Rembrandt.[2] *Bust of an Old Man Looking Left* is made of discrete lines: from the coarser lines of the robe, to the fine, descriptive, sinuous lines of the facial wrinkles and hair, to the cross-hatching in black chalk to the right of the beard. *Study of an Old Man with an Open Book*, which Rembrandt used as a study for Saint Paul in his painting *Peter and Paul Disputing* (Melbourne, National Gallery of Victoria), dated 1628, similarly shows the use of lines of red and black chalk, often cross-hatched. There are nonetheless considerable differences between *Study of an Old Man with an Open Book* and *Bust of an Old Man Looking Left*, most notably the execution of the latter in separate lines of red and black chalk contrasted with the thicker application and greater blending of the lines in *Study of an Old Man with an Open Book*, as well as sculptural white highlights absent in *Bust of an Old Man Looking Left*. These differences in handling create a greater three-dimensional effect in *Study of an Old Man with an Open Book*,[3] also achieved by the fully realized rendering of the light. The fabric beneath the beard on Lievens's *Old Man* appears flat and unstructured. Although lines play an important role in the Berlin drawing, it is already more tonal than *Bust of an Old Man Looking Left*. The verso of the Hague drawing (fig. 1c) shows strong outer contours and finer

1 Bauch 1960, pp. 176–77, fig. 161 on p. 179 (as Rembrandt); Royalton-Kisch 1990, p. 134, and in his draft entry on the British Museum website for the drawing *Horse Lying Down* (Royalton-Kisch 2008–09, Ff,4.121; FAWK,ADD.25), which he compares in its mixed-chalk technique and execution to *Bust of an Old Man Looking Left* (cat. no. 1.2). Royalton-Kisch formerly attributed *Horse Lying Down* to Lievens (Royalton-Kisch 1991, pp. 410–15).

2 Benesch did not include it in his corpus of Rembrandt drawings. Schatborn published it as by Lievens (Amsterdam and Washington 1981–82, no. 64, and Amsterdam 1988–89, no. 12), supported by a detailed stylistic analysis.

3 These differences in handling were noted by Schatborn (see Amsterdam 1988–89, pp. 16–17, pl. III on p. 11) and later Bevers (Bevers 2006, pp. 24–26).

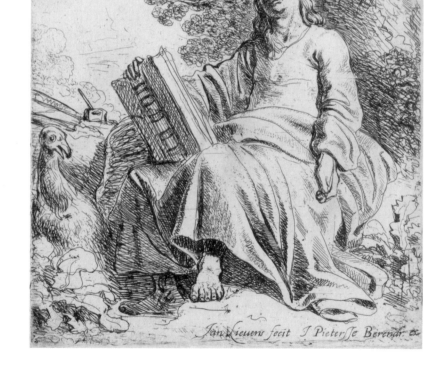

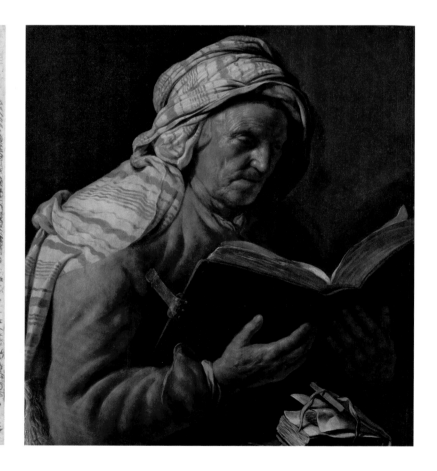

Figure 1a. Jan Lievens
Saint John the Evangelist on Patmos,
ca. 1625–26
Etching, state 2 (of 4), 15.6 × 14.1 cm
(6¼ × 5⁸⁄₁₆ in.)
Rotterdam, Museum Boijmans
Van Beuningen, BdH 11639

Figure 1b. Jan Lievens
Old Woman Reading, ca. 1625
Oil on panel, 78 × 68 cm (31¹¹⁄₁₂ × 27¹⁄₆ in.)
Amsterdam, Rijksmuseum, SK-A-4702

**Figure 1c. Rembrandt,
also attributed to Jan Lievens**
Drapery Study, a Mantle
(verso of cat. no. 1.2), 1629–30
Red chalk on pale yellow prepared paper,
13.7 × 11.6 cm (5³⁄₈ × 4⁹⁄₁₆ in.)
The Hague, Private Collection

Figure 1d.
Detail of fig. 1a

inner ones, and hatching with short lines along the contours. A close parallel occurs in the handling of drapery in early prints by Lievens, such as *Saint John the Evangelist on Patmos* (figs. 1a and 1d).[4]

The handling of Lievens's *Old Man* (cat. no. 1.2) strongly corresponds to that in another depiction of an elderly person—this time a woman (cat. no. 1.3)—that has never been thought to be by Rembrandt and is today accepted as the work of Lievens.[5] The costume, illumination, and features in the *Old Woman* are quite similar to those in Lievens's painting *Old Woman Reading* in the Rijksmuseum (fig. 1b). This in turn further strengthens the attribution of the *Old Man Looking Left* to Lievens. Made on pale yellow prepared paper in the manner of Lastman, as is also the verso of cat. no. 1.2 (see fig. 1c), the *Old Woman* is drawn in the same linear, descriptive fashion, with distinctive similarities seen in the bold black chalk strokes over the red that define the right lapel of her robe and those indicating the shoulder and collar of the robe of Lievens's *Old Man*.

Rembrandt uses black chalk in his early chalk figure studies quite differently, where it tends to describe deep shadows. In the Berlin drawing (cat. no. 1.1), black chalk creates the powerful recession of folds in the old man's cloak and robe. In two slightly later drawings of old men, Rembrandt uses precise touches of smudgy black chalk for tonal and textural accents, as seen in the single dark shadow in the neck of the *Old Man* in Stockholm (cat. no. 2.2) and in the robe

and hairline of the *Old Man* in the Louvre (cat. no. 2.1). Differences in handling also translate into differences in expression. In the Stockholm and Louvre drawings, the dramatic distribution of light and shadow concentrates attention on the eyes of the old men, which are turned inward in contemplation. This contrasts with Lievens's bravura linearity in cat. no. 1.2, which, while displaying compelling mastery of draftsmanship, does not convey the nuances of his sitter's ruminative psychological state to the degree encountered in cat. nos. 2.1 and 2.2. — **LH**

4 B. 4; Hollstein 9.
5 Attributed to Lievens in Amsterdam 1988–89, no. 11; formerly to Nicolaes Maes and later attributed by Sumowski to Rembrandt's first pupil, Gerrit Dou (Sumowski, *Drawings,* 539⁹). See Rubinstein in Washington, Milwaukee, and Amsterdam 2008–09, under no. 95, not exhibited.

2.1

Rembrandt

Bust of an Old Man Looking Right

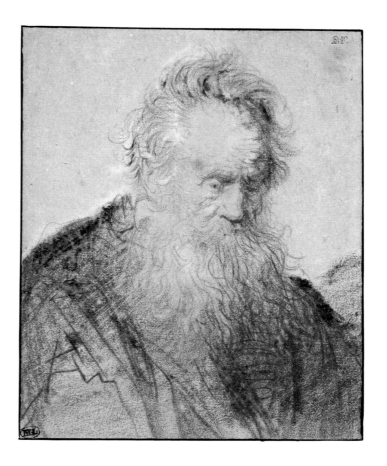

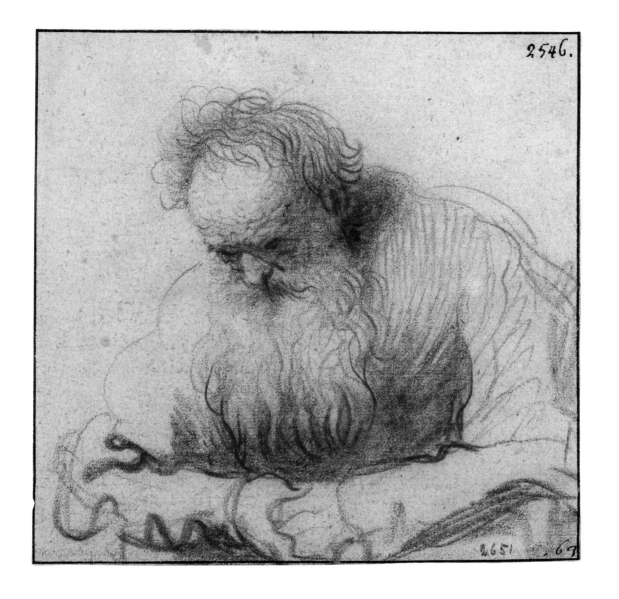

2.2

Rembrandt

Bust of an Old Man with Folded Arms

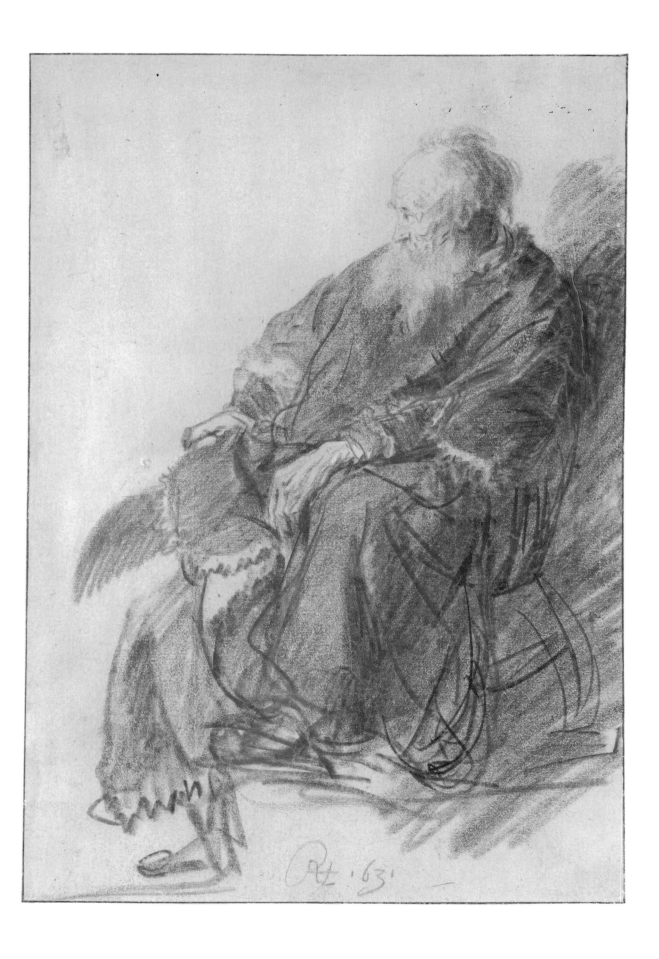

2.3

Rembrandt

Bearded Old Man Seated in an Armchair

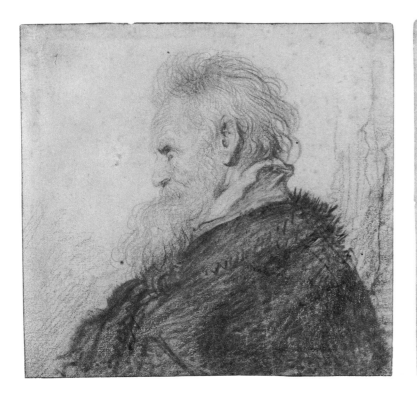

2.4

Jan Lievens

Bust of a Bearded Old Man in Profile
Verso: Drapery Study: A Sleeve (?)

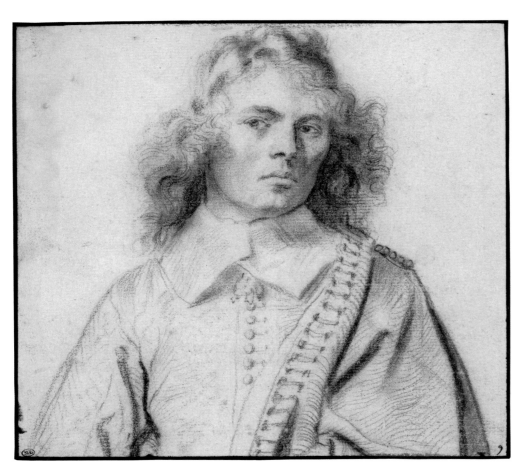

2.5

Jan Lievens

Bust of a Man with Abundant Curly Hair

2.1 Rembrandt

Bust of an Old Man Looking Right, ca. 1629/30

Red and black chalk, white gouache heightening (oxidized) on pale yellow prepared paper, 11.4 × 9.1 cm (4½ × 3⁹⁄₁₆ in.)
Paris, Musée du Louvre, Département des Arts graphiques, 22581

2.2 Rembrandt

Bust of an Old Man with Folded Arms, ca. 1629/30

Red and black chalk, 14.7 × 14.5 cm (5¾ × 5¹¹⁄₁₆ in.)
Stockholm, Nationalmuseum, NMH 2651/1863

2.3 Rembrandt

Bearded Old Man Seated in an Armchair, 1631

Red and black chalk on pale yellow prepared paper, 22.9 × 15.9 cm (9 × 6¼ in.)
Private Collection

2.4 Jan Lievens

Bearded Old Man in Profile, ca. 1631
Verso: *Drapery Study: A Sleeve (?)*, ca. 1631

Red chalk with touches of black chalk (recto), red chalk (verso),
13.7 × 13.8 cm (5⅜ × 5⁷⁄₁₆ in.)
Washington, D.C., National Gallery of Art,
Gift of Mrs. Lessing J. Rosenwald, 1987.20.11

2.5 Jan Lievens

Bust of a Man with Abundant Curly Hair, ca. 1650

Black chalk, 19.5 × 21.2 cm (7¹¹⁄₁₆ × 8⅜ in.)
Paris, Musée du Louvre, Département des Arts graphiques, 22394

As seen in Rembrandt's *Bust of an Old Man with Folded Arms* in Stockholm (cat. no. 2.2), which was possibly made from the same model as Lievens's *Bust of an Old Man Looking Left* (cat. no. 1.2), Rembrandt quickly shed the use of a more linear rendering in his chalk drawings and created a manner based on greater tonal contrasts. He shaded the face and the chest above the crossed hands, enveloping these areas in evocative shadows of different tones. There is exceptional variation in the chalk strokes, from the wispy hair to the powerful, rather abstract folds of the sleeves. He also introduces open contours and unworked areas (inner sleeves and hands), which contrast with the more consistently worked-up manner of Lievens's drawing.

By 1631 Rembrandt's brilliant and unique style of tonal chalk drawing reached new heights in a group of red chalk, mostly full-length, figure studies of old men, including cat. no. 2.3.[1] Unusually in Rembrandt's drawings, it is signed *RHL* (Rembrandt Harmensz Leidensis = Rembrandt Harmen's son of Leiden) and dated 1631, indicating that Rembrandt considered it a noteworthy drawing.[2]

From his earliest career, Rembrandt deftly and consistently used the paper tone. Using the Lastmanesque light yellow-toned paper to give a glowing luminescence to the unmarked passages of the sheet, Rembrandt went on to execute the figure in a dizzying range of chalk thicknesses, exploiting the vast and full potential of the friability and warm luminosity of the red-chalk medium. All the while, he orchestrated the unified, dramatic, and active flow of light upon the figure from left to right. He enveloped the old man's back in a pool of shadow created by deep deposits of red chalk, perhaps made by a moistened chalk stick. These thick chalk applications, as well as the ones indicating the robe and feet at the bottom, are suffused with enormous energy. The extreme sensitivity of the chalk application in the head and hands contrasts with the powerfully drawn passages in the robe and feet. The back of the head is enveloped in shadow, so that we perceive the ear through the soft focus of half-light. The dramatic fall of light is integral to the old man's expression of open-eyed perception and slight recoil. Rembrandt later used the study twice for the figure of Jacob, in a grisaille painting and an etching of *Joseph Telling His Dreams*, in which Joseph tells his shocked elderly father, Jacob, of his dreams of triumphing over his brothers and even his own parents.[3]

Bearded Old Man in Profile in Washington (cat. no. 2.4) has only recently garnered wide acceptance as by Lievens, although Royalton-Kisch and Andrew Robison still believe it to be by Rembrandt.[4] In the opinions of the authors of this catalogue, it represents the very closest that Lievens comes to Rembrandt's tonal chalk style of the early 1630s before the two parted ways, Rembrandt to Amsterdam and Lievens to England. Despite the use of the red chalk for a tonal effect,

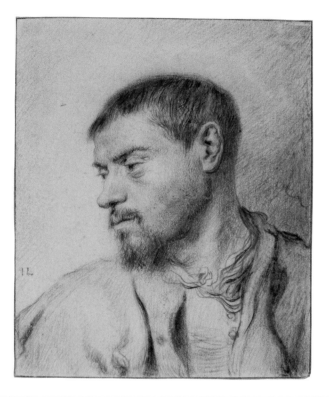

Figure 2a. Jan Lievens
Study of a Man's Head and Shoulders; Head Turned and Looking Left, His Hair Close-Cut with Small Beard and Mustache, ca. 1630
Red and black chalk, 17 × 13.5 cm (6⅝ × 5¼ in.)
London, The British Museum, 1836,0811.341

the drawing is still conceived mainly as lines and planes. The body of the old man is seen in profile, characteristic for Lievens but not for Rembrandt, and thus is flatter and displays far less structure than *Bearded Old Man Seated in an Armchair* (cat. no. 2.3). The head—its hair, wrinkles, beard, and ear—is executed in lines, and there is not a sense of enveloping shadow or dramatic illumination. This is seen especially clearly in the old man's ear, the linear handling of which is close to the ear in *Bust of an Old Man* (cat. no. 1.2). Although there is a beautiful range of chalk thicknesses, from delicate in the head to thick and textural in the robe, we encounter neither the full nuances of tonal shading seen in cat. no. 2.1 nor the use of the blank paper for light effects. Again, handling ultimately serves expressive effect, and here too one finds a certain lack of specificity. The eyes are shadowed but rather flat, making it difficult to distinguish whether the man is in contemplation or merely drowsy.

The versos of the two busts of old men here attributed to Lievens (cat. nos. 1.2 and 2.4) both contain drapery studies. They reveal that Lievens made drapery studies—probably more frequently than what this surviving pair records. In the Washington drapery study (verso of cat. no. 2.4), which is possibly slightly later than the verso of cat. no. 1.2 (fig. 1c), there is no hatching with short lines. Rather, one sees shaded folds with distinct, clearly defined forms, with very fine shading next to the folds. Accepted Lievens drawings such as *Bust of a Man*

with Abundant Curly Hair (cat. no. 2.5) of around 1650 show this same handling of drapery.[5] The drapery in the Louvre sheet (cat. no. 2.5) in turn is consistent with that in the signed *Study of a Man's Head and Shoulders* (fig. 2a) from Lievens's Leiden years.[6] In sum, Lievens has a soft, supple, and consistent approach to rendering drapery, which contrasts with Rembrandt's more three-dimensional treatment, with its wide range of strokes and textures. —**LH**

1 See also the ones in Berlin (Benesch 41; Bevers 2006, no. 4), Haarlem, Teylers Museum (Benesch 4; Plomp 1997, no. 321), and Washington, D.C., National Gallery (Benesch 37).

2 Cf. Bevers 2006, p. 34, under no. 4.

3 Grisaille in Amsterdam, Rijksmuseum, *Corpus*, II, A 66, ca. 1633–34; etching B. 37, dated 1638. See Schatborn et al. in Berlin, Amsterdam, and London 1991–92, no. 2; see also Boston and Chicago 2003–04, nos. 50–53.

4 Included in Benesch 42, it was first attributed to Lievens by Schatborn (Amsterdam 1988–89, p. 12, pl. IV); see also Rubinstein in Washington, Milwaukee, and Amsterdam 2008–09, no. 98. Royalton-Kisch maintains Rembrandt's authorship (see Royalton-Kisch 1990, p. 134), and Robison stated his support of the attribution to Rembrandt in conversation in January 2009.

5 Sumowski dates the Louvre sheet to circa 1650 (see Sumowski, *Drawings*, 1661⁵), which Marieke de Winkel has confirmed on the basis of costume.

6 Sumowski, *Drawings*, 1589. See also Royalton-Kisch 2008–09, no. 2.

LIEVENS

57

Rembrandt

It is not known exactly when Govert Flinck entered Rembrandt's studio. Arnold Houbraken, who obtained his information from Flinck's son Nicolaes (born in 1646), writes that Flinck was first apprenticed to Lambert Jacobsz in Leeuwarden, where Jacob Backer (1608–1651), Flinck's senior by seven years, also worked. According to Houbraken, Flinck left to go to Amsterdam at the same time as Backer, who painted a group portrait there in 1633–34 of the regentesses of the Civic Orphanage (Burgerweeshuis).[2] It is possible that Flinck joined the studio run by the Amsterdam art dealer Hendrick Uylenburgh,[3] for whom Rembrandt had been working since 1631.[4] Houbraken relates that Flinck studied with Rembrandt for a year, a period of

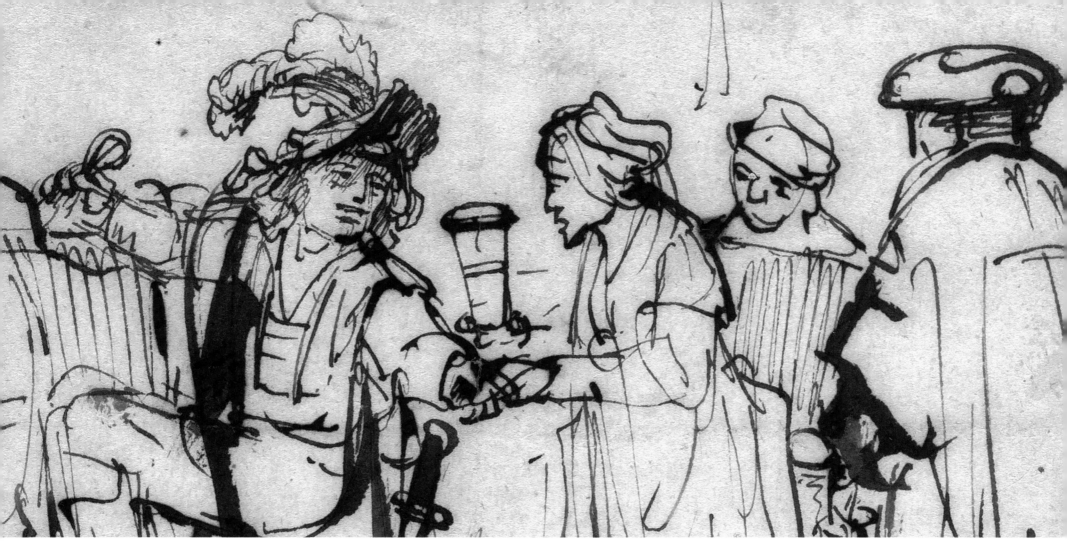

Govert Flinck

Cleves, 1615–Amsterdam, 1660

training that probably took place after May 1635, when Rembrandt set up as an independent painter in the Nieuwe Doelenstraat, rather than during his stay with Uylenburgh, who ran a workshop for the production of paintings.[5] Houbraken also reports that "various of his pieces were taken for, and sold as, genuine paintings by Rembrandt."[6] These were most likely paintings he made, but did not sign, while working in Rembrandt's studio, or unsigned work made in the following years. Finally, Houbraken says, it appears that after leaving Rembrandt's studio, Flinck took great pains to shed the master's style. While Flinck's early paintings and drawings clearly display Rembrandt's influence, his later works, particularly the portraits and his-

tory paintings, are more classicist in character. Most of the drawings that have survived were produced after he left the master's studio. These are mainly figure studies (often executed on blue paper), biblical representations, and a few landscapes. Flinck died two months after signing a contract to produce twelve history paintings for Amsterdam's new City Hall.

1 Houbraken 1718–21, vol. 2, pp. 18–27.
2 On December 7 the Civic Orphanage paid for the canvas on which this group portrait was to be painted; Bauch 1926, p. 65; Sumowski, *Paintings*, 74.
3 Dudok van Heel 2006, p. 203.
4 Dudok van Heel 2006, p. 202.
5 Dudok van Heel 2006, p. 202.
6 Houbraken 1718–21, vol. 2, p. 21.

3.1

Rembrandt

Nude Woman with a Snake

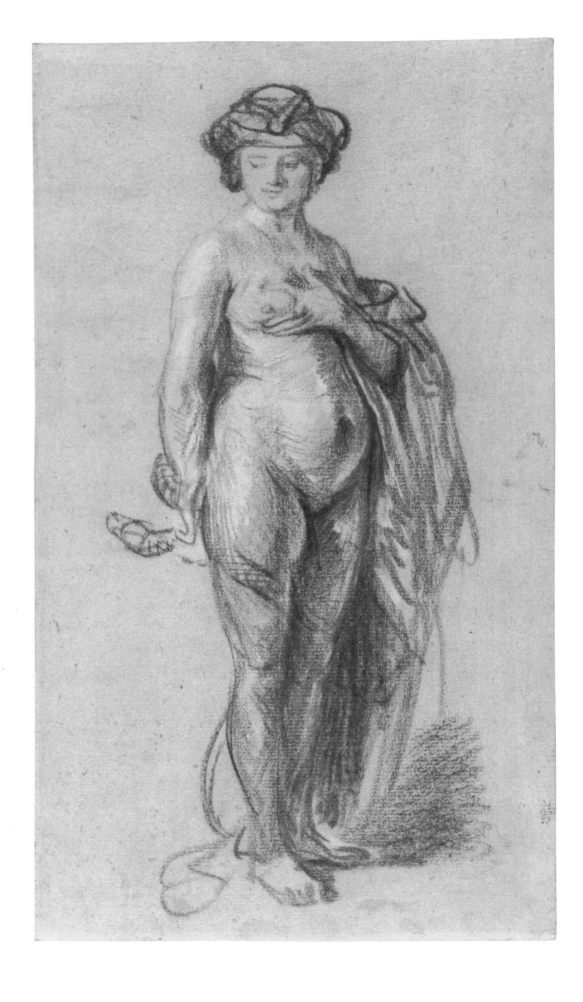

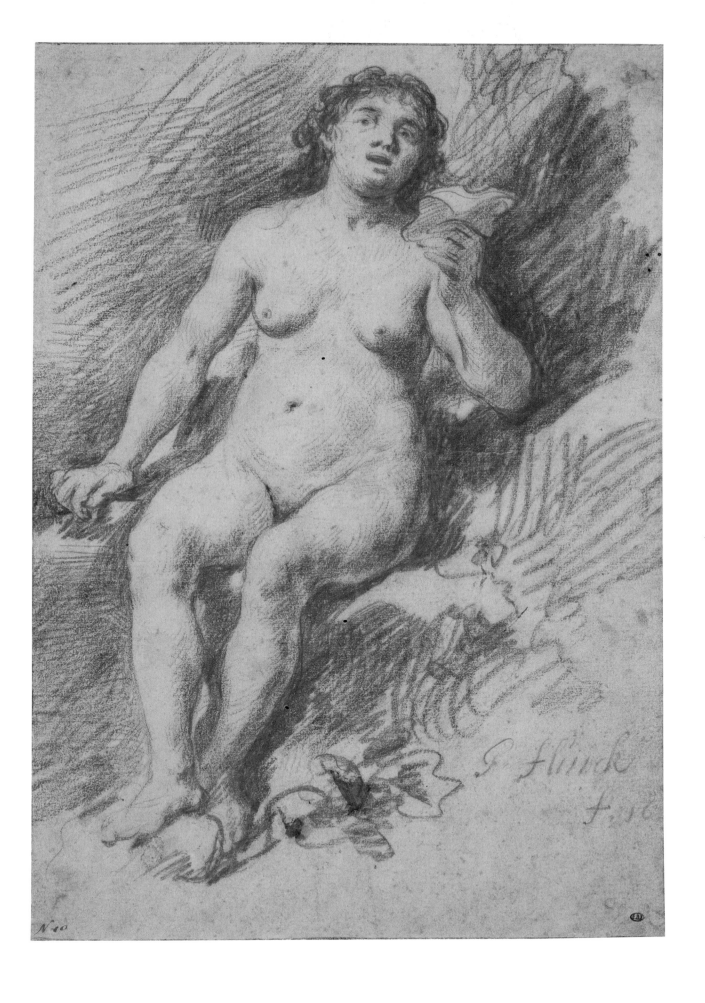

3.2

Govert Flinck

*Nude Woman as Bathsheba with
King David's Letter*

3.1 Rembrandt

Nude Woman with a Snake, ca. 1637

Red chalk, white gouache heightening, 24.7 × 13.7 cm (9¹¹⁄₁₆ × 5⁷⁄₁₆ in.)
Los Angeles, The J. Paul Getty Museum, 81.GB.27

3.2 Govert Flinck

Nude Woman as Bathsheba with King David's Letter,
ca. 1637–38

Red chalk, 34.2 × 23.2 cm (13⁷⁄₁₆ × 9⅛ in.)
Paris, École nationale supérieure des Beaux-Arts, 390

Rembrandt's nude woman in the guise of Cleopatra (cat. no. 3.1) was probably not drawn from a live model since the figure has a rather classical appearance and because during the course of instruction and after much practice, artists learned to draw nudes from memory.[1] Cleopatra (66–30 B.C.) was queen of Egypt and the lover of Julius Caesar and later Mark Antony. After the latter's death, she took her own life by allowing herself be bitten by an asp. In this drawing she holds the snake's head with her right hand, letting the rest of the creature wrap itself around her body. With her left hand she clasps her breast. Rembrandt's drawing has been connected with the figure of Eve in the 1638 etching *Adam and Eve*[2] and with the woman in the etching *Artist Drawing from the Model* of about 1639 (see fig. x in Holm Bevers's essay in this catalogue).[3] This drawing was probably made around that time.

Flinck's drawing (cat. no. 3.2) has more of the character of a life drawing.[4] Holding a letter in her hand, the woman plays the part of the Old Testament figure of Bathsheba, whom King David saw bathing and summoned by means of a letter. David had Bathsheba's husband, the army commander Uriah, sent to "the forefront of the hottest battle," where he was killed, freeing David to marry Bathsheba (2 Samuel 11:2–27). Flinck's drawing, the date of which has been cut off, can be placed in the second half of the 1630s. The year 1638 — the earliest date in Flinck's drawn oeuvre and after his stay with Rembrandt — appears on the drawing *Standing Man in Middle-Eastern Costume* (fig. 3a), in the Abrams album on loan to the Fogg Museum in Cambridge, Massachusetts.[5]

Striking differences between the nudes of these two artists include Flinck's liberal use of hatching around the figure and Rembrandt's use of white gouache next to the red chalk to heighten the contrasts. Moreover, in Rembrandt's drawing the handling of line is more varied and there is a broader scale of light and dark lines. The fine parallel and crisscrossed lines shading the body of Flinck's Bathsheba are not encountered in Rembrandt's drawing, in which the shaded areas on Cleopatra's body consist of all sorts of lines, rendered in delicate tones (on the shoulder, for example) and dark tones (the area between the robe and her left leg). Typical of Rembrandt are the forms drawn with more powerful lines over a more finely rendered sketch, as seen in the headdress and the folds of the robe draped over Cleopatra's left arm. The mesh of hatching so characteristic of Flinck consists of adjacent groups of lines placed at varying distances from one another. This irregular cross-hatching surrounds the figure of Bathsheba. Fanning out in all directions, the lines overlap and reinforce one another, especially on the right, where the figure casts its shadow. The leaf motif at the lower right suggests an outdoor setting.

In a number of respects Flinck's nude is comparable to the signed

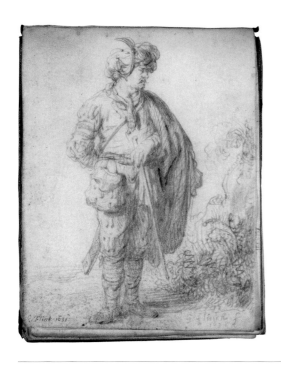

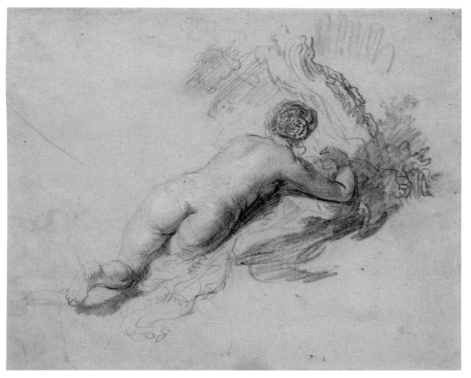

Figure 3a. Govert Flinck
Standing Man in Middle Eastern Costume, 1638
Black chalk on vellum, 15.2 × 11 cm
(6 × 4⁵/₁₆ in.)
The Maida and George Abrams Collection, Harvard Art Museum/Fogg Museum, Cambridge, fol. 46 recto in an album with fifty-three leaves, 1999.123.46r

Figure 3b. Attributed to Govert Flinck
Reclining Female Nude Seen from Behind, ca. 1639
Black and white chalk, 19.5 × 23.4 cm
(7¹¹/₁₆ × 9¼ in.)
Stockholm, Nationalmuseum, 33/1956

black-chalk drawing of 1638 in the Abrams album (fig. 3a), which is nonetheless smaller and therefore more delicately executed. The oriental figure type is quite Rembrandtesque, and the style of drawing is inspired by Rembrandt's etchings.[6] Indeed, a similar figure occurs in a Rembrandtesque painting by Flinck dated 1637, *The Lamentation at the Foot of the Cross*.[7] Characteristic of Flinck's drawing is the detailed depiction of the clothing and the shaded areas covered with hatching and cross-hatching. This is particularly true of the sketchily rendered natural setting, in which shrubs and leaves are depicted in profusion, even superimposed on preliminary hatching.

Most of Flinck's drawings of models date from the 1640s and are not Rembrandtesque in character. In his biography of Flinck, Houbraken relates that it later cost Flinck a great deal of effort to "unlearn" Rembrandt's manner,[8] as his nudes on blue paper clearly show. There is a drawing in Stockholm, *Reclining Female Nude Seen from Behind* (fig. 3b), that probably preceded Flinck's later drawings.[9] This nude was formerly attributed both to Rembrandt and to Flinck, but even though it does bear some resemblance to Rembrandt's Cleopatra, many stylistic features are more characteristic of Flinck. The recumbent nude was modeled with many fine and, in some areas, carefully drawn hatchings, with the dark shadows placed next to the figure, reminiscent of those seen in the drawing of Bathsheba. Contours were reinforced with dark lines in several places, such as the

right of the arm and the rather messily drawn headdress. The busy pattern surrounding the figure of Bathsheba is lacking, but the hatching to the right of and above the figure represents a modest and more delicate version of these lines. The way in which the foliage to the right of the tree trunk was drawn over hatching occurs in a comparable manner in the drawing in the Abrams album. The drapery under the figure, rendered rather shapelessly with loose, twisting lines, also seems to exclude Rembrandt as the author of the drawing. Finally, an old tree such as the one seen on the right, behind the recumbent woman, is a motif characteristic of Flinck and one that occurs frequently in his paintings and drawings. This drawing thus represents a link between the Rembrandtesque nude of Bathsheba and his many nudes drawn on blue paper in the 1640s. — **PS**

1 Benesch 137; Goldner 1988, no. 114.
2 B. 28.
3 B. 192.
4 Sumowski, *Drawings*, 895.
5 Signed in black chalk at lower right, *g.flinck.f / 1638*. Inscribed by a later hand in brown ink at lower left, *C(?) / Flink 1631*; London, Paris, and Cambridge 2002–03, no. 48 (illus.).
6 For example, Rembrandt's 1632 etching *The Persian*, B. 152.
7 New York, art dealer Jack Kilgore & Co.; Sumowski, *Paintings*, 612; London, Paris, and Cambridge, 2002–03, under no. 48.
8 Houbraken 1718–21, vol. 2, p. 21.
9 Benesch 193a; Stockholm 1992–93, no. 132.

4.1

Rembrandt

Lot and His Daughters

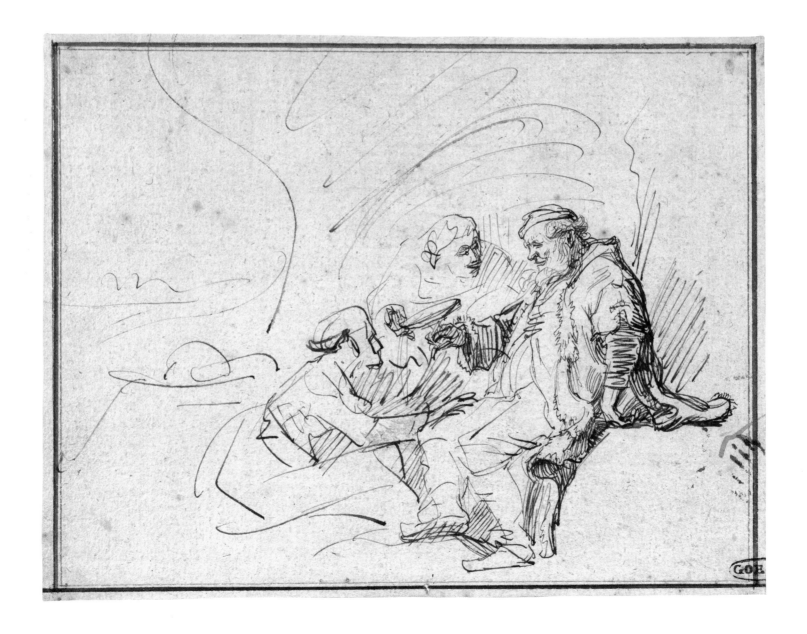

Govert Flinck

Joseph Interpreting the Prisoners' Dreams

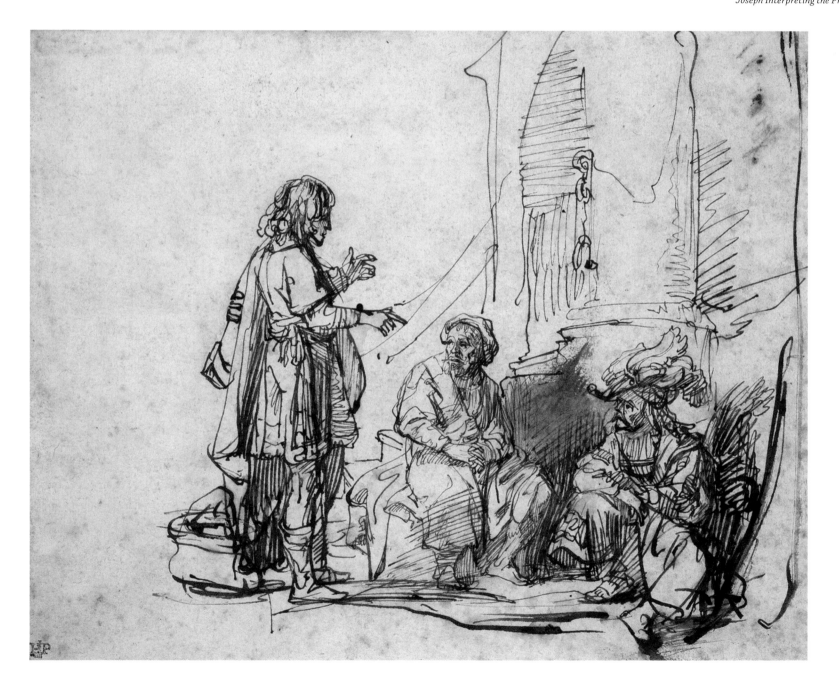

4.1 Rembrandt

Lot and His Daughters, ca. 1638

Pen and brown ink, 15.2 × 19.1 cm (6 × 7½ in.)
Weimar, Klassik Stiftung, Graphische Sammlungen, Sch. I, 874/0001

4.2 Govert Flinck

Joseph Interpreting the Prisoners' Dreams, ca. 1638

Pen and brown ink, brush and brown wash, 17.4 × 20.6 cm (6⅞ × 8⅛ in.)
The Art Institute of Chicago, Clarence Buckingham Collection, 1967.144

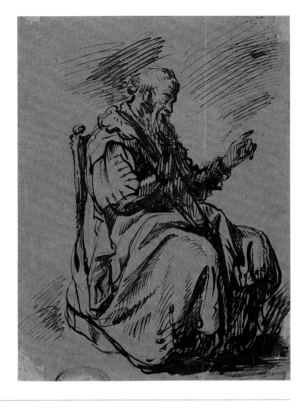

Rembrandt's *Lot and His Daughters* (cat. no. 4.1) depicts the Old Testament story in which Lot and his family flee from the burning cities of Sodom and Gomorrah. Lot's daughters, fearful of remaining alone in the world and childless, make their father drunk and seduce him in a cave (Genesis 19:30–38).[1] Rembrandt precisely indicates the salient elements of the story: Lot's drunken state is apparent from the tipsy way he holds his drinking cup, which his daughter steadies with her hand. Her facial expression clearly betrays her intentions, while that of Lot reveals a certain pleasure. The sitting daughter has placed her right hand on Lot's thigh, an invitation he cannot resist.

Rembrandt portrayed Lot in more detail than the other figures. The daughter on the left was drawn with loose, sketchy lines, while with the other daughter, at center, only her face and right hand are rendered in any detail. Despite the sketchiness, the forms suggest plasticity and structure. Characteristic of Rembrandt's working method are the open contours composed of unconnected lines, as seen in particular in the body of the daughter seated on the left. The forms, while not precisely described, are nonetheless clearly suggested. The shadows between the figures are consistently applied, thus taking account of the light falling from the left. They are rendered with various kinds of oblique hatching, whereby the blank areas come clearly to the fore. Very characteristic of Rembrandt is the way

he drew the nose of the daughter on the left as a separate form against the outline of the face. The inside of the cave is evocatively rendered with thick pen strokes, such that the figures are completely integrated into their surroundings. The drawing belongs to a group of biblical representations from the period that Flinck worked with Rembrandt in 1635–36.

Joseph Interpreting the Prisoners' Dreams (cat. no. 4.2) is one of the drawings previously thought to be by Rembrandt but now attributed to Flinck.[2] Accused of attempting to violate Potiphar's wife, Joseph was thrown into prison, where he interpreted the dreams of Pharaoh's baker and butler (see also cat. no. 7). He foretells that the butler will be released and restored to his position, but that the baker will be hanged (Genesis 40). The style of drawing was directly inspired by that of Rembrandt, for example, in *Lot and His Daughters*. Despite the similarities, however, there are striking differences. The pupil's drawing was executed with much more hatching, and the figures, in contrast to Rembrandt's, all display the same degree of detail. Flinck drew his figures more precisely, and they are "described" with less variation of line than Rembrandt uses. The contours, moreover, enclose the three figures nearly equally strongly on all sides, whether illuminated or in shadow. Flinck's shaded areas are thus created mainly by hatching, whereas in Rembrandt's drawing the varied handling of line also contributes to the shading. Flinck left little of

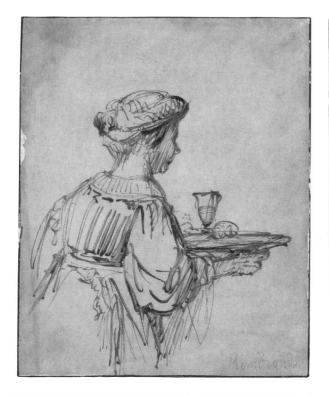

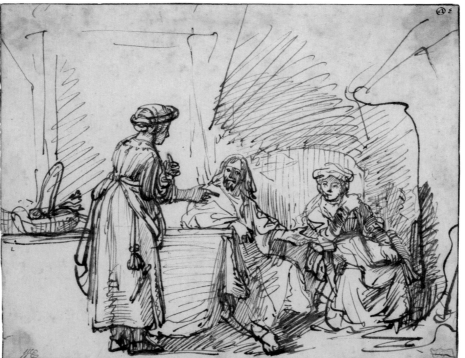

Figure 4a. Govert Flinck
Seated Old Man with a Raised Hand, ca. 1638
Pen and brown ink over a sketch in
black chalk on blue paper, 24.5 × 18.1 cm
(9⅝ × 7⅛ in.)
Melbourne, National Gallery of Victoria,
Felton Bequest, 1923, 1278.784-3

Figure 4b. Govert Flinck (?)
Woman with a Tray, ca. 1638
Pen and brown ink on brownish paper,
16.5 × 12.8 cm (6½ × 5 in.)
New Haven, Yale University Art Gallery,
1890.33

Figure 4c. Attributed to Govert Flinck
Christ in the House of Martha and Mary,
ca. 1638
Pen and brown ink, 15.8 × 19.4 cm
(6³⁄₁₆ × 7⅝ in.)
Haarlem, Teylers Museum, O*46

the white paper in reserve within the figures' contours, unlike Rembrandt, whose seated figure on the left is almost completely composed of blank paper.

No early, signed pen-and-ink drawings by Flinck are known, but the *Seated Old Man with a Raised Hand* in Melbourne (fig. 4a) bears an old inscription, *Godefredo Flinck da Cleves, scolaro di Rembrandt in Amsterdam* (Govert Flinck of Cleves, pupil of Rembrandt in Amsterdam).[3] This drawing is dated to about 1638, contemporaneous with the *Standing Man in Middle-Eastern Costume* (fig. 3a). The pen-and-ink drawing of the old man was executed with the same fullness of detail and even handling of line as the figures in *Joseph Interpreting the Prisoners' Dreams* (cat. no. 4.2) and, for that matter, the red-chalk drawing of the seated nude as Bathsheba (cat. no. 3.2).

Several drawings have been connected to the *Seated Old Man* in Melbourne, including a sheet in New Haven, *Woman with a Tray* (fig. 4b),[4] in which the handling of line is very similar. A drawing in Haarlem, *Christ in the House of Martha and Mary* (fig. 4c)[5]—previously considered the work of Rembrandt, despite the doubts cast on this attribution by various authors[6]—displays the same characteristics, but on a smaller scale and with more delicacy of line. This drawing portrays the story of Christ's visit to Martha and Mary. While Martha busies herself with household chores—her work basket stands on the table—Mary sits with Christ, who raises his hand to signify

that Mary has righteously remained beside him (Luke 10:38–42). In addition to Flinck's characteristically profuse hatching, with lines running in all directions, the outlines here are fairly uniform in character, even on the side where the light falls. The result of this uniform handling is that the composition seems rather flat. This is also true of the figure of Martha, who stands somewhat stiffly in space at the left and whose arm is covered by hatching. This figure is comparable to the woman in the New Haven drawing, who can be considered a sketchier variant of the figure in the Haarlem sheet.

The above-mentioned works belong to a group of drawings displaying the same characteristics, and can all therefore be attributed to Flinck. The group also includes, among others, *Christ Walking on the Waves* in the British Museum in London.[7] —**PS**

1 Benesch 128.
2 Benesch 80.
3 Sumowski, *Drawings*, 948ˣ, ca. 1638.
4 Sumowski, *Drawings*, 954ˣ; Sumowski dates the drawing to the early 1640s.
5 Benesch 79; Plomp 1997, no. 322.
6 Doubts were raised by Von Seidlitz, Hofstede de Groot, Kruse, Kauffmann, Lugt, and others; see Plomp 1997, no. 322.
7 Attributed to Flinck by Martin Royalton-Kisch; Benesch 70; Royalton-Kisch 1992, no. 7; Royalton-Kisch 2008–09, no. 7.

5.1

Rembrandt

*Three Studies of the Prodigal Son
and a Woman*

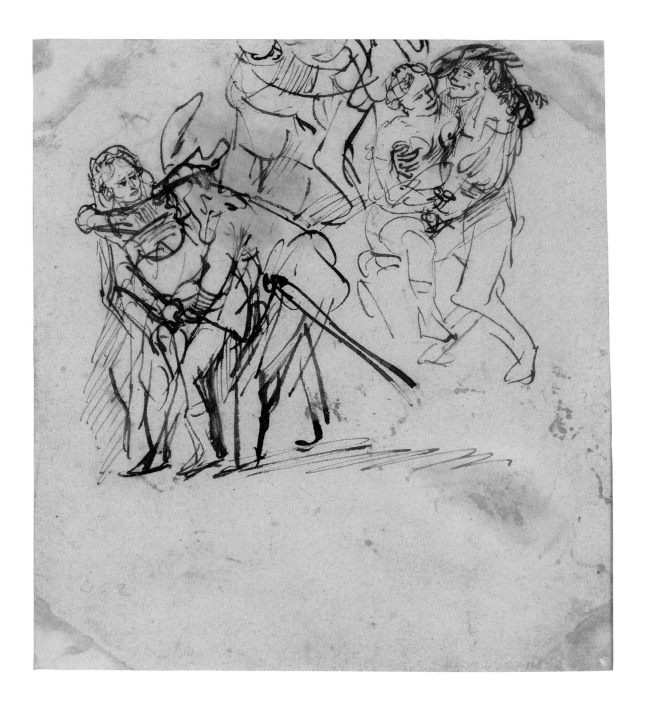

Govert Flinck

The Departure of the Prodigal Son

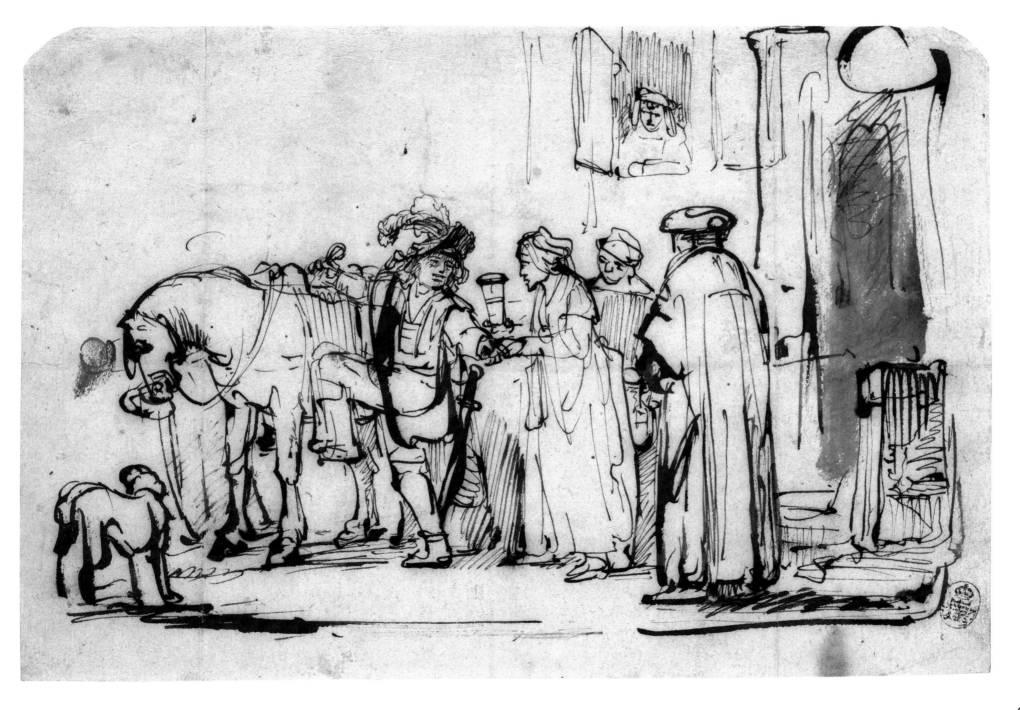

5.1 Rembrandt

Three Studies of the Prodigal Son and a Woman,
ca. 1635–36

Pen and brown ink, 17.3 × 15.5 cm (6¾ × 6¹⁄₁₆ in.)
Berlin, Staatliche Museen, Kupferstichkabinett, KdZ 2312 verso

5.2 Govert Flinck

The Departure of the Prodigal Son, ca. 1635–36

Pen and brown ink, 19.3 × 27.5 cm (7⅝ × 10¹³⁄₁₆ in.)
Dresden, Staatliche Kunstsammlungen, Kupferstich-Kabinett, C 1309

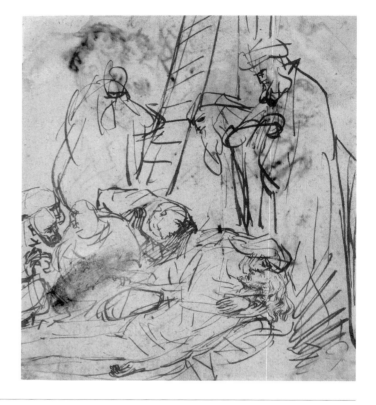

Rembrandt's *Three Studies of the Prodigal Son and a Woman* (cat. no. 5.1) appears on the verso of a representation of *The Lamentation of Christ at the Foot of the Cross* (fig. 5a),[1] a composition that possibly originated in conjunction with a series of seven paintings of the Passion of Christ, which Rembrandt was commissioned to make by *Stadhouder* Frederik Hendrik.[2] The drawing, however, was not used as a preparatory study. In this depiction, which is very broadly conceived and drawn with open, loosely connected lines, the faces of Christ and Mary form the expressive focal point.

The verso displays three figure studies portraying a man and a woman drawn in the same style. The uppermost study was partly cut off when the sheet was trimmed at the top. The sketches represent three scenes from Christ's parable of the prodigal son, in which the prodigal son attempts to seduce a harlot at an inn. According to the parable (Luke 15:11–32), the prodigal son received an inheritance from his father's estate and squandered it all; he then returned home, where he was nonetheless taken back by his joyful father (also depicted by Rembrandt, cf. cat. no. 20.1).

The three studies were first sketched in with fine lines (clearly seen in the legs of the figures on the right) and then worked up with broader lines, in the course of which Rembrandt continually introduced improvements to achieve the correct poses. In the scene on the left, the woman resists the overtures of the young man, who tries to put his hand up her skirt; she attempts to fend him off with her arm while holding her knees tightly together to thwart his advances. Her right arm was drawn in two positions, and it is clear that the second, definitive version was executed with heavier lines than the first. In the scene on the right, the woman—who has clearly decided to surrender herself—allows the man to touch her breast and put his hand between her legs. For her part, she accepts his advances, giving him a friendly look while the prodigal son flashes a triumphant gaze at the viewer. The third scene, at the top of the sheet, the last to be drawn, is probably another version of the scene on the left. Depictions of successive episodes of the same story are often encountered in drawings by Rembrandt and his pupils.

Rembrandt also portrayed the subject of the prodigal son carousing with a harlot at an inn in a painting of 1635, in which he used himself and his wife, Saskia, as models.[3] As in the scene depicted here on the right, the couple is portrayed sitting, and the man looks at the viewer as he raises his glass in triumph.

Flinck's drawing (cat. no. 5.2) shows a different episode of the story—*The Departure of the Prodigal Son*—featuring the young man, sporting a plumed hat, leaving his parental home. As he mounts his horse, he is given something to drink before setting off.[4] This drawing has been attributed to Rembrandt as well as to a number of his pupils.[5] The figure of the prodigal son wearing a plumed hat was

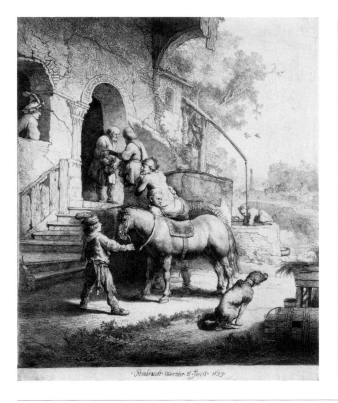

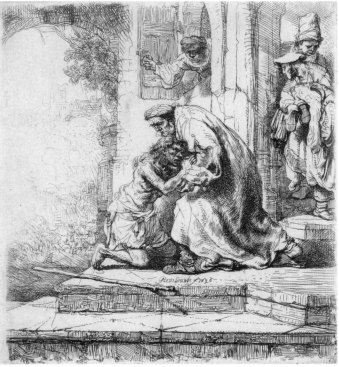

Figure 5a. Rembrandt
The Lamentation of Christ at the Foot of the Cross (recto of cat. no. 5.1), ca. 1635–36
Pen and brown ink, 17.3 × 15.5 cm (6¾ × 6⅛ in.)
Berlin, Staatliche Museen, Kupferstichkabinett, KdZ 2312 recto

Figure 5b. Rembrandt
The Good Samaritan, 1633
Etching and burin, 4th state, 24.7 × 21 cm (9¾ × 8¼ in.)
Amsterdam, Rijksmuseum, Rijksprentenkabinett, RP-P-1962-48

Figure 5c. Rembrandt
The Return of the Prodigal Son, 1636
Etching, one state, 15.7 × 13.8 cm (6³⁄₁₆ × 6⁷⁄₁₆ in.)
Amsterdam, Rijksmuseum, Rijksprentenkabinett, RP-P-1961-1039

clearly inspired by the figure in Rembrandt's drawing. Their features also display striking similarities, although the face of the departing son lacks the directness seen in Rembrandt's sheet and is drawn more cautiously and with less intensity of expression. Other motifs, too, show a reliance on Rembrandt: we find a similar horse in Rembrandt's 1633 etching *The Good Samaritan* (fig. 5b),[6] and comparable architecture with a figure in an open window was borrowed from the 1636 etching *The Return of the Prodigal Son* (fig. 5c).[7] Finally, the glass offered to the departing son is inspired by the raised glass in Rembrandt's aforementioned painting of 1635. It is not only these borrowings that betray the hand of a pupil, but also the style, which is not in keeping with Rembrandt's drawings of 1635–36, precisely the period that Govert Flinck spent in Rembrandt's studio. Strangely enough, only one of the horse's hind legs is visible, and it is placed much too far forward, in the very place where Rembrandt's etching shows one of the Good Samaritan's legs (fig. 5b).

The drawing displays stylistic similarities to other drawings, also previously considered to be the work of Rembrandt but now attributed to Flinck. On the whole, Flinck's figures are more precisely "described," and, in comparison with Rembrandt's drawing, display fewer sketchy, interrupted lines. Moreover, Rembrandt draws fewer details: feet, for example, either are omitted or are not worked out in detail. Flinck's figures have nearly complete outlines, whereas Rem-

brandt always leaves open spaces in the contours. Characteristic of Flinck are the rather uniform, flat areas of hatching between the figures, while the hatching in Rembrandt's drawing is sketchier and more tightly integrated into the composition. Composed of lines drawn in various directions, the hatching on the wall to the right of the entrance to the house makes a somewhat messy impression. In rather random places, Flinck drew broad, sometimes graceful outlines, not always taking into account the light falling from the left. Such loose contours are encountered in Flinck's *Seated Old Man* in Melbourne (fig. 4a) and *Joseph Interpreting the Prisoners' Dreams* (cat. no. 4.2). In contrast to the method he employed in those drawings, Flinck used less profuse hatching in *The Departure of the Prodigal Son*, instead imitating Rembrandt's application of similar groups of lines. The drawing thus would appear to originate in 1635–36, the year of Flinck's apprenticeship, in direct imitation of Rembrandt's depictions of the prodigal son. — **PS**

1 Benesch 100; Bevers 2006, no. 9.
2 Munich, Alte Pinakothek; *Corpus*, II, nos. A 65, A 69, III, nos. A 118, A 126, A 127. See also Pieter van Thiel in Berlin, Amsterdam, and London 1991–92, no. 13.
3 Dresden, Gemäldegalerie, 1559; *Corpus*, III, no. A 111.
4 Benesch 81 (Rembrandt); Sumowski, *Drawings*, 1521b^xx (attributed to Philips Koninck); Dresden 2004, no. 67 (attributed to Govert Flinck).
5 Dresden 2004, no. 67, under literature.
6 B. 90.
7 B. 91.

Rembrandt

The Actor Willem Ruyter as Saint Augustine

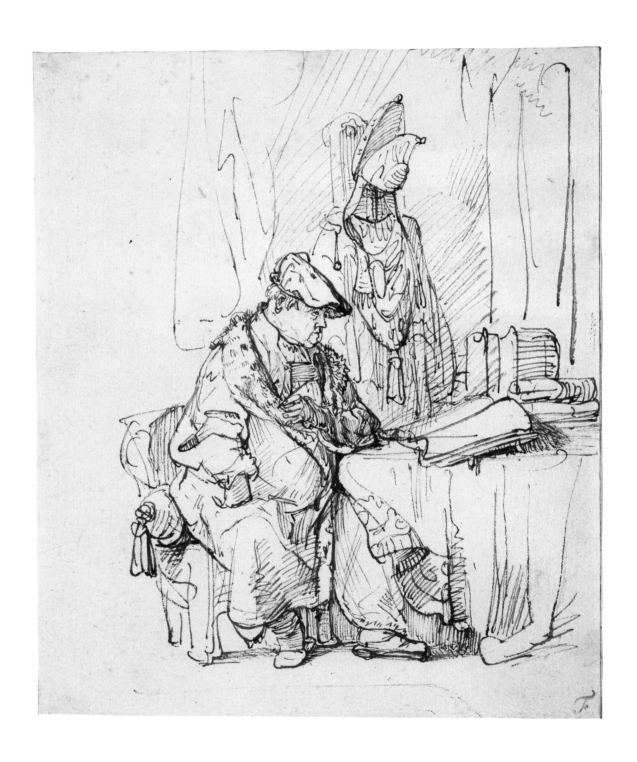

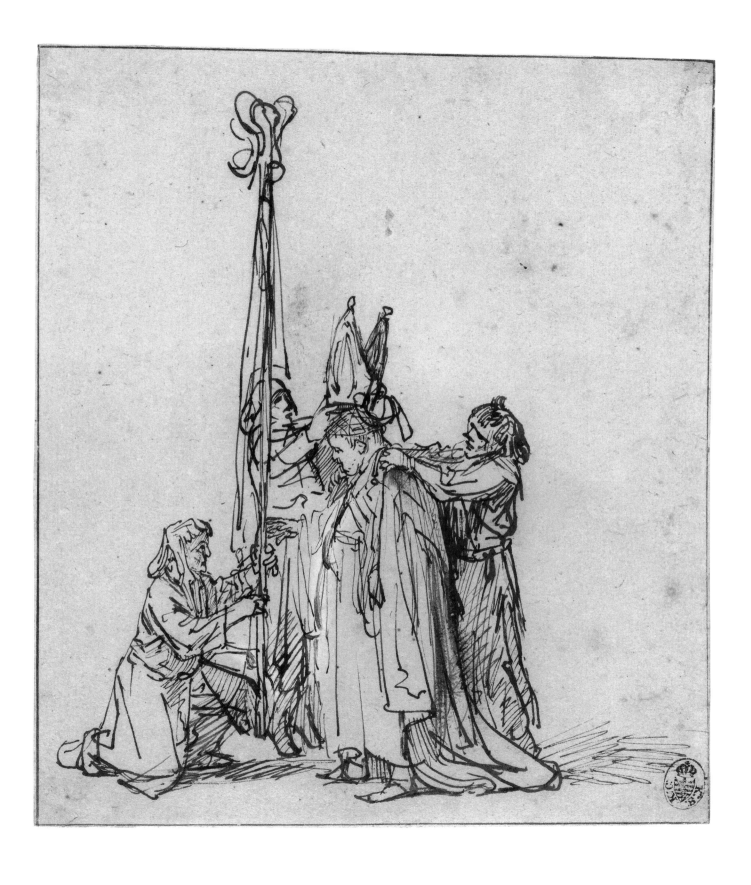

Govert Flinck

*Putting a Bishop's Costume on the
Actor Willem Ruyter*

6.1 Rembrandt

The Actor Willem Ruyter as Saint Augustine, ca. 1638

Pen and brown ink with some corrections in white, 18.3 × 15 cm (7³⁄₁₆ × 5⅞ in.)
Chatsworth, The Duke of Devonshire and the Trustees of the Chatsworth
Settlement, 1018

6.2 Govert Flinck

*Putting a Bishop's Costume on the Actor
Willem Ruyter*, ca. 1638

Pen and brown ink and white heightening on light brown prepared paper,
21.2 × 18 cm (8⅜ × 7⅛ in.)
Dresden, Staatliche Kunstsammlungen, Kupferstich-Kabinett, C 1388

The drawings made by Rembrandt and his pupils include a number of studies of figures in historical dress, traditionally connected with the Amsterdam theater. The character of the clothing in those drawings, however, suggests that they were fantasy garb and not stage costumes (see also cat. no. 16). There are also drawings of a corpulent man identified as the actor Willem Ruyter (1587–1639).[1] Apparently Ruyter's distinctive features and build prompted Rembrandt to draw him more than once and to use him as a model for historical figures.

In the drawing at Chatsworth (cat. no. 6.1), we see Ruyter seated at a table, wearing a fur-trimmed robe (called a tabard) and a flat beret.[2] Behind him, a bishop's mantle and miter hang from a hook, which is why it was previously assumed that the drawing depicts the actor in the role of Bishop Gozewijn in Joost van den Vondel's play *Gijsbrecht van Amstel*, which was first performed in January 1638 in Amsterdam. It was thought that he was practicing his part with a faraway look in his eyes. Since Ruyter holds a pen in his left hand, and, moreover, the book with clasps lying on the table is a folio volume and does not resemble the text of a play, it is more likely that Rembrandt could have had in mind a Father of the Church, such as Saint Augustine, and thus used the actor merely as a model. It is not known to what extent the drawing was made from life.

Ruyter also appears in the drawing attributed to Flinck, *Putting*

a Bishop's Costume on the Actor Willem Ruyter (cat. no. 6.2), in which a miter is being placed on his head while helpers drape a mantle around his shoulders and hand him a crozier.[3] It is likely that the subject of this drawing is, in fact, the actor being dressed to play the part of Gozewijn.

The drawings were executed in pen, and a bit of white was used in both to make corrections: in the case of the seated figure, the contour of his right sleeve was corrected above the chair; in the case of the standing actor, his paunch was evidently sketched in too voluminously and subsequently reduced in size. Although similar in conception, the two drawings are very different in execution. To begin with, Rembrandt introduced more variety and differentiation in both the nature and strength of the lines, whereas Flinck's lines are less varied. This is also true of the hatching, which Rembrandt applied delicately and in a manner appropriate to the forms, lending the figure plasticity and three-dimensionality, while Flinck's figures are all shaded with the same kind of hatching, consisting of lines of nearly the same thickness, which therefore make a flatter impression. The abundance of hatching is characteristic for many of Flinck's Rembrandtesque drawings (cat. nos. 3 and 4). Rembrandt's less dominant hatching is more subordinate to the final design, and there is altogether more space between the lines and areas of hatching. Rembrandt took great pains to render such motifs as hands and feet, and this is also true

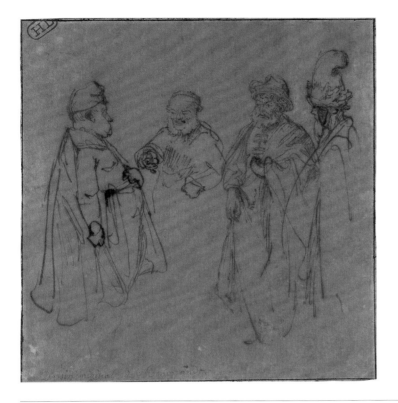

Figure 6a. Rembrandt
The Actor Willem Ruyter and Other Players,
ca. 1638
Pen and brown ink on brownish paper,
15.1 × 14.2 cm (5¹⁵⁄₁₆ × 5⁹⁄₁₆ in.)
Rouen, Museum of Fine Arts, AG 1868.9.77

for facial expressions—a remarkable example being the man's eyes, which stare out from under his beret. Flinck's faces, by contrast, are more cursorily drawn, which can be explained to some degree by their smaller size in relation to the sheet. The expression on the face of the helper, who looks up at the actor as he hands him the crozier, strongly recalls the look on the face of Rembrandt's figure, which Flinck may have taken as his example.

Rembrandt also drew Ruyter from memory on a sheet with various preparatory studies for the group of scribes in a painted grisaille in Berlin, *The Preaching of John the Baptist*.[4] In another sketch, Rembrandt seems to have portrayed Ruyter as an innkeeper, which, actually, as the owner of the inn next door to the theater, he was in real life.[5] There is yet another portrait of Ruyter,[6] as well as a sheet with three other figures in historical costumes facing him, the closest one pointing and laughing at him (fig. 6a). This composition could well recall actual behavior when actors dressed to go onstage reacted to each other's costumes. In this case, a fellow actor laughs at Ruyter. —**PS**

1 For this identification and the life of the actor, see Van de Waal 1969; Dudok van Heel 1979; Schatborn and De Winkel 1996.
2 Benesch 120.
3 Benesch 121; Dresden 2004, no. 104.
4 Berlin, Staatliche Museen, Kupferstichkabinett, KdZ 3773; Benesch 141; *Corpus*, III, no. A 106.
5 London, Victoria and Albert Museum, Dyce 435; Benesch 235.
6 Amsterdam, Rijksmuseum, Rijksprentenkabinet, RP-T-1996-6; Schatborn and de Winkel 1996.

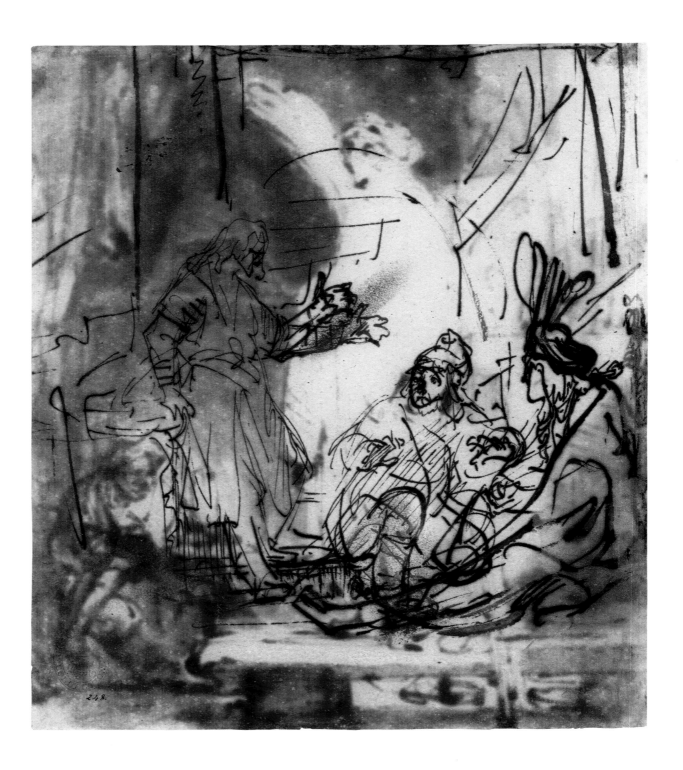

7.1

Rembrandt

Joseph in Prison Interpreting the Dreams of Pharaoh's Baker and Butler

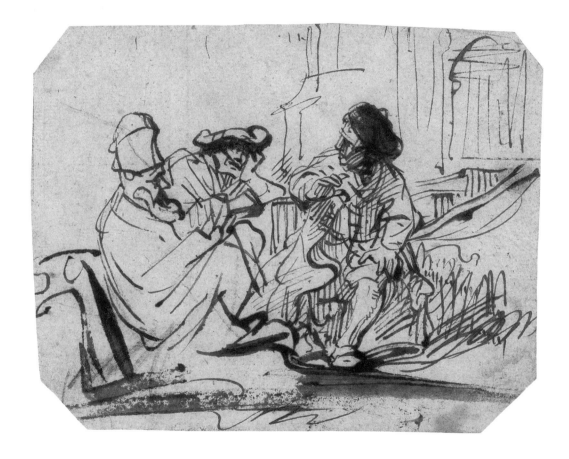

7.2

Govert Flinck

*Joseph in Prison Interpreting the Dreams of
Pharaoh's Baker and Butler*

7.1 Rembrandt

Joseph in Prison Interpreting the Dreams of Pharaoh's Baker and Butler, ca. 1639

Pen and brown ink on light brown prepared paper, 18.8 × 16.4 cm (7⁷⁄₁₆ × 6½ in.)
London, The British Museum, Gg,2.248 verso

7.2 Govert Flinck

Joseph in Prison Interpreting the Dreams of Pharaoh's Baker and Butler, ca. 1639

Pen and brown ink, traces of black chalk, 11.4 × 13.5 cm (4½ × 5⁵⁄₁₆ in.)
Los Angeles, The J. Paul Getty Museum, 2007.5

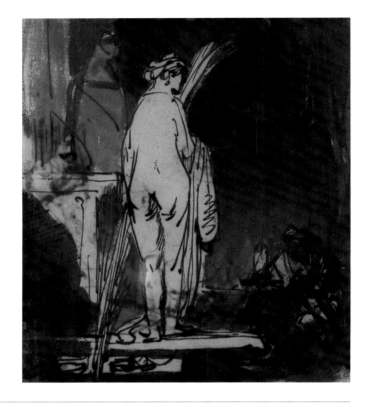

Episodes from the Old Testament story of Joseph were repeatedly portrayed by Rembrandt and his pupils (see also cat. no. 4). Sold into slavery by his jealous brothers, Joseph was transported to Egypt, where he became steward of the household of Potiphar, captain of Pharaoh's guard. Potiphar's wife tried in vain to seduce Joseph and finally accused him of trying to assault her. Joseph was thrown into prison, where he met Pharaoh's baker and butler, whose dreams he interpreted. According to Joseph, the butler's dream meant that he would be released from prison and restored to his position within three days, while the baker's dream meant that within three days he would be hanged (Genesis 40:1–20).

The verso of Rembrandt's drawing (cat. no. 7.1) shows an artist drawing from a female model (fig. 7a), a preparatory study for an etching that is usually dated to about 1639.[1] This study, robustly executed in pen and brush and iron-gall ink, shines through on the other side of the sheet.

The depiction of Joseph in prison is very sketchily and cursorily rendered. Joseph leans against a low wall at the foot of a winding staircase that also appears to the right of his head. He and the baker (in the middle) are portrayed in fine lines, whereas the butler (on the right), wearing a plumed hat, is drawn with more forceful lines. His outstretched leg partly obscures the legs of the baker, who throws up his hands in fear upon hearing Joseph's interpretation of his dream.

Joseph's face is drawn in elementary forms in a manner often seen in Rembrandt's work: a pointed chin, two strokes for the nose, and a line for the eyes and eyebrows; the faces of the other prisoners are also summarily rendered. Rembrandt drew Joseph's gesturing left arm in two positions, the second version higher and darker than the first, which he then overlaid with shadow.

Govert Flinck depicted the same subject in a drawing (cat. no. 7.2),[2] as well as in a grisaille (a painting executed only in shades of brown) (fig. 7b).[3] These representations derive from a 1512 etching by Lucas van Leyden, in which Joseph sits in the middle, the baker on the left, and the butler in a plumed hat on the right (fig. 7c).[4] The spatial conception of the prison in the grisaille was inspired by Lucas van Leyden's print.

In Flinck's drawing, as in the etching by Lucas van Leyden, the three figures are seated, with Joseph on the lower right, sitting on the stairs, gesturing with his right hand as he speaks. The prisoner on the left, who is depicted in the least detail, wears a tall hat; his arms are raised in what is probably a gesture of fright. The man in the middle, wearing a beret, seems to be listening in a relaxed pose, indicating that he is most likely the butler, who will eventually escape with his life. Rembrandt depicted Joseph bareheaded, but in Flinck's drawing he wears a flat headdress—as he does in the etching by Lucas van Leyden—though one without feathers.

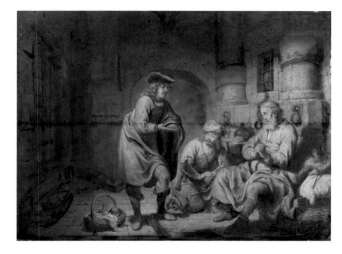

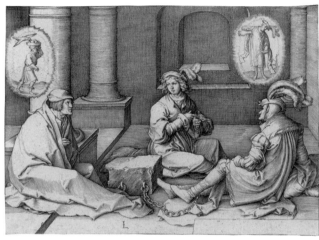

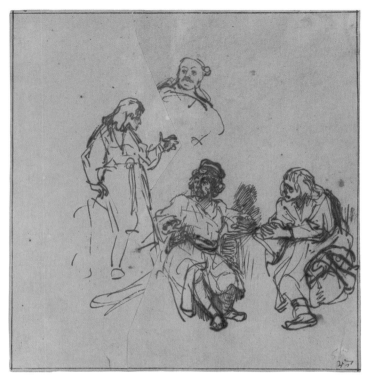

Figure 7a. Rembrandt
The Artist Drawing from a Model, ca. 1639
(verso of cat. no. 7.1)
Pen and brown ink, brush and brown
wash on light brown prepared paper,
18.8 × 16.4 cm (7⁷⁄₁₆ × 6½ in.)
London, The British Museum, Gg,2.248
verso

Figure 7b. Govert Flinck
*Joseph in Prison Interpreting the Dreams of
Pharaoh's Baker and Butler*, ca. 1639
Oil on panel, 40.8 × 53.2 cm (16¹⁄₁₆ × 21 in.)
Amsterdam, Private Collection

Figure 7c. Lucas van Leyden
*Joseph Interpreting the Dreams of the Baker
and Butler*, 1512
Engraving, 12.6 × 16.5 cm (4¹⁵⁄₁₆ × 6½ in.)
Amsterdam, Rijksmuseum,
Rijksprentenkabinet, RP-P-OB-1595

Figure 7d. Rembrandt
*Joseph in Prison Interpreting the Dreams of
Pharaoh's Baker and Butler*, ca. 1639
Pen and brown ink on light brown prepared
paper; Joseph is on a separate, irregularly
cut sheet, 20 × 18.7 cm (7⁷⁄₈ × 7³⁄₈ in.)
Los Angeles, The J. Paul Getty Museum,
95.GA.18

Flinck rendered his figures very sketchily with broad pen strokes of varying intensity, and it seems reasonable to assume that the style of Rembrandt's likewise sketchy drawing in London (cat. no. 7.1) served as his example. Flinck's drawing displays many lines of the same thickness but also very forceful lines, which he used, for example, on the shaded side of the face and the hat of the figure on the left, as Rembrandt would have done. He also used broad, dark lines to delimit the group at the bottom. Joseph was portrayed with the profuse hatching characteristic of Flinck—consisting of lines running in all directions and sometimes superimposed on one another—that we encounter in a number of other Rembrandtesque drawings by his hand (cat. nos. 3 and 4). The shadow Joseph casts to the right is barely distinguishable from the shadows on his body, which therefore stands out less from the background, reducing its plastic effect. His pose and the portrayal of his expressive right hand recall the central figure in Rembrandt's drawing in the Getty Museum (fig. 7d),[5] which itself is directly connected with his drawing in London (cat. no. 7.2). The sheet on which this composition was drawn was cut at some point, and the two pieces were later rejoined. In the left-hand piece, Joseph is seen in the same pose in which he occurs in the London drawing, leaning, or half-sitting, on a low wall as he speaks. On the other piece of paper, the baker sits with upraised hands while the butler listens, bent over, his hands folded in relief, as he listens to the interpretation of the dream. Rembrandt drew the figure of the baker in the most detail, notably with hatching indicating shadows, and sketched another version of his head in simple lines above. In contrast to the London drawing, the butler does not wear a plumed hat. The Getty drawing shows a more elaborate version of the composition, so it may well have been made later than the drawing in London. — **PS**

1 Benesch 423; Royalton-Kisch 1992,
 no. 27; B. 192.
2 Sumowski, *Drawings*, 948ˣ.
3 Sumowski, *Paintings*, 621.
4 B. 22.
5 Not in Benesch; Turner and Hendrix
 2001, no. 48.

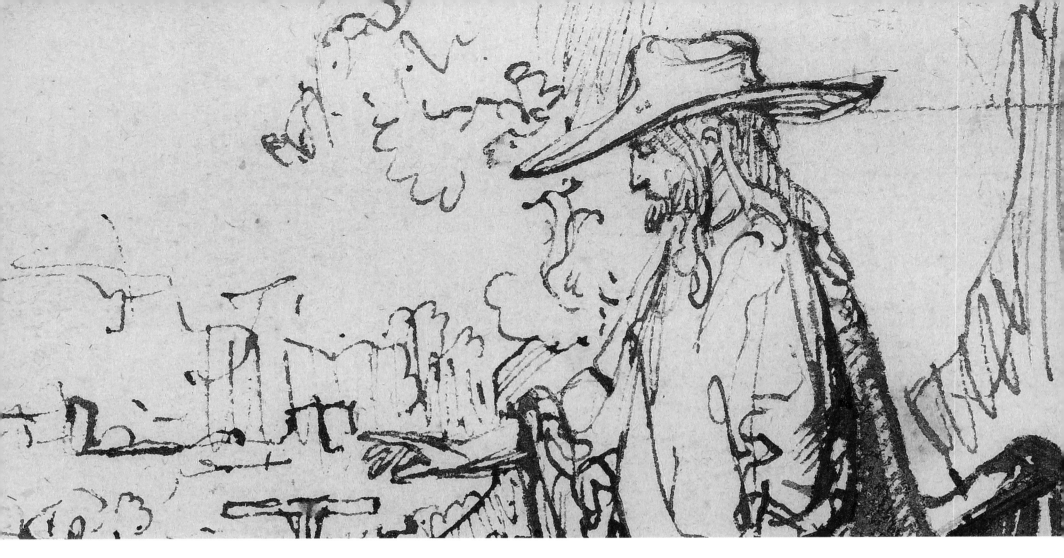

Rembrandt

Ferdinand Bol's artistic training began in his native city, probably in the workshop of Jacob Gerritsz Cuyp. He had completed this first phase of his education by December 1635, when Dordrecht documents refer to him as "painter." He must have left for Amsterdam in 1636, and certainly by 1637 he was active in Rembrandt's workshop, where he remained until 1641. A dated picture from that year attests that by then he had established himself as an independent master in Amsterdam.[1]

Bol ranks among seventeenth-century Holland's most successful artists. Like Rembrandt, he specialized in portraits and paintings of biblical, mythological, and allegorical subjects. His Rembrandtesque

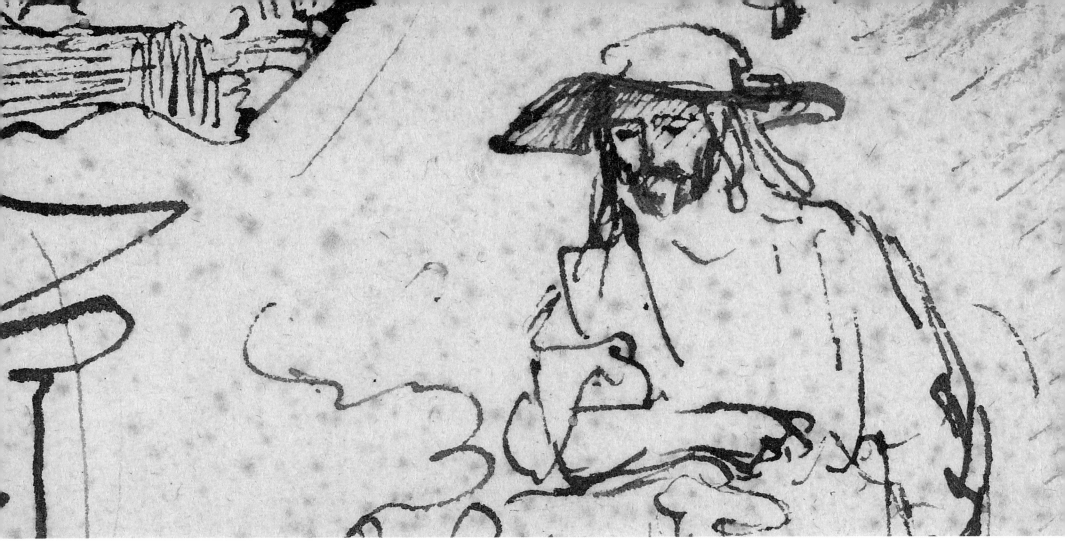

Ferdinand Bol

Dordrecht, June 1616–Amsterdam, July 1680

pictures of the 1640s are distinguished by their robust figures and an increasingly refined palette of light, local colors. Around 1650, Bol began to work in the Flemish style favored by the Amsterdam elite. From the late 1640s through the 1660s, Bol won several prestigious commissions for paintings to decorate the newly constructed Amsterdam City Hall and the Admiralty, and for group portraits of the governors of the Lepers' Asylum and Wine Merchants' Guild.[2] Approximately 190 paintings survive,[3] and he also produced about sixteen etchings.

Bol was a prolific and skillful draftsman. His drawings include composition studies for paintings, models for his etchings, portraits, single figures, sketches of biblical subjects, and a few landscapes. While many date from the late 1630s and early 1640s, when he studied with Rembrandt, a significant proportion of his oeuvre consists of studies for paintings and prints from the 1650s and 1660s. The task of identifying Bol's hand among the scores of school drawings in Rembrandt's manner of the 1630s is not an easy one. Sumowski established a core group of about thirty-five works securely attributable to him,[4] and another forty or so can be assigned to him on the basis of their close similarities to those documented works. Many other drawings ascribed to Bol are by different hands.

1 Dordrecht 1992–93, p. 96, and Sumowski, *Paintings*, vol. 1, pp. 282–87.
2 Sumowski, *Paintings*, vol. 1, pp. 291–425, and Blankert 1982.
3 Melbourne and Canberra 1997–98, p. 243, and Blankert 1982.
4 Sumowski, *Drawings*, 87–122.

8.1

Rembrandt

The Annunciation

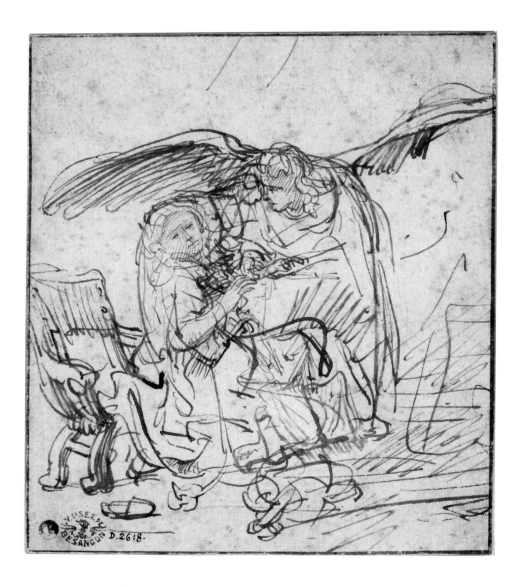

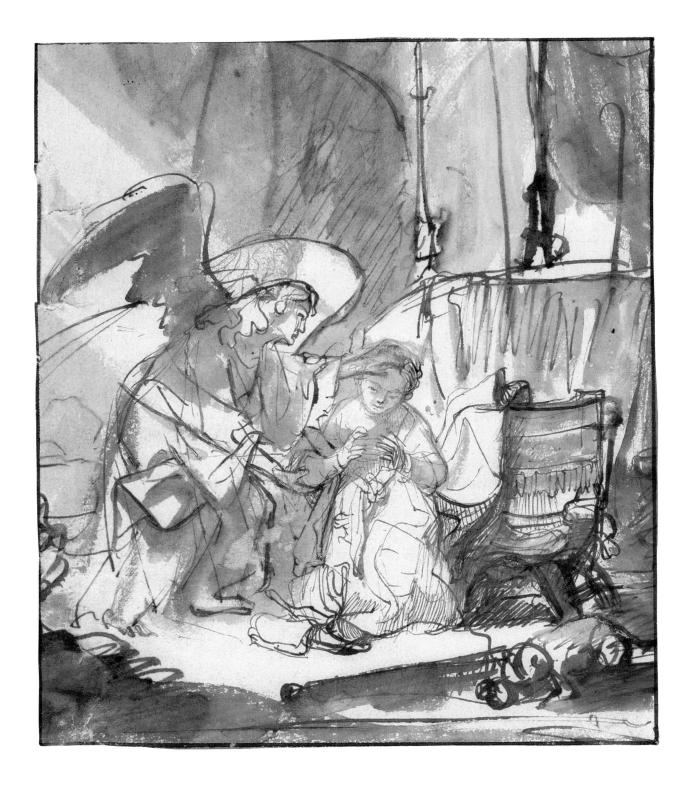

8.2

Ferdinand Bol

The Annunciation

8.1　Rembrandt

The Annunciation, ca. 1635

Pen and brown ink, white gouache corrections, 14.4 × 12.4 cm (5¹¹⁄₁₆ × 4⅞ in.)
Besançon, Musée des Beaux-Arts et d'Archéologie, D. 2618

8.2　Ferdinand Bol

The Annunciation, ca. 1636–40

Pen and brown ink, brush and brown wash, 19.4 × 16.5 cm (7⅝ × 6½ in.)
Oslo, Nasjonalmuseet for kunst, arkitektur og design, NG.K&H.B. 15591

Rembrandt's *Annunciation* (cat. no. 8.1) presents an uncanonical interpretation of the Virgin's reaction to the arrival of the angel Gabriel. His sudden appearance has taken her by surprise, and she has slipped off her chair and collapsed on the floor. Mary turns away from him with a look that gives visual expression to the biblical text: "she was troubled at his saying, and cast in her mind what manner of salutation this should be." Gabriel gently takes hold of her wrist to steady her and addresses her solicitously: "Fear not, Mary, for thou hast found favor with God."[1]

The Annunciation belongs to a group of drawings datable on the basis of their style and technique to the middle of the 1630s. The group includes three works in this exhibition: *Christ Carrying the Cross* (cat. no. 13.1), *Three Studies of the Prodigal Son and a Woman* (cat. no. 5.1), and *The Angel Departs from Manoah and His Wife* (cat. no. 18.1).[2] The penwork of these studies is distinguished by vigorous, densely concentrated strokes, multiple, fluid contours, and shading represented by forceful zigzags. The delicate hatching on the faces of Mary and Gabriel recurs in a sheet of studies—also in the exhibition (cat. no. 14.1)—for the grisaille painting *Saint John the Baptist Preaching*, of circa 1634–35.[3]

After sketching the composition of *The Annunciation* with a sharp quill pen, Rembrandt reinforced the chair and the angel's body and wings and added the dark, looping contours on the Virgin's skirt that suggest her precipitous movement. He sketched the angel's right arm at least twice. In the first draft, it extended straight out, and his hand touched the top of Mary's head. In the final version, the hand takes hold of her wrist. A third variation might be embedded in the tangle of lines. Finally, Rembrandt deleted with white gouache a segment of the dark contour along the bottom of the skirt, as well as the short diagonal shading strokes beneath it, and a few lines above it.

The Annunciation (cat. no. 8.2) ranks among Ferdinand Bol's finest and most characteristic drawings, its attribution established by comparison with the core group of studies securely assigned to him. The vertical and diagonal zigzag strokes resemble those in *The Messenger of God Appears to Joshua* (fig. 8a)[4] and *The Holy Family in an Interior* (fig. 12a). The thicker contours, such as those of the cat, recall *The Dream of Jacob* (fig. 8b),[5] a study for a painting dated 1642. In addition, *The Dream of Jacob* and other drawings affirm that the handling of the wash in *The Annunciation* is typical for Bol (cf. cat. no. 9.2 and fig. 12a). Bol joined Rembrandt's workshop about 1636, so his *Annunciation* presumably dates from the later 1630s.

Bol characteristically took over the principal features of Rembrandt's composition, rearranged them, and tempered the highly charged emotional expression in his model. The Virgin has left her chair, dropping her book, but instead of slumping to the floor, she kneels with hands folded. Her countenance is serious, although not

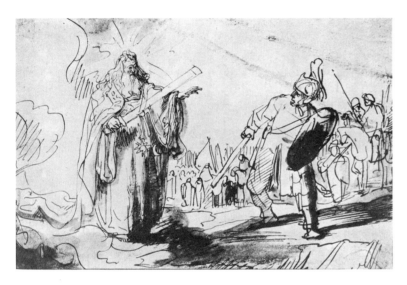

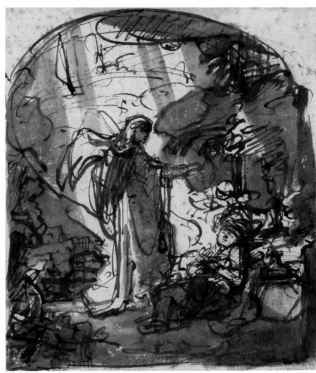

necessarily "troubled." Bol followed Rembrandt's unorthodox depiction of the messenger propping up the prospective Mother of God: Gabriel rests one hand on top of Mary's head, as in Rembrandt's initial sketch, and with the other gently takes hold of her elbow.

Rembrandt's dynamic penwork underscores the physical and emotional agitation called for by his interpretation of the text. Bol dramatized his composition with an expressive distribution of light and shadow. A wide, diagonal reserve behind the angel marks a reversion to the traditional iconography, which shows Gabriel arriving on a shaft of light. The burst of light casts heavy shadows on the angel's leg and the underside of his wing, on Mary's head and chest, and in the space between them. Emulating the technique Rembrandt used in *Seated Woman with an Open Book on Her Lap* (cat. no. 9.1), Bol evoked the shadows with wash applied in broad, bold strokes. However, compared to Rembrandt's drawing, Bol's brushwork is excessive, and his deployment of light and shade undisciplined. The shadows obscure the angel's hands and the Virgin's face, essential vehicles for emotional expression, and the scattered highlights undermine the clarity of the composition. — **WWR**

1 Luke 2:29–30.
2 Others are Benesch 132, 133, and 178. See Schatborn in Paris 2006–07, pp. 14 and 24, note 24.
3 Benesch 140, and Bevers 2006, no. 12.
4 Sumowski, *Drawings*, 90.
5 Sumowski, *Drawings*, 92.

9.1

Rembrandt

Seated Woman with an Open Book on Her Lap

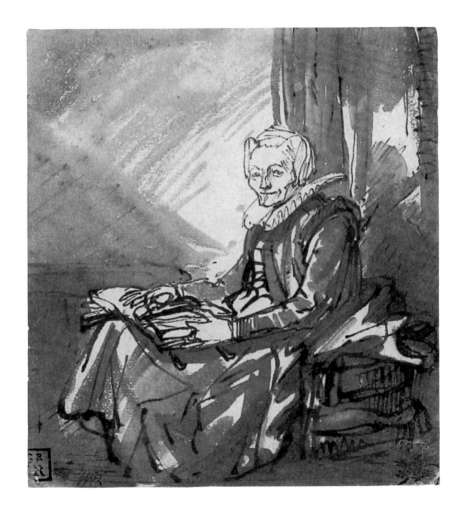

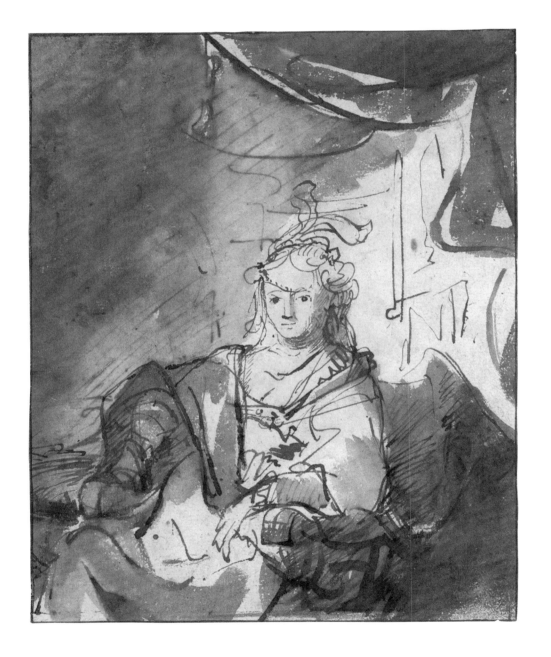

9.2

Ferdinand Bol

Seated Woman in an Interior

Rembrandt
Seated Woman with an Open Book on Her Lap,
ca. 1635–40

Pen and brown ink, brush and brown wash, 12.6 × 11 cm (4¹⁵⁄₁₆ × 4⁵⁄₁₆ in.)
Rotterdam, Museum Boijmans Van Beuningen, Koenigs Collection, R 10

9.2 **Ferdinand Bol**
Seated Woman in an Interior, ca. 1637–40

Pen and brown ink, brush and brown wash, 16.2 × 12.8 cm (6³⁄₈ × 5¹⁄₁₆ in.)
Berlin, Staatliche Museen, Kupferstichkabinett, KdZ 18533

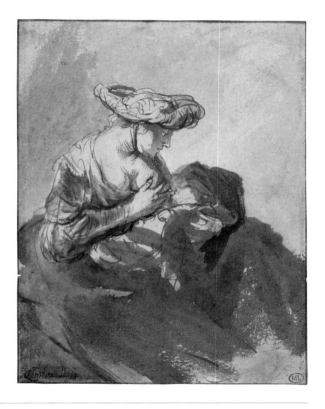

Rembrandt presumably executed *Seated Woman with an Open Book on Her Lap* (cat. no. 9.1) as a study for a painted portrait, but a related picture, if one existed, has not been identified. The drawing's technique and finished appearance recall the study he made during the course of the work on an oil portrait of 1639 of Maria Trip,[1] and the Rotterdam drawing may have served a similar purpose. It, too, dates from the later 1630s.

Rembrandt initially sketched the figure and summarily indicated the setting with fine lines in a light brown ink. Then he added the washes and strengthened selected contours, for example, on the skirt, bodice, book, and chair. Rembrandt took exceptional care with the execution of this composition. Light and shadow converge on the woman's head and collar, parts of which show against the reserve in the background and the rest within a reserve left in the wash that shades the upper right quadrant. To the woman's right he noted the shadows cast by her head and body. The crucial passages of the portrait—the hands, book, spectacles, and, especially, the face, cap, and collar—are sketched in detail. On her hands and arms, as on the collar and head, he carefully controlled the interplay between contour and reserve.

Seated Woman in an Interior (cat. no. 9.2)—like *The Annunciation* (cat. no. 8.2)—exhibits all the distinctive traits of Bol's draftsmanship as we know it from works securely attributed to him. The broad

brushstrokes that apply the wash, some from a lightly charged brush, recall the handling of a study of a woman nursing a child (fig. 9a),[2] which Bol adapted for a lost painting recorded in a copy. The handling of the pen, particularly in the eyes and the contours of the shoulders and arms, is comparable to that in a sketch for a portrait of Admiral Michiel de Ruyter (fig. 9b).[3] *Seated Woman in an Interior* dates from the later 1630s and the De Ruyter study from the 1660s, which illustrates the consistency of Bol's technique throughout his career.

Bol's composition bears a striking resemblance to a drawing, also preserved in Berlin, that represents a seated woman accompanied by the attributes of the goddess Minerva (fig. 9c).[4] Although their formats differ, the two compositions share a number of elements—the curtain at the upper right, the arched recess at the left, the feathered cap (in *Minerva,* the feather added in black chalk), and the drapery that extends over the back of the chair—and it seems plausible that they are designs for the same project. If so, the exhibited sheet might be a first draft that was elaborated in the more finished version with Minerva's attributes. In any event, no painting or etching related to these studies has come to light.

Easily identified as Bol's work, *Seated Woman in an Interior* is also readily distinguishable from Rembrandt's. As in *The Annunciation,* Bol emulated the impetuousness and flair of Rembrandt's draftsmanship but not the nuanced handling of *Seated Woman with an Open Book*

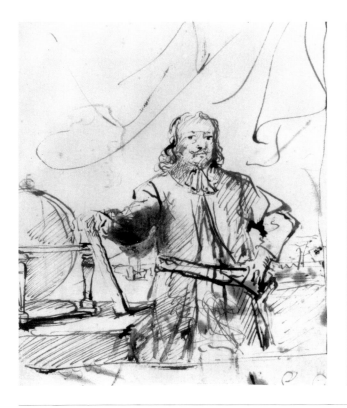

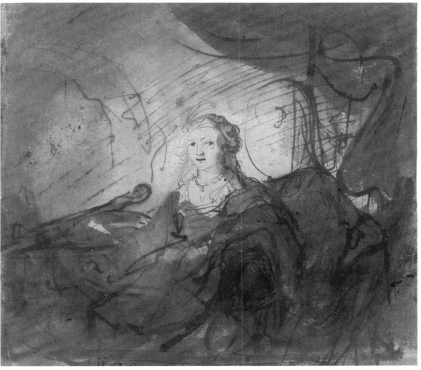

Figure 9a. Ferdinand Bol
Woman Nursing a Child, ca. 1640–45
Pen and brown ink, brush and brown wash,
red chalk, 14.9 × 11.2 cm (5¹³/₁₆ × 4³/₈ in.)
Paris, Musée du Louvre, Département des
Arts graphiques, R.F. 29734

Figure 9b. Ferdinand Bol
*Study for a Portrait of Admiral Michiel
de Ruyter*, 1667
Pen and brown ink, brush and brown wash,
20.9 × 16.9 cm (8¼ × 6¹¹/₁₆ in.)
Formerly Bremen, Kunsthalle, 1710
(lost during WWII)

Figure 9c. Ferdinand Bol
Minerva, ca. 1637–40
Black and red chalk, pen and brown ink,
and brush and brown wash, 17 × 18.5 cm
(6¹¹/₁₆ × 7⁵/₁₆ in.)
Berlin, Staatliche Museen,
Kupferstichkabinett, KdZ 1102

on Her Lap. Compared to Rembrandt's penwork, many of the lines in Bol's drawing are fussy and superfluous. The wash in Rembrandt's drawing, although seemingly applied with great flair, is carefully controlled and fosters the coherence of the composition and the prominence of the sitter's head and hands. Bol's brushstrokes are comparatively coarse and less modulated, and he deploys them to produce scattered, localized shadows that undermine the clarity of the image. —**WWR**

1 Royalton-Kisch 1992, no. 26.
2 Sumowski, *Drawings*, 96.
3 Sumowski, *Drawings*, 121.
4 Sumowski, *Drawings*, 166.

Rembrandt

*Three Studies of a Bearded Man
on Crutches and a Woman*

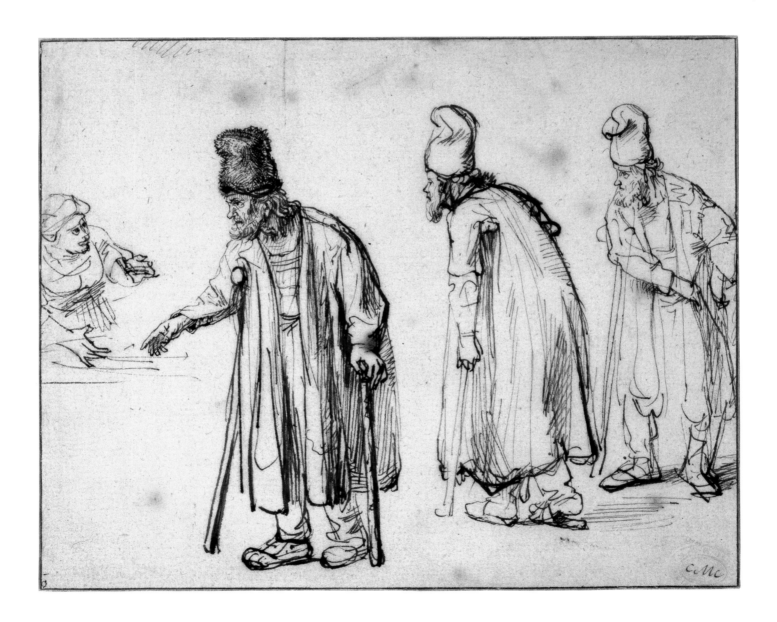

Ferdinand Bol

*Three Studies of an Old Man
in a High Fur Cap*

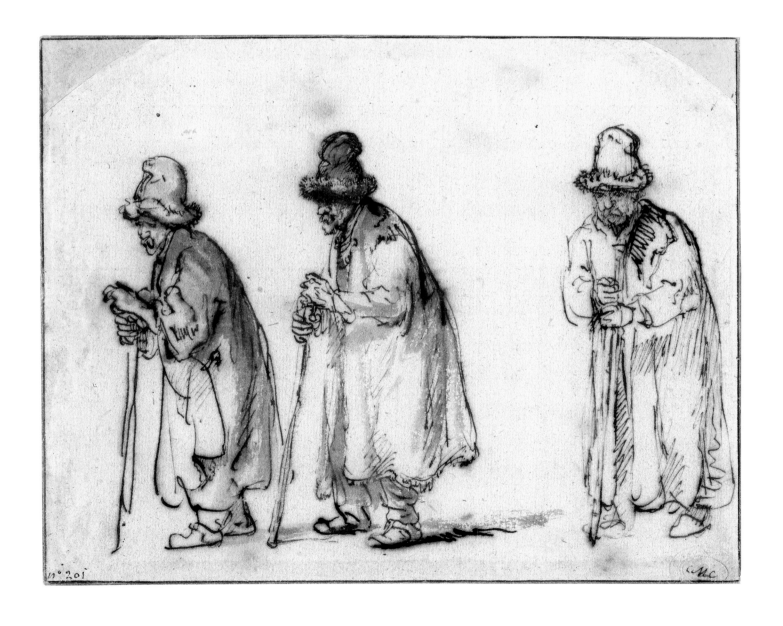

10.1 Rembrandt

Three Studies of a Bearded Man on Crutches and a Woman, 1636–40

Pen and brown ink, 15.2 × 18.5 cm (6 × 7⁵⁄₁₆ in.)
London, The British Museum, Gg,2.252

10.2 Ferdinand Bol

Three Studies of an Old Man in a High Fur Cap,
1636–40

Pen and brown ink, brush with gray-brown wash added by a later hand,
15.1 × 18.5 cm (5¹⁵⁄₁₆ × 7⁵⁄₁₆ in.)
London, The British Museum, Gg,2.251

Rembrandt was especially interested in the depiction of beggars and other types of vagrants. The prints of the French artist Jacques Callot (1592–1635) served as examples for him. Many beggars and cripples appear in Rembrandt's prints and drawings, above all in the period of the late 1620s to the later 1630s. There is even one etching in which Rembrandt portrays himself as a beggar wearing a plaintive expression, sitting on the side of the road and holding out his hand.[1] Since the Middle Ages such subjects had possessed a satirical character, but that became less pronounced during the course of the seventeenth century.[2]

Rembrandt's drawing of three views of a crippled man with a stick (cat. no. 10.1) displays various methods of handling.[3] The man on the left, who turns toward a woman, is the most highly worked up. He leans on the stick under his right arm and holds a shorter stick with his left hand. He stretches his hand out to the woman, who reacts to him rather violently with upraised hands. His face and fur hat are carefully drawn and described, and his coat is deeply shadowed on the right side, where several dark contour lines are also drawn. The man in the middle is depicted obliquely from the rear, and he walks with two crutches. This figure is less fully rendered, with little hatching and a few dark contour lines. This also applies to the figure on the right, although in his case Rembrandt omits the dark contours. The man leans on a stick as he puts his hand in his pocket.

We thus see the same figure three times, in various postures and with various methods of execution. It is also characteristic of Rembrandt that these are not three unrelated figures, but rather that the method of narrative in these depictions gives the impression of three moments in a single story whereby the woman first reacts to the crippled man, and then later he sticks his hand in his trouser pocket to put money into it.

The drawing that was formerly given to Rembrandt and here attributed to Bol (cat. no. 10.2) shows three views of a man wearing a fur hat.[4] Bol uses not only pen but also brush and brown wash; the gray wash was added later by another hand. While Bol probably used Rembrandt's drawing as a starting point, his version displays less variation in several respects. His figures are worked up in pen to about the same degree, and their poses are rather undifferentiated; the left two figures stand with the same posture, merely shown from different vantage points. The figure on the right is shown more frontally, but all three support themselves on a stick in the same manner. All three wear the same hat with a fur brim, just as Rembrandt's beggars do; two are shaded with brown wash. The creation of the forms in the two drawings also differs: Rembrandt's tauter handling of line and hatching lends the figures plasticity. The placement of shadows clearly suggests the bodies under the clothing. In the drawing by Bol, the handling of line is looser and sketchier, which is also true of the

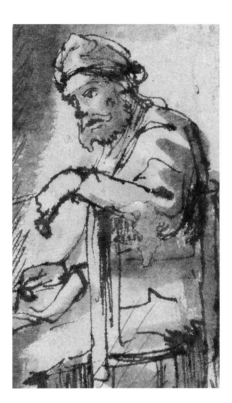

Figure 10a. Ferdinand Bol
Detail of Joseph seated, from *The Holy Family in an Interior* (fig. 12a)

hatching. Above all, the dark accents that Bol places here and there have a random character and in general lack a sense of plasticity. The left hand of the man at left clearly shows this, especially in comparison with the precision of the hands in the man that Rembrandt drew on the left side of his sheet. The execution of Bol's left-hand figure is thoroughly comparable to that of Joseph in *The Holy Family in an Interior* (fig. 10a).[5] The attribution to Bol is based upon the correspondence with similar drawings.[6]

Rembrandt's drawing has been variously dated, by some to the early 1630s, and by others later.[7] As there are few reasons to support an earlier dating, it is more probable that the drawing was made when Bol was with Rembrandt, thus from about 1636. Bol's earliest painting is from 1641, and therefore his drawing would also have been done before then, in the second half of the 1630s. Bol's drawing is a good illustration of how the pupils used Rembrandt's drawings as a basis for their own. — **PS**

1 B. 174.
2 Stratton 1986, pp. 78–79.
3 Benesch 327; Royalton-Kisch 1992, no. 8.
4 Benesch 688; Royalton-Kisch 1992, no. 36.
5 Schatborn 1994, p. 22.
6 See, for example, cat. no. 11.2 and fig. 11a.
7 See Royalton-Kisch 1992, no. 8, under literature.

11.1

Rembrandt

Esau Selling His Birthright to Jacob

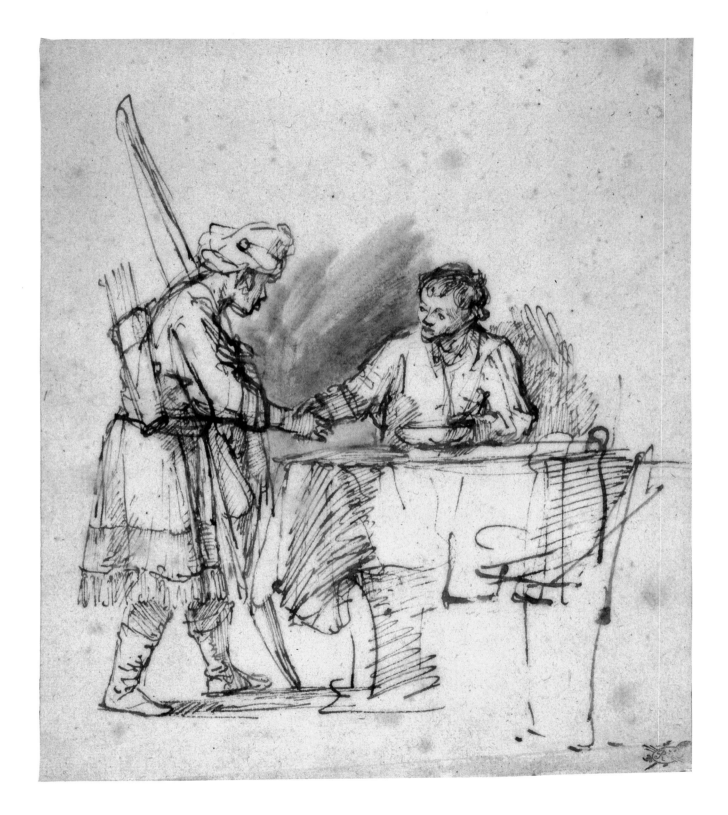

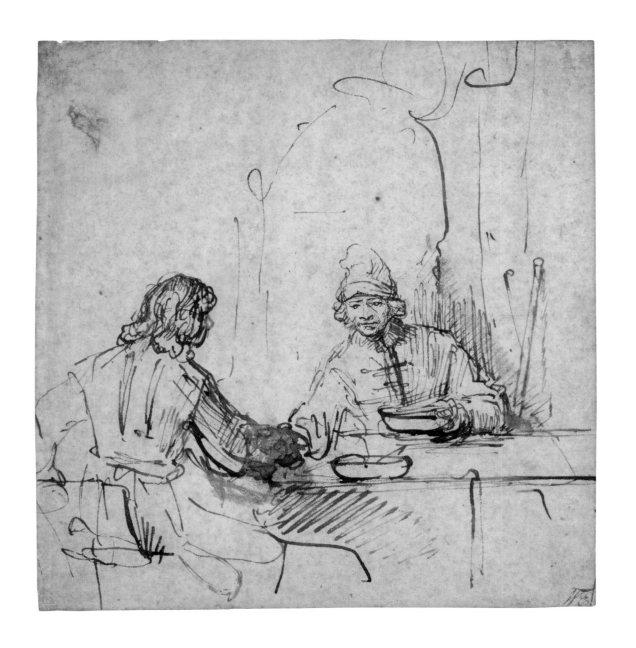

11.2

Ferdinand Bol

Esau Selling His Birthright to Jacob

11.1 Rembrandt

Esau Selling His Birthright to Jacob, ca. 1640

Pen and brown ink, touched with brush and brown-gray wash,
20 × 17.3 cm (7⅞ × 6¹³⁄₁₆ in.)
London, The British Museum, Gg,2.250

11.2 Ferdinand Bol

Esau Selling His Birthright to Jacob, ca. 1640

Pen and brown ink, corrections with white gouache,
15.5 × 14.8 cm (6⅛ × 5¹³⁄₁₆ in.)
Amsterdam, Historisch Museum, Bequest of C. J. Fodor, TA 10285

A moment from the story of the twin brothers Jacob and Esau (Genesis 25:29–34) is here represented. Esau returns from the hunt, tired and hungry, to find his brother eating. Appealing to Jacob, Esau agrees to sell his birthright in exchange for food. In Rembrandt's drawing (cat. no. 11.1) we see Jacob sitting at a table, while Esau walks in from the left with a bow in his left hand and a quiver on his back.[1] The exchange is settled with a handshake as Jacob lifts his plate, giving it to Esau. Within the composition, the handshake occupies a central place, which is strengthened by the brush-drawn shadow. Esau leans toward Jacob a bit, while Jacob fixes his gaze upon his brother. Through Esau's posture and Jacob's gaze, Rembrandt lends the event great intensity.

The figures are carefully represented with equal amounts of fine lines and darkened contours throughout that clarify their forms. Fine hatching also plays an important role in the definition of form and light, both of which lend plasticity to the figures. The wash makes the handshake emerge and also enforces the connection between the two brothers. The table is not thoroughly worked up and especially at right it is only generally, and rather messily, suggested. In making these lines, Rembrandt filled in and thereby balanced the composition.

Another version of the subject, first given to Rembrandt and now attributed to Bol (cat. no. 11.2), shows the same narrative moment in a different manner.[2] Both brothers sit at the table, extending their hands to one another. The brother behind the table must be Esau, who comes in from the exterior wearing a fur cap and clutching his staff to his side. He takes the plate from Jacob, who is shown from behind. (There is another plate on the table, which is not described in the Bible.) Accepting the proposition that Bol took Rembrandt's drawing as a starting point, the pupil demonstrates that while he followed Rembrandt, he nevertheless imposed his own interpretation of the event. A print by Willem Swanenburg after Paulus Moreelse may have played a role here. It also shows the brothers sitting at a table, with Jacob extending his plate to Esau while they shake hands.[3] But the motif of the figure seated behind the table, and more generally the style of the drawing, seem to derive from Rembrandt's representation, in which the dark contours are added to an earlier version, drawn with a finer pen. Bol's linework, however, is looser and sketchier, particularly in the figure of Jacob, who is shown from behind and is not clearly defined, especially in his lower body, which barely has form. Here it would appear that the draftsman took as his model a roughly drawn section of Rembrandt's drawing, which describes the table at lower right. In the background Bol drew a rounded archway through which Esau has entered, but the looping lines only slightly evoke the architecture. The hands are covered with white gouache, probably because Bol drew and redrew them repeatedly.

The loose penwork and rather coarse sketchiness are charac-

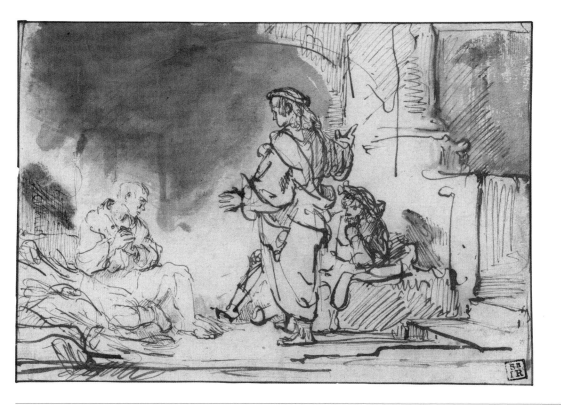

teristic of Bol. Another example is *Joseph Telling the Dreams of the Prisoners* (fig. 11a),[4] a drawing in Hamburg with nearly the same composition a painting in Schwerin, earlier given to Bol and now attributed to one of his German students, Godfried Kneller (1646–1723).[5] This pupil used the drawn representation by Bol as a model for his painting, which he made in the mid-1660s. This drawing (fig. 11a) shows loose penwork comparable to that in *Esau Selling His Birthright to Jacob,* in which rather unsteady fine lines alternate with dark broad lines that only generally accentuate the forms. The profile and hair of the standing Joseph in the Hamburg drawing are quite comparable to those of Jacob in the Amsterdam sheet. Eyes with small highlights also occur in both drawings, which in turn were adopted from Rembrandt's figure of Jacob in the London sheet. Bol also indicated shadow in both drawings with occasionally broad hatching.

Rembrandt's drawing is likely contemporary with *Christ as a Gardener Appearing to Mary Magdalene* (cat. no. 12.1), circa 1640, and with the signed and dated drawings of that year (see cat. no. 21.1). Bol's drawing *Esau Selling His Birthright to Jacob* probably dates to about the same time. — **PS**

1 Benesch 606; Royalton-Kisch 1992, no. 37.
2 Benesch 564; Broos 1981, no. 12; a copy is located in the British Museum, London, 1873,0510.3544; Hind 1915, no. 129.
3 Broos 1981, p. 54, fig. c.
4 Sumowski, *Drawings*, 101, dates the drawing later in the 1640s.
5 Blankert 1982, no. D1; Sumowski, *Paintings*, 970 (for full bibliography).

12.1

Rembrandt

Christ as a Gardener Appearing to Mary Magdalene

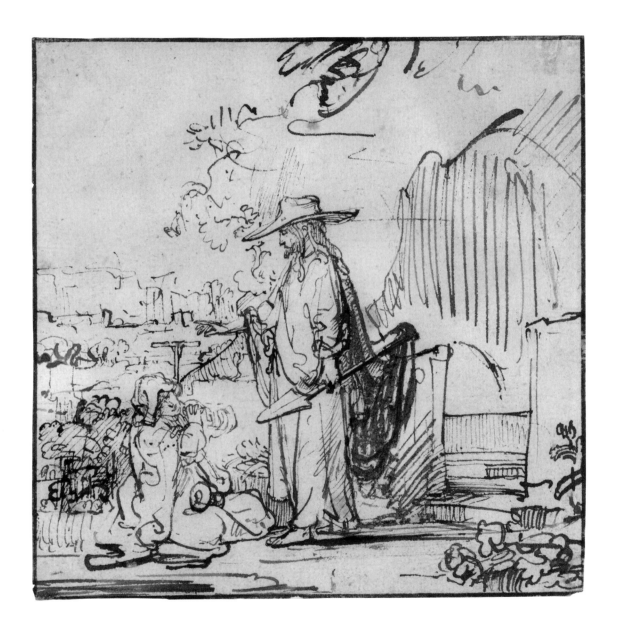

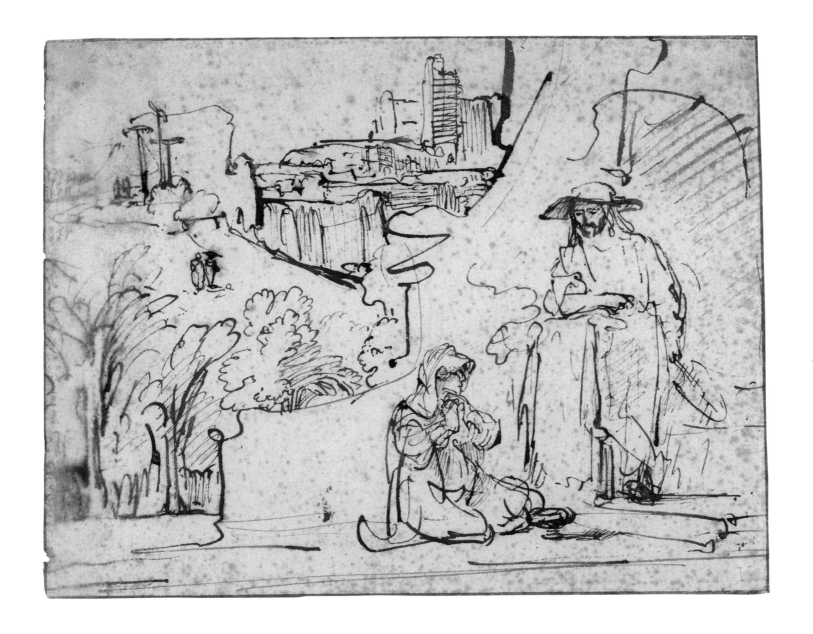

12.2

Ferdinand Bol

*Christ as a Gardener Appearing
to Mary Magdalene*

12.1 Rembrandt

Christ as a Gardener Appearing to Mary Magdalene,
ca. 1640

Pen and brown ink, corrections with white gouache, indented for transfer,
15.4 × 14.6 cm (6¹⁄₁₆ × 5¾ in.)
Amsterdam, Rijksmuseum, Rijksprentenkabinet,
Gift of Mr. and Mrs. De Bruijn-Van der Leeuw, 1949, RP-T-1961-80

12.2 Ferdinand Bol

Christ as a Gardener Appearing to Mary Magdalene,
ca. 1640

Pen and brown ink, 15.4 × 19.1 cm (6¹⁄₁₆ × 7⁹⁄₁₆ in.)
Amsterdam, Rijksmuseum, Rijksprentenkabinet,
Gift of Mr. Cornelius Hofstede de Groot, 1930, RP-T-1930-29

Both drawings represent the same moment in the story of Christ's Resurrection (John 20:8–18). After Christ died, Mary Magdalene visited his tomb and found that the stone in front of its entrance had been removed and it was empty. After two angels had asked her why she was crying, she turned around to encounter a gardener, unaware that he was in fact Jesus. She recognized him when he called her name and told her, "Do not touch me, for I am not yet ascended to my Father." Mary Magdalene then went to the disciples to tell them that Christ had risen from the grave.

The depiction of this story had a long tradition, and Rembrandt was certainly familiar with the prints of it by Lucas van Leyden (1494 or 1498–1533)[1] and Albrecht Dürer.[2] The figure of Christ in Rembrandt's drawing seems to be borrowed from *The Appearance of Christ to His Mother* from the Small Passion series of woodcuts by Dürer.[3] The prints of Lucas and Dürer depict the same moment shown in Rembrandt's drawing, when Jesus gestures and speaks.

In a painting of 1638, Rembrandt had represented the moment in which Jesus stands behind Mary Magdalene, while the angels appear by the tomb, precisely as it is recounted in the Bible.[4] Rembrandt's drawing depicts a slightly later moment, showing Jesus dressed as a gardener, with a broad-brimmed hat and shovel and speaking.[5] As he speaks, he raises his right hand. Mary Magdalene sits before him, clenching her hands and wringing them downward.

Between Mary Magdalene and the hand of Jesus appears the cross in the distance, as a reminder of Christ's death by crucifixion. Beyond that, summary contours render visible the city of Jerusalem, which also appears in the painting.

The drawing by Bol (cat. no. 12.2) represents the same scene in a horizontal format.[6] Here, Jesus does not speak and stands by a small wall; in the background, three crosses are drawn on the hill of Golgotha, and to the right of that is the city of Jerusalem. Previously attributed to Rembrandt, the drawing's current attribution to Bol is based on stylistic correspondence with a number of drawings that are regarded as being by him (for example, fig. 11a). Characteristic of Bol are loose, variable, fine, and sometimes randomly placed dark lines, in addition to occasionally coarse sketchy lines that suggest form. One encounters these in *The Holy Family in an Interior*, which dates to around the same time (fig. 12a).[7] This drawing, while also employing brush washes, exhibits the same characteristics in the linework, albeit more pronounced.

There are also considerable differences between the two drawings. In Rembrandt's drawing (cat. no. 12.1), Jesus stands in profile in the center, while Bol (cat. no. 12.2) places him to the side, leaning on a small wall and with one leg crossed over the other. Rembrandt has carefully rendered important details in his figure, for example, his taut profile, the hand gesturing as he speaks, and the precise place-

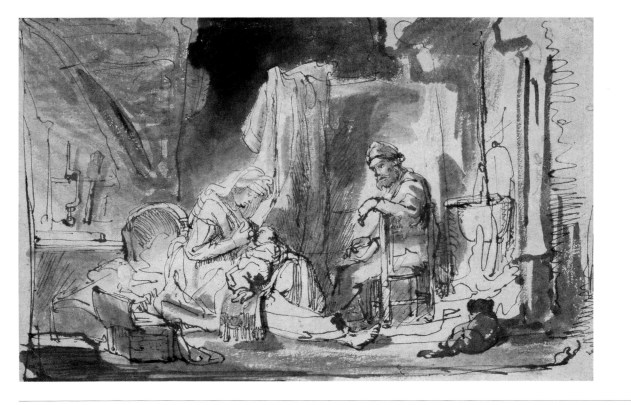

Figure 12a. Ferdinand Bol
The Holy Family in an Interior, ca. 1640
Pen and brown ink, brush and brown wash,
18 × 27.2 cm (7⅛ × 10¹¹⁄₁₆ in.)
Darmstadt, Hessisches Landesmuseum,
AE 592

ment of the feet, which lends Christ an imposing presence, in contrast to his nonchalant pose in the drawing by Bol. Moreover, the face, the hands, and above all the feet of Jesus in Bol's drawing are rendered rather formlessly, which makes the figure appear flaccid. The face of Mary Magdalene, which in Rembrandt's drawing turns toward us, expresses shock more clearly than it does in Bol's drawing.

Bol borrows from Rembrandt's painting, especially the buildings in the background, as well as Rembrandt's drawing. As in the aforementioned painting, Bol places the city of Jerusalem in the background, where it looms large against the picture surface and is rendered with random thick pen lines. These weaken the contrast between background and foreground in comparison with Rembrandt's drawing, in which the city is evoked primarily by fine, small lines. Bol's handling of line in some passages defines form in a capricious manner, for example, the somewhat decorative line that delineates the border of the wall behind the figures, which displays a few superfluous, curly loops.

Although Rembrandt's drawing is generally dated to around 1643 or a bit later, an earlier date seems more probable. First of all, its style can be compared to two signed and dated drawings of 1640, *Portrait of Cornelis Claesz Anslo*[8] and *Two Men in Oriental Dress in Discussion* (cat. no. 21.1). In these two drawings, the figures are depicted with the same clarity, animation, and in places extensive detail, rendered in a mixture of fine and forceful lines. Also, hatching that creates shadows plays an important role. These comparisons thus indicate that Rembrandt's *Christ as a Gardener Appearing to Mary Magdalene* was made around the same time. Moreover, the earliest known dated painting by Bol is from 1641, when he was an independent artist; thus, his drawings made in Rembrandt's style would date to before then, circa 1640.

A print was made after Rembrandt's drawing by Mathys Pool after 1700 as part of a series of illustrations of biblical and other subjects, all after drawings by Rembrandt.[9] — **PS**

1 B. 177 and 177a.
2 B. 47.
3 B. 46.
4 London, Royal Collection, Her Majesty Queen Elizabeth II, 1154. *Corpus*, III, A 124.
5 Benesch 538; Schatborn 1985A, no. 22.
6 Benesch 537; Schatborn 1985B, pp. 94–95.
7 Sumowski, *Drawings*, 195ˣ; Märker and Bergsträsser 1998, no. 31.
8 Paris, Musée du Louvre, Département des Arts graphiques, collection Edmond de Rothschild, 192.DR. Benesch 759; Paris 2006–07, no. 30.
9 B. 69; Schatborn 1981, pp. 13–14.

Rembrandt

Gerbrand van den Eeckhout, a talented and highly versatile artist, worked as a painter, draftsman, and occasional printmaker. He was the son of the goldsmith Jan Pietersz van den Eeckhout, from whom he could have received his first artistic training. Although an apprenticeship with Rembrandt is not documented, Arnold Houbraken recounts that he was Rembrandt's pupil. In addition, Van den Eeckhout's style points to activity in Rembrandt's workshop before he produced his earliest surviving paintings in the early 1640s, e.g., *Gideon's Sacrifice* (1642).[1] This would place him with Rembrandt at the same time as Ferdinand Bol, Govert Flinck, and Jan Victors. He also was in contact with Rembrandt in later years.

Gerbrand van den Eeckhout

Amsterdam, 1621–Amsterdam, 1674

The majority of Van den Eeckhout's paintings show biblical subjects, but he also depicted subjects from mythology and ancient history and produced individual portraits, group portraits, landscapes, and genre pictures. All of these exhibit his indebtedness to Rembrandt, though it is also possible to discern certain influences from Pieter Lastman, whom Eeckhout had come to know through his teacher. His pictorial style is characterized by a painstaking thoroughness. As a draftsman, Van den Eeckhout was exceptionally versatile and treated a wide range of subject matter, which he rendered in a variety of techniques. His large surviving drawn oeuvre includes preliminary designs for paintings and compositional sketches, landscapes, portraits, and designs for book illustrations. One quite distinct group consists of late figure studies executed in brush and ink (cat. no. 17.2). Van den Eeckhout began to sign many of his drawings in the 1640s, occasionally adding dates as well, thereby providing a basis for further attributions. The earliest securely attributed drawings, two designs for the above-mentioned *Gideon's Sacrifice*, date from 1641–42 (figs. 13a, 14b).[2] Additional works from the early 1640s can be related to these. Recently, his drawn oeuvre has been expanded by the addition of a few works dating from his apprenticeship in Rembrandt's workshop in the second half of the 1630s. Most of these were previously thought to be by Rembrandt himself.[3]

1 Sumowski, *Paintings*, 392.
2 Sumowski, *Drawings*, 60; Braunschweig 2006, nos. 7–8.
3 Bevers 2005, pp. 468–69, 482; Bevers 2006, pp. 192–97.

13.1

Rembrandt

Christ Carrying the Cross

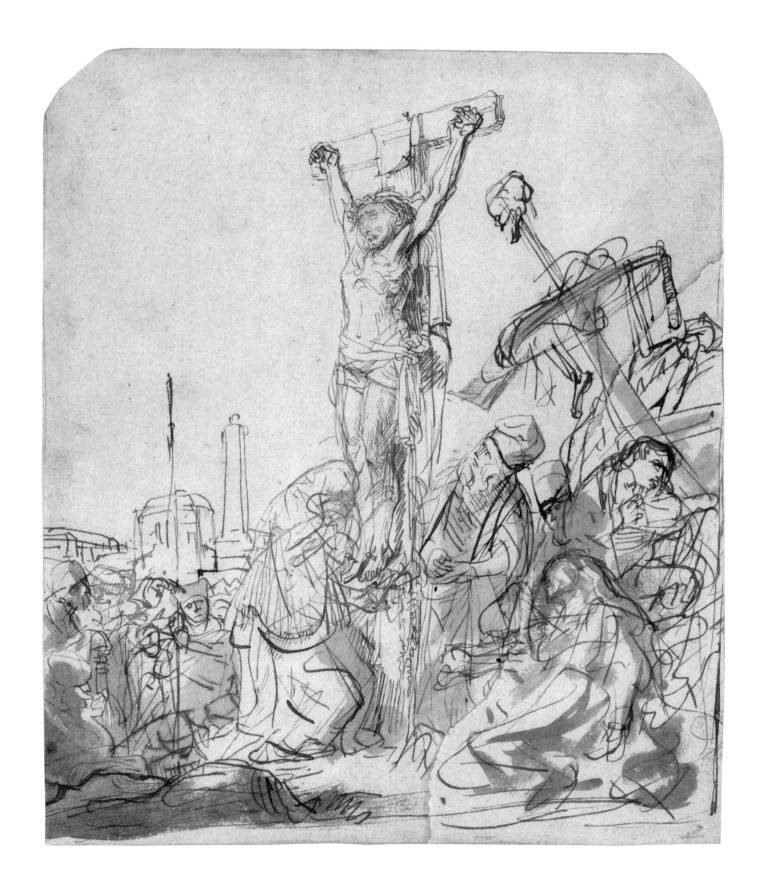

13.2

Gerbrand van den Eeckhout

The Crucifixion

13.1 Rembrandt
Christ Carrying the Cross, ca. 1635

Pen and brown ink, brush and brown wash, 14.4 × 26 cm (5⅝ × 10¼ in.)
Berlin, Staatliche Museen, Kupferstichkabinett, KdZ 1554

13.2 Gerbrand van den Eeckhout
The Crucifixion, ca. 1640

Pen and brown ink, brush and gray-brown wash, with some lead white;
sheet patched together at right edge, 21.8 × 17.9 cm (8⁹⁄₁₆ × 7¹⁄₁₆ in.)
Berlin, Staatliche Museen, Kupferstichkabinett, KdZ 12954

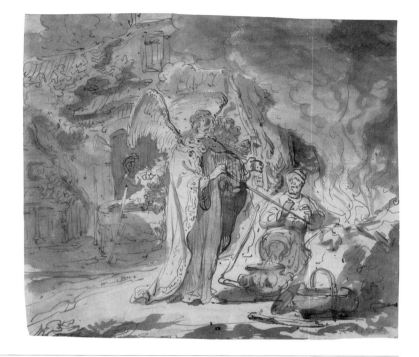

Two drawings with dramatic scenes from the Passion of Christ, both from the mid- and late 1630s, illustrate distinctly the differences between the drawing style of Rembrandt and that of his pupil Gerbrand van den Eeckhout. In the earlier scholarly literature both were regarded as the work of Rembrandt, and only recently was *The Crucifixion* attributed to his pupil.

Rembrandt's *Christ Carrying the Cross* depicts the dramatic moment when Jesus collapses under the weight of the cross. He turns his head toward his mother, who sinks to the ground in a swoon and is caught by a man accompanying her, presumably the Apostle John. A smeared ink spot above the figure of Mary immediately draws the viewer's attention to her. Behind the cross on the left are two soldiers, one of whom is pressing downward on the cross while the other raises his arm to strike Christ with his whip.[1] Veronica rushes in from the right, carrying the *sudarium* (veil) with outstretched arms. Next to her stands a woman with a veil. In the left foreground, another soldier carries on his shoulder a basket that presumably holds hammer and nails for the crucifixion.

In the pupil's drawing one encounters Mary collapsed in a swoon to the right of the crucified Christ, and behind her John wringing his hands in grief. Van den Eeckhout was apparently not satisfied with the first version of these two figures; their present forms were sketched on a separate piece of paper that he glued onto the larger one. Next to them stands Joseph of Arimathea, gazing upward at Christ, and opposite him Mary Magdalene bends over Christ's feet. The artist rendered the latter figure in two different poses, first bending low, and then more erect. On the left in the middle distance are several other figures, presumably soldiers and a crowd of bystanders. Calvary scenes traditionally depict Christ between the two crucified thieves, but here instead there is the unusual motif of the corpse of a man broken on a wheel.

Rembrandt's composition is loosely sketched yet clearly structured. The heads of his figures form an elongated oval, and their movements follow Christ's motion to the left. This effect is further strengthened by the figure of the soldier on the left, which Rembrandt further developed with dark brushstrokes including the long shadow. Thus, despite its wild pen strokes, Rembrandt's composition is ultimately unified and coherent. To concentrate the scene, Rembrandt omitted all suggestions of landscape. Only the faces of the two main figures are worked out more precisely, so as to bring their expressions of human suffering into focus. While presenting a similarly informal use of line, Van den Eeckhout's *Crucifixion* is dominated by a tangle of shapes and figures that are not always clearly separated from each other, and his lines are less controlled than those in Rembrandt's drawing. The arrangement of the background figures on the left is incoherent, and in the muddle of curving lines at the right edge

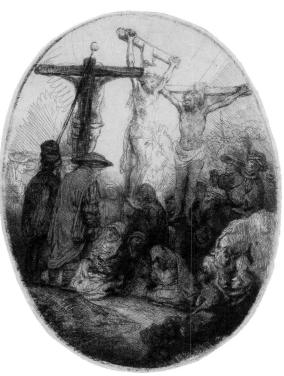

Figure 13a. Gerbrand van den Eeckhout
Gideon's Sacrifice, ca. 1642
Pen and brown ink, brush and gray and brown wash, 16.1 × 17.9 cm (6⅜ × 7 1/16 in.)
Braunschweig, Herzog Anton Ulrich-Museum, Kunstmuseum des Landes Niedersachsen, Z 330

Figure 13b. Gerbrand van den Eeckhout
Hannah Presenting Samuel to Eli, ca. 1665
Pen and brown ink, brush and brown and gray wash over black chalk, 17.2 × 16 cm (6¾ × 6 5/16 in.)
Warsaw, University Library, Zb.d.452

Figure 13c. Rembrandt
Christ Crucified between Two Thieves ("Oval Crucifixion"), ca. 1640
Etching, 13.6 × 10 cm (5 5/16 × 3 15/16 in.)
Amsterdam, Rijksmuseum, Rijksprentenkabinet, RP-P-1961-1030

one cannot discern whether there is a figure supporting the swooning Virgin, as in *Christ Carrying the Cross*. A superabundance of individual elements—the wheel on the right, for example, and the figures and city silhouette on the left—detracts from the main event. In contrast to the loose lines of the other figures, the figure of Christ is carefully modeled with delicate hatching. Fussy strokes such as these are not typical of Rembrandt. For this, his pupil took Rembrandt's etching *Christ Crucified between Two Thieves* ("Oval Crucifixion") as a model (fig. 13c).[2] Another prototype for his composition was Rembrandt's etching *Small Calvary* from circa 1635.[3] Borrowing from the master's prints was a common practice in Rembrandt's workshop.

Specific features of the style of drawing in *The Crucifixion* are also foreign to Rembrandt, most notably the sharp-edged brush strokes of flat wash distributed across the entire sheet. Also typical of Van den Eeckhout is the quite regular parallel hatching placed flatly against the shapes, seen in the figures of Mary Magdalene and Joseph of Arimathea. Finally, one encounters Van den Eeckhout's characteristic figure types, in particular, the schematic, cartoonlike heads in the background. The very same heads occur in *Saint Paul Preaching in Athens* (cat. no. 14.2) and *A Quack and His Public* (cat. no. 15.2).

Of the drawings recently attributed to Gerbrand van den Eeckhout, which must have been produced in the second half of the 1630s, none are signed or documented by being connected with his paintings. His earliest signed painting, *Gideon's Sacrifice,* dates from 1642,[4] by which time he was already an independent artist. There are two preliminary drawings for it (figs. 13a and 14b),[5] where one finds the same restless, tangled lines, flat brush washes, and regular, parallel hatching. These drawings also contain heads composed of simple lines like those in *The Crucifixion*. One can also compare *The Crucifixion* with the artist's late drawings from the mid-1660s, for example, the sketch for the painting *Hannah Presenting Samuel to Eli* (fig. 13b).[6] Both in his pose and facial features, the figure of the priest standing next to Hannah is very similar to Joseph of Arimathea from *The Crucifixion*. In its loose modeling with pen and brushstrokes, the kneeling figure of Hannah on the right resembles the earlier Mary. In his late work Van den Eeckhout borrowed stylistic elements from his early compositions. —**HB**

1 Above these two figures one can make out fragments of a mounted figure, lost when the sheet was cut.
2 B. 79.
3 B. 80.
4 Sumowski, *Paintings*, 392. Whereabouts unknown.
5 Braunschweig, Herzog Anton Ulrich-Museum, Z 330 and Z 242. Sumowski, *Drawings*, 601–2; Braunschweig 2006, nos. 7–8.
6 Sumowski, *Paintings*, 455; Sumowski, *Drawings*, 649.

14.1

Rembrandt

Listeners for Saint John the Baptist Preaching

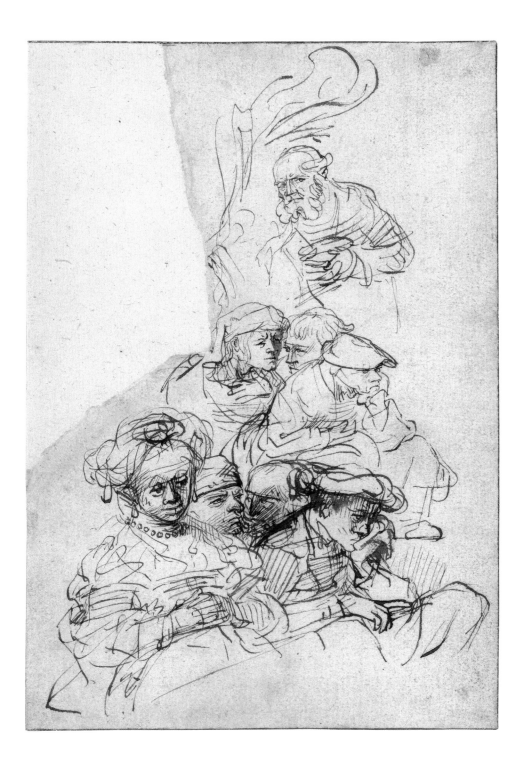

Gerbrand van den Eeckhout

Saint Paul Preaching in Athens

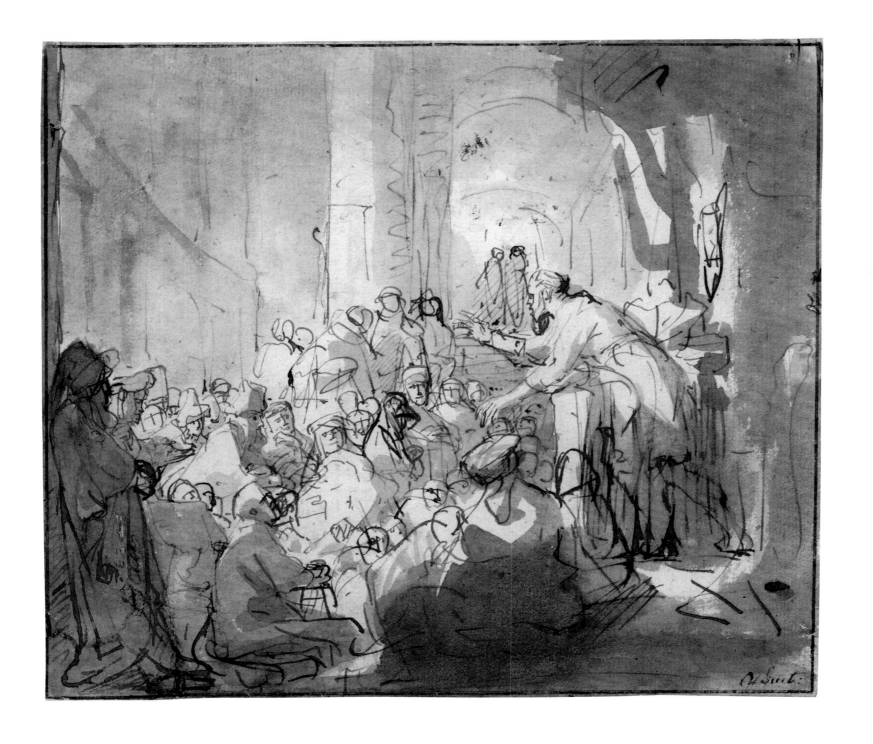

14.1 Rembrandt
Listeners for Saint John the Baptist Preaching,
ca. 1634–35

Pen and brown ink, touched with brush and brown wash, with some lead white,
18.9 × 12.5 cm (7⁷⁄₁₆ × 4⁷⁄₈ in.)
Berlin, Staatliche Museen, Kupferstichkabinett, KdZ 5243

14.2 Gerbrand van den Eeckhout
Saint Paul Preaching in Athens, ca. 1635–40

Pen and brown ink, brush and brown and reddish brown washes, lead white
heightening, touched with red chalk, 18 × 20.7 cm (7¹⁄₈ × 8³⁄₁₆ in.)
London, The British Museum, T,14.7

Both of these drawings depict groups of listeners. Rembrandt's pen drawing was executed in connection with his painting *Saint John the Baptist Preaching* from 1634–35,[1] one of his masterpieces from that period (fig. 14a). In preparation for it, the artist produced a number of detail studies.[2] Gerbrand van den Eeckhout's pen and wash drawing depicts Saint Paul preaching in Athens, a subject rarely treated in Northern European art, but one for which there was a famous precedent in a scene from Raphael's Vatican tapestry series depicting the acts of the apostles. This composition was widely known thanks to the engraving of it by Marcantonio Raimondi.[3] Van den Eeckhout, however, based his version on Rembrandt's Berlin painting. From it he selected the center section that extends from the figures of the scribes on the left to that of the Baptist on the right. In both compositions the middle distance is filled with a group of people illuminated as though spotlit and sharply set off from the shadowed foreground figures. In order to lend greater visibility to the heads and upper bodies of the crowd, both artists showed them from slightly above and arranged in rows at an angle to the picture plane. The poses and gestures of the two preachers are also similar.

Rembrandt's drawing concentrates on the facial expressions of the listeners, some in agreement, some unconvinced, others either uninvolved or dismissive. Accordingly, he presents the heads from a close vantage point. As it happened, he ultimately used only two of these figures in his painting, the woman with folded hands on the left in the bottom row and the man half hidden next to her. He successfully captured their emotional reactions upon hearing the preacher's admonitions, outlining their bodies with loose strokes and modeling them with only a few lines. He placed particular emphasis on their faces and the positions of their arms. The heads in the foreground row are rendered in greater detail than those behind them. Rembrandt first sketched these faces with a few simple strokes, then worked them up more precisely to give them individualized features and to indicate light and shadow. For the latter he used diagonal parallel hatching, placing his lines at varied intervals to suggest different tonal values. The half-obscured head in the bottom row, most heavily shadowed, is covered with hatching in dark, parallel strokes, while the less intense shadow around the eyes and chin of the head next to it is indicated by hatching of a more open character.

Van den Eeckhout's drawing is dominated by a collection of heads drawn with simple lines and with far less individuality. They are formed by geometric shapes, with crossed strokes suggesting brows and noses, dashes for mouths, circles and dots for eyes. Most wear droll, even stupid, glassy-eyed expressions that give no indication of what they are thinking. The depiction of heads with schematic lines is derived from Rembrandt; similar heads appear in his drawings from the 1630s (cat. no. 13.1). Yet for all his simplification,

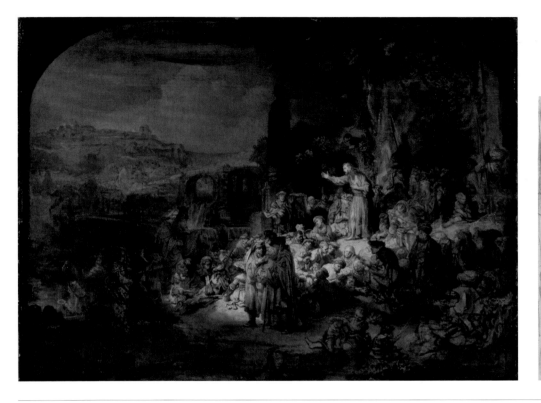

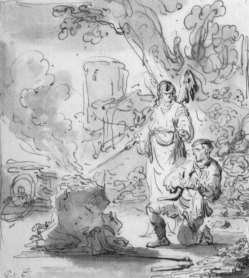

Figure 14a. Rembrandt
Saint John the Baptist Preaching,
ca. 1634–35
Oil on canvas laid on panel, 62.7 × 81 cm
(24⅝ × 31⅞ in.)
Berlin, Staatliche Museen, Gemäldegalerie,
828 K

Figure 14b. Gerbrand van den Eeckhout
Gideon's Sacrifice, ca. 1642
Pen and brown ink, brush and gray wash,
17.5 × 15.1 cm (6¹⁵⁄₁₆ × 5¹⁵⁄₁₆ in.)
Braunschweig, Herzog Anton Ulrich-
Museum, Kunstmuseum des Landes
Niedersachsen, Z 242

Rembrandt always imbues his faces with a wide range of expressions with minimal yet varied strokes. This occurs in another drawing with studies for the painting *Saint John the Baptist Preaching* in the Berlin Kupferstichkabinett. It contains figures and heads that are similar in scale to those of Van den Eeckhout's *Saint Paul Preaching in Athens* but considerably more individualized.[4]

The loose, occasionally angular lines of the pupil's drawing have parallels in Rembrandt drawings from the mid-1630s, for example, the study for the aforementioned *John the Baptist Preaching*. Yet Van den Eeckhout's lines are more agitated and imprecise, rendering many of his forms unclear. Other drawings discussed here, specifically *A Quack and His Public* (cat. no. 15.2) and *The Crucifixion* (cat. no. 13.2), are very similar to *Saint Paul Preaching in Athens* with respect to the looping pen lines, the extensive uniform washes, the regular and flat parallel hatching (albeit not present in the drawing of *A Quack*), and the small heads reduced to token strokes. Other sheets can be associated with these, among them *The Departure of Rebecca from Her Parents' Home* in the Staatsgalerie, Stuttgart (fig. xiv in Holm Bevers's essay in this catalogue).[5] While in the scholarly literature all of these works were formerly assumed to be by Rembrandt himself, they can now be convincingly attributed to his pupil Gerbrand van den Eeckhout. Stylistic and formal links with Van den Eeckhout's drawings are evidenced by the two Braunschweig designs for the 1642 painting

Gideon's Sacrifice, with their similar, agitated pen lines, identical washes, and related head types (figs. 13a and 14b).[6] Finally, one might point out a salient detail in the fishlike mouths of the preaching Paul in the drawing discussed here and of Gideon in one of the Braunschweig sheets (fig. 14b).[7] These drawings were produced during the pupil's apprenticeship under Rembrandt in the second half of the 1630s. — **HB**

1 Berlin, Staatliche Museen, Gemälde-
galerie, 828K. Bredius 1971, no. 555;
Corpus, III, no. A 106.
2 Benesch 140, 141, 142, 142A, 336;
Bevers 2006, no. 11–12.
3 B. 44.
4 Benesch 141; Bevers 2006, no. 11.
5 Benesch 147. Also associated with
these are the *David and Jonathan
Strengthening Their Bond of Friendship*
in Birmingham (Benesch 74a) and
The Young Solomon Riding on an Ass in
the Louvre, Paris (Benesch 146).
6 Sumowski, *Paintings,* 392; Sumowski,
Drawings, 601–2; Braunschweig 2006,
nos. 7–8.
7 Already noted in Royalton-Kisch 1992,
no. 97. Benesch 601; Braunschweig
2006, no. 8.

15.1

Rembrandt

A Quack and His Public

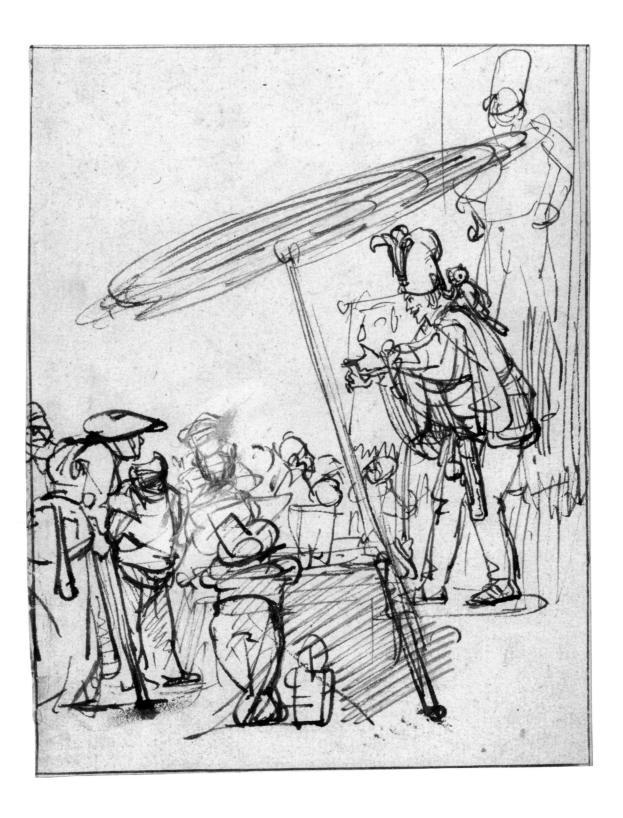

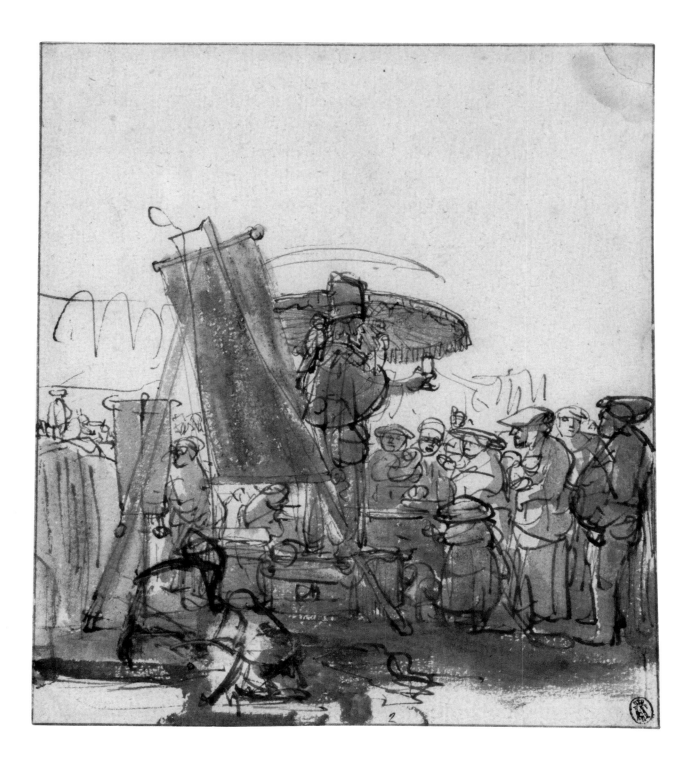

15.2

Gerbrand van den Eeckhout

A Quack and His Public

15.1 Rembrandt

A Quack and His Public, ca. 1635–37

Pen and brown ink, corrections in lead white, 20 × 14.7 cm (7⅞ × 5¹³⁄₁₆ in.)
Berlin, Staatliche Museen, Kupferstichkabinett, KdZ 5268

15.2 Gerbrand van den Eeckhout

A Quack and His Public, ca. 1637–40

Pen and brown ink, brush and brown wash with corrections in lead white,
18.8 × 16.6 cm (7⁷⁄₁₆ × 6⁹⁄₁₆ in.)
London, The Samuel Courtauld Trust, The Courtauld Gallery, D.1978.PG.186

Quacks were regular performers at parish and village fairs, hawking all manner of dubious remedies. They were a popular moralizing subject in Dutch painting, one that clearly illustrated the fact that people are easily fooled, and indeed want to be fooled. The two drawings have a number of features in common, for example the Chinese umbrella and the two billboards, which were standard props in the quack's presentation. The arrangement of the figures is also quite similar, although the version in the Courtauld Gallery is more detailed. Both drawings were thought to be by Rembrandt himself in the earlier scholarly literature, in which the London version was regarded as a later elaboration on the more summary drawing in the Berlin Kupferstichkabinett.[1] Yet the London sheet is clearly the work of the same hand that produced *The Crucifixion* (cat. no. 13.2) and *Saint Paul Preaching in Athens* (cat. no. 14.2), which are now attributed to Rembrandt's pupil Gerbrand van den Eeckhout.

Close comparison of the two sheets reveals that Van den Eeckhout borrowed from his teacher's composition and reworked it. In his drawing, the scene is observed from a greater distance and from a different vantage point. Now the quack occupies the center of the image and is shown from the rear as he turns to the right to face his audience. In Rembrandt's drawing, we see the front faces of the large billboard, apparently painted with the portrait of a learned doctor. Van den Eeckhout turned the panels around, so that we now see

their backs. His pupil shifted the large umbrella into the background—lending a cohesiveness to Rembrandt's composition.

In Rembrandt's drawing, the quack, wearing a short cloak and a tall hat, with a purse dangling at his side, bends toward his audience with a mischievous expression and wildly gesticulates with his hands. This figure appears in an almost identical pose in a small Rembrandt study from this same period in the Art Gallery of Ontario (fig. 15a).[2] In Van den Eeckhout's drawing, the man's costume is quite similar; however, the gesture of holding out a glass of elixir is stiff and dry. Rembrandt only summarily indicated figures farther in the background, covering one that he had made too large[3] with lead white, and thus creating greater emphasis on the grouping on the left. Here the most prominent figure is a woman leaning on her cane and bent forward as though transfixed. In Van den Eeckhout's composition even the onlookers in the middle distance are worked out to a degree of detail; but, lined up somewhat monotonously, they fail to create a sense of interaction between the quack and his public. Van den Eeckhout copied almost verbatim the woman with a hat secured by a wide ribbon, though he did not give her the same riveted expression. As an afterthought, Rembrandt added the figure of a boy seen from the rear with his legs crossed and his arms propped on a table as he eagerly watches the performance. This figure may have led Van den Eeckhout—also as an afterthought—to introduce the group of a

Figure 15a. Rembrandt
A Standing Quack, ca. 1637
Pen and brown ink, 10.2 × 8.6 cm
(4 × 3⅜ in.)
Toronto, Art Gallery of Ontario,
Gift from the estate of R. Fraser Elliott,
2005/246

mother and child in the foreground.[4] In his version, the boy appears farther back, next to the makeshift stage, but he has now become just a doll-like creature with no visible inner life. A potbellied man appears on the far right.[5] On the left side, Van den Eeckhout expanded the scene to include a view of the distance with tiny elevated standing figures.

Gerbrand van den Eeckhout's use of line imitates Rembrandt's drawing style from the second half of the 1630s, as evidenced in the Berlin sketch. Yet Rembrandt's pen strokes are richly varied. The outlines of the figures on the left and the charlatan on the right, as well as the child in the foreground, are executed with heavier lines that clearly establish them as the dominant figures. His pupil also drew the quack, the small child, and the potbellied man with wider strokes, indicating that they are closer to the foreground than the other figures. Yet Van den Eeckhout's pen strokes are altogether more schematic than Rembrandt's. Rembrandt used loose hatching to render shaded areas, for example, on the inside of the quack's sleeve. With a few vertical lines he indicated the figure's shadow on the display billboard behind him, and swift zigzag strokes define the area shaded by the umbrella. His pupil turned to washes to suggest shadows. His uniform, spotty areas of wash, with mostly smooth edges distributed across the entire sheet, are wholly atypical of Rembrandt, whose washes are more varied and transparent. They are, however, a charac-

teristic feature of Van den Eeckhout's work, especially his early drawings (cat. nos. 13.2, 14.2). Even in his later years, he continued to employ washes in this way. The greater quantity of detail is also typical of his compositions, as are the schematic heads of the background figures. One encounters these in *The Crucifixion* (cat. no. 13.2) and *Saint Paul Preaching in Athens* (cat. no. 14.2), a feature that confirms the attribution of *A Quack and His Public* to Van den Eeckhout. — **HB**

1 Benesch 416–17. Seilern 1961, no. 186; London 1983, no. 11. At the symposium devoted to Rembrandt's autograph drawings at London's Courtauld Institute in the summer of 2007, there was considerable discussion about the relationship between the two drawings of quacks in Berlin and London.

2 Benesch 418; Lochnan 2008, no. 20. Also comparable is the single figure of a quack in the Albertina, Vienna, 32765; Benesch 294 A.

3 Due to later abrasion, the obscured lines are again visible.

4 He later masked the figure of the child with lead white, probably because it struck him as too dark. Owing to the subsequent abrasion of the white pigment, the lines have become visible once again.

5 This figure could also have appeared in Rembrandt's composition, which has been trimmed along the left edge.

Rembrandt

Study of a Woman in an Elaborate Costume
Seen from the Back

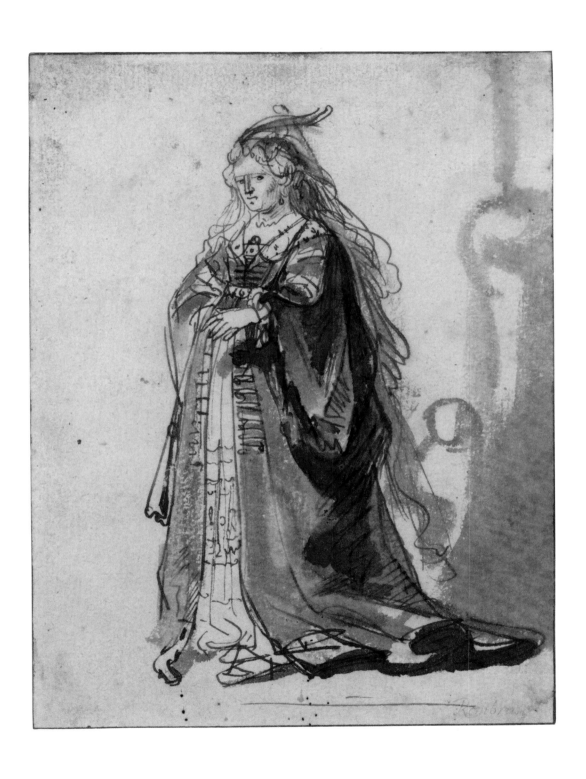

Gerbrand van den Eeckhout

Study of a Woman in an Elaborate Costume
Seen from the Front

16.1 Rembrandt

*Study of a Woman in an Elaborate Costume
Seen from the Back*, ca. 1638

Pen and brown ink, brush and brown wash on reddish prepared paper,
19.8 × 13.1 cm (7¹³⁄₁₆ × 5⅛ in.)
Leipzig, Museum der Bildenden Künste, NI.470

16.2 Gerbrand van den Eeckhout

*Study of a Woman in an Elaborate Costume
Seen from the Front*, ca. 1638

Pen and brown ink, brush and brown wash, with traces of lead white,
18.4 × 13.9 cm (7¼ × 5½ in.)
Berlin, Staatliche Museen, Kupferstichkabinett, KdZ 3115

A group of drawings from the Rembrandt workshop from the late 1630s consists of full-length depictions of women dressed in ornate costumes.[1] Earlier scholarly opinion that these represent actresses from the tragedy *Gijsbrecht van Amstel* by the Dutch playwright Joost van den Vondel[2] has recently been refuted.[3] Instead, it seems likely they are costume studies that could be used in history paintings when needed. The woman in the Leipzig study wears an imaginary costume combining invented elements with features from earlier, sixteenth-century fashion that Rembrandt would have known from prints. Gerbrand van den Eeckhout based his study on the figure of Samson's bride in Rembrandt's 1638 painting *Samson Posing the Riddle at His Wedding Banquet* in the Dresden Gemäldegalerie.[4] The entire group of drawings was once considered the work of Rembrandt himself;[5] however, stylistic differences within the group reveal them to be by various hands. Today, only the costume study in the Leipzig museum is accepted as the work of Rembrandt. All the others are doubtless the work of pupils, including the one here juxtaposed with the Leipzig study.

Rembrandt's penwork is extremely refined. He first sketched his figure with fine lines, then developed it further using a brush. Finally, with broad pen strokes clearly executed with great pressure, he accented certain elements of the back of the costume—the short bodice, the pointed train, the long panels of heavy fabric hanging from the sleeves—so that they assume strong three-dimensionality.[6] The light striking the figure is suggested with thin strokes. For example, the left shoulder and upper arm are described with a single delicate line; the ruff is modeled with thin strokes of curved hatching that become increasingly transparent as they approach the most brightly illuminated spot. The woman's head is rendered with particular care, in both its wealth of detail and the way the light strikes it. The fur on her cap is suggested by dense, spiky strokes; and lines, becoming thicker or thinner depending on the intensity of the light, capture the rounded form of her hat in three dimensions.

The lines in Van den Eeckhout's drawing are more uniform. Those on the illuminated side of the figure at left are as thick as those on its opposite, shaded side. Whereas Rembrandt rendered his figure's ruff with great finesse, the woman's breast area in Van den Eeckhout's drawing is modeled with strokes of uniform thickness. Her elaborate headdress and facial features exhibit none of the delicately nuanced use of line seen in the corresponding portions of Rembrandt's figure.

The use of wash to produce painterly lighting effects is another important factor in separating the two drawings. Rembrandt used a thin wash in medium brown that does not stand out markedly from the slightly reddish tone of the paper. He clearly moved his brush quite freely and swiftly from top to bottom, such that some of his strokes have smooth edges in their upper segments but become

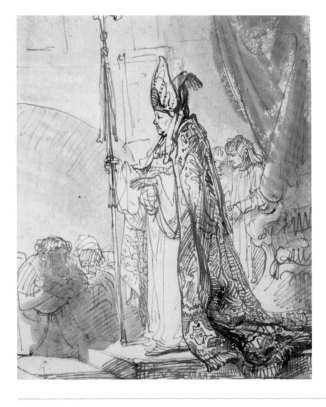

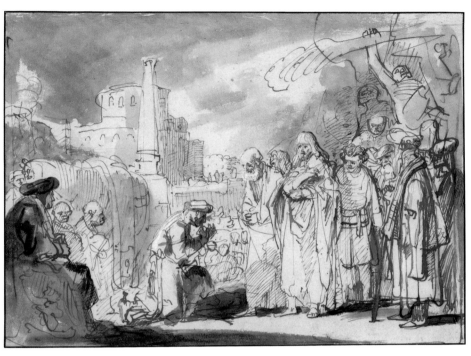

Figure 16a. Gerbrand van den Eeckhout
Gijsbrecht van Amstel before Bishop Gozewijn, ca. 1638
Pen and brown ink, brush and brown wash with white heightening, 20.9 × 16.5 cm (8¼ × 6½ in.)
Braunschweig, Herzog Anton Ulrich-Museum, Kunstmuseum des Landes Niedersachsen, Z 552

Figure 16b. Gerbrand van den Eeckhout
The Centurion of Capernaum Kneeling before Christ, ca. 1635–37
Pen and brown ink, brush and gray and brown washes, corrected with white gouache (oxidized), some lines in black chalk in the upper left, 19 × 25.5 cm (7½ × 10¹/₁₆ in.)
Paris, Frits Lugt Collection, Institut Néerlandais, 5197

increasingly transparent as they proceed downward. His strokes are often loosely placed next to each other, leaving glimpses of the reserve of the paper between them. Also, they do not precisely fill his outlines, so that there are lighter strips near the edges. The brushwork is transparent, and there is a rich play of light and reflection, lending the figure distinct presence and vitality.

Van den Eeckhout's brushstrokes are far less differentiated. Here, the wash follows the outlines and completely fills the shapes. The strokes are broad and dense, particularly on the right side, where very dark, defined areas predominate, forming strong contrasts with the lighter washes and the white tone of the paper. The paper ground is only rarely visible between the washed areas. In an effort to strengthen shapes and create accents, Rembrandt liberally drew with his pen over sections that had already been washed. In his pupil's work, the washes lie on top of the lines, and the shapes appear more two-dimensional.

Comparable drawings that can be related to the Berlin costume study have traditionally been held to be works by Rembrandt but are also doubtless by his pupil.[7] Like the Berlin sheet, they display uniform brush washes and a somewhat loose, ornamental use of line. In some of these sheets there are flat parallel hatchings as well. Comparable washes and hatching can be seen in Van den Eeckhout's drawings of religious and narrative subjects from the late 1630s (cat. nos. 13.2, 14.2, 15.2). Another of these, the Braunschweig drawing *Gijsbrecht van Amstel before Bishop Gozewijn* (fig. 16a), displays rather crude, schematic, angular heads in the background. Similar heads appear in other drawings from the second half of the 1630s that have recently been attributed to Gerbrand van den Eeckhout, for instance *The Centurion of Capernaum Kneeling before Christ* (fig. 16b) in the Frits Lugt Collection , Paris, and the Louvre's *The Young Solomon Riding on an Ass*.[8] Finally, an interesting costume detail supports the attribution of the Berlin study to Rembrandt's pupil. In his later years, Van den Eeckhout had a particular fondness for Phrygian caps in his depictions of Old Testament female figures. Indeed, in the Berlin sheet, he first drew a cap with a Phrygian form and with an attached veil tilted forward, but then changed it into a plume curving backward from the woman's forehead.[9] — **HB**

1 Benesch 316–21.
2 Van de Waal 1969, pp. 147–49; Albach 1972, p. 122, note 1; Albach 1979, pp. 17–18.
3 De Winkel 2006, pp. 244–46.
4 *Corpus*, III, no. A 123.
5 Benesch 316–21; Sumowski 1956–57, p. 258.
6 Owing to considerable pressure, the tip of his pen obviously separated, so that more ink flowed along the edges of the strokes than in the middle. Moreover, the edges are slightly incised.
7 Benesch 122, 123, 312, and 318.
8 Benesch 77 and 146.
9 This was pointed out by Marieke de Winkel in a letter of November 5, 2008. I am extremely grateful to her for information about the costumes in both drawings.

17.1

Rembrandt

Study of Hendrickje Sleeping

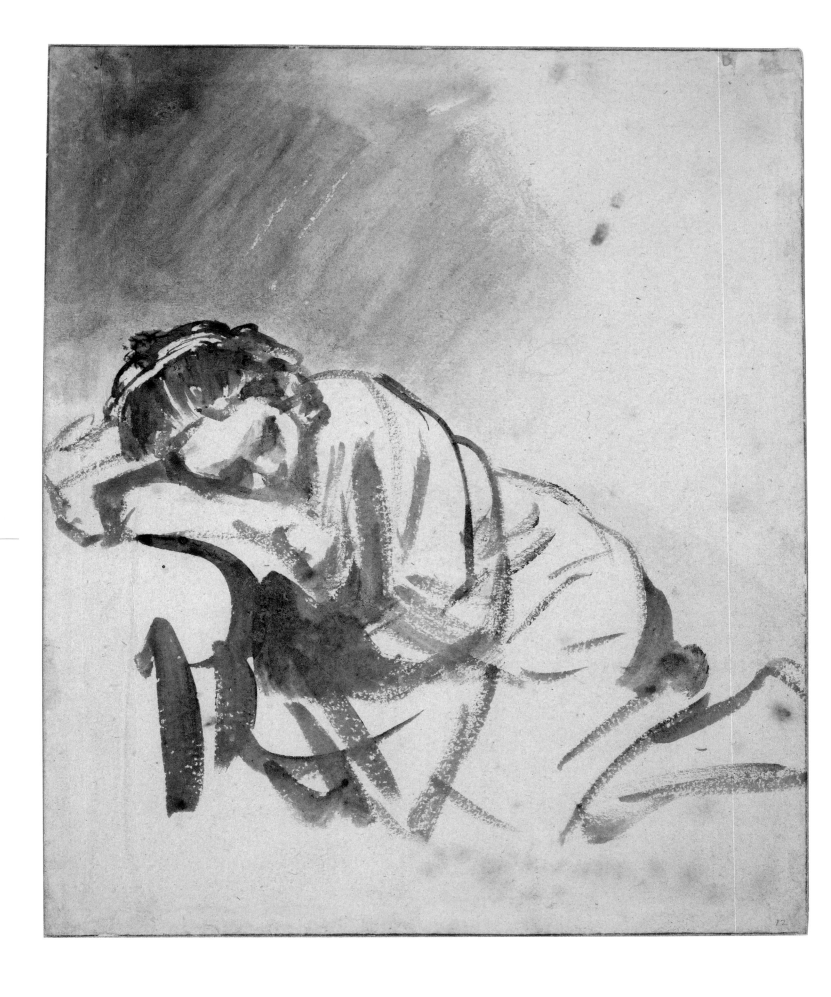

Gerbrand van den Eeckhout

Reclining Young Man

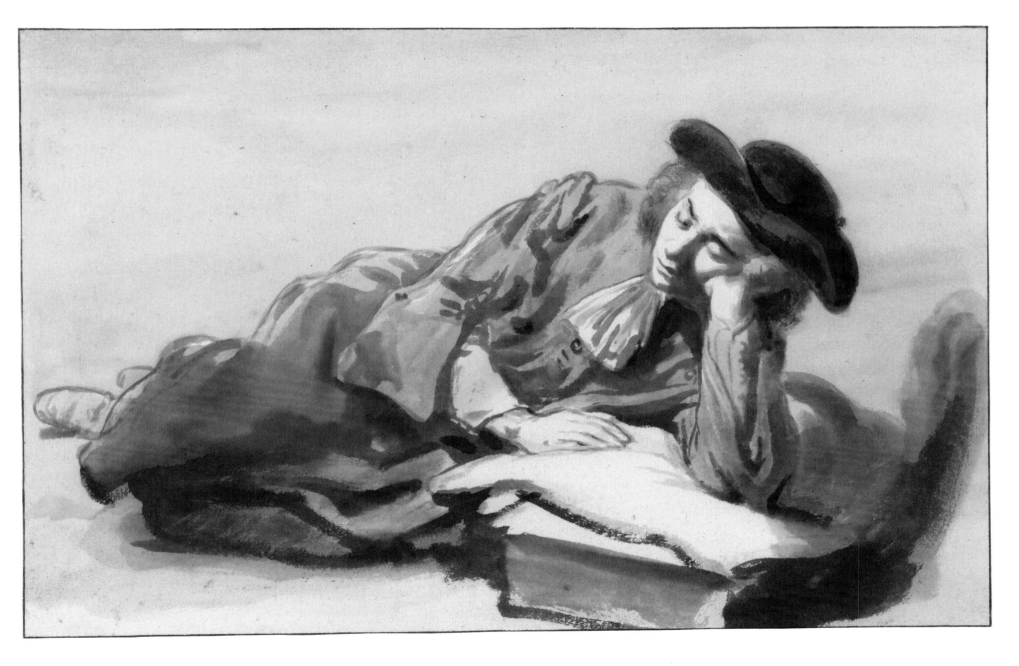

17.1 Rembrandt

Study of Hendrickje Sleeping, ca. 1654–55

Brush and brown wash, with some white gouache
mixed in places with the wash, 24.6 × 20.3 cm (9¹¹⁄₁₆ × 8 in.)
London, The British Museum, 1895,0915.1279

17.2 Gerbrand van den Eeckhout

Reclining Young Man, ca. 1670

Brush and brown ink, 20 × 30.6 cm (7⅞ × 12¹⁄₁₆ in.)
Amsterdam, Rijksmuseum, Rijksprentenkabinet, RP-T-1948-401

A singular group of drawings by Gerbrand van den Eeckhout, including the present depiction of a young man lying on the floor, comprises separate figure studies executed in a painterly fashion with a broad brush and brown ink wash.[1] Although none of these sheets are signed, Van den Eeckhout was already thought to be their author by the late eighteenth century.[2] Moreover, they are similar in style to other autograph drawings by him.[3]

Various scholars have recognized the precedent for this group of drawings in Rembrandt's *Study of Hendrickje Sleeping*, one of the master's few drawings executed solely with a brush. Hendrickje Stoffels was born around 1626 and is first documented in connection with Rembrandt in 1649. In 1654 their daughter Cornelia was born, and in that same year Hendrickje was condemned by Amsterdam's church council for her adulterous relationship with the painter. During this period Rembrandt portrayed his lover in numerous drawings and paintings. Additional studies executed with a reed pen but comparable to the present sheet are in the British Museum, London,[4] and in the Nationalmuseum, Stockholm (fig. 17a).[5] In the painting *Hendrickje Bathing* in the National Gallery, London, dated 1654, the young woman wears her hair in the same way as in the present drawing, and the broad brushstrokes compare well with the broad brush lines of the Stockholm sheet.[6]

Rembrandt's portrait of Hendrickje asleep is one of the most intimate, personal compositions in Rembrandt's drawn oeuvre. In it the artist created a convincing suggestion of space with only a few casual brush strokes. He apparently sketched his beloved on a very bright day, evidenced by the strong light that enters from the upper right, presumably through the top, open part of a window. Hendrickje has curled up on a low couch, resting her head on her right arm against a back cushion. She wears a chemise that loosely envelops her body and leaves her arm and left ankle exposed. The brushstrokes precisely register the angle of the light. Rembrandt sketched in thin lines the parts of her garment on the right, around her buttocks and across her left leg, but used broad, darker strokes on the left side, opposite the light. The latter indicate shadows and simultaneously lend the figure a palpable solidity. The transparent shading in the upper left, growing ever lighter toward the center of the sheet, enhances the three-dimensionality of the young woman's form.

Van den Eeckhout's drawing depicts a young man lying on the floor, his head supported by his left arm, which is propped against a cushion that appears to lie atop a thick folio volume. Here the light falls from the left. Space is suggested by the shadow cast by his brightly illuminated body. The reflection of the light is rendered with much the same subtlety as in Rembrandt's study. Van den Eeckhout finished his drawing by washing around the figure in brown ink with his brush but used the bright reserves of the paper on the left side of

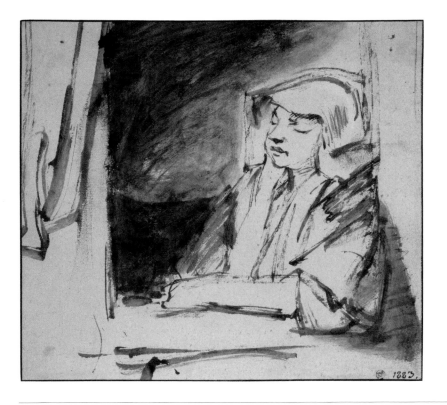

Figure 17a. Rembrandt
Hendrickje Leaning in a Window, ca. 1655
Pen and brown ink, brush and brown
and white washes, 16.2 × 17.5 cm
(6⅜ × 6¹⁵⁄₁₆ in.)
Stockholm, Nationalmuseum, 2084/1863

the face, in the folds of the cravat, and on the cushion, such that they form a sharp contrast to the darker areas.

Rembrandt handled his brush like a broad pen, laying down single strokes that are clearly distinguishable from one another. Van den Eeckhout, by contrast, largely modeled his figure with washes between the contour lines. These lines are continuous throughout, whereas in Rembrandt's work they are fragmentary, especially in the lower section. Also noteworthy is the greater wealth of detail in Van den Eeckhout's drawing. The man's long overcoat and cravat, even individual buttons, are precisely described. The same is true of his hands and his face, in which the mouth, nose, eyes, and brows are rendered in considerable detail. Rembrandt's drawing is much more casual; the details of the young woman's body and clothing are only summarily indicated. Hendrickje's facial features are captured with mere dabs in two shades of brown, yet one recognizes her familiar prominent cheekbones and rather broad nose. The only thing Rembrandt worked out in greater detail is the hair band—a head ornament considered a token of love in the seventeenth century. It stands out against the dark hair, which lends weight to the head and sets it off from the shadowy background. Similarly, the man's hat forms the darkest accent in Van den Eeckhout's study.

Rembrandt obviously drew swiftly. In some spots, especially on the left side, he bore down with a brush loaded with ink, making thick strokes with sharply defined edges. In others, especially the illuminated areas on the right, his lines are thinner and more transparent, and since he used a drier brush, the edges of his strokes are broken and indistinct, softening the transitions to the light surface of the paper. Van den Eeckhout's brushstrokes and areas of wash have generally smooth, closed edges, and they are less transparent than those of Rembrandt. In a few spots there is an abrupt juxtaposition of contrasting tonal values, notably in the shadow on the right. Flat washes are characteristic of Van den Eeckhout and appear even in his early drawings from the 1630s (cat. nos. 13.2 and 16.2).

Like Rembrandt's *Study of Hendrickje Sleeping*, Gerbrand van den Eeckhout's brush drawings have previously been dated to the mid-1650s.[7] Yet details of the clothing of the man lying on the floor in the Amsterdam drawing, his overcoat, his cravat, and his round hat with the brim turned up, point to a later date of around 1670.[8] Accordingly, one can date the entire group of his brush drawings to that period, much later than Rembrandt's *Study of Hendrickje Sleeping*. Thus, Rembrandt's sketch of Hendrickje did not necessarily have to be Van den Eeckhout's direct inspiration. — **HB**

1 Sumowski, *Drawings*, 782ˣ–97ˣ.
2 Sumowski, *Drawings*, 782ˣ.
3 A useful comparison is the *Study of a Young Man Sleeping*, executed in chalk and brush, in Amsterdam's Rijksprentenkabinet, A 4305 (Sumowski, *Drawings*, 634). In addition, there are great similarities between the brush study of a young man in the Courtauld Gallery, London, D.1952.RW.4287 (Sumowski, *Drawings*, 793ˣ), and the brush drawing *Jacob's Dream* in the Victoria and Albert Museum, London, Dyce Collection, cat. 1874, no. 439 (Sumowski, *Drawings*, 713ˣ).
4 Benesch 1174; Royalton-Kisch 1992, no. 59; Royalton-Kisch 2008–09, no. 52.
5 Benesch 1101–2; Stockholm 1992–93, nos. 157–58.
6 Bredius 1971, no. 437; London 1988–89, no. 11, and X-ray photograph illus. 74.
7 Sumowski, *Drawings*, 782ˣ–97ˣ.
8 I am grateful to Marieke de Winkel for her thoughts regarding the clothing and its dating (letter of November 5, 2008).

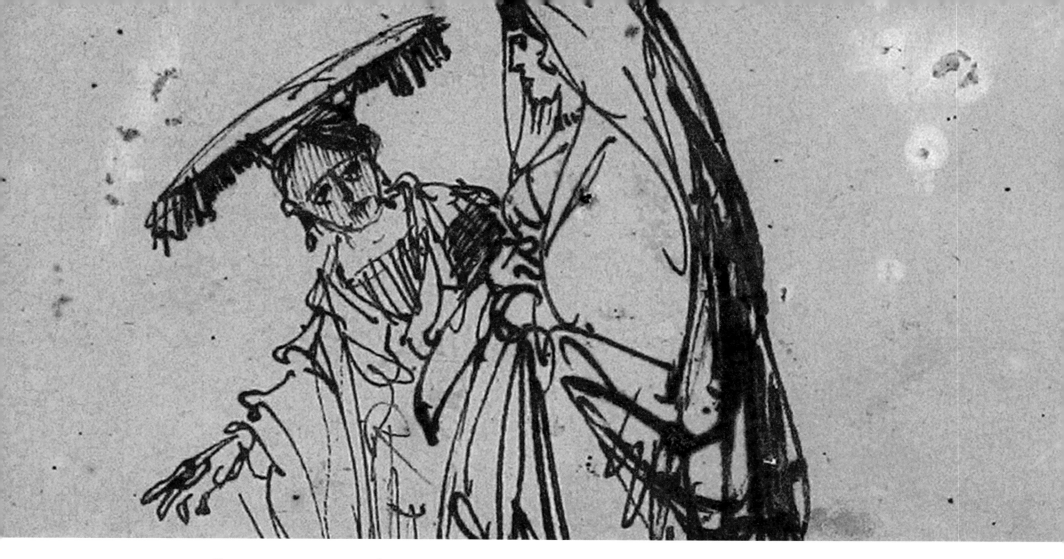

Rembrandt

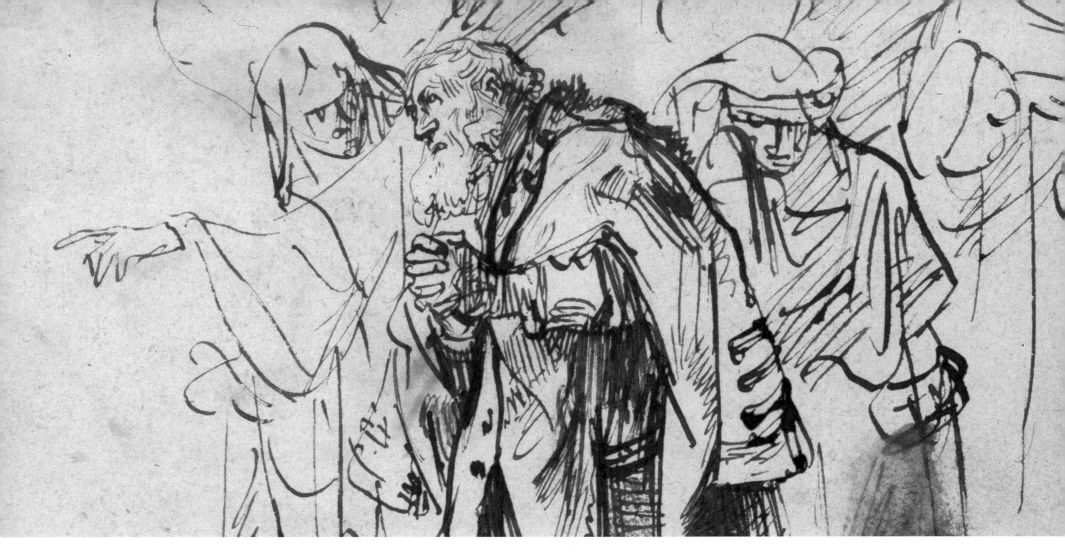

Jan Victors

Amsterdam, 1619/20–East Indies, after 1676

There are no documents contemporary with his lifetime confirming that Jan Victors apprenticed in Rembrandt's workshop. The earliest testimony comes from 1722, when he is described, along with Ferdinand Bol, as one of Rembrandt's best pupils.[1] On the basis of his early work, however, one can conclude that he served an apprenticeship under Rembrandt in the second half of the 1630s. He could have begun in May 1635, when Rembrandt had left Uylenburgh's workshop and moved into his new house in the Nieuwe Doelenstraat. His apprenticeship would thus coincide with those of Ferdinand Bol, Gerbrand van den Eeckhout, and Govert Flinck.

Victors's painterly oeuvre is quite extensive. The earliest dated pictures were painted in 1640, by which time Victors was presumably an independent artist. There are also paintings whose style indicates that they could have been produced as early as the second half of the 1630s. In the 1640s and 1650s he painted mainly large-format narrative works with Old Testament themes that are closely imitative of Rembrandt in their composition and style and on first glance bear resemblance to Govert Flinck as well.[2] Victors also worked as a portraitist and in his later years as a genre painter. He appears to have abandoned painting after 1670. His quite small draftsmanly oeuvre was first assembled in 1992 by Sumowski and was expanded in 2007 with the inclusion of a few sheets from his apprentice years in Rembrandt's workshop.[3]

1 Biesboer 2001, p. 345.
2 Zafran 1977; Manuth 1987; Sumowski, *Paintings*, vol. IV, pp. 2589ff.
3 Sumowski, *Drawings*, 2324[xx]–47[xx], Bevers 2007.

18.1

Rembrandt

*The Angel Departs from Manoah
and His Wife*

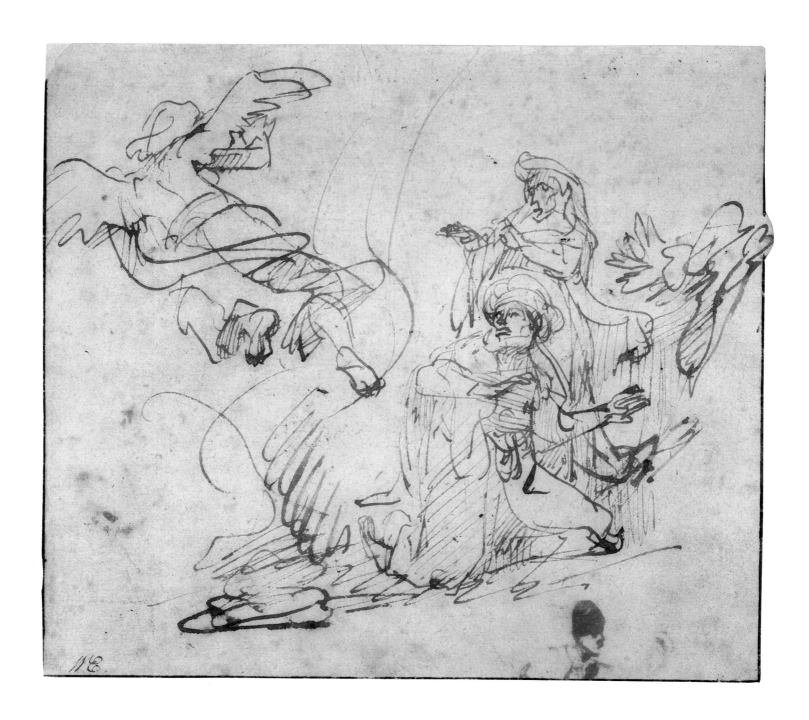

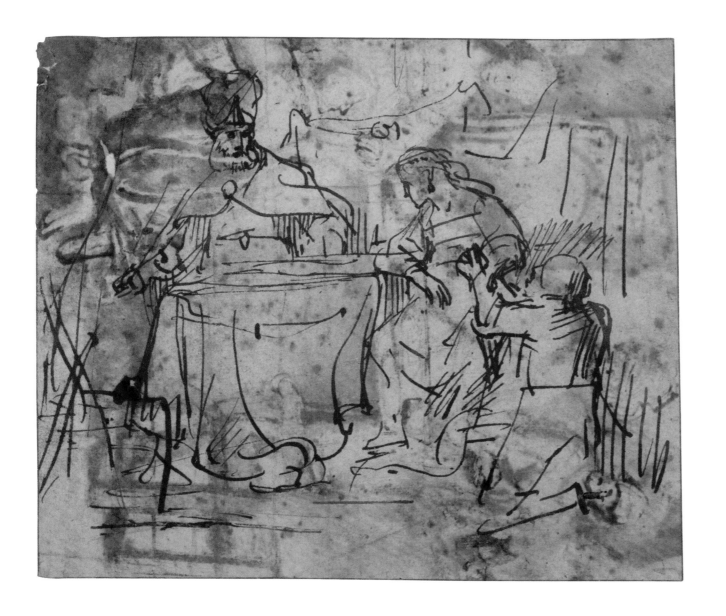

18.2

Jan Victors

Haman Begs Esther for Mercy

18.1 Rembrandt
The Angel Departs from Manoah and His Wife,
ca. 1635–38

Pen and brown ink, 17.4 × 19 cm (6⅞ × 7½ in.)
Berlin, Staatliche Museen, Kupferstichkabinett, KdZ 3774

18.2 Jan Victors
Haman Begs Esther for Mercy, ca. 1638

Pen and brown ink, isolated strokes of red chalk
unrelated to the composition, 14.9 × 17 cm (5⅞ × 6¹¹⁄₁₆ in.)
Kunsthalle, Kupfertickhkabinett, Der Kunstverein in Bremen, 09/730 recto

Both of these drawings depict stories from the Old Testament and exhibit distinct parallels in design and style of drawing. Each depicts an event involving considerable drama that is enacted by animated figures with vigorous arm gestures. In both drawings, three figures occupy a relatively constricted space in which two of them are set apart from the third.

Rembrandt depicted a story popular with him and his pupils.[1] An angel announced to Manoah and his barren wife the birth of a son, Samson, who would one day free Israel from the rule of the Philistines. When the couple brought him an offering of thanks, the angel ascended through the flames of the offering table. Seeing this, Manoah and his wife were terrified, for only then did they realize that the angel was a messenger from God (Judges 13:1–20). Jan Victors's drawing depicts Esther's feast. Esther, a Jewess, was the wife of the Persian king Ahasuerus. Haman, the favored prince at court, planned to murder all the Jews in Ahasuerus's realm. Esther learned of his intention and confronted her husband with it during a feast. Haman promptly begged Esther for mercy, but Ahasuerus was enraged and condemned the prince to death (Esther 7:1–8). Haman is shown on the right, kneeling before Esther, who has turned away. Behind the table Ahasuerus stands gazing at Haman in fury. It is highly probable that Jan Victors took his teacher's composition as a model, for in addition to stylistic and formal similarities, the figures are analogous

in their poses and the way their heads turn. Both show only sparing suggestions of space, in Rembrandt a shrub or tree on the right, in Victors a curtain on the left and what is presumably a wall hanging on the right.

The contours and hatching in Rembrandt's Manoah drawing are of varying thickness, suggesting shadows and lending three-dimensionality to his figures. The soles of the angel's feet, his wings, and the S-shaped lines spiraling around his body are strongly accented, while the outlines of his body are sketched with thinner strokes. As a result, there is a vivid sense of his rising from the ground in a powerful upward thrust. The strokes delineating the side of the figure of Manoah closest to the fire are thin and interrupted, especially in the area of his shoulder. By contrast, his shaded side is rendered with thicker and more continuous outlines.[2] Rembrandt accented Manoah's mouth, nose, eyes, and cheeks with strong, dark strokes, thereby emphasizing his expression of amazement and better setting him apart from the figure of his wife standing behind him.

Numerous areas of hatching of differing density and direction indicate shadows. Rembrandt applied them with extreme precision. For the shadow cast by the angel on Manoah's hip and right leg he used thin, widely spaced parallel lines so that the hatching would not be too dark, because this was the side facing the fire. The hatching strokes on the shaded side opposite the fire are equally thin but placed

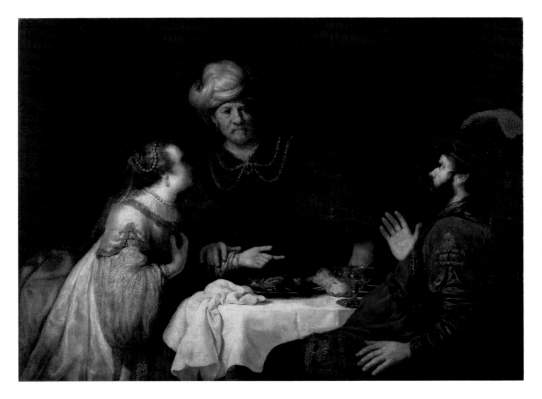

Figure 18a. Jan Victors
Haman Begs Esther for Mercy, ca. 1635–40
Oil on canvas, 126.5 × 168 cm
(49¹³⁄₁₆ × 66⅛ in.)
Cologne, Wallraf-Richartz-Museum,
WRM 1016

Figure 18b. Jan Victors
Haman Begs Esther for Mercy, ca. 1638
(verso of cat. no. 18.2)
Pen and brown ink, brush and brown wash,
black chalk, white gouache heightening,
14.9 × 17 cm (5⅞ × 6¹¹⁄₁₆ in.)
Kunsthalle, Kupfertickhkabinett,
Der Kunstverein in Bremen, 09/730 verso

closer together, suggesting darker surfaces. Broader, darker lines are found on the deeply shadowed inside of Manoah's robe below his extended left thigh, which is sketched briefly in outline and clearly stands out against the darker zones.

The pen strokes in the Victors drawing present a similar combination of sketchy outlines and dense areas of hatching, but they are more confused and not nearly as subtle. Because of their uniformity, it is difficult to distinguish between foreground and background. For example, the figure of Haman is sketched in lines just as wide as those of his adversary farther back in space. The same can be said of the other linework, with the exceptions of the thick strokes representing a stool standing on the left and the thin lines on Ahasuerus's and Esther's shoulders. These were intended to suggest light falling from the upper left, as in the related painting in Cologne (fig. 18a). Victor's hatchings are also more uniform than those in Rembrandt's drawing and the width of their strokes hardly varies. The uniformity of pen strokes creates little sense of space and depth. This yields the impression that the figures and objects—especially the table at which they are seated—are all on a single plane parallel to the picture surface. Finally, there are weaknesses in the draftsmanship. For example, the precise placement of Esther's left hand, with which she fends off Haman's entreaty, is unclear. One suspects that Ahasuerus has placed his clenched fist on the table, as in the Cologne painting,

but the gesture of his extended right arm is equally indistinct.

The Angel Departs from Manoah and His Wife belongs to a group of Rembrandt's biblical illustrations from the mid- and late 1630s executed with sketchy pen lines (see cat. nos. 13.1, 7.1).[3] Jan Victors clearly imitated this drawing style. The Bremen sheet, once thought to be the work of Rembrandt,[4] was recognized early on as the work of one of his pupils and attributed to Jan Victors because of its close connections to the artist's paintings in Cologne and one in Braunschweig dating from 1635–40 and 1642, respectively.[5] Another indication that it was produced by Victors is the drawing on the verso (fig. 18b), which depicts the same scene in a slightly altered form, this time in a painterly brush technique. Although atypical of Rembrandt, Victors doubtless learned this style of drawing in the master's workshop from other pupils' drawings. Around 1625–28 Rembrandt's artistic compatriot from his Leiden years, Jan Lievens, had executed comparable brush drawings[6] that possibly inspired Ferdinand Bol, Victors's fellow pupil.[7] A number of pen drawings from the second half of the 1630s that are now attributed to Victors[8] have similar brush drawings on the verso, including *Lot and His Family Departing from Sodom* (cat. no. 19.2). The detailed style of these brush drawings and the modeling of the figures recall Victors's paintings from this same period. — **HB**

1 Saxl 1939; Münster 1994, pp. 71–72.
2 Rembrandt drew the man's left hand in two different positions.
3 Benesch 97, 100, 423, 445.
4 In 1922, Benesch already considered the sheet to be the work of a pupil from the mid-1630s (Benesch 1922, p. 35); however, Valentiner once again accepted it as an autograph sheet by Rembrandt (Valentiner 1925 and 1934, no. 204).
5 Sumowski 1956–57, p. 261. Sumowski, *Paintings*, 1721 and 1729. Victors dealt with this same theme in two paintings now in Kassel (ca. 1640–42) and in Greenville, South Carolina (1651); Sumowski, *Paintings*, 1727 and 1749.
6 Sumowski, *Drawings*, 1630ˣ; Dresden 2004, no. 47; Washington, Milwaukee, and Amsterdam 2008–09, no. 93.
7 Sumowski, *Drawings*, 87, 126ˣ–28ˣ, and 138ˣ–39ˣ.
8 See Bevers 2007.

19.1

Rembrandt

Ruth and Naomi

19.2

Jan Victors

Lot and His Family Departing from Sodom

19.1 Rembrandt

Ruth and Naomi, ca. 1638–39

Pen and brown ink on light brown prepared paper, 18 × 12.5 cm (7¹/₁₆ × 4¹⁵/₁₆ in.)
Rotterdam, Museum Boijmans Van Beuningen, MB 1958/T32 recto

19.2 Jan Victors

Lot and His Family Departing from Sodom,
ca. 1638–39

Pen and brown ink, brush and brown wash, 22.6 × 23.5 cm (8¹⁵/₁₆ × 9¼ in.)
Vienna, Albertina, 8767

These two drawings demonstrate how closely Rembrandt's drawings can resemble those of his pupils. *Lot and His Family Departing from Sodom* displays many features of Rembrandt's drawing style from the second half of the 1630s, and for that reason has been thought to be a work by his own hand.[1] Only recently, however, was it attributed to his pupil Jan Victors.[2] It presents obvious stylistic and formal similarities to Rembrandt's drawing *Lot and His Daughters* from circa 1638 in Weimar and *Ruth and Naomi* from circa 1638–39 in Rotterdam, so it would appear that Victors was familiar with both of these sheets by his teacher. It was only natural that Victors borrowed the figure of Lot from Rembrandt's drawing when he himself depicted an episode from the Lot story. Moreover, Rembrandt's masterly sketch *Ruth and Naomi* provided an ideal prototype for Victors's grouping of two figures heading off on a journey, one of them pointing the way with an expressive outstretched arm.

Rembrandt's drawing depicts an event from the Old Testament story of Ruth (Ruth 1). After the deaths of her husband and her sons, Naomi wished to return from the land of the Moabites to her home in Bethlehem. She begged her two Moabite daughters-in-law to go back to their families, but one of them, Ruth, remained faithful to Naomi and chose to accompany her. In the drawing, Ruth, recognizable by her large sun hat, indicates with her outstretched arm and expressive turning toward her mother-in-law that she wishes to accompany her on the journey. With her other hand, the fingers of which are visible next to the dense hatching on her left shoulder, she seems to tug at Naomi imploringly. Jan Victors's drawing depicts an episode from the story of Lot (Genesis 19:15–16). With his wife and two daughters, the God-fearing Lot leaves the city of Sodom, which God has vowed to destroy because of its iniquity. He is accompanied by an angel who shows him the way. Behind Lot, who wrings his hands in despair over having to abandon his home, one sees his wife, wiping her tears on a cloth, with their daughters behind her.[3]

Rembrandt's drawing is limited to only a few outlines and other strokes indicating the essential forms, whose illuminated and shaded sections are quite effectively suggested by varied line thicknesses. The two women are shown outside, clearly exposed to bright sunlight falling from the upper left. To indicate this, Rembrandt used very wide, dark strokes for the shaded portions of the figure of Naomi, which casts a short shadow on the ground; he also emphasized the long veil at her back with lines placed close together.[4] Ruth wears a broad-brimmed hat that shades her face (indicated with parallel hatching) and her upper body, which is accordingly drawn with broader lines. In his determination to capture light effects realistically, Rembrandt used very thin lines to describe the brightly illuminated top of the hat, while sketching the deeply shadowed underside with its tassels with much broader strokes. The lower part of Ruth's

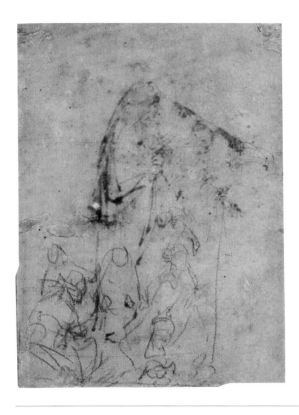

Figure 19a. Rembrandt
Joseph Relating His Dreams, ca. 1638–39
(verso of cat. no. 19.1)
Red chalk, 18 × 12.5 cm (7¹⁄₁₆ × 4¹⁵⁄₁₆ in.)
Rotterdam, Museum Boijmans
Van Beuningen, MB 1958/T32 verso

Figure 19b. Jan Victors
Abraham's Sacrifice, ca. 1638–39
(verso of cat. no. 19.2)
Black chalk, pen and brown ink, brush and
brown wash, with lead white heightening
(oxidized), 22.6 × 23.5 cm (8¹⁵⁄₁₆ × 9¼ in.)
Vienna, Albertina, 8767 verso

body, also in full sunlight, is indicated by thinner lines. A somewhat broader stroke representing the outer contour of Naomi sets the two figures apart.

While Victors's composition is expanded to include Lot's wife and daughters, the core grouping of Lot and the angel is formally and stylistically quite similar to the two women in Rembrandt's drawing. Their contours are suggested by long, loose vertical lines and sweeping curves in the areas of their wide sleeves. In both cases the shaded portion of the face is indicated by thin parallel hatching. Yet the pen strokes in the pupil's work are somewhat less assured and more uniform than those in Rembrandt's drawing. In Victors's sheet, there is no clear distinction between illuminated areas and shaded ones in the main figures and those of the wife and daughters in the background. As seen in the figure of Ruth, Rembrandt frequently left the lower portion of his figures unfinished; by contrast, his pupil conscientiously drew in their feet. Victors modeled his Lot figure by means of washes and zigzag and parallel hatching. Comparable areas of hatching occur in Rembrandt's sheet in Weimar (cat. no. 4.1), but there is no use of washes; here and elsewhere in Rembrandt's drawings, it is rare to encounter washes in combination with extensive hatching. In contrast to the Rembrandt sheet, where the outlines on the illuminated side of Lot are thinner than those on the shaded side, the lines in Victors's figure of Lot do not register the play of light; moreover, his

outlines are all equally heavy and broad. In contrast to Rembrandt, he employs hatching not only on the shaded side but also on the illuminated side, and it is less refined in execution. The facial features of the two figures are quite similar, but in Rembrandt's drawing they are more precise and reflect the fall of light more effectively.

Rembrandt's *Ruth and Naomi* is one of a group of drawings from roughly 1638/39 that are executed in iron-gall ink on paper washed with yellowish brown.[5] The verso contains a sketch in red chalk that served as the design for Rembrandt's 1638 etching *Joseph Relating His Dreams* (fig. 19a).[6] Another important piece of evidence for the attribution to Victors of the Vienna *Lot and His Family Departing from Sodom* is the scene of *Abraham's Sacrifice* (fig. 19b) on the verso. That composition, worked out in great detail and painterliness with considerable brush work, is quite typical of Victors. Other early examples of his draftsmanship utilize both sides of the paper as well, one drawing executed with a pen, the other with a brush (cat. no. 18.2). —**HB**

1 Benesch 129; Sumowski, *Drawings*, under 2329ˣˣ. Yet other writers, such as Falck (Falck 1927, pp. 171–73, as Philips Koninck), Valentiner (Valentiner 1925 and 1934, no. 37, as possibly the work of a pupil after a Rembrandt original), and elsewhere Sumowski (Sumowski 1961, p. 4, as perhaps by Govert Flinck), expressed doubts about the attribution of the sheet to Rembrandt.

2 Bevers 2007, pp. 52–53.

3 The features of the scene are based on a composition by Rubens that survives in a reversed reproduction engraving by Lucas Vorsterman (Hollstein 1).

4 Owing to later oxidation of the iron gall ink, the edges of the strokes have bled into the paper, so that they now appear broader than they did when fresh.

5 Starcky 1985, pp. 258ff.; Bevers 2006, nos. 20–24.

6 B. 37; Giltaij 1977, pp. 2–5; Giltaij 1989, pp. 111–12.

Rembrandt

Carel Fabritius

Middenbeemster, 1622–Delft, 1654

Carel Fabritius and his younger brother, Barent (1624–1673), probably received their first training from their father, Pieter Carelsz, a schoolmaster who was also a painter in Middenbeemster to the north of Amsterdam. In the 1640s Fabritius was working with Rembrandt at the same time as Samuel van Hoogstraten and Abraham Furnerius. In 1641 he married Aeltje Velthuijsen, who died in Amsterdam in 1643, probably after the birth of a daughter. Despite the fact that he was subsequently recorded as living in Middenbeemster, Fabritius probably continued to work with Rembrandt in Amsterdam. In 1650 he left for Delft, where he married Agatha van Pruyssen. He died in 1654, following the explosion of the powder magazine in Delft.

Fabritius's small painted oeuvre comprises two distinct groups: a number of history paintings, inspired by Rembrandt, and the works that place him, together with Pieter de Hooch and Johannes Vermeer, among the most important representatives of the Delft School.[1] A number of Rembrandtesque drawings have recently been attributed to Fabritius, which are in some respects related to his paintings.[2]

1 The Hague and Schwerin 2004–05.
2 Schatborn 2006.

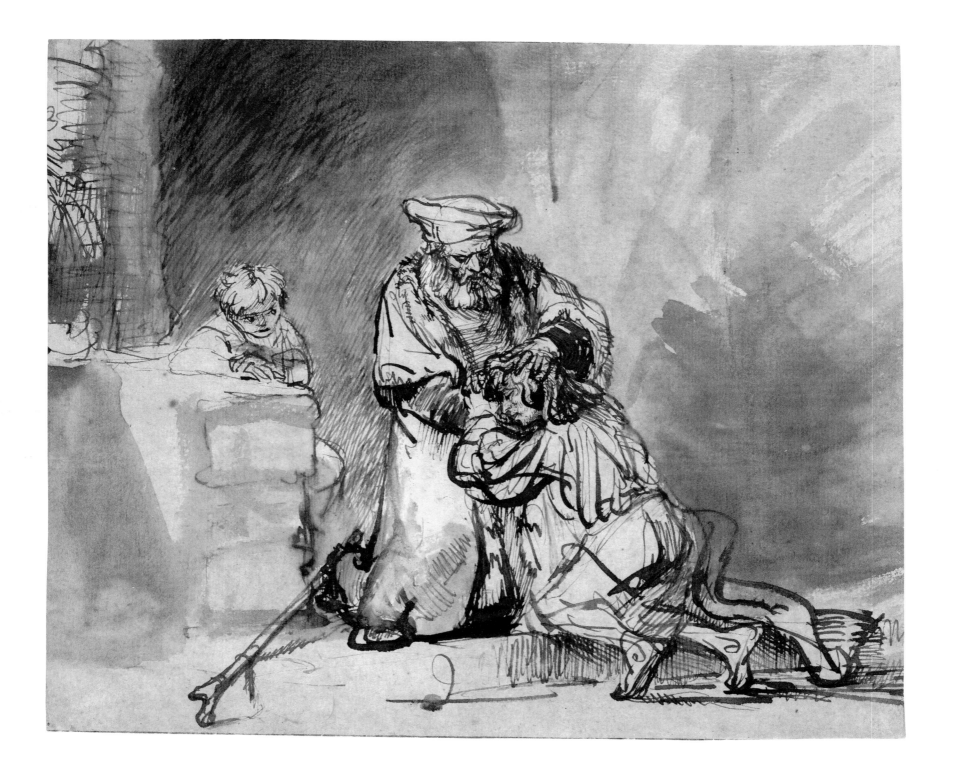

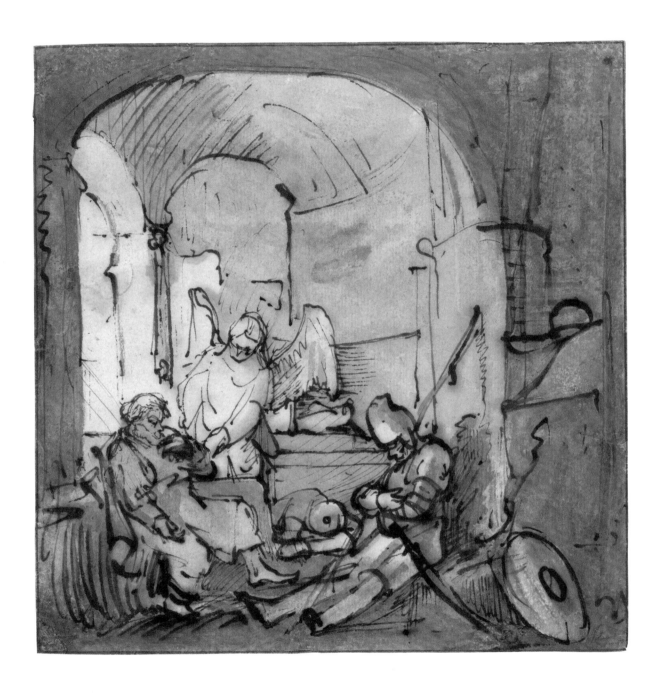

20.1

Rembrandt

The Return of the Prodigal Son

20.2

Carel Fabritius

The Liberation of Saint Peter

20.1 Rembrandt
The Return of the Prodigal Son, ca. 1642

Pen and brown ink, brush and brown wash, white heightening,
19.1 × 22.7 cm (7⁹⁄₁₆ × 8¹⁵⁄₁₆ in.)
Haarlem, Teylers Museum, O*48

20.2 Carel Fabritius
The Liberation of Saint Peter, mid-1640s

Pen and brown ink, brush and blue-gray wash, 16.7 × 15.6 cm (6⁹⁄₁₆ × 6⅛ in.)
Amsterdam, Rijksmuseum, Rijksprentenkabinet,
Gift of Mr. Cornelius Hofstede de Groot, 1906, RP-T-1930-31

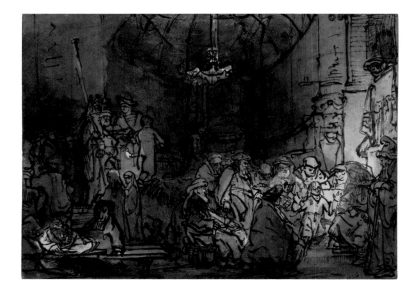

In one of Christ's parables, the prodigal son returns home penitently after a debauched life and is lovingly received by his father (Luke 15:11–32). The Bible says that the deeply affected father, seeing his son approaching, ran to him and kissed him, but in Rembrandt's drawing (cat. no. 20.1) the father welcomes his kneeling son in front of the entrance to his house.[1] Rembrandt rendered this event with great emotion. His depiction, which departs from the biblical passage, shows the son on his knees, his cloak slipping off, sorrowfully begging for forgiveness with his eyes closed. His folded hands rest on the right hand of his father, who has dropped his cane and laid his left hand on his son's head in a gesture of pardon. On the left Rembrandt added a little boy, who leans on a low wall, observing the scene with a look at once curious and uncomprehending.

The monumental figures and the features of both father and son, seen slightly from below, were laid in with a fine pen. Rembrandt went on to use heavier lines to realize the final forms, creating several shaded passages. The dark contours play an important role in achieving plasticity, by improving upon and clarifying previously drawn lines. For example, the place where the father's right leg bends was covered with white, and a new, straighter contour line drawn to the left of it. The curve of the son's thigh was made clearer by placing a looping line over it. The areas of hatching, consisting of lines varying in character and drawn in various directions, are also important in

the shading and delineation of the forms. The little boy was drawn only with fine lines and not elaborated with heavy lines; this serves to characterize him as a secondary figure and to clarify the distance between him and the scene in the foreground. The dark doorway was indicated with the brush over fine hatching, while only the brush was used to render light and shade on the wall of the house and on the low wall to the left. The subtle effect of the brushwork in the background, contrasting with the figures worked out in dark lines, produces a strong sense of three-dimensionality. The evocative rendering of the figures' attitudes and emotions lends the drawing great eloquence.

The Liberation of Saint Peter (cat. no. 20.2) was first attributed to Rembrandt and later to Ferdinand Bol.[2] It depicts the story of the apostle Peter, who was imprisoned by King Herod. On the night before Peter was to be brought forth to the people, an angel appeared in a shining light in his cell and led him out of the city to safety (Acts 12:1–11).

The scene was drawn in pen and then worked up with the brush with a blue-gray wash unusual in Rembrandt's work. The attribution of the drawing to Fabritius is based on its strong stylistic similarities to a drawing in the Oskar Reinhart Collection in Winterthur, *The Twelve-Year-Old Jesus in the Temple* ("*Christ Disputing with the Doctors*") (fig. 20a).[3] The lines used to portray a scribe at the lower left (fig. 20b) bear a close stylistic resemblance to the motif of Saint

Figure 20a. Carel Fabritius
The Twelve-Year-Old Jesus in the Temple
(*"Christ Disputing with the Doctors"*),
mid-1640s
Pen and brown ink, brush and brown
and gray washes, corrections in white,
22 × 29.5 cm (8¹¹⁄₁₆ × 11⅝ in.)
Winterthur, Oskar Reinhart Collection
'am Römerholz,' 1932.2

Figure 20b
Detail of 20a

Figure 20c
Detail of 20d

Figure 20d. Carel Fabritius
The Sentry, 1654
Oil on canvas, 68 × 58 cm
(26¾ × 22¹³⁄₁₆ in.)
Schwerin, Staatliches Museum, G 2477

Anthony and a pig on a relief above a gate (fig. 20c) in Fabritius's painting in Schwerin, *The Sentry*, which is signed and dated 1654 (fig. 20d).[4] This relief, painted only in gray-brown, is quite like a drawing in its character. It is primarily the scribe's hands and sleeves and the general, nonspecific nature of the outlines that betray the hand of Fabritius. The stylistic similarities between the painted relief and the drawing in Winterthur have led to the attribution of still more drawings to Fabritius (see cat. no. 21.2).[5]

Fabritius mainly adopts from Rembrandt the dark contours and profuse hatching, though Fabritius's application of these elements is different and they are less integrated into the overall composition. Lines and hatching therefore play a rather independent role, contributing less to the spatial effect and the modeling of the figures. While Rembrandt worked up only the figures in more forceful lines, Fabritius applied such lines throughout the composition. This is even more true of the drawing in Winterthur (fig. 20a). The sleeping Peter on the left and the guard on the right are in shadow and completely absorbed into their surroundings. The wash prevents them from standing out sharply against the background, and they make a rather flat impression. The angel, who stands clearly in the stream of light cast outward, was drawn with a finer pen. Fabritius placed several zigzags of hatching in a corkscrew shape on the wall at the upper left and again on the right, forming the shadow cast by the guard's

stick. Corkscrew-shaped lines also occur in the Winterthur drawing. Rembrandt did not use such stylistic elements to render space and employed such darker lines only to complete the figures' forms. By differentiating the lines and hatching, Rembrandt achieved greater plasticity and a clearer definition of light and shade. Several early paintings by Fabritius display lines and hatching comparable to those in his drawings, which confirms their attribution to him.[6] — **PS**

1 Benesch 519.
2 Sumowski, *Drawings*, 220ˣ, as
 Ferdinand Bol.
3 Benesch 500.
4 The Hague and Schwerin 2004–05,
 no. 12, illus.
5 Schatborn 2006.
6 Schatborn 2006, figs. 8–12.

21.1

Rembrandt

Two Men in Oriental Dress in Discussion

21.2

Carel Fabritius

*The Messenger Presenting
Saul's Crown to David*

21.1 Rembrandt

Two Men in Oriental Dress in Discussion, 1641

Pen and brown ink, with corrections in white, 22.8 × 18.4 cm (9 × 7¼ in.)
London, The Samuel Courtauld Trust, The Courtauld Gallery, D.1978.PG.190

21.2 Carel Fabritius

The Messenger Presenting Saul's Crown to David,
mid-1640s

Pen and brown ink, brush and brown and gray washes,
16.9 × 19.3 cm (6⅝ × 7⅝ in.)
Amsterdam, Rijksmuseum, Rijksprentenkabinet,
Gift of Mr. Cornelius Hofstede de Groot, 1906, RP-T-1930-15

Rembrandt was fascinated by exotic characters, whose looks and dress reminded him of biblical personages. The two oriental figures in Rembrandt's drawing (cat. no. 21.1) probably did not pose for him but were depicted instead variously from memory and after examples by other artists.[1]

The man standing on the left wears an open cloak and under it a caftan with frogging, which was regarded as typically oriental and was also associated with Polish dress. He wears boots and a sash with a metal button and fringe around his waist. His tall cap was drawn from the imagination, as was the headdress of the other man, whose gesture and open mouth show that he is addressing his companion.[2] In the first version, this man is leaning with both arms on the low wall, but Rembrandt altered this pose, redrawing the arm to make a conversational gesture and applying darker lines below the arms to indicate a flap of his cloak draped over the wall. He stands on the step in front of a doorway, the top of which is suggested by a semicircular line. Because he used the drawing as an example for his pupils, Rembrandt unusually added his signature and the date of 1641, thus emphasizing his authorship.

Rembrandt executed the drawing exclusively in pen and used opaque white at the lower left to correct and shorten the length of the cloak. Characteristic of the master is the great variety of pen lines. The composition was laid in with fine lines, after which ever-heavier lines were added until the forms assumed their definitive shape. This working process is clearly visible in the rendering of the arms in the second and final version of the man behind the low wall. The man standing at the left, who was worked out in the most detail, has a marked plasticity and volume imparted by the hatching lines, drawn in varying thicknesses and in various directions, and which also show careful attention to the play of light and to the whiteness of the blank paper in the illuminated areas. The subtle distinction of line also contributes substantially to the rendering of the various materials.

In Fabritius's drawing (cat. no. 21.2), King David is visited by a messenger who brings him the crown and bracelet of Saul, whom he has slain (2 Samuel 1:1–10). Although Saul himself had asked the messenger to slay him, David nonetheless had the messenger killed. Standing near the king is the servant who will carry out the sentence, wearing a plumed hat and resting his hands on his sword.

In making this drawing, Fabritius employed the same style as Rembrandt, only applying its constituent aspects in different relationships. As in Rembrandt's drawing, the dark contours improved upon and worked up a first sketch; Fabritius depicted the figures and the space as well with broad, heavy lines of the pen. King David, too, is almost entirely enclosed by heavy contours, while the fine lines within them contribute little to the modeling of the figure. This makes David less expressive than Rembrandt's figures. Large areas of the

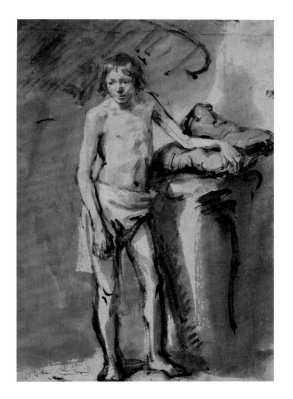

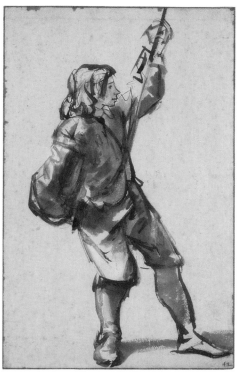

Figure 21a. Carel Fabritius
Standing Male Nude, ca. 1646
Pen and brown ink, brush and brown
wash, white gouache heightening,
19.8 × 13.3 cm (7¹³⁄₁₆ × 5¼ in.)
Vienna, Albertina, 8827

Figure 21b. Attributed to Carel Fabritius
Standing Young Man Holding a Sling,
mid-1640s
Pen and brown ink, brush and brown wash,
29.2 × 18 cm (11½ × 7⅛ in.)
Amsterdam, Rijksmuseum,
Rijksprentenkabinet, RP-T-1930-34

drawing are shaded with wash. Only David, the man with the sword, and the indistinctly rendered background are brightly illuminated. The process of sketching and more refined overdrawing discernible in Rembrandt's figures is absent in those of Fabritius.

The play of line in the heavy contours, such as those of the baldachin, is similarly encountered on the prison walls in *The Liberation of Saint Peter* (cat. no. 20.2). We also encounter it in the Winterthur drawing (fig. 20a) and in *Standing Male Nude*, formerly assigned to Rembrandt but recently attributed to Fabritius (fig. 21a and fig. vii in Holm Bevers's essay in this catalogue).[3] Fabritius sketched this study when Rembrandt was drawing the same model on the copper plate for his etching *Male Nudes Seated and Standing ("The Walking Trainer")* (fig. vi in Bevers's essay).[4] Samuel van Hoogstraten also drew the model at that time (fig. viii in Bevers's essay).[5] A drawing, *Standing Young Man Holding a Sling*, comparable in style to Fabritius's drawing in Vienna, was also recently attributed to Fabritius (fig. 21b).[6] —**PS**

1 Benesch 500a.
2 Kindly communicated by Marieke
 de Winkel.
3 Benesch 709; Schatborn 2006,
 pp. 136–37.
4 B. 194.
5 Paris, Musée du Louvre, RF 4713;
 Benesch A 55; Sumowski, *Drawings*,
 1253ˣ. A third drawing of this model is
 in the British Museum in London;
 Benesch 710; Royalton-Kisch 1992,
 no. 87, as school of Rembrandt,
 retouched by Rembrandt.
6 Schapelhouman 2006, p. 30, fig. 26.

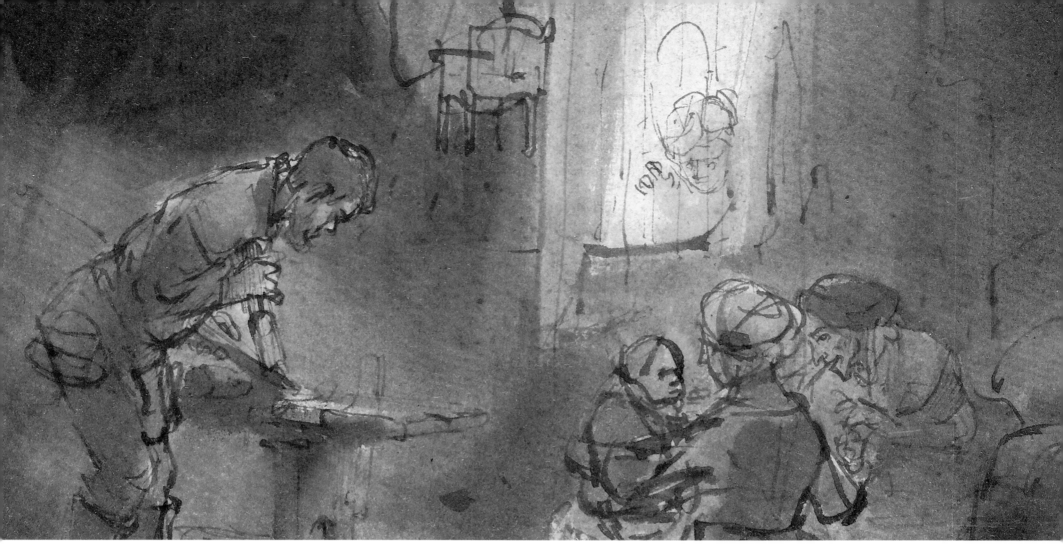

Rembrandt

The painter, draftsman, and etcher Samuel van Hoogstraten was a successful, socially prominent, and cosmopolitan artist who enjoyed the patronage of the emperor in Vienna and the London elite as well as the Dordrecht patriciate. A cultured man, he wrote poetry and plays, as well as *Inleyding tot de Hooge Schoole der Schilderkonst* (*Introduction to the Illustrious School of the Art of Painting*), the only treatise on art authored by one of Rembrandt's pupils. In that volume, Van Hoogstraten recorded that after he had studied with his father, the painter Dirck van Hoogstraten, Rembrandt was his "second master," and his fellow pupils included Abraham Furnerius and Carel Fabritius.[1] Van Hoogstraten entered Rembrandt's workshop after October 1641

Samuel van Hoogstraten

Dordrecht, 1627–Dordrecht, 1678

and had returned to Dordrecht by January 1648.[2] From 1651 to 1656 he worked at the imperial court in Vienna, where he impressed the emperor with his trompe l'oeil paintings, and traveled through Italy.[3] His perspective pictures also brought him commissions (and the admiration of Samuel Pepys) during a sojourn in England from 1662 to 1667.[4]

Van Hoogstraten's Rembrandtesque phase lasted only from 1644 to about 1650. In his later paintings he skillfully adopted different styles, generally following the dominant trend of the period toward bright colors applied with a seamless touch, consistent lighting, well-defined contours, and ideal settings with classicizing architecture.

In addition to trompe l'oeil illusions, peep boxes, head studies, and numerous portraits, he also depicted genre, allegorical, and biblical subjects.[5]

Van Hoogstraten was a versatile draftsman. About 150 drawings survive. Most represent biblical narratives or genre scenes, but he also drew sheets of studies, single figures, and nudes.[6] His technique is indebted to Rembrandt's work of the early to middle 1640s, and the great majority of his drawings date from the period of his training or to the first years of his independent career. Although Van Hoogstraten worked primarily in ink and wash, for greater painterly effect he occasionally combined those media with red chalk.[7]

1 Van Hoogstraten 1678, pp. 11, 95, 257.
2 Brusati 1995, pp. 24–25, and 273, note 28. Roscam Abbing 1993, pp. 34–36. The will he signed in Dordrecht in October 1641 is the latest document that places him in his native town.
3 Roscam Abbing 1993, pp. 42–49. Brusati 1995, pp. 52–78.
4 Roscam Abbing 1993, pp. 58–65. Brusati 1995, pp. 91–109.
5 Sumowski, *Paintings*, 823–903, pp. 1286–91.
6 Sumowski, *Drawings*, 1100–1276ˣˣ.
7 See cat. no. 23.2 in this catalogue.

Rembrandt

The Holy Family in the Carpenter's Workshop

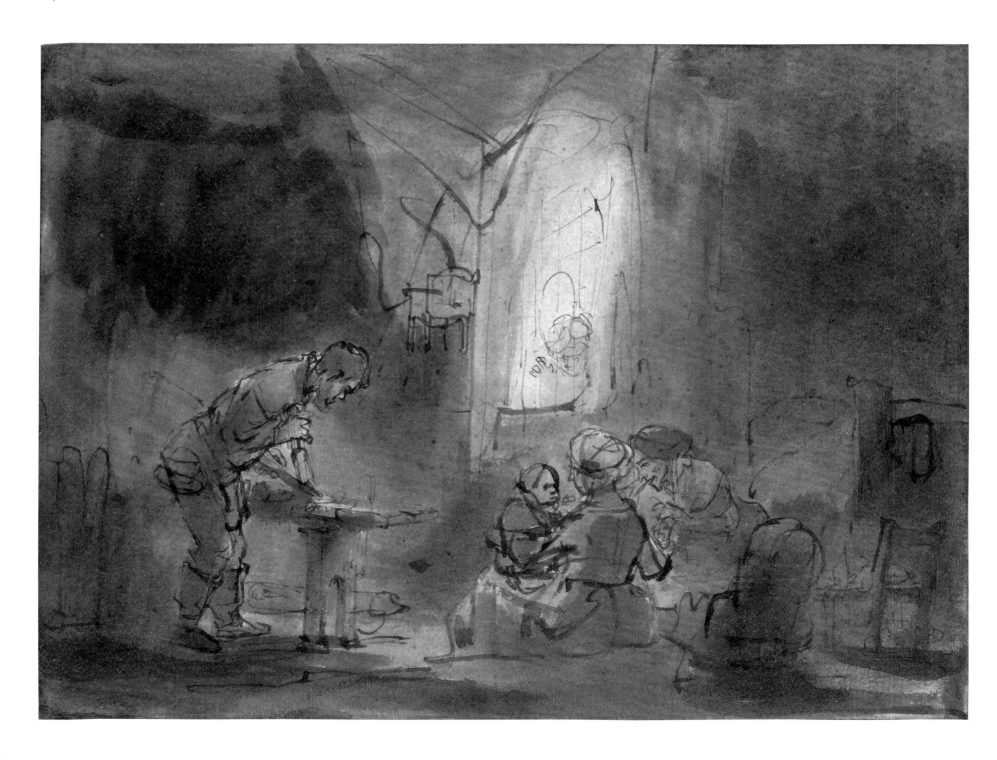

Samuel van Hoogstraten

The Adoration of the Shepherds

22.1 Rembrandt
The Holy Family in the Carpenter's Workshop, ca. 1645

Pen and brown ink, brush and grayish brown wash, touches of red chalk
and white gouache corrections, 18.4 × 24.6 cm (7¼ × 9¹¹⁄₁₆ in.)
London, The British Museum, 1900,0824.144

22.2 Samuel van Hoogstraten
The Adoration of the Shepherds, 1646–47

Pen and brown ink, brush and brown wash over sketch in black chalk,
some red chalk and white gouache heightening, 15.3 × 20.4 cm (6 × 8¹⁄₁₆ in.)
Hamburg, Kunsthalle, 22050

The elaborate finish and pictorial technique of *The Holy Family in the Carpenter's Workshop* (cat. no. 22.1) distinguish this drawing as one of Rembrandt's most ambitious studies of light penetrating a dark interior.[1] He started work with a sharp quill pen, sketching the composition with thin lines such as those that describe the window mullions and the head and fingers of the woman tapping on the glass. Apart from the reserve left in the window, Rembrandt covered nearly all the paper's surface with wash. Judiciously layering and blending the liquid medium, he relied on gradations of brown and grayish brown tones to model the figures, define the space, and suggest the evanescent shadows projected by the pale light as it diffuses through Saint Joseph's austere workshop. A few tiny reserves of white paper—for example, on Joseph's head, nose, neck, and worktable—introduce sparkling reflections among the shadows. Rembrandt created some of the reserves by leaving the area untouched, but others, as on the Virgin's knee, he scratched into the wet wash. The brushwork ranges from the delicate, seamless modulation of tones in the shading of Joseph's body to the broad, loose strokes with which Rembrandt layered the darker wash over the lighter one to describe the deeply saturated shadows on the wall above him. He defined the core of the composition with a few thick, decisive contours that outline the cradle and the window sill as well as the figures of the Child, the Virgin, and Joseph.

The predominance of the wash, exceptional in Rembrandt's work, and the tonal effects he achieved with it have been likened to the technical virtuosity of the etching *Saint Jerome in a Dark Chamber* of 1642.[2] In both works, he tested the limits of the medium in search of new means of depicting figures and objects enveloped in the fluctuating shadows of a dimly illuminated room. Whether the drawing dates from the same time as the print, as Benesch and most other scholars have maintained, is not certain. Acknowledging that the unusual technique makes it difficult to date the drawing precisely, Royalton-Kisch more plausibly assigned it to the middle of the 1640s. He noted that Joseph leans over his workbench in a nearly identical posture in the *Holy Family* painting of 1645 and pointed to the emphatic contours that loop around the figures of the Virgin and Child, which relate the penwork to that of drawings from the middle forties.[3]

The later date would place Rembrandt's work closer in time to Samuel van Hoogstraten's *The Adoration of the Shepherds* of 1646–47 (cat. no. 22.2). Drawings such as *The Holy Family in the Carpenter's Workshop* made a strong impression on Rembrandt's pupils, some of whom experimented with pictorial techniques and refined gradations of tone.[4] In *The Adoration of the Shepherds* and other biblical compositions from the second half of the 1640s, Van Hoogstraten pursued painterly effects with all the means at his disposal, but they remain subordinate to the narrative clarity and anecdotal detail at which he

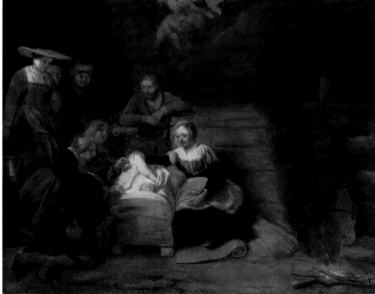

Figure 22a. Samuel van Hoogstraten after Rembrandt
The Adoration of the Shepherds, 1646–47
Red chalk, pen and brown ink, brush
and gray, red, and brownish-gray wash,
touches of black chalk, and white gouache,
26 × 18.9 (10¼ × 7⁷⁄₁₆ in.)
London, The British Museum,
1895,0915.1203

Figure 22b. Samuel van Hoogstraten
The Adoration of the Shepherds, 1646–47
Pen and brown ink, brush and brown wash,
with traces of white gouache, 7.3 × 10.7 cm
(2⁷⁄₈ × 4³⁄₁₆ in.)
New York, The Metropolitan Museum of
Art, Given in memory of Felix M. Warburg,
1941, 41.21.2

Figure 22c. Samuel van Hoogstraten
The Adoration of the Shepherds, 1647
Oil on canvas, 57.5 × 71 cm
(22⅝ × 27¹⁵⁄₁₆ in.)
Dordrecht, Dordrechts Museum,
DM/980/567

excelled.[5] In the *Adoration* he skillfully used brown wash in three strengths to distribute light consistently and alternate light and shaded areas to create an illusion of space. Like Rembrandt, he evoked the shadows in the deepest recesses of the barn interior by layering dark over light tones. The contours are descriptive and neatly enclose the forms—thin and fluent in brightly illuminated areas such as the head and upper body of the woman with a basket, thick and solid in shaded passages like the back of the kneeling shepherd at the center. Compared to Rembrandt's tour de force, with its few bold, summary contours and washes that evoke a palpable atmosphere of changing light and shadow, the neatly finished (and fully signed) work by his twenty-year-old pupil is competent, workmanlike, and prosaic.

The composition acknowledges Rembrandt's painting *The Adoration of the Shepherds*, which dates from 1646, when Van Hoogstraten was his pupil.[6] A copy of the picture, executed predominantly in red chalk and red wash, has recently been attributed to Van Hoogstraten (fig. 22a).[7] He developed his variant of Rembrandt's *Adoration* in a couple of pen-and-ink sketches and a small composition study worked up in brown wash (fig. 22b).[8] In the exhibited drawing, he reduced the number of figures, who now gather around the Virgin and Child, rather than surging forward from the rear door, as they do in the earlier design (fig. 22b) and in Rembrandt's canvas (see fig. 22a). The black-chalk preliminary sketch in the shaded area above the cattle indicates

that Van Hoogstraten initially considered following the prior study (fig. 22b), where the post rises behind the Virgin, and Joseph stands to its left. The series of drawings culminated in a painting of 1647 (fig. 22c).[9] The Hamburg sheet must date from 1646, when Rembrandt completed his *Adoration*, or the following year, when Van Hoogstraten executed his picture (fig. 22c). —**WWR**

1 Royalton-Kisch 1992, no. 43,
 pp. 111–12.
2 B. 105. See Royalton-Kisch 1992, p. 111;
 Benesch 516.
3 Royalton-Kisch 1992, p. 111.
4 Rembrandt pupil, *Kitchen Scene*,
 Benesch 747 recto; Sadkov 2001,
 no. 342, pp. 246–48.
5 Sumowski, *Paintings*, vol. 2, p. 1286.
6 Munich, Alte Pinakotek, 393; Bredius
 1971, p. 574.
7 Sumowski, *Drawings*, 1792ˣ, as Nicolaes
 Maes. Royalton-Kisch 2008–09,
 Samuel van Hoogstraten, no. 3.
8 Sumowski, *Drawings*, 1135ˣ–1137ˣ;
 Plomp 2006, pp. 40–41, fig. 50. See
 also Dordrecht 1992–93, pp. 190–92,
 and Bremen 2000–01, pp. 78–79.
9 Signed and dated 1647. Sumowski,
 Paintings, 823, repr. on p. 1306,
 and Dordrecht 1992–93, pp. 190–92.

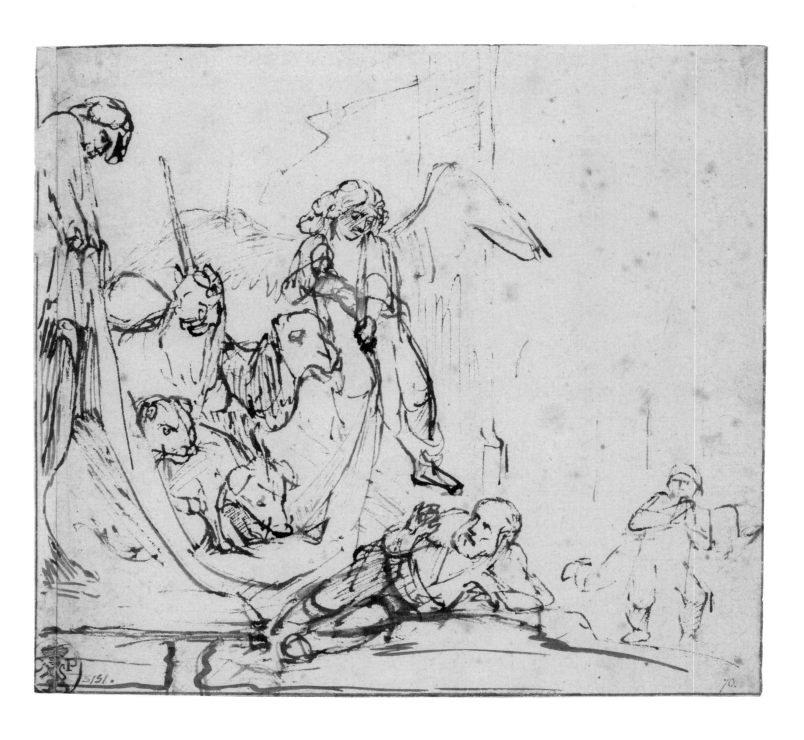

23.1

Rembrandt

Peter's Vision of the Unclean Beasts

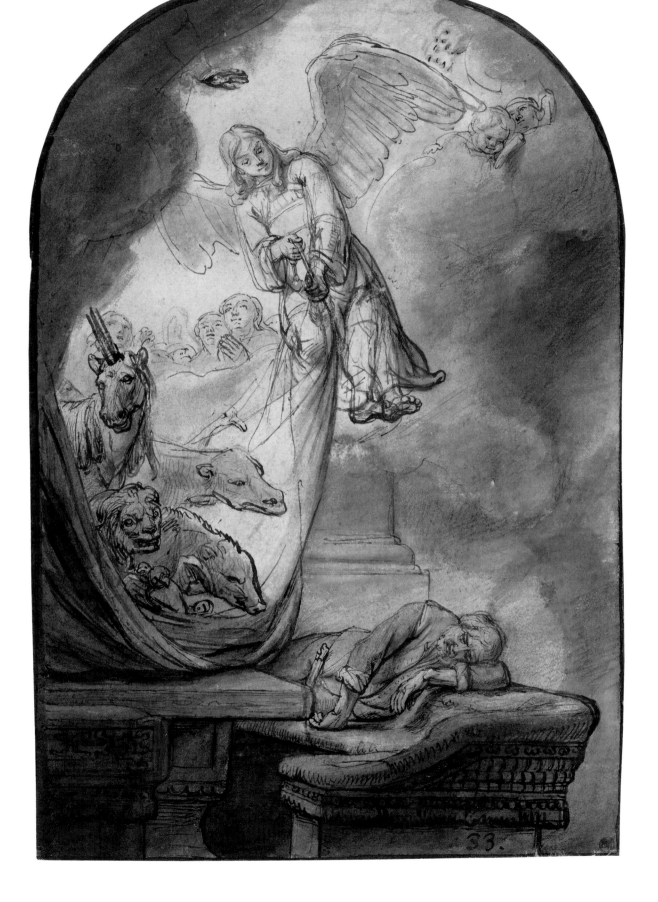

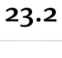

23.2

Samuel van Hoogstraten

Peter's Vision of the Unclean Beasts

23.1 Rembrandt
Peter's Vision of the Unclean Beasts, ca. 1645–47

Pen and brown ink with white gouache corrections; a strip of paper 5 mm wide
attached to left side of sheet, additions in gray ink by later hand at left edge,
lower left, and bottom, 17.9 × 19.3 cm (7¹/₁₆ × 7⅝ in.)
Munich, Staatliche Graphische Sammlung, 1392

23.2 Samuel van Hoogstraten
Peter's Vision of the Unclean Beasts, ca. 1646–47

Pen and brown and gray ink, brush and brown and gray washes, red and
black chalk with white gouache heightening and corrections; original framing
line in brown ink, 25 × 15.8 cm (9¹³/₁₆ × 6¼ in.)
Stockholm, Nationalmuseum, NMH 1986/1863

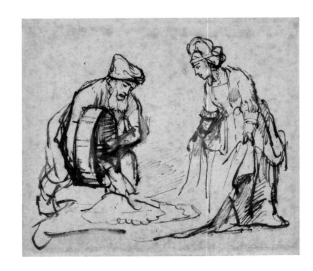

In order to propagate Jesus' teaching beyond its Jewish base, his disciples had to renounce dietary restrictions and other tenets of Mosaic law that limited their contact with Gentiles. God conveyed this to Peter through a vision. The apostle fell into a trance and saw "a certain vessel descending unto him, as it had been a great sheet knit at the four corners, and let down to the earth." The sheet held "all manner of four-footed beasts, and wild beasts, and creeping things, and fowls of the air." A voice commanded Peter to kill and eat those creatures. Shocked, he protested that he had never consumed flesh of animals proscribed by Jewish law as "common or unclean." "What God hath cleansed," the voice replied, Peter must not call common.[1]

A painting in an Amsterdam collection by the Italian artist Domenico Fetti probably challenged Rembrandt to address this rarely illustrated subject (cat. no. 23.1).[2] Improvising and correcting his sketch as he worked, he pasted a narrow strip of paper to the left edge of the original sheet to extend the figure of the angel. Another revision improved the technique used by the central angel to support his burden. Rembrandt initially drew this angel's right arm reaching across the chest to grasp the sheet above his left hand. He deleted that arm with opaque watercolor and, with two looping contours, redrew it with the elbow flexed. The new right fist, indicated by a circular stroke, grips the sheet, which the angel winds around the back of his neck to steady the weight on his shoulders. After sketching the con-

tours and delicate shading of Peter's lower body with a sharp, lightly charged quill pen, Rembrandt took a reed pen and superimposed dark, saturated lines that suggest the flailing of the apostle's legs as he tries to scramble away. A bystander at the right, astonished by the unearthly menagerie, clasps his hands and lurches backward. Rembrandt first showed the man running away, as a third leg in full stride attests.

Although most scholars have dated Rembrandt's drawing to circa 1655–60, Sumowski convincingly assigned it to the later 1640s.[3] The looping, continuous contours that define the animals and the central angel do not resemble the angular, broken outlines in works of the late 1650s. However, those fluid contours, the rendering of the angel's face and hair, and the vigorous, zigzag lines on the camel's neck are characteristic of Rembrandt's penwork of the forties (fig. 23a).[4]

The Munich drawing is Rembrandt's only depiction of this theme, and Samuel van Hoogstraten's variant the sole example by one of his pupils (cat. no. 23.2). Comparison of Van Hoogstraten's version with his closely related *The Visitation* of 1646 (fig. 23b) confirms that it dates from the period of his training in Rembrandt's workshop and was produced as an immediate response to the master's model.[5] In a cursory preliminary sketch, Van Hoogstraten established the arched format and the locations of the angel, the sheet and animals, and the slumbering apostle (fig. 23c).[6] The pose of the angel—frontal, upright, his head cocked slightly to the right—is closer to the figure

Figure 23a. Rembrandt
Boaz and Ruth, ca. 1645
Pen and brown ink, white gouache,
12.6 × 14.3 cm (4¹⁵⁄₁₆ × 5⅝ in.)
Amsterdam, Rijksmuseum,
Rijksprentenkabinet, 1930:9

Figure 23b. Samuel van Hoogstraten
The Visitation, 1646
Pen and brown ink, brush and brown wash,
red chalk, black chalk, touches of white
gouache, 24.4 × 24.6 (9⅝ × 9¹¹⁄₁₆ in.)
Amsterdam Historisch Museum, A10153

Figure 23c. Samuel van Hoogstraten
Peter's Vision of the Unclean Beasts,
ca. 1646–47
Pen and brown ink, brush and (later?)
gray wash, 7 × 4.6 cm (2¾ × 1¹³⁄₁₆ in.)
Munich, Staatliche Graphische Sammlung,
1544

in Rembrandt's drawing than to the leftward-leaning angel in Van Hoogstraten's final composition. Van Hoogstraten's decision to tilt the angel's body necessitated some adjustments during work on the Stockholm drawing: he deleted the proper left hand and redrew it in a higher position, moved the proper left leg farther to our right, and changed the angle of the foot.

If the principal features of Van Hoogstraten's work—the angel, the animals, the sheet, and the location of the figure of Peter—correspond closely to Rembrandt's model, the two drawings are remarkably dissimilar in other respects. Rembrandt interpreted Peter's vision as a "live" event: fully conscious, the terrified apostle cowers at the sight of the approaching vessel. That a bystander also witnesses the apparition affirms its material presence. Confronted by Rembrandt's bold, imaginative departure from the letter of the text, Van Hoogstraten characteristically reverted to it. The Bible states that Peter fell into a trance, and so Van Hoogstraten represented him in a deep sleep, during which the disciple imagines the unclean beasts as if in a dream. To underscore the visionary character of the experience, Van Hoogstraten resorted to the conventional trappings of a heavenly spectacle: angels nestle amidst swirling clouds and adore God, whose hand emerges at the upper left, embodying the voice that spoke to Peter.

While Rembrandt used only a pen, Van Hoogstraten executed his variant in a combination of media applied with a painterly technique.

In his treatise on painting, Van Hoogstraten advised draftsmen to introduce pictorial effects into their ink-and-wash compositions by working them up "with red chalk and colored chalks, almost as if one was painting with colors."[7] Here, he used red chalk primarily to enhance or accentuate specific passages, in places smudging the medium or applying it wet, so that it reads as color rather than line. —**WWR**

1 Acts of the Apostles 10:9–16. Munich
 and Amsterdam 2001–02, pp. 246–48,
 nos. 66 and 67.
2 Logan 1979, pp. 118–19; Šafařík 1990,
 pp. 237–39; Mantua 1996, pp. 193–94;
 and Munich and Amsterdam 2001–02,
 pp. 247–48.
3 Sumowski, *Drawings*, 1127ˣ; and
 Munich and Amsterdam 2001–02,
 pp. 248–49, note 11.
4 Schatborn (Amsterdam 1984–85, p. 52,
 no. 2) dates *Boaz and Ruth* (fig. 23a) to
 the middle of the 1640s.
5 Sumowski, *Drawings*, 1121ˣ and 1127ˣ.
6 Sumowski, *Drawings*, 1149ˣ; Munich
 and Amsterdam 2001–02, pp. 244–49,
 no. 67.
7 Van Hoogstraten 1678, p. 31; Brusati
 1995, p. 32, and p. 276, note 45.

Rembrandt

The Baptism of the Eunuch

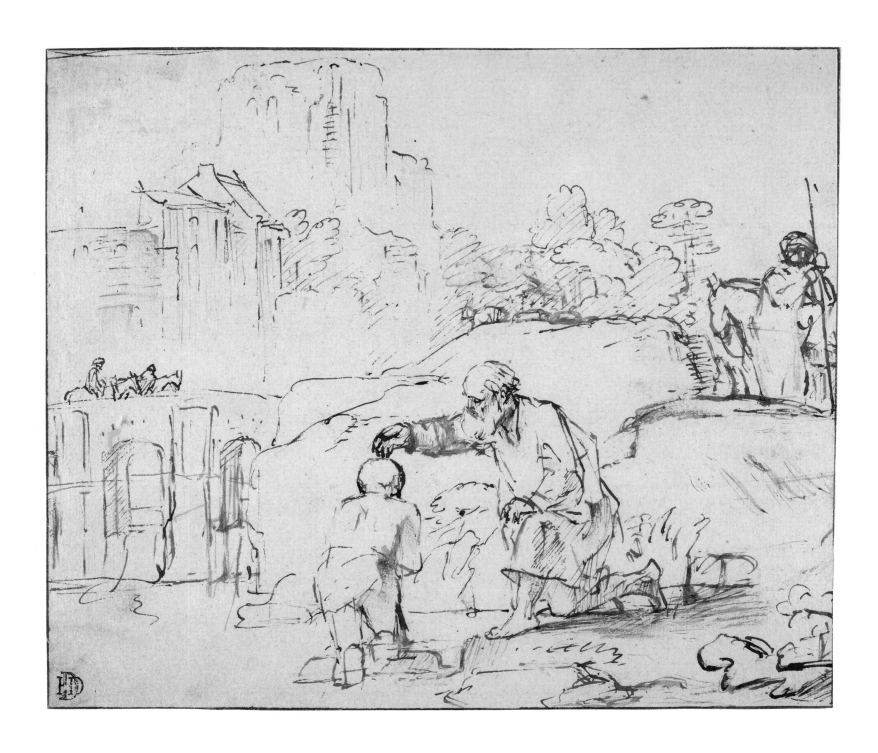

Samuel van Hoogstraten

The Baptism of the Eunuch

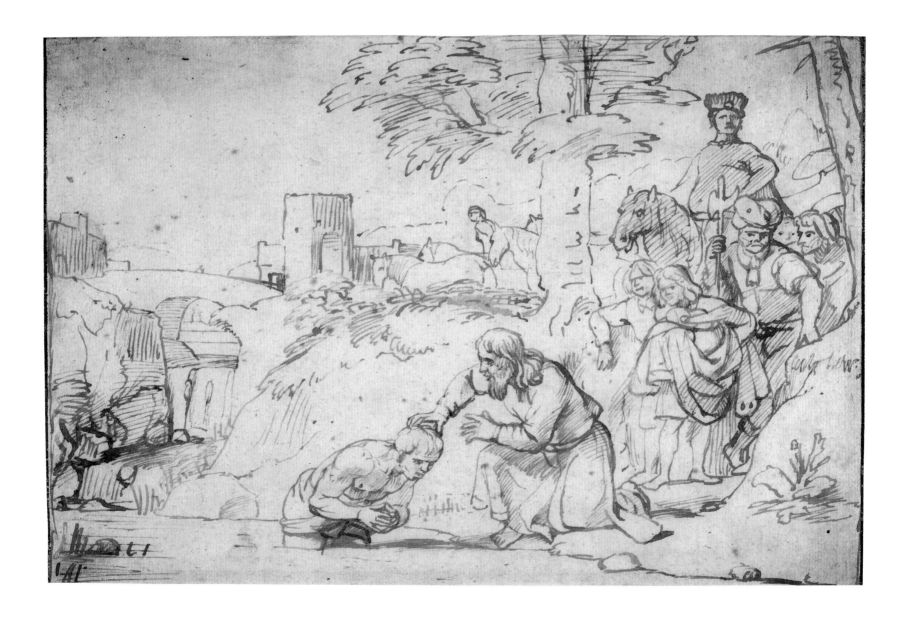

24.1 Rembrandt
The Baptism of the Eunuch, ca. 1650–52

Pen and brown ink, partially incised, 18.2 × 21.1 cm (7³⁄₁₆ × 8⁵⁄₁₆ in.)
Ottawa, National Gallery of Canada, 18909

24.2 Samuel van Hoogstraten
The Baptism of the Eunuch, ca. 1656–60

Pen and brown ink, 15.1 × 21.8 cm (5¹⁵⁄₁₆ × 8⁹⁄₁₆ in.)
Ottawa, National Gallery of Canada, Gift of Marianne Seger, 42006

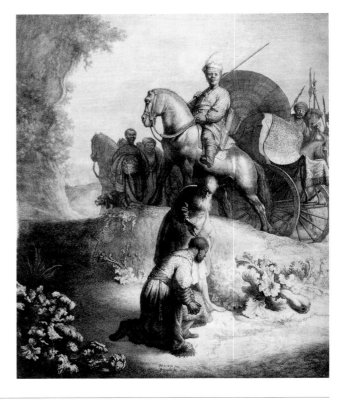

Philip the deacon approached a chariot carrying a eunuch who served as treasurer to the queen of Ethiopia. They conversed about a passage in the writings of Isaiah. Moved by Philip's interpretation of the text as a prophecy of Jesus' sacrifice, the Ethiopian embraced Christianity. When they neared a body of water, he ordered the chariot to stop, and Philip baptized him.[1]

Rembrandt's drawing (cat. no. 24.1), which dates from the early 1650s, is the latest of five works he devoted to this theme.[2] In two early paintings—one known only from a print (fig. 24a)—and an etching of 1641, he developed the exoticism and narrative embellishments that Pieter Lastman had introduced to the iconography of the subject.[3] The costumes of the Ethiopian's bodyguards, the chariot with its outsized parasol, and the overwrought expressions of the attendants divert the viewer's attention from the solemn ritual enacted by Philip and the distinguished convert.

In the Ottawa drawing, Rembrandt omitted extraneous narrative details and depicted the baptism as a private moment of profound spiritual consequence. Here the Ethiopian retinue consists merely of a horse and a single witness who watches passively from the road atop the bank. Wearing only a loincloth, the eunuch kneels in the shallows with his back to us. We cannot see his hands or face, which leaves the austere figure of the deacon as the cynosure of the composition. With his eyes focused on the simple gesture that signifies acceptance in the Christian faith, Philip kneels on one knee and leans forward resolutely, his gentle hand barely grazing the convert's bowed head.

The penwork supports the compositional strategy that centers on Philip's role. To frame the baptismal scene, Rembrandt rendered the foreground figures, plants, and bank with slightly heavier outline—some broadened by smudging—than those used in the rest of the work. He drew the deacon with complete contours and diagonal hatchings that lend weight to his clothing, but only faintly sketched the eunuch's back and legs with broken lines and minimal modeling. By thickening the contours of the initiate's head and Philip's forearm and hand, he accentuated the site where the spiritual transformation occurs. Although Rembrandt selectively reinforced individual strokes, the handling overall is restrained and relies on nuances, rather than forceful contrasts, in the breadth of the lines. Most of the landscape background, for example, is rendered with fine contours that vary little in density and tonal value. The same delicate touch occurs in the more summarily sketched *Homer Reciting*, which is signed and dated 1652 (fig. 24b).[4] Comparison with the latter work confirms that the Ottawa sheet and a few other biblical compositions executed in a similarly refined technique belong to the same period.[5]

The drawing by Samuel van Hoogstraten (cat. no. 24.2) incorporates the principal features of Rembrandt's composition: the oblong format, Philip's pose, the location of the two protagonists in the

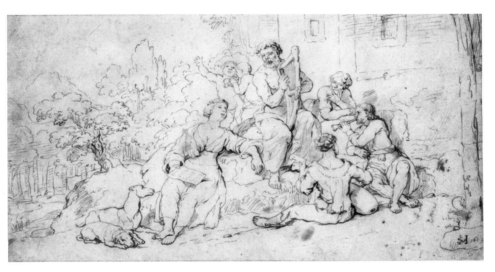

Figure 24a. Jan van Vliet, after Rembrandt
The Baptism of the Eunuch, 1631
Etching and burin, 59.2 × 49.1 cm
(23⁵/₁₆ × 19⁵/₁₆ in.)
London, The British Museum, 1983,U.459

Figure 24b. Rembrandt
Homer Reciting, 1652
Pen and brown ink, 25.5 × 18 cm
(10¹/₁₆ × 7¹/₈ in.)
Amsterdam, Jan Six Collection,
"Pandora" Album

Figure 24c. Samuel van Hoogstraten
Arcadian Musical Scene, 1653
Pen and brown ink over traces of black
chalk, 14.8 × 27.1 cm (5¹³/₁₆ × 10¹¹/₁₆ in.)
Paris, Frits Lugt Collection, Institut
Néerlandais, 44

center foreground, and the broad landscape with a river and road that converge on an arched stone bridge. For the mounted retainer and gaping onlookers, he borrowed from Rembrandt's early paintings (fig. 24a). In a notable departure from Rembrandt's model, Philip plants his hand firmly on the eunuch's head to administer the baptism by immersion, the form of the rite Van Hoogstraten evidently regarded as historically correct.[6]

The technique of Van Hoogstraten's *Baptism of the Eunuch*, with its disciplined contours and uniform, parallel shading strokes, hardly resembles the painterly washes and varied Rembrandtesque line of his earlier drawings (cat. nos. 22.2, 23.2). Exposed during his travels in Central Europe and Italy (1651–56) to the classicizing movement in European art, Van Hoogstraten adapted his draftsmanship to the prevailing trend. As early as 1653, as documented by a dated drawing of that year (fig. 24c), he had developed the regular hatchings, consistent lighting, and clarity of form that characterize his *Baptism of the Eunuch*. This approach enabled him to model the figures convincingly in the round. However, compared to the strategic modulation of Rembrandt's strokes, the draftsmanship is monotonous, and the homogenous, unarticulated line diffuses the visual impact of the composition.

In his treatise on painting Van Hoogstraten encouraged young artists to strengthen their ability to design narrative compositions by repeatedly sketching scenes from the Bible and other literary sources.[7]

His recommendation surely reflects a pedagogical routine devised by Rembrandt, who assigned his students to draw "histories," for which they could consult his own works and those in his extensive collection as models. This accounts for the numerous clusters of drawings of the same subject comprised of an original by the master and one or more variants by pupils, some of which are included in this catalogue (cat. nos. 8, 11, 12, 23, 30, 36). When teaching his own students, Van Hoogstraten followed this practice: every week his pupils had to submit a new composition for his critique.[8] We do not know when Van Hoogstraten studied Rembrandt's Ottawa drawing (or a lost version or copy of it), but he almost certainly did not see it until he returned from his *Wanderjahre* in 1656. If so, a decade after leaving Rembrandt's workshop, he continued to train his hand and imagination by composing a variant of the master's model. —**WWR**

1 Acts of the Apostles 8:26–39. Philip the deacon was not the apostle Philip. Bonebakker 1998, p. 6, and Bonebakker 2003, p. 29.
2 Amsterdam 1996, pp. 44–45, no. 2, and Munich and Amsterdam 2001–02, pp. 197–205, nos. 49–51.
3 Amsterdam 1996, pp. 44–45, no. 2, and Amsterdam 1991–92, p. 58.
4 Benesch 913.
5 Benesch 871, 912, 916, 983.
6 Ottawa, Cambridge, and Fredericton 2003–05, p. 113.
7 Van Hoogstraten 1678, pp. 191–92, and essay by Holm Bevers in this catalogue, pp. 21–22.
8 Houbraken 1718–21, vol. 2, p. 162.

Rembrandt

Today, Abraham Furnerius is known as a landscape draftsman, although he is documented as having made paintings.[1] His career was cut short by his early death at age twenty-six. Furnerius was born in Rotterdam, the son of a doctor. In 1641, his sister married the painter Philips Koninck, and Furnerius may have begun his artistic training with his brother-in-law or Philips's brother, Jacob, who were both talented landscapists. He probably entered Rembrandt's studio around 1642. By that time, at age fourteen, he apparently was already a gifted landscape specialist, as he is so described by Samuel van Hoogstraten in a lively account of an art-theoretical discussion among himself, Furnerius, and Carel Fabritius when they were fellow students in

Abraham Furnerius

Rotterdam, ca. 1628–Rotterdam, May 6, 1654

Rembrandt's studio in the early 1640s.[2] At that time, Rembrandt was actively producing landscape drawings, many based on sketching trips in and around Amsterdam. These had a profound influence on Furnerius, both stylistically, as seen in his penchant for dark, painterly ink outlines and loose wash in the rendering of tree foliage, and thematically, as his drawings are evocative of and sometimes actually depict real topography. It is not known how long Furnerius remained in Rembrandt's studio, or when he moved back to Rotterdam, where he died, although Rembrandt's lingering influence on his art suggests he stayed in Amsterdam through the 1640s and perhaps the early 1650s.

None of Furnerius's drawings are dated, so chronology is problematic and there are no certain signed drawings by him. His drawn oeuvre has been reconstructed around old attributions based upon inscribed drawings.[3]

1 The inventory of his widow lists paintings by him. See Bredius 1915–22, vol. 5, pp. 1645–47, for this and further documents.
2 Van Hoogstraten 1678, p. 95; Hofstede de Groot 1906, p. 400.
3 See Sumowski, *Drawings,* vol. 4.

25.1

Rembrandt

Houses on the Bulwark "The Rose,"
Amsterdam

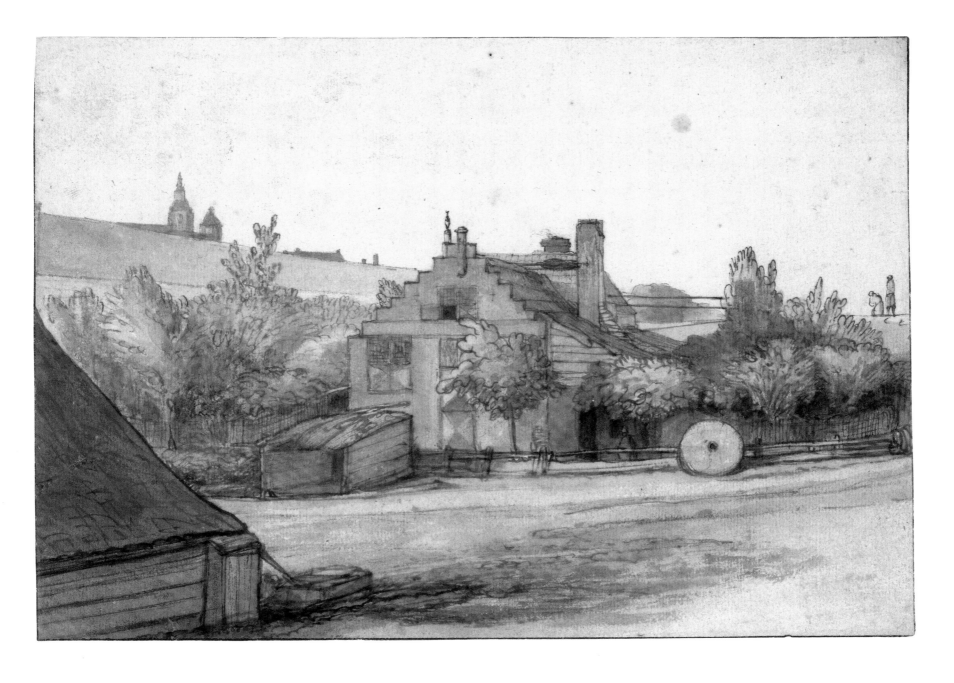

25.1 Rembrandt

Houses on the Bulwark "The Rose," Amsterdam,
ca. 1645–50

Pen and brown ink, brush and brown wash on brown tinted paper,
13.5 × 21.1 cm (5⁵⁄₁₆ × 8⁵⁄₁₆ in.)
Budapest, Szépmüvészeti Múzeum, 1578

25.2 Abraham Furnerius

A House on the Bulwark "The Rose," Amsterdam,
ca. 1645–50

Pen and brown ink, brush and brown, red, and gray-blue washes,
16.5 × 23.1 cm (6½ × 9⅛ in.)
Haarlem, Teylers Museum, P*65

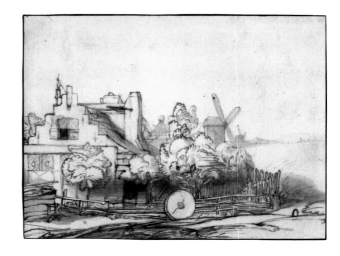

The sheet in Budapest (cat. no. 25.1) and one other from an entirely different vantage point (Benesch 1263, formerly in Chatsworth and now in the Thaw Collection, Pierpont Morgan Library) are two surviving views of the bulwark called "The Rose" that Rembrandt made on open-air sketching trips.[1] The bulwark was located at the end of the Rozengracht (*gracht* = canal) in the western part of Amsterdam, not far from where Rembrandt moved after the 1658 sale of his big house on the Sint Antoniesbreestraat. Always perceptive to the action of wind, light, weather, and atmosphere, Rembrandt captured these fleeting intangibles with febrile sensitivity in the Budapest rendering of the bastion. He tuned his handling and media to achieve these effects, fully exploiting the liquidity of wash and ink line. First, he toned the paper with a light brown wash, creating a sense of moisture-laden atmosphere. Then he must have sketched the composition lightly in pen before laying in broad washes with nuanced tonal gradations. These include the middle dark tone in the stepped gable and trees and the darkest tone, for example, in the chimney and end wall of the middle-sized cottage second to the right. He also let the reserve of the washed paper shine through in the pointed gable and its surrounding trees and in other areas of the same side of the complex of cottages. These broad areas of light and shadow unify the complex of houses and trees and create dramatic tenebrism reflecting the rapid interaction of sun and clouds in

the windy Dutch sky.[2] Finally, he again used a quill pen, now with a thick nib fully loaded with dark brown ink, to reinforce outlines and details. The linework is dynamic, varied, and directional, as showcased in the trees surrounding the cottages, swept forward by the wind. This rather wet handling of wash and line conjures a sense of atmosphere, shifting light, and wind, all at once.

Although it is likely that Furnerius actually joined Rembrandt on his sketching trip(s) to the bulwark "The Rose," his two surviving drawings of the gabled house on this site in Haarlem (cat. no. 25.2) and London (fig. 25a), seen from closer in than in the Budapest sheet, were not necessarily drawn at the same time.[3] Not only did he apparently follow Rembrandt's lead in drawing this particular site, but he also emulated to some extent the wet handling of such Rembrandt drawings as the one in Budapest. In the Haarlem drawing he laid in the cottages and trees with washes of mixed colors of brown, red, and gray-blue. These lively and attractive washes end up creating a descriptive rather than atmospheric effect, with the red evoking the tile of the roof at left. Furnerius occasionally used color in his drawings (see Sumowski, *Drawings*, 995ˣˣ and 1020ˣˣ), and it is interesting to speculate on the influence here, as Rembrandt did not use watercolor in his landscape drawings. The tonality of the washes shows some tenebrism, but not the enormous range of contrasts seen in the Budapest sheet. Furnerius also applies the lines over the washes,

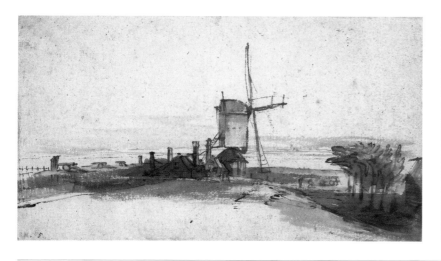

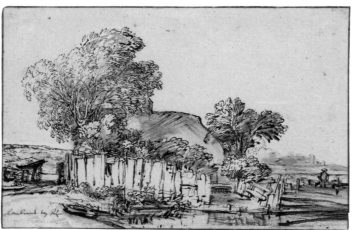

Figure 25a. Abraham Furnerius
House near the "de Rose" Bulwark,
Amsterdam, ca. 1650–54
Pen and brown ink, brush and brown wash,
some outlines indented under the trees
to the right, 15.1 × 19.7 cm (5¹⁵⁄₁₆ × 7¾ in.)
London, The British Museum, Oo,9.87

Figure 25b. Rembrandt
Mill on the Bulwark "The Blue Headland,"
ca. 1645–50
Pen and brown ink, brush and brown
and gray-brown washes, 11.6 × 19.8 cm
(4⁹⁄₁₆ × 7¹³⁄₁₆ in.)
Paris, Frits Lugt Collection, Institut
Néerlandais, 5174

Figure 25c. Rembrandt
Cottage with a White Paling, ca. 1648
Pen and brown ink, brush and brown
wash, white gouache heightening,
light purple wash added by a later hand,
17.1 × 25.5 cm (6¾ × 10¹⁄₁₆ in.)
Amsterdam, Rijksmuseum,
Rijksprentenkabinet, 1981:1

but, again unlike Rembrandt, he concentrates on specific descriptive elements such as the windows, the gable steps, and the wood siding. The drawing shows Furnerius's highly characteristic bushy, wind-blown leaves rendered in pen outline over wash. This salient Furnerius element has much in common with Rembrandt (the Budapest sheet providing a good comparison), but with Rembrandt's foliage showing more variation in atmosphere, movement, and light. Naturalistic detail notwithstanding, Furnerius artfully experiments with the composition. The London drawing, the less worked up of the two, contains windmills, which in the more finished Haarlem sheet are replaced by figures strolling on the bulwark's wall. It has been suggested that both sheets were made in the studio, based on sketches made on the spot.[4] In sum, Furnerius creates an apparent portrait of a place, whereas Rembrandt portrays a place in dramatic interaction with the elements.

The dating of the Budapest Rembrandt and the Haarlem Furnerius is not clear-cut. Furnerius studied with Rembrandt circa 1642–48. We can compare the sketchy style of the Budapest sheet with that of Rembrandt's *Mill on the Bulwark "The Blue Headland"* (*Blauwhoofd*) in the Lugt collection (Benesch 1333; fig. 25b), probably from the mid-1640s. Though more summary, the billowing foliage in the Haarlem sheet is comparable to that in Rembrandt's *Cottage with a White Paling* in Amsterdam (fig. 25c) for his 1648 etching.[5]

While there are no indisputably signed or otherwise documented drawings by Furnerius, the Haarlem drawing is one of the most solid attributions due to the annotation *fürnerüs* on the verso that is in old, perhaps seventeenth-century, handwriting.[6] —**LH**

1 Cf. Turner 2006, no. 219.
2 For the most eloquent description of Rembrandt's capturing of the Dutch marine climate in this drawing, see Budapest 2006, pp. 66–68.
3 For the Haarlem drawing and a drawing in Frankfurt, see Sumowski, *Drawings*, 1022ˣˣ, and Plomp 1997, p. 160, no. 157, who refers to the previous attribution to Van den Eeckhout, changed in the 1860s, for further literature. For the London drawing, see Sumowski, *Drawings*, 999ˣˣ and Royalton-Kisch 2008–09, formerly attributed to Rembrandt.
4 Amsterdam and Paris 1998–99, p. 197.
5 B. 232.
6 As noted by Plomp 1997, p. 160, no. 157.

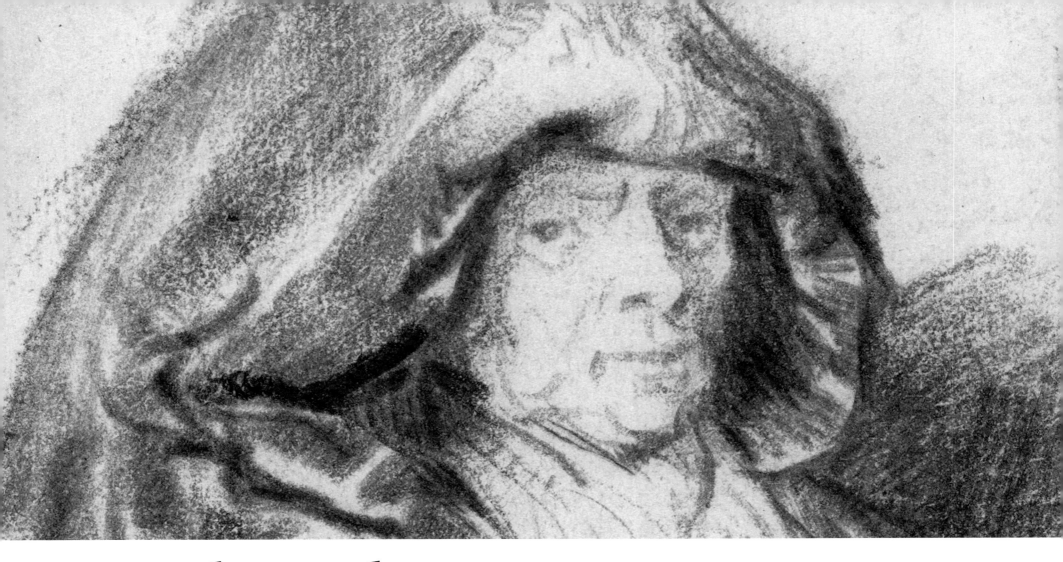

Rembrandt

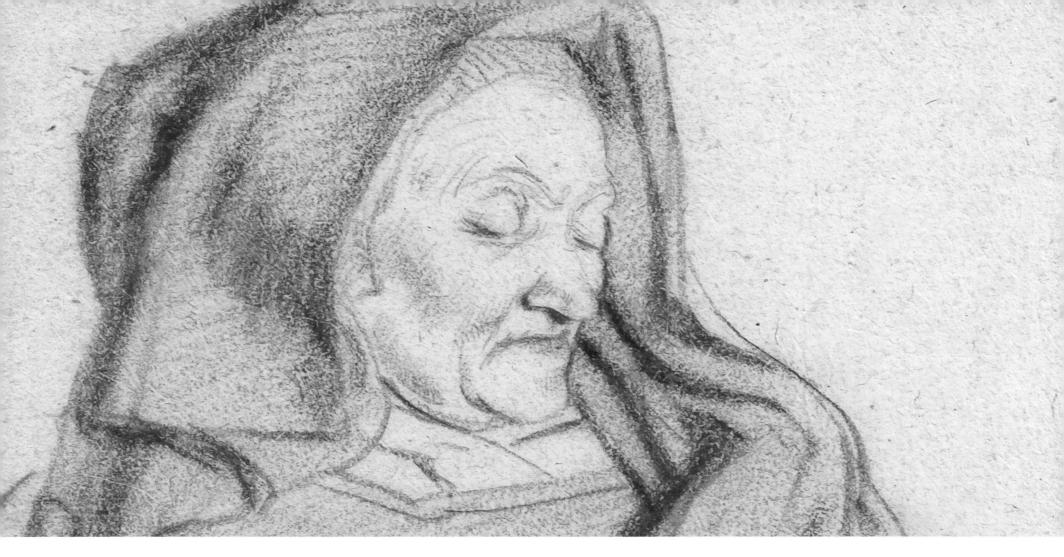

Nicolaes Maes

Dordrecht, January 1634–Amsterdam, December 1693

Houbraken recorded that Nicolaes Maes took lessons from a drawing master and "learned...the art of painting from Rembrandt."[1] Maes probably entered Rembrandt's workshop in the late 1640s, although the precise dates of his training in Amsterdam remain undocumented. By December 1653, the nineteen-year-old artist had returned to his native Dordrecht.[2]

Maes's standing as one of the most innovative Dutch painters of his generation rests on approximately forty pictures of domestic scenes that he produced between 1654 and about 1660. His paintings of women engaged in household chores combine Rembrandtesque facture and light effects with original narrative compositions that range from solemn to gently humorous. After 1660, he pursued a successful career as a portraitist, which motivated him to move in 1673 to Amsterdam.

More than one hundred drawings by Maes have survived.[3] All probably date from the 1650s, with securely datable sheets ranging from 1653 to 1658.[4] They include household scenes, figure studies, biblical subjects, and landscapes. Maes drew with red chalk, brown ink, and brown or gray wash, occasionally combining red chalk with washes for a rich pictorial effect. Many of Maes's drawings relate directly or indirectly to the design and execution of his paintings.[5]

1 Houbraken 1718–21, vol. 2, p. 273.
2 Robinson 1996, p. 280.
3 Robinson 1996, pp. 97–99.
4 Robinson 1996, pp. 101–2.
5 Robinson 1996, pp. 101–30.

26.1

Rembrandt

Simeon and the Christ Child

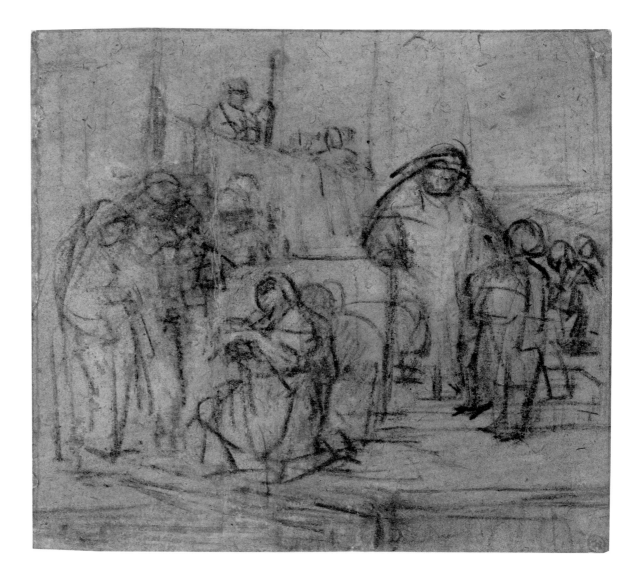

26.2

Nicolaes Maes

The Adoration of the Shepherds

26.1 Rembrandt
Simeon and the Christ Child, ca. 1640

Black chalk, white gouache heightening, 14.4 × 15.3 cm (5 11/$_{16}$ × 6 in.)
Berlin, Staatliche Museen, Kupferstichkabinett, KdZ 4269

26.2 Nicolaes Maes
The Adoration of the Shepherds, ca. 1658

Red chalk, 15.8 × 13.6 cm (6 ¼ × 5 ⅜ in.)
Rotterdam, Museum Boijmans Van Beuningen, Koenigs Collection, R. 54 verso

Joseph and Mary brought their newborn son to the temple to offer the customary sacrifice of a pair of turtledoves or pigeons. There, they encountered the elderly Simeon, to whom the Holy Spirit had revealed that before he died he would see the Savior. Simeon took the child in his arms and intoned, "Lord, now lettest thou thy servant depart in peace, according to thy word; For mine eyes have seen thy salvation." The aged prophetess Anna witnessed the revelation, and she "gave thanks likewise to the Lord, and spake of him to all them that looked for redemption in Jerusalem."[1] Rembrandt depicted Simeon with the Christ Child in paintings, drawings, and prints from the late 1620s into the 1660s, and the subject was a popular one among his pupils (see cat. no. 40).[2]

The exhibited sketches by Rembrandt and Nicolaes Maes represent a type of drawing that rarely survives: compositional projects scribbled casually on any available scrap of paper. Later collectors and dealers, and no doubt the artists themselves, routinely discarded these informal working studies, and many that remain have been preserved only because they appear on the versos of more finished works.

In Rembrandt's drawing (cat. no. 26.1), Simeon kneels in the left foreground, holding the child, while Anna heavily descends the stair, steadying herself with a stick in one hand; the other rests on a boy's shoulder. Mary and Joseph stand with other witnesses at the left.

Long, angular strokes summarily outline the figures and setting. Rembrandt used a cheap paper flecked with occlusions and loose fibers, and its rough surface accepted the friable chalk unevenly, so many lines appear soft and porous. In places he revised his initial draft with darker contours, pressing hard into the paper. For example, he decided to shift Simeon to the left and firmly redrew the outer contours of the skirt of his robe and, with a decisive, looping stroke and two descending lines, extended the profile of his bent knee and the leg below it. Scattered touches of white gouache highlight the figure of Simeon and the group at the left.

Of Rembrandt's few surviving sketches of this type, a red-chalk study in Rotterdam (fig. 26a) represents an early draft for the 1638 etching *Joseph Relating His Dreams*.[3] Even more schematic than *Simeon and the Christ Child*, it shows, in reverse, the bare outlines of the figures that make up the central group in the print. Peter Schatborn tentatively suggested that a handful of other chalk studies, including *Simeon and the Christ Child*, might be projects for prints.[4] Acknowledging the many differences in format and composition, Holm Bevers plausibly characterized *Simeon and the Christ Child* as a study for the eponymous etching of circa 1640.[5] Bevers's dating is supported by the close resemblance of Anna and her attendant to the elderly Zacharias in the *Visitation* painting of 1640, who similarly hobbles down a stair with his hand on a boy's shoulder.[6]

Figure 26a. Rembrandt
Joseph Relating His Dreams, ca. 1638–39
(verso of cat. no. 19.1)
Red chalk, 18 × 12.5 cm (7 ¹⁄₁₆ × 4 ¹⁵⁄₁₆ in.)
Rotterdam, Museum Boijmans
Van Beuningen, MB 1958/T32 verso

Figure 26b. Nicolaes Maes
The Adoration of the Shepherds, 1658
Oil on panel, 59.4 × 87 cm (23 ⅜ × 34 ¼ in.)
Montreal, The Montreal Museum of
Fine Arts, Purchase, Horsley and Annie
Townsend Bequest, 962.1520

Figure 26c. Nicolaes Maes
The Adoration of the Shepherds, ca. 1658
Pen and brown ink, brush and brown wash,
white gouache over red chalk,
21.5 × 20.4 cm (8 ½ × 8 ¹⁄₁₆ in.)
Bayonne, Musée Bonnat, 1472

The date and function of Maes's red-chalk sketch (cat. no. 26.2) are not problematic, because the sketch relates to a signed and dated painting of 1658 (fig. 26b).[7] Two other studies for the picture are on the recto and verso of a sheet in the Musée Bonnat, Bayonne. The recto represents an earlier plan for the composition (fig. 26c), which Maes based in part on a canvas of 1647 by Samuel van Hoogstraten and drawings related to it (cat. no. 22.2 and figs. 22b, 22c).[8] Although less finished than the Bayonne recto, the red-chalk sketch exhibited here marks a more advanced stage of the design. The shepherds gather to the right of the manger, as in the painting, and Maes has positioned the oxen and some of the figures where they will appear in the finished work. He made minimal corrections on the sketch itself, adjusting the hat of one of the standing shepherds and, with a sharper chalk, reworking the arm of a kneeling shepherd so that it points upward.

Quickly jotted down to record a fresh compositional idea, Maes's drawing served the same purpose as Rembrandt's study for *Joseph Relating His Dreams*. Its schematic handling, with the oxen and human figures reduced to two-dimensional outlines, is closer to that of the Joseph sketch than to that of *Simeon and the Christ Child*, with its layers of revisions. —**WWR**

1 Luke 2: 22–38.
2 Stechow 1940; Schwartz 2006,
 pp. 362–67.
3 See cat. no. 19.1 and Giltaij 1988,
 pp. 60–62, no. 13 verso. For the
 etching (B. 37) and related studies,
 see Amsterdam and London 2000–01,
 pp. 159–61, no. 31.
4 Munich and Amsterdam 2001–02,
 p. 37. See also Bonebakker 2003,
 pp. 38–40, and Bevers 2006, p. 104.
5 Bevers 2006, pp. 102–4, no. 25.
 The etching is B. 49.
6 Bevers 2006, p. 102, note 2.
7 Sumowski, *Paintings*, 1318.
8 Sumowski, *Drawings*, 1861ˣ.

27.1

Rembrandt

Old Woman with a Large Headdress

27.2

Rembrandt

Old Woman Seated

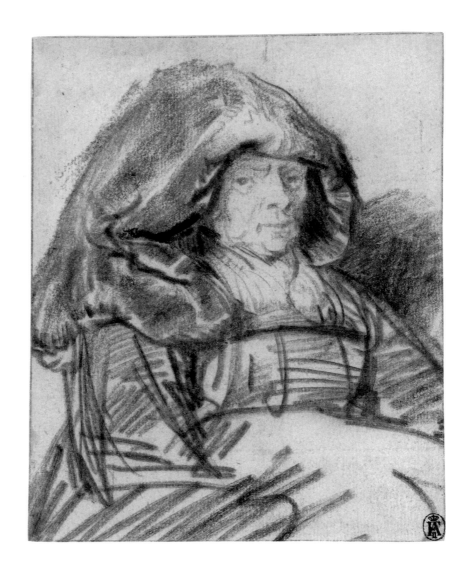

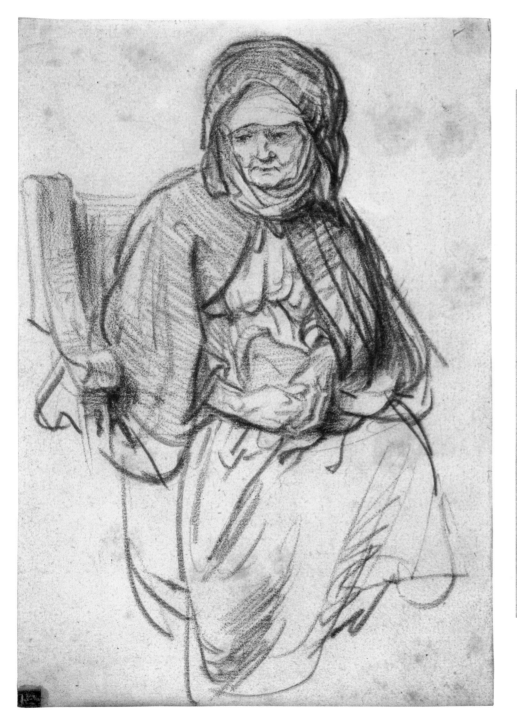

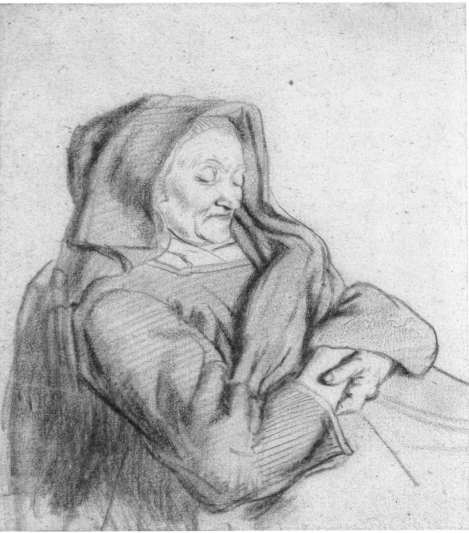

27.1 Rembrandt
Old Woman with a Large Headdress, ca. 1640–43

Black chalk, 13.8 × 10.9 cm (5⁷⁄₁₆ × 4⁵⁄₁₆ in.)
London, The Samuel Courtauld Trust, The Courtauld Gallery, D.1978.PG.191

27.2 Rembrandt
Old Woman Seated, ca. 1647

Red chalk, 23.7 × 15.7 cm (9⁵⁄₁₆ × 6³⁄₁₆ in.)
Paris, Musée du Louvre, Département des Arts graphiques, 193 D.R.

27.3 Nicolaes Maes
Old Woman Asleep, ca. 1655

Red chalk, 17.8 × 15.1 cm (7 × 5¹⁵⁄₁₆ in.)
Paris, Frits Lugt Collection, Institut Néerlandais, 588

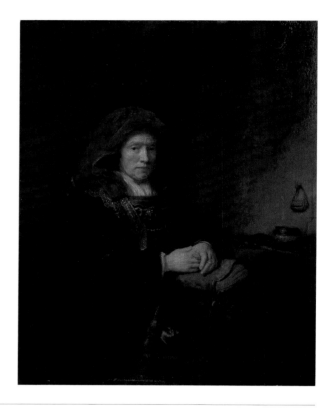

Rembrandt drew large-scale figure studies in red chalk and black chalk and occasionally combined both media in a single drawing. Most of these studies date from the 1620s and 1630s (see cat. nos. 1.1, 2.3, 3.1). *Old Woman with a Large Headdress* (cat. no. 27.1) is one of the few datable after 1640. It relates to a painting of 1643 that was formerly attributed to Rembrandt himself but is now regarded as a product of his workshop (fig. 27a).[1]

Rembrandt summarily indicated the bust, arms, and skirt with long, zigzag strokes and a few vigorous contours. He focused his attention on the face and particularly the elaborate headdress, which he represented with translucent gray tones produced either by stumping (smudging the lines) or by applying powdered chalk with a damp cloth or batting. The light obliterates the contour of the headdress at the top and left, and it causes reflections and highlights simulated by the porous areas of tone and the reserves of white paper. A few contours next to the face and in the recesses of the folds of the headdress are reinforced with dark strokes from a moistened piece of chalk.

Rembrandt also focused on the head and upper body in the red-chalk study *Old Woman Seated* (cat. no. 27.2). The armchair, cloak, headdress, and face, with its pensive expression, are remarkably finished. Rembrandt modeled the side of the cloak that faces the light with fine parallel strokes, exploiting the friability of the soft chalk to impart a reflective translucency to the lines. On the shaded side, he

moistened the chalk and went over the initial sketch with darker strokes on the lower contour of the headdress, the shoulder, and the arms. He also used the moist chalk to strengthen selected contours all around. When he moved the woman's proper right hand and cuff to a lower position, he adjusted the contour along the bottom of the cloak.

Old Woman Seated has been dated as early as the mid-1630s and as late as circa 1654.[2] Comparison with drawings of the middle thirties, such as the red-chalk *Nude Woman with a Snake* (cat. no. 3.1) and a black-chalk study of an elephant dated 1637,[3] underscores the technical and formal differences between those works and the exhibited sheet. Its closest affinities are rather with the few black-chalk figures on this scale from the later 1640s, such as the study of Susanna of circa 1647 in Berlin and a drawing in the Louvre of a man seated in a chair, which belongs to the same period.[4]

Nicolaes Maes's study of an aged woman asleep (cat. no. 27.3) is one of several red-chalk drawings of half-length female figures that date from the middle of the 1650s.[5] A few relate directly to the production of paintings that depict women doing household chores, praying, or dozing off over their reading. The handling of *Old Woman Asleep* closely resembles that of the study of a lacemaker (fig. 27b), which Maes adapted for a painting dated 1655 (fig. 27c).[6] The sheet is exceptionally well preserved, so the lines remain crisp, and shaded areas retain their original tonal values. Maes made good use of techniques

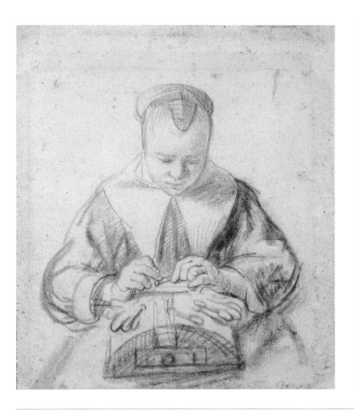

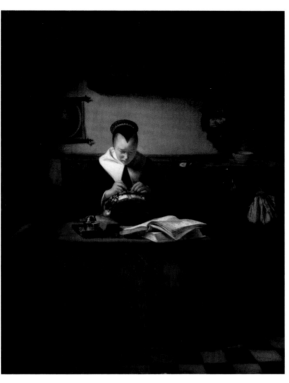

Figure 27a. Rembrandt Workshop
Old Woman with a Book, 1643
Oil on panel, 61 × 49 cm (24 × 19⁵⁄₁₆ in.)
St. Petersburg, The State Museum,
Hermitage, GE 759

Figure 27b. Nicolaes Maes
Lacemaker, 1655
Red chalk, 14.1 × 11.8 cm (5½ × 4⅝ in.)
Rotterdam, Museum Boijmans
Van Beuningen, MB 199

Figure 27c. Nicolaes Maes
A Young Lacemaker, 1655
Oil on panel, 55 × 43.7 cm
(21⅝ × 17³⁄₁₆ in.)
Ottawa, National Gallery of Canada, 6189

he learned from Rembrandt: the sleeve and headdress at the right are delicately stumped, the darker contours and recesses of the clothing are drawn with forceful strokes from a moistened chalk, and the fine parallel shading lines imitate those in drawings such as *Old Woman Seated*. Maes skillfully recorded the woman's facial expression and the details of her costume, as well as the consistent fall of light over the surfaces of the figure.

That said, Maes's figure is recessive and constrained by its mimetic purpose. Because of Rembrandt's pictorial technique, his women appear more ample, substantive, and fluid. He uses a range of different strokes, integrates finished passages with lightly worked areas, and strategically distributes darker accents. Rembrandt's contours do not merely enclose the figures. Loose and mobile, they occasionally stray outside the form, implying the dynamic interaction of the figure and the surrounding space. —**WWR**

1 Bredius 1971, no. 361.
2 Paris 2006–07, no. 15.
3 Benesch 457.
4 Benesch 590 and 769. On the Berlin
 drawing, see also Bevers 2006, no. 27.
 On the Louvre sheet, see Paris
 2006–07, no. 37.
5 Sumowski, *Drawings,* 1776–78,
 1808ˣ–11ˣ, 1817ˣ–18ˣ.
6 Sumowski, *Drawings,* 1776, and
 Sumowski, *Paintings,* 1342.

28.1

Rembrandt

Joseph Sold into Slavery by His Brothers

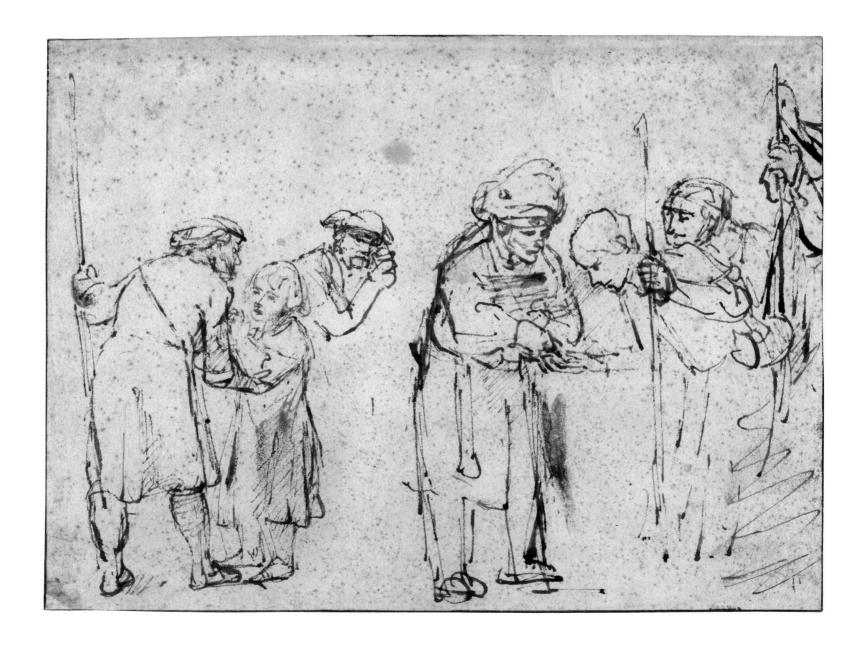

Nicolaes Maes

Sheet of Studies of Eavesdroppers

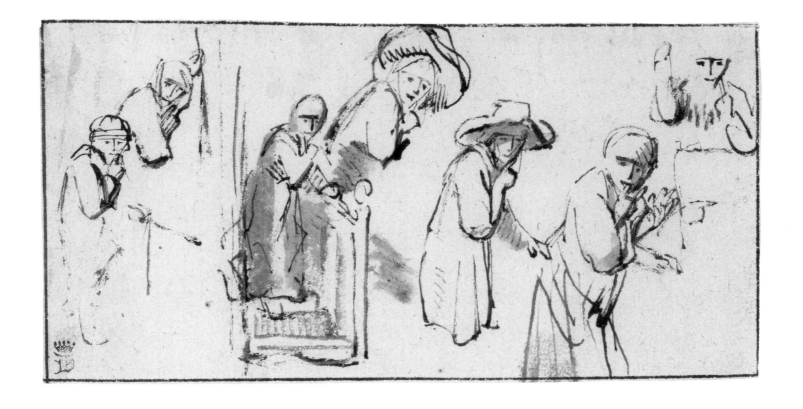

28.1 Rembrandt
Joseph Sold into Slavery by His Brothers, ca. 1652

Pen and brown ink, smudged in places, with white gouache corrections,
15.6 × 20.5 cm (6⅛ × 8¹/₁₆ in.)
Berlin, Staatliche Museen, Kupferstichkabinett, KdZ 1119

28.2 Nicolaes Maes
Sheet of Studies of Eavesdroppers, ca. 1655

Pen and brown ink, brush and brown wash, 9.8 × 19 cm (3⅞ × 7½ in.)
Rotterdam, Museum Boijmans Van Beuningen, Koenigs Collection, R. 63

Joseph's brothers were envious that their father, Jacob, favored their young sibling and were affronted by the boy's prediction that he would one day reign over them. While tending their flocks far from home, they sold him as a slave to a passing group of merchants, who took him to Egypt.[1]

Reflecting on Rembrandt's ability to portray the gamut of human feelings by scratching a few lines into a tiny area of paper, Arnold Houbraken remarked that, in his drawings of narrative subjects, meaning and technique are essentially equivalent. Rembrandt drew hundreds of sketches, wrote Houbraken, in which the faces express emotion so naturally that "one can read from the pen strokes what each one wants to say."[2]

In *Joseph Sold into Slavery by His Brothers* (cat. no. 28.1), the spare lines are so skillfully adapted to their expressive purpose that the marks do seem inseparable from the emotion and body language they represent. The brother who receives the money leans eagerly over his outstretched hand and watches greedily as the merchant counts out twenty pieces of silver.[3] Rembrandt sketched the lower part of this figure with skittish, vibrant contours that suggest motion and underscore the tension in his awkward stance. The curved outline that follows his backside merges with a kinetic zigzag stroke, reinforcing the impetuous inclination of his upper body. Rembrandt drew his head in stark profile and with a predatory expression described by the single firm contour of his sharply pointed nose and chin and the dot of ink that simulates his beady eye.

In studied contrast to the loose contours and curves he used to draw the greedy youth, Rembrandt depicted the stolid merchant with straight, continuous strokes, reinforced in places with heavier, darker outlines. He added bulk to the figure with delicate shading below his waist, denser horizontal strokes across the chest that evoke frogging on his coat, and a large turban. The line of his mouth turns down at the corner, and the solid horizontal strokes of his eyes make them dark and grave. He does not look at the hand into which he deposits the silver, but at the young man's face, as if appalled by his callousness and cupidity. Rembrandt delicately touched the merchant's face with white gouache to soften his expression.[4]

Rembrandt depicted the seventeen-year-old Joseph as a vulnerable, pudgy child with a round, open face and small mouth. He drew the boy's eyes with a lightly charged pen, exposing some of the underlying paper. The highlight animates the poignant upward glance that registers Joseph's desperate appeal for compassion. Unyielding, his brother grasps the boy's elbow to coax him into the custody of his new masters. Rembrandt strengthened the contour of the brother's shoulder and redrew the arm with the elbow lower, thus enhancing the pressure of his grip. Both figures are drawn with spare, straight contours, but the folds of Joseph's coat are carefully outlined and

Figure 28a. Nicolaes Maes
Lovers, with an Old Man Listening, ca. 1655
Oil on panel, 72.5 × 52.1 cm
(28½ × 20½ in.)
Boston, Museum of Fine Arts, Museum
purchase with funds donated by contribu-
tion, 89.504

modeled with delicate parallel hatchings. Rembrandt smudged those modeling strokes with his finger or a dry brush to simulate the shadow cast by the brother.

Joseph Sold into Slavery by His Brothers, which dates from the early 1650s, exemplifies the technique of pen drawing that Nicolaes Maes learned to emulate.[5] Like Rembrandt's other pupils, Maes assimilated the basic principles of the master's draftsmanship, but not the nuance and inventiveness of his handling. On the sheet of studies exhibited here, Maes sketched variant poses and gestures of men and women eavesdropping (cat. no. 28.2). He developed the figure at the upper right of the sheet in a painting dated 1655 and the two at the far left in a picture datable to the same year (fig. 28a).[6]

Here, as in many of his drawings, Maes abbreviated the nose and forehead with two solid lines in the shape of a "T." This was a venerable draftsman's convention, but Maes adapted it from works by Rembrandt of the early 1650s, such as *Homer Reciting* (fig. 24b) and *Joseph Sold into Slavery by His Brothers.*[7] In the latter drawing, the "T" provided structure to the head second from the right, but Rembrandt animated the features with varied penwork. The eyes and mouths in Maes's sketch consist of simple dots and dashes, which lack the delicate inflections that contribute to the expression of emotion in Rembrandt's work.

In Maes's study sheet (cat. no. 28.2), the simple, straight contours of the man third from the right and the livelier, broken outlines of the woman on the stair emulate the diverse linear vocabulary of Rembrandt's drawing. Like Rembrandt, Maes accentuated crucial contours, such as elbows and shoulders, and he used light parallel hatchings, some of them smudged, for modeling and shading. Yet Maes's lines lack both the boldness and the delicacy of Rembrandt's, with their judicious dark accents, gentle swelling and tapering, subtle curves, and skips and starts that evoke volume, movement, and the effects of light. —**WWR**

1 Genesis 37:17–28.

2 "Anger, hatred, sorrow, joy, and so on, everything represented so naturally that one can read from the pen strokes what each one wants to say" (Toren, haat, droefheid, blydschap, en zoo voort, alles staat zoo natuurlyk afgebeelt dat men uit de prentrekken lezen kan wat elk zeggen wil). Houbraken 1718–21, vol. 1, p. 270.

3 He is presumably Judah, who persuaded the others not to kill Joseph but to sell him, so they could rid themselves of their despised sibling and profit from the transaction.

4 Bevers 2006, p. 161.

5 See Bevers 2006, p. 161, for the dating of Rembrandt's drawing.

6 Sumowski, *Paintings,* 1355. The woman at the upper right of the study sheet was adapted for the painting *A Young Woman with Two Men in a Cellar, with a Young Woman Listening,* which is signed and dated 1655. Sumowski, *Paintings,* 1349.

7 *Homer Reciting* (Benesch 913) is signed and dated 1652. See cat. no. 24, note 5, in this catalogue. Rembrandt also used this abbreviation in *Raguel Welcomes Tobias* (Benesch 871).

29.1

Rembrandt

*Landscape with the House
with the Little Tower*

Nicolaes Maes

View of Dordrecht

29.1 Rembrandt
Landscape with the House with the Little Tower,
ca. 1651

Pen and brown ink, brush and brown wash, 9.7 × 21.5 cm (3¹³/₁₆ × 8⁷/₁₆ in.)
Los Angeles, The J. Paul Getty Museum, 83.GA.363

29.2 Nicolaes Maes
View of Dordrecht, ca. 1653

Pen and brown ink, brush and brown wash, touches of white gouache heightening,
12.3 × 25.7 cm (4¹³/₁₆ × 10⅛ in.)
Cambridge, Harvard Art Museum/Fogg Museum,
Bequest of Frances L. Hofer, 1979.210

The country property with the House with the Little Tower (*Het Torentje*) lay to the south of Amsterdam near the Schinkel canal and just off the road to the village of Amstelveen. Rembrandt drew the manor (cat. no. 29.1) from the opposite bank of the Schinkel looking from west to east. The house and its surroundings, seen from a different perspective, appear in an etching datable circa 1651,[1] about the time he executed the drawing.

The large reserve in the immediate foreground represents the Schinkel canal. To the left, the opposite bank is indicated by delicate horizontal lines between short vertical strokes that simulate reeds or grasses and their reflections in the water. A long diagonal and a succession of short vertical lines follow a ditch that leads toward the farmhouse at the far left. On the opposite bank, an open field stretches toward the line of trees that borders the Amstelveen Road, which Rembrandt traced with dots and light horizontal strokes that traverse the sheet.

Rembrandt's drawing exemplifies his seemingly magical ability to transform blank paper into active pictorial space by framing the reserved areas with a few strategically placed strokes of his pen. The only articulation of the stretch of water and meadow is the solid horizontal stroke to the left of center and the broken, smudged, subtly curved lines to the right, which delimit the bank of the canal and the border of the field. The prospect unfolds in horizontal bands that extend across the entire vista. The pronounced oblong format and the representation of space recall the more complex panorama depicted in the etching *Landscape with a View toward Haarlem ("The Goldweigher's Field")* (fig. 29a).[2] The print dates from 1651, close to the date of the drawing.

Rembrandt depicted the trees and the house with minute dots, arcs, and vertical and diagonal lines, varying the number and length of his strokes according to the strength of the reflected sunlight. He brushed the crowns of the trees with a thin film of pale brown wash, interspersed with reserves that simulate the brightest reflections. Around the manor, the lines are denser and darker and the wash more consistent, particularly in the heavily shadowed foliage that obscures part of the house. The tower and the walls to the left shimmer vibrantly, due to their delicate, broken contours and the careful application, with a half-charged brush, of a pale wash around small reserves.

No landscape paintings by Nicolaes Maes have been identified, although one was documented in 1663 in a house in Delft,[3] and only a few landscape drawings have survived. Sumowski established the attribution of *View of Dordrecht* (cat. no. 29.2), and a related study of that city's *Vriese Poort* (Friesian Gate) (fig. 29b),[4] by comparing the latter to a landscape sketch, clearly by the same hand, on the recto of an autograph drawing by Maes (fig. 29c).[5] Maes's landscape drawings must postdate his return to Dordrecht in 1653.

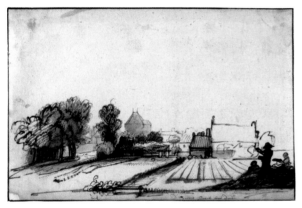

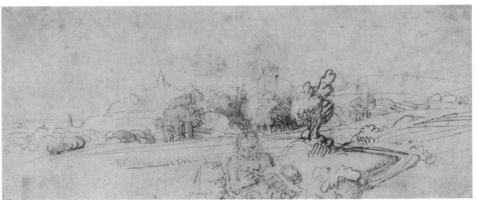

Figure 29a. Rembrandt
Landscape with a View toward Haarlem ("The Goldweigher's Field"), 1651
Etching and drypoint, 12 × 31.7 cm
(4¾ × 12½ in.)
Amsterdam, Rijksmuseum,
Rijksprentenkabinet, RP-P-1962-91

Figure 29b. Nicolaes Maes
Landscape with the Vriese Poort (Friesian Gate), *Dordrecht*, ca. 1653
Pen and brown ink, brush and brown wash,
18.7 × 26.5 cm (7⅜ × 10⁷⁄₁₆ in.)
Amsterdam, Stichting P. and N. De Boer

Figure 29c. Nicolaes Maes
Landscape with (Partial) Figures in Foreground, ca. 1653
Pen and brown ink, 7.5 × 18.5 cm
(2¹⁵⁄₁₆ × 7⁵⁄₁₆ in.)
Lille, Palais des Beaux-Arts, Pluchart 1030 recto

In his view of Dordrecht, Maes left extensive reserves in the field that occupies the deep foreground. The long horizontal lines, some accentuated by the kind of sawtooth stroke that appears in the left center of the Getty sheet, clearly emulate the articulation of the landscape in Rembrandt's drawing and etching (fig. 29a). Maes's strokes are comparatively coarse, and they lack the breaks, arcs, and subtle gradations that, in Rembrandt's work, not only delimit the space but animate it by mimicking visual phenomena such as the fleeting reflection of light.

Maes rendered the crowns of the trees schematically with round or sawtooth contours. He modeled the foliage, the low wall, and the roofs of nearby buildings with nearly identical, parallel pen lines and a homogenous layer of wash, which barely acknowledge the gradations of shadow and light. The tones of the wash range only from the darker brown in the mills and the line of trees and buildings bordering the far side of the field to a lighter brown across the distant city skyline.

While Maes resorted to the expedients of a limited battery of pen lines and uniform application of wash, Rembrandt labored hard to achieve naturalistic effects of light, space, and atmosphere, for example, by painstakingly differentiating the pen strokes and tones of wash in the trees. Instead of relying on a fixed vocabulary of lines and brushwork, Rembrandt devised, on the spot, convincing graphic equivalents for the natural phenomena he saw before him, such as the

short, delicately inflected vertical strokes—none of them exactly identical—that plausibly represent the reeds or stubbly grasses on the bank of the canal and across the field at the left. —**WWR**

1 Discussed in Goldner 1988, no. 119;
 Amsterdam and Paris 1998–99,
 pp. 314–19.

2 B. 234.

3 Robinson 1996, p. 286.

4 Sumowski, *Drawings*, 1900ˣ.

5 See Sumowski, *Drawings*, 1763 recto.
 In addition to the exhibited drawing,
 and those reproduced in figs. 29b
 and 29c, a landscape with a cottage
 beside a canal (Sumowski, *Drawings*,
 1901ˣ, now in New York, Metropolitan
 Museum of Art, 2002.90) is also
 securely attributable to Maes. For
 other landscapes ascribed to Maes,
 albeit with less certainty, see
 Sumowski, *Drawings*, 1899ˣ and 1899aˣ,
 Amsterdam, Vienna, New York, and
 Cambridge 1991–92, no. 60, and
 an unpublished view of Nijmegen in
 a Dutch private collection.

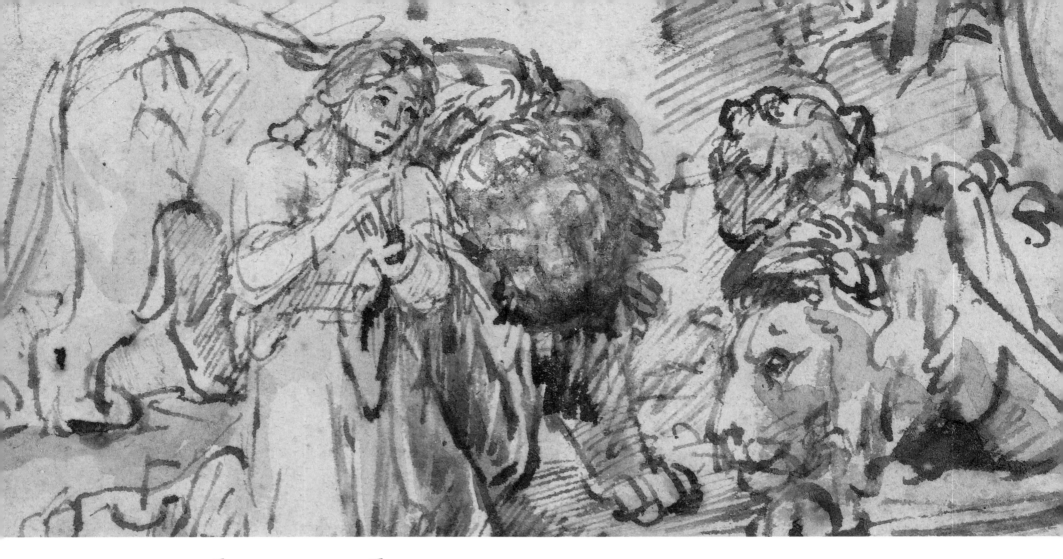

Rembrandt

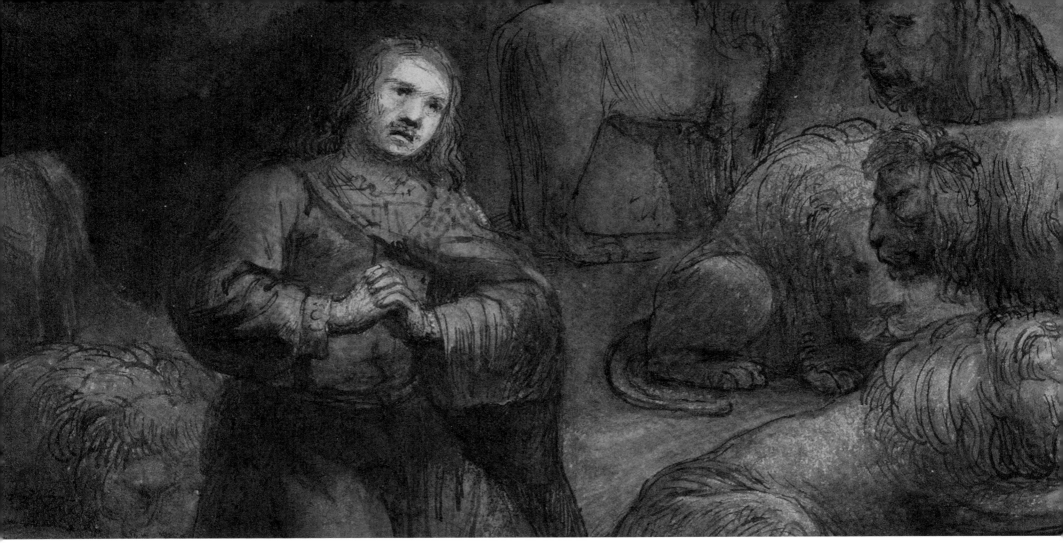

Constantijn Daniel van Renesse

Maarssen, 1626–Eindhoven, 1680

Constantijn Daniel van Renesse was born into a family of scholars.[1] He began studying languages at the University of Leiden in 1639, then in 1642 switched to mathematics. From 1653 until his death in 1680 he held the post of town clerk in Eindhoven. He was not a professional artist, but like other cultivated men in Holland at that time he produced drawings as an amateur. From 1649 at the latest until around 1652/53, perhaps even later, he took occasional drawing lessons from Rembrandt. This was at the same time that Willem Drost (cat. nos. 33–35) and Nicolaes Maes (cat. nos. 26–29) were active in Rembrandt's workshop. His surviving works are mainly drawings but also include a few paintings and engravings. The earliest drawings date from 1640

and 1642, the period of his studies in Leiden.[2] These early sheets show the influence of the genre painter Pieter Quast rather than Rembrandt. Most of his surviving drawings date from the early 1650s and 1660s. They are primarily biblical scenes, portraits, and figure studies. A few of Van Renesse's drawings have obvious corrections, some of them made by Rembrandt. Others could have been made by Van Renesse himself or by Samuel van Hoogstraten (see Holm Bevers's essay in this catalogue).

1 Vermeeren 1978–79.
2 Sumowski, *Drawings*, p. 4955, and Sumowski, *Drawings*, 2143.

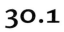

30.1

Rembrandt

Daniel in the Lions' Den

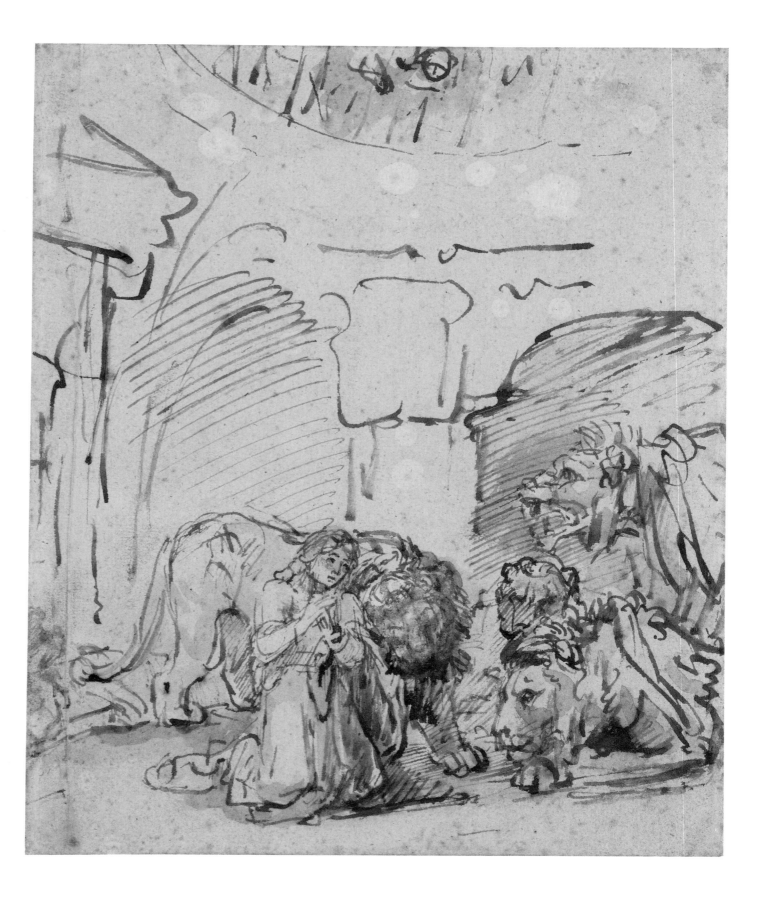

Constantijn Daniel van Renesse

Daniel in the Lions' Den

30.1 Rembrandt
Daniel in the Lions' Den, ca. 1649

Pen and brown ink, brush and brown wash, with some lead white heightening
(partly oxidized), 22.2 × 18.5 cm (8¾ × 7⁵/₁₆ in.)
Amsterdam, Rijksmuseum, Rijksprentenkabinet,
Gift of Mr. Cornelius Hofstede de Groot, 1906, RP-T-1930-17

30.2 Constantijn Daniel van Renesse
Daniel in the Lions' Den, 1649–52

Black chalk, pen and brown ink, brush and brown wash, heightened with white,
20.6 × 32 cm (8⅛ × 12⅝ in.)
Rotterdam, Museum Boijmans Van Beuningen, MB 200 recto

Rembrandt's and Van Renesse's drawings depict an event from the life of Daniel. The Old Testament (Daniel 6:1–29) recounts how the young Daniel, a displaced Jew, rose to a position of honor at the Babylonian court of Nebuchadnezzar and his successor, Darius. His rivals sought to destroy him and convinced Darius to decree that anyone found praying to any god or personage except himself during the next thirty days would be thrown to the lions. Daniel was thereby apprehended and, against the will of the king, condemned to die. God, however, intervened, causing the lions to spare him.

Rembrandt's drawing depicts a kneeling Daniel among the lions in a pit surrounded by round arches. At the upper edge of the sheet appears the head of the king, looking down to see whether his protégé is still alive. An early copy of the composition in Braunschweig[1] includes a second head next to that of the king and another recumbent lion on the left edge. These have evidently been cut off in the Amsterdam sheet, except for the hind legs of the recumbent lion, which are still visible.

Van Renesse's drawing, executed in horizontal format, also shows Daniel, his hands clasped in prayer, kneeling amid recumbent and standing lions. There are only a few depictions by Rembrandt and his circle from the third section of the Old Testament, the books of the prophets, which include that of Daniel. One can therefore assume that when undertaking his drawing, Van Renesse used Rembrandt's drawing as a model. The figure of Daniel suggests as much, as his pose is quite similar to that in Rembrandt's version. It is also possible that Rembrandt's pupil knew the engraving by Johann Sadeler and an engraving after Rubens by Willem de Leeuw,[2] for in them, as in his own drawing, there are bones and human skulls, evidence that the lions' den was a place of execution. As inspired by the engraving after Rubens, the setting is a dark cavern, not the arcaded space depicted by Rembrandt.

Comparing the drawings by Rembrandt and Van Renesse, one encounters not only distinct stylistic differences but also divergent interpretations of the story. Rembrandt presents the story dramatically—the lions to the right stare at the terrified Daniel, and one roars at him. This is also apparently the very moment in which tragedy is averted. One of the beasts already rubs his head against Daniel's shoulder like a tame house cat, and the appearance of the head of King Darius hints at Daniel's rescue. In Van Renesse's version, all the lions have already been tamed, omitting the sense of the menace that gives the story its drama. Moreover, his beasts seem stiff and unnatural, whereas Rembrandt's are rendered realistically, in both their poses and their behavior. It would seem that Van Renesse had never seen a lion and took as his model the relatively awkward-looking animals in the engraving by Johann Sadeler. Rembrandt, however, had firsthand

Figure 30a. Constantijn Daniel van Renesse
Inscription in pen and brown ink on the verso of cat. no. 30.2.

experience of the beasts, evidenced by his vivid studies of North African Berber lions imported into Holland.[3]

Rembrandt drew with a reed pen, with strokes of varying thickness. The figures of Daniel and the lions are loosely outlined with minimal numbers of lines. Areas of shadow are effectively indicated by transparent washes and occasional spots of diagonal hatching of varying thickness and density.[4] The head of the lion next to Daniel's shoulder was apparently too heavy and dark at first, so Rembrandt lightened it with lead white. There is also a tiny amount of lead white beneath the young man's eyes, which must have struck the artist as too large; with the application of the lead white, he made them narrower in order to emphasize Daniel's upward gaze. All of this stands in sharp contrast to the typically finicky drawing of Van Renesse. After first sketching the composition in black chalk, Van Renesse worked up his drawing in a painterly manner and in great detail, employing a brush and brown ink and a fine, scratchy pen. In style and technique his work has little in common with Rembrandt's drawing style. However, there are drawings by Rembrandt's pupil Samuel van Hoogstraten that are executed in a similarly thorough manner, and Van Renesse could have been familiar with them (see cat. nos. 22.2 and 23.2, figs. 22a, 23b).

Many of Van Renesse's drawings are signed and dated, including the present sheet, which bears the artist's signature on the recto and the date 1652. The inscription on the back is particularly informative: "The first drawing shown to Rembrandt, in 1649 the 1st of October, it was the second time that I had been to Rembrandt." The two inscriptions differ somewhat in their penmanship, but both are in his hand. They can be interpreted to mean that on October 1, 1649, Van Renesse showed his work to his drawing teacher for his evaluation, then finally finished it in 1652.[5] It may have been at that time that he added the pen strokes in dark brown ink, accentuating the figure of Daniel, the manes and feet of the lions, the skulls and bones, and the terrain of the foreground, as these were laid on top of the washes and a first sketch in a lighter ink. The inscription also indicates that Van Renesse and Rembrandt were in contact before October 1, 1649, the date of the pupil's second visit to the master. A similar verso inscription appears on another drawing by Van Renesse: "second composition for Rembrandt 1649."[6] Van Renesse's obvious borrowings from Rembrandt's Daniel composition indicate that the latter also dates from around 1649. —**HB**

1 Braunschweig 2006, no. 41.
2 Hollstein 125 and 3.
3 Benesch 1211, 1214–16. See Schatborn in Berlin, Amsterdam, and London 1991–92, p. 96, no. 26.
4 The somewhat unruly lines are comparable to those in the drawing *Saint Jerome in an Italian Landscape* in the Kunsthalle, Hamburg (Benesch 886; Bremen 2000–01, no. 67); the lion in that drawing also conforms quite precisely to the animals in the Daniel drawing. For the dating, see Schatborn (Schatborn 1986, pp. 22ff.), who proposed an earlier date.
5 For the meaning of the inscription and the dating, see Sumowski, *Drawings*, 2145, and Giltaij 1988, no. 130.
6 *The Judgment of Solomon;* "tweede ordinatie bij RemBrant [*sic*]." Sumowski, *Drawings*, 2151.

Rembrandt

The Return from Egypt

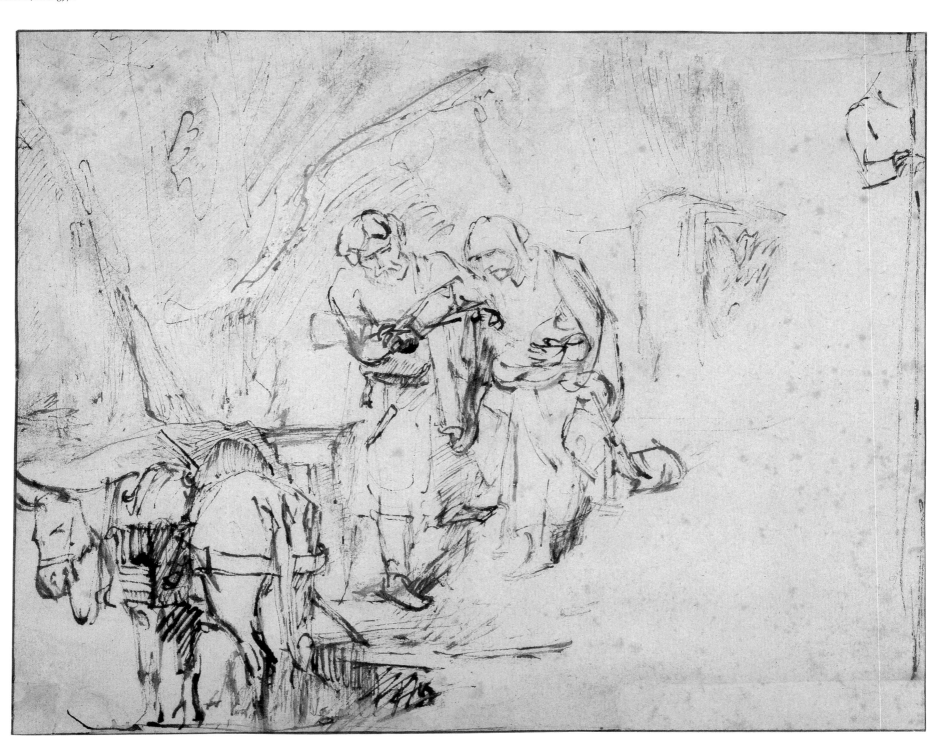

Constantijn Daniel van Renesse

The Return from Egypt

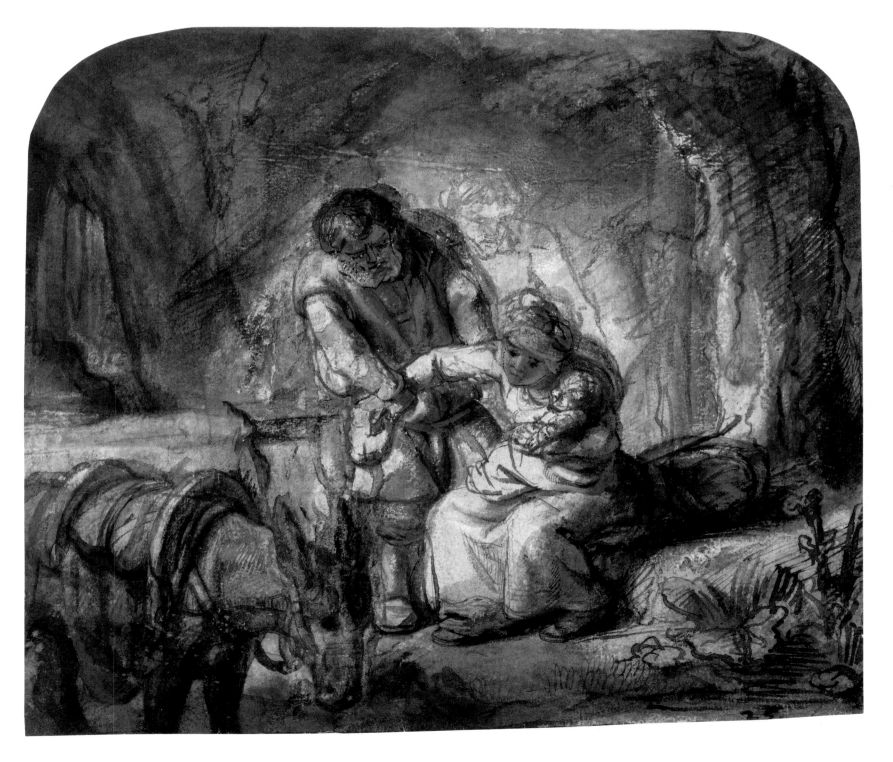

31.1 Rembrandt
The Return from Egypt, ca. 1652

Pen and brown ink, slightly washed, corrections in white gouache,
19.3 × 24.1 cm (7⅝ × 9½ in.)
Berlin, Staatliche Museen, Kupferstichkabinett, KdZ 5262

31.2 Constantijn Daniel van Renesse
The Return from Egypt, ca. 1652

Black chalk, pen and brown and gray ink, brush and gray wash, red chalk,
with white heightening, 19.5 × 22.3 cm (7¹¹⁄₁₆ × 8¾ in.)
Dresden, Staatliche Kunstsammlungen, Kupferstich-Kabinett, C 1443 recto

Rembrandt depicted the flight of the Holy Family into Egypt and their rest on the journey a number of times, especially in prints. By contrast, the present Rembrandt drawing shows the couple at the end of their stay in Egypt as they set out on their return to Israel.[1] Depictions of this moment in the biblical story are quite rare, and Rembrandt's choice of it attests to his interest in representing passing events of little historical importance but of great human interest. The artist has closely followed the biblical text, which reads: "Arise, and take the child and his mother, and go into the land of Israel. For they are dead that sought the life of the child. "And he [Joseph] arose, and took the child and his mother, and came into the land of Israel" (Matthew 2:20–21). Rembrandt depicts only the essential figures and motifs: Mary with her baby, summarily suggested, under her left arm; Joseph, who tenderly helps her down a slight incline; the ass that will carry her; a small stream spanned by a plank; and a cliff and shrubbery in the background.

There are numerous corrections in the figures and in the background. The lead white used for these later oxidized and assumed an unsightly gray-black tinge. The most important corrections occur on the figures' right arms. Joseph's arm was first bent at a sharper angle, and its subsequent placement closer to his body necessitated a change in the couple's clasped hands. A sketch for the altered version of Joseph's shoulder and arm and for the two hands appears in the upper right corner of the sheet. Similarly coarse and somewhat angular lines from a reed pen are found in a group of Rembrandt's biblical scenes from the early 1650s.[2]

Two quite faithful copies, both made by pupils, in the British Museum, London,[3] and another sold on the art market in Paris,[4] document the popularity of the composition in Rembrandt's workshop. Of particular interest, however, is the drawing by Constantijn Daniel van Renesse in the Dresden Kupferstich-Kabinett. It closely relates to Rembrandt's version in its placement of the figures, the inclusion of the ass, and the landscape motifs. Joseph's pose and gestures are almost identical, although one can see that the artist first tried a slightly different pose for him directly above the figure of the Virgin. The outlines of that first version, originally obscured by lead white, have become visible again over the course of time. In contrast to Rembrandt's drawing, the ass here faces forward, and Mary is seated. Joseph has just taken her arm to help her up.

In the present context, the verso inscription from the early 1650s on the Dresden sheet is of particular interest, as it contains a critique of the image with suggestions for corrections. These lines have been attributed to Samuel von Hoogstraten,[5] but this cannot be confirmed.[6] Van Renesse might have written the inscription himself. It reads: "As for changes, it would be better if the ass were seen from behind rather than having all three heads facing out of the picture."

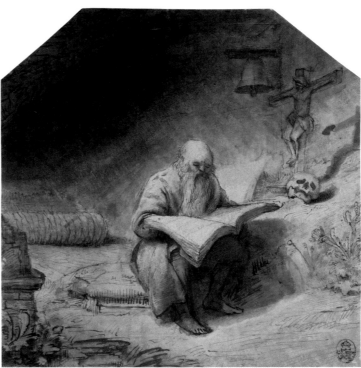

Figure 31a
Inscription in pen and brown ink on the
verso of cat. no. 31.2.

**Figure 31b. Constantijn Daniel
van Renesse**
Reading Hermit, ca. 1652
Pen in brown ink, brush and brown wash,
21.2 × 20.2 cm (8³⁄₈ × 8 in.)
Dresden, Staatliche Kunstsammlungen,
Kupferstich-Kabinett, C 1447

Also more foliage should be pictured around the tree. 1. Joseph is lifting too forcibly and rudely. 2. Mary has to hold the child with greater care, for a tender child does not like being held so tight. Joseph is too short and too thick, his head grows out of his [chest], and both of their heads are too big."[7] In light of these comments, one is led to suspect that the Berlin Rembrandt drawing could be a corrected version. There, the donkey turns into the picture space, as the critique recommends. It no longer draws attention away from the heads of the two main figures, and with its back to the viewer it more clearly suggests an impending journey. Joseph's and Mary's gestures are calmer and more deliberate; Joseph no longer pulls up Mary's arm but gently lifts it from below. Finally, the heads of the two figures are somewhat smaller.

One can assume that Van Renesse produced the Dresden drawing as an exercise in Rembrandt's workshop. It is, however, a matter of debate as to how the two drawings relate to each other. The pupil could have based his version on Rembrandt's corrected composition, though deliberately departing from it in certain details—showing Mary seated, for example, and turning the animal around—thereby producing a variant rather than a slavish copy. Another pupil could then have critiqued this variant on the back of the sheet in comparison to their teacher's version. Yet since Rembrandt occasionally made corrections on his pupils' drawings, one cannot wholly exclude the possibility that

the Berlin sheet was produced as the master's pictorial commentary on the criticism leveled at the work of his pupil.

The Dresden drawing was formerly attributed to either Samuel van Hoogstraten[8] or Barend Fabritius;[9] similarly detailed, painterly brush drawings by both artists survive. Van Renesse could have been attracted to this technique in such drawings by Van Hoogstraten (see cat. nos. 22.2 and 23.2). The small, doll-like figures, the soft forms, and the scraggly, fussy lines are more typical of Constantijn Daniel van Renesse than of Van Hoogstraten.[10] Van Renesse's drawing *Reading Hermit,* also in Dresden (fig. 31b),[11] serves as a good stylistic comparison. Moreover, it has similarly shaped leaves in the foreground. —**HB**

1 Tümpel 1970, no. 60.
2 E.g., Benesch 904–6.
3 Hind 1915, no. 131.
4 Auction, Paris, Hôtel Drouot (Ader Picard Tajan), November 27, 1990, no. 66.
5 Although Brusati discerned Rembrandt's handwriting in portions of it, this identification must be rejected entirely. Rembrandt's writing is altogether different. Brusati 1995, pp. 31, 275, note 40; Dresden 2004, no. 14.
6 I am grateful to Michiel Roscam Abbing for confirming this (letter dated December 1, 2008).
7 See Broos 1981–82, p. 258; Dresden 2004, no. 14; Bevers 2006, no. 45. Minor corrections to the traditional reading are provided in Schwartz 2006, p. 126, and Roscam Abbing 2006, pp. 31–32, no. NRD 17.
8 Brusati 1995, p. 31.
9 Dresden 2004, no. 14.
10 Bevers 2005, p. 480.
11 Sumowski, *Drawings,* 2167aˣ. Also related in the formation of the figures and heads are the drawings Sumowski, *Drawings,* 2162ˣ and 2167ˣ.

VAN RENESSE

191

32.1

Rembrandt

Road with Trees and a Bridge
Leading to a House

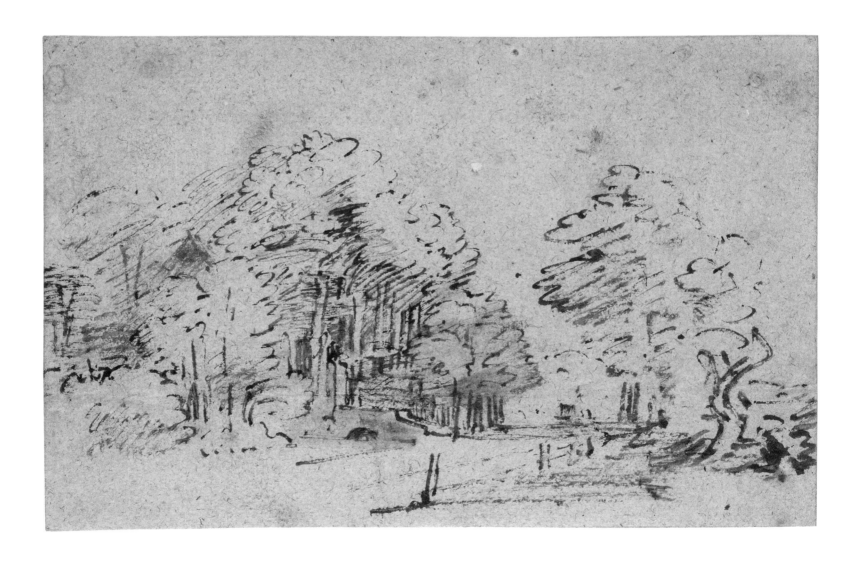

Constantijn Daniel van Renesse

Cottages beneath High Trees
in Bright Sunlight

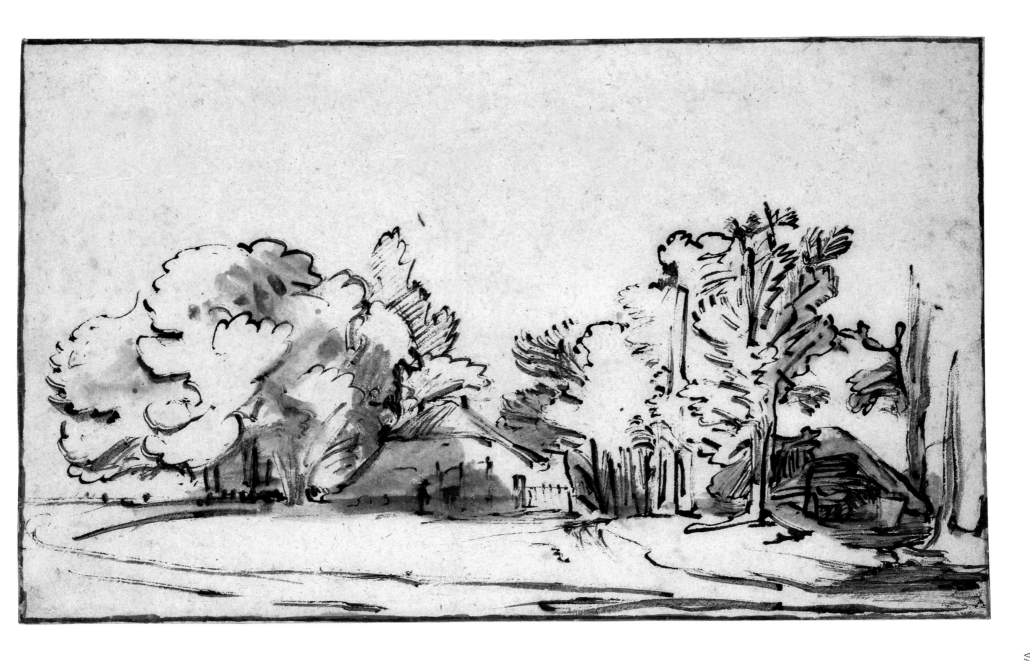

32.1 Rembrandt

Road with Trees and a Bridge Leading to a House,
ca. 1660

Pen and brown ink, brush and gray-brown wash on light brown cartridge paper,
13.5 × 20.4 cm (5⁵⁄₁₆ × 8¹⁄₁₆ in.)
Amsterdam, Rijksmuseum, Rijksprentenkabinet,
Gift of Mr. and Mrs. De Bruijn-Van der Leeuw, 1949, RP-T-1961-85

32.2 Constantijn Daniel van Renesse

Cottages beneath High Trees in Bright Sunlight,
ca. 1660

Pen and brown ink, brush and brown wash, 19.6 × 31.1 cm (7¾ × 12¼ in.)
Berlin, Staatliche Museen, Kupferstichkabinett, KdZ 2694 recto

There is only one known landscape drawing by Constantijn Daniel van Renesse exhibiting the characteristic drawing style, with painterly brush washes and finnicky pen strokes,[1] that one frequently encounters in his biblical illustrations (cat. nos. 30.2, 31.2). The sheet discussed here, *Cottages beneath High Trees in Bright Sunlight,* differs considerably from this style and is executed with a reed pen in broad, sketchy strokes of the pen that are reminiscent of Rembrandt. Together with the stylistically identical *Amstel Landscape with Bathers,* also in the Berlin Kupferstichkabinett (fig. 32a),[2] this drawing was formerly held to be a masterwork by Rembrandt from the late 1650s. Upon closer consideration, however, both drawings are actually dissimilar to anything in Rembrandt's drawn oeuvre, and their formal weaknesses are inescapable. A few years ago both sheets were attributed to the Rembrandt pupil Van Renesse.[3] The touchstone for this new attribution was the Warsaw drawing *Elisha and the Youths of Bethel* (fig. 32b),[4] which served as the model for a signed engraving by the artist dated 1653.[5] That drawing exhibits a sketchy style quite similar to that of the Berlin sheets, and one that clearly differs from Van Renesse's usual labored approach.

It is particularly instructive to compare the Warsaw drawing to the *Amstel Landscape with Bathers.* The pen strokes in both works are broad and somewhat uniform, and the movements of the doll-like figures are typically angular and awkward. In both cases the contours are indicated with schematic lines, the faces lightly shaded with extremely fine, angled parallel hatching. The related Berlin landscape *Cottages beneath High Trees in Bright Sunlight* presents many of the same features. The tops of the trees are formed like those in the Warsaw sheet, and in both cases the artist employed a broad reed pen, the tip of which splayed in a number of spots under the pressure of his hand. Also identical are the broad strokes in the foreground. On the right half of the verso of the Berlin landscape, and turned at a ninety-degree angle, are three barely visible heads rendered in black chalk (fig. 32c). They have nothing to do with Rembrandt, but compare quite well to a signed portrait study by Van Renesse from 1669.[6] The different drawing styles of pupil and teacher are obvious if one compares the Berlin sheet to Rembrandt's similar drawing of a related motif, also made with a reed pen, the *Road with Trees and a Bridge Leading to a House* in Amsterdam's Rijksprentenkabinet.

With the simplest of means, largely through alternating broad and thin strokes, continuous and interrupted lines, Rembrandt produced a wide range of shimmering tones that convincingly evoke bright sunlight on the road and on the tops of the trees that are suggested with open loops. The atmospheric effect is further enhanced by the light brown tone of the "cartridge paper." Deep shadows in the underbrush between the lighter trunks of the trees and on the underside of their crowns of foliage are rendered in broad independent

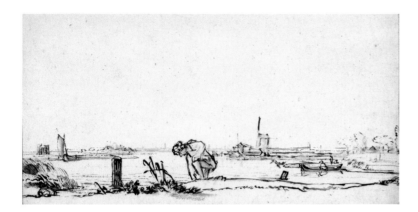

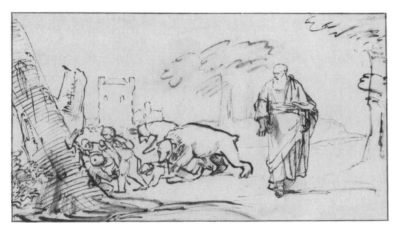

strokes and diagonal hatching that has been partially smudged. The hatching also lends the forms three-dimensionality. Using a brush, Rembrandt lightly washed the shaded side of the bridge leading across the ditch on the left. Additional delicate washes, which have been smudged on the right, appear in the crowns of the shorter trees beside the road, which stand in the shade of the taller ones. Depth is also created by the tree stump and shrubbery on the right, added later with broad, dark lines and effectively set off against the light, interrupted lines of the group of trees behind them. The interrupted line between the two clumps of trees indicates the roof of a house in the distance.

Van Renesse's drawing presents a similar but less subtle use of line. His treetops have outlines of different shapes—round, pointed, and lobed—yet the width of the lines hardly varies. As a result of this and the uniform, spotty washes, his composition seems flat. The washes are schematically placed between the outlines and lack transparency. Their sharp edges create abrupt transitions between shaded and light areas; this is entirely atypical of Rembrandt, who frequently smudged his washes at the edges. In Rembrandt's drawing, depth is effectively suggested by the post in the foreground, the diminution of the posts to the right, and the scratchy lines representing the road. By contrast, the broad strokes on the left in the middle distance and on the right foreground of Van Renesse's drawing, also suggesting a road, appear as flat, formless bands that fail to create actual depth.

The Amsterdam study, which was probably sketched from nature, is one of Rembrandt's latest landscape drawings and is dated to around 1660. The spare, casual lines resemble those of the master's late narrative drawings.[7] The related landscape drawing by Van Renesse was likely produced during this same period, at the beginning of the 1660s, or a few years after the drawing in Warsaw for the engraving of 1653. It would thus appear that even after 1653, when he became town clerk in Eindhoven, Van Renesse was still in contact with Rembrandt and still taking drawing lessons from him. —**HB**

1 Hamburg, Kunsthalle, 22817. Sumowski, *Drawings*, 2172ˣ; Bremen 2000–01, no. 86.
2 Benesch 1352; Bevers 2006, pp. 202–3.
3 Royalton-Kisch 2000.
4 Sumowski, *Drawings*, 2149.
5 Hollstein 2. The fact that Van Renesse identifies himself as not only the engraver but also the designer (*fe et inventor*) confirms that the model drawing was his own.
6 Geneva, Jean Bonna Collection. Sumowski, *Drawings*, 2155. Royalton-Kisch's attribution of the landscape on the recto at the Rembrandt symposium in Melbourne in 1997, without any knowledge of the verso, which was only discovered in 1998 when the drawing was lifted off its old cardboard backing, was confirmed by these black chalk heads.
7 As a comparison, there is most notably the *Pyrrhus Pardons the Captives and Turns Them Over to Fabritius* in the British Museum, London, 1943,1113.69 (Benesch 1045A; Royalton-Kisch 1992, no. 61; Royalton-Kisch 2008–09, no. 54).

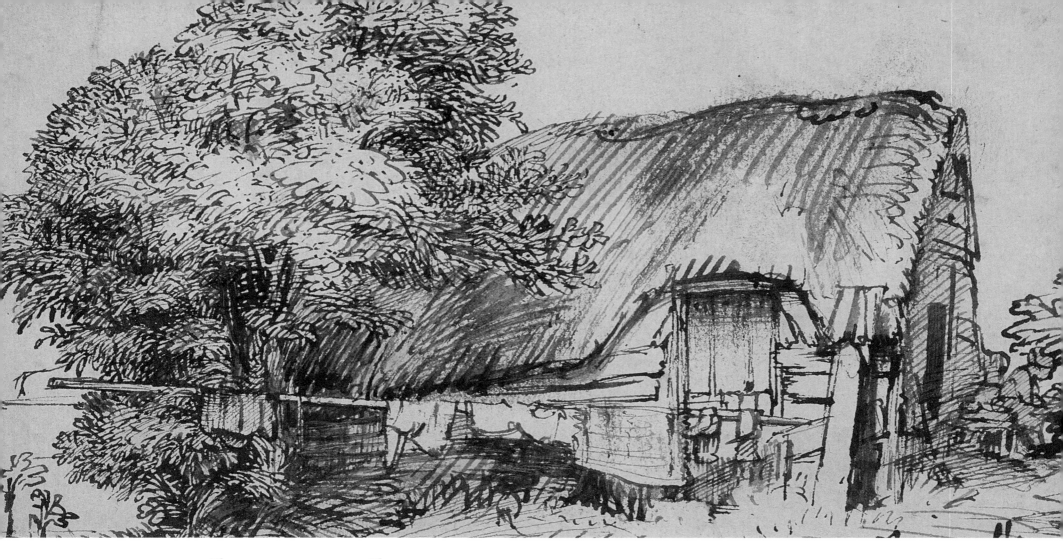

Rembrandt

Willem Drost worked as a painter, engraver, and draftsman.[1] In the mid-1640s he possibly studied under Rembrandt pupil Samuel van Hoogstraten (cat. nos. 22–24); then, toward the end of that decade, he entered Rembrandt's workshop. Although there are no documents to confirm this, Houbraken reports that Drost apprenticed with Rembrandt, and the style of his paintings and drawings would seem to confirm this. His earliest certain work is the *Self-Portrait as a Draftsman* (fig. 34b), engraved in 1652, by which time Drost had become an independent artist. In the mid-1650s he traveled to Italy. He is mentioned there in a document from 1655 that places him in Venice, where he was buried in 1659.

Willem Drost

Amsterdam, 1633–Venice, 1659

Although Drost is considered one of Rembrandt's most talented pupils, his surviving oeuvre is small. What remains are biblical narrative paintings, allegorical half-figures, portraits, and studies of heads. No signed drawings by him are known. The two sheets *Ruth and Naomi* (fig. 33b) and *Noli me Tangere* (fig. 35a) from the early 1650s, can be attributed to him with certainty, however,[2] as they are designs for paintings by him in Oxford and Kassel.[3] From these two, scholars have assembled a number of drawings that are similar in style and are in all probability by him.[4] They are noteworthy for their use of dense, uniform areas of hatching with strong lines. Lugt and Benesch laid the ground work by assembling a group of drawings with these

stylistic features, arguing that they were not by Rembrandt but by an unknown pupil.[5] Valentiner and Pont then attributed the group to Willem Drost.[6]

1 Bikker 2005.
2 Sumowski, *Drawings*, 546, 547[x].
3 Sumowski, *Paintings*, 311 and 315; Bikker 2005, nos. 1 and 5.
4 Sumowski, *Drawings*, 547a[x]–69[xx]; Schatborn 1985B, pp. 100–103.
5 They started with the drawings *Saint Jerome in a Grotto* in the Louvre, Paris (Sumowski, *Drawings*, 550[x]), and *Rest on the Flight into Egypt* in the British Museum, London (Sumowski, *Drawings*, 557[x]). Lugt 1933, under 1286; Benesch under A 94.
6 Valentiner 1925 and 1934, vol. 2, pp. xxxi–xxxiii; Pont 1960, pp. 210–19.

Rembrandt

Manoah's Offering

Willem Drost

*The Angel Departing from
the Family of Tobit*

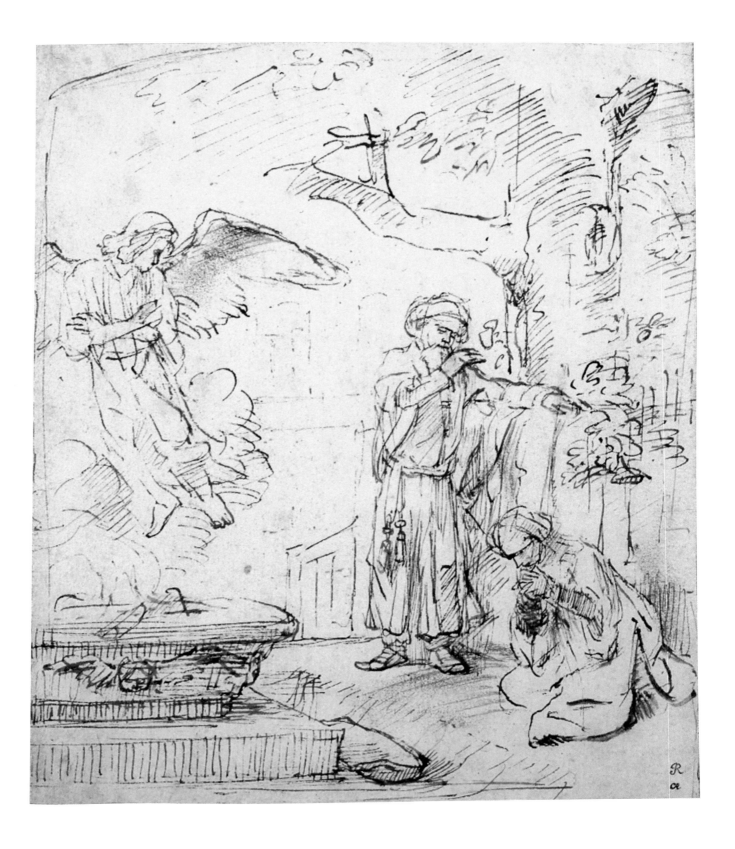

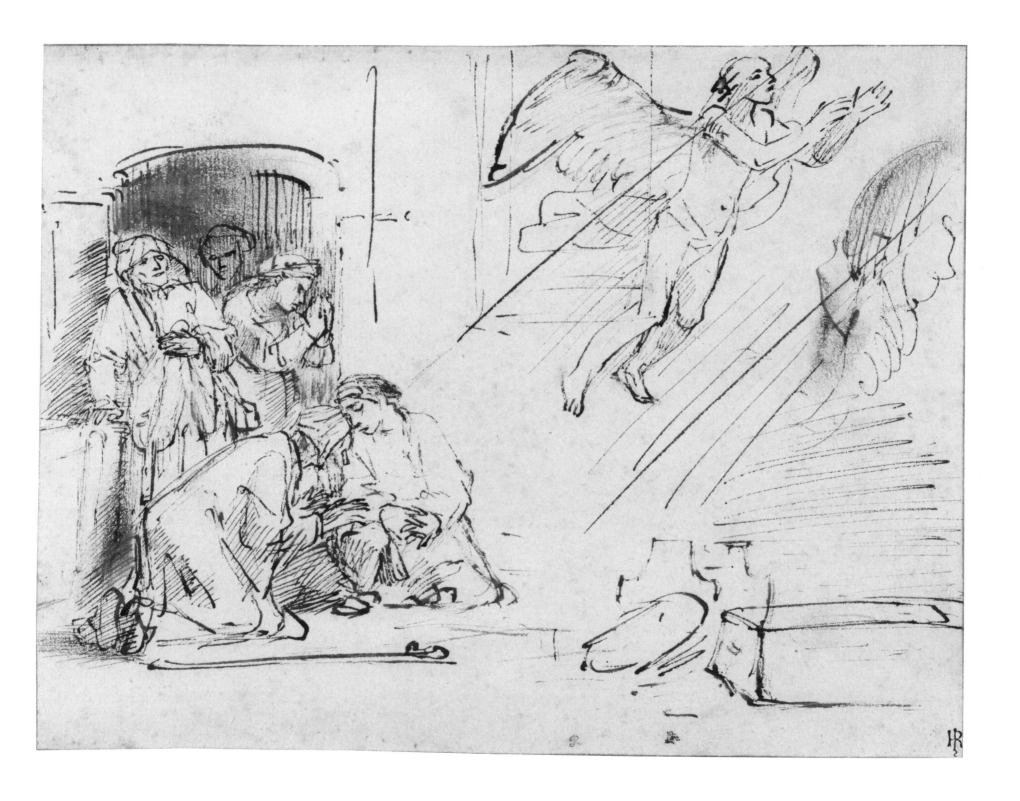

33.1 Rembrandt
Manoah's Offering, ca. 1652

Pen and brown ink, partially rubbed with a finger or a dry brush,
20.8 × 18 cm (8³⁄₁₆ × 7¹⁄₈ in.)
Paris, Frits Lugt Collection, Institut Néerlandais, 5803

33.2 Willem Drost
The Angel Departing from the Family of Tobit,
ca. 1652

Pen and brown ink, partially rubbed with a finger or a dry brush,
19.3 × 24.5 cm (7⁵⁄₈ × 9⁵⁄₈ in.)
New York, The Pierpont Morgan Library, I, 197

Rembrandt and his pupils frequently drew the same biblical subjects, mostly those from the Old Testament. *Manoah's Offering*[1] was one of these exercises. The book of Judges (13:1–20) recounts how an angel appeared to Manoah and his barren wife and announced the birth of a son who would liberate Israel from the hands of the Philistines. When the couple brought him an offering in gratitude, the angel ascended in the altar's flames. Upon seeing this, they fell to the ground, realizing only then that the messenger was sent from God.

In the mid-1630s, Rembrandt made a drawing of this event exhibiting dramatically animated figures (cat. no. 18.1). In the later drawing discussed here, that energetic approach has given way to a more serene composition. The wife has dropped to her knees in an attitude of prayer, and Manoah stands next to a tree, psychologically withdrawn and with his eyes closed. He braces himself against a railing with his left arm and brings his right arm up to his face as if to protect himself from the angelic vision. Here the angel is smaller than in the earlier version and shown from the front.

Rembrandt's drawing, which can be dated for stylistic reasons to around 1652,[2] apparently served as a workshop model, for the composition was freely imitated by various pupils.[3] Its influence even appears in a drawing of a related theme, Willem Drost's *The Angel Departing from the Family of Tobit*. This sheet depicts the moment in which the angel leaves Tobit's house after he has been cured of blindness by his son Tobias, whom the angel had guided home safely (Tobias 12:1–22). The story of Tobias was an especially popular subject in Rembrandt's circle.[4] Drost's composition is essentially based on Rembrandt's etching *The Angel Departing from the Family of Tobit* from 1641 (fig. 33a).[5] The aged Tobit, on the left, and his son on the right are kneeling on the ground. Behind them, in the entrance to the house, stands Tobit's wife, Hannah, together with Tobias's wife, Sarah, and several other figures. Drost's drawing presents the complete figure of the angel, whereas in Rembrandt's etching only his legs are visible. The movement of the figure is quite similar to that of the angel in Rembrandt's Manoah drawing. The other figures in Drost's composition also appear to have been influenced by that drawing. The kneeling Tobias resembles the kneeling wife of Manoah, and the two women behind him recall the figure of Manoah himself. Like Manoah, Hannah braces herself with one arm, and the head, posture, and arm placement of Sarah, standing next to her on the right are very close to those of Manoah. In addition, the figures in both sheets have similar facial expressions.

Rembrandt's drawing was executed with a relatively fine, occasionally scratchy pen. The figures of Manoah and his wife and the offering table are worked out in considerable detail; the tree with its spreading crown is sketchily suggested. The outlines, the drawing

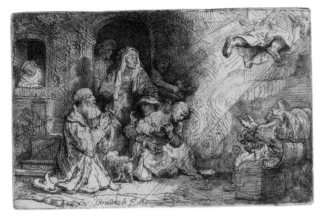

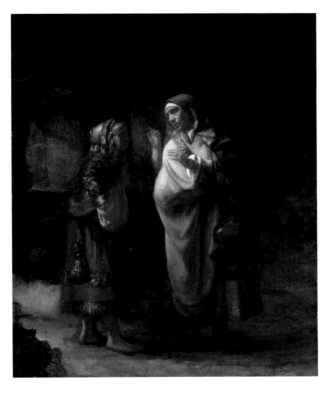

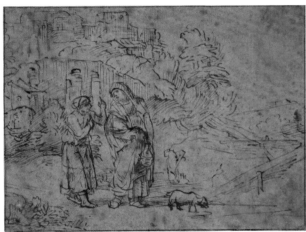

Figure 33a. Rembrandt
The Angel Departing from the Family of Tobit, 1641
Etching, 10.3 × 15.4 cm (4¹/₁₆ × 6¹/₁₆ in.)
Amsterdam, Rijksmuseum,
Rijksprentenkabinet, RP-P-OB-83

Figure 33b. Willem Drost
Ruth and Naomi, ca. 1651–52
Pen and brown ink with some lead white,
18.7 × 23.5 cm (7³/₈ × 9¹/₄ in.)
Bremen, Kunsthalle, 54/437

Figure 33c. Willem Drost
Ruth and Naomi, ca. 1651–52
Oil on canvas, 89 × 71 cm (35 × 27¹⁵/₁₆ in.)
Oxford, The Ashmolean Museum, A 390
(WA 1929.1)

within the outlines, and the numerous areas of hatching are highly varied. The flames from the altar throw light on Manoah and his wife from the left, and accordingly the contours on their illuminated sides are somewhat thinner than those in shadow, and the diagonal and vertical hatching suggesting darker areas is predominantly visible on the figures' shaded sides and in their cast shadows. Due to varied spacing between strokes, some areas of hatching are darker than others. In many places—for example, inside the angel's wing, on the ground at Manoah's feet, and behind his wife's back—Rembrandt rubbed the ink between the hatching lines. He thereby produced lightly shaded areas that heighten the spatial effect.

Drost's drawing of Tobias presents similar stylistic features: detailed modeling of some of the figures, long, occasionally interrupted contours, parallel hatching, and places where the ink has been rubbed. Drost was also careful to draw the illuminated sides with thinner lines than the shaded ones, as seen in Tobias's left shoulder. In Drost's work, however, the areas of hatching are considerably more prominent; their strokes are broader, more schematic, and not as carefully differentiated as in Rembrandt's. In some places the hatching obscures the individual form, extending beyond its boundaries. This occurs in the figure of Tobit, on the left, and in the head in the center of the door opening, and compromises the three-dimensionality of the forms. Interestingly, as in Drost's drawings, the brushwork in his paintings frequently consists of parallel strokes, generally on a diagonal.[6] Whereas in Rembrandt's Manoah the lines were drawn with an eye to creating space—the offering stone in the foreground is rendered with a broad pen, and the house facade in the background is only suggested with a few interrupted lines—there is no variation in the pen strokes in Drost's composition. His uniform lines and unvarying hatching result in pictorial flatness.

One finds a quite similar use of line in the Bremen study (fig. 33b)[7] for Willem Drost's painting *Ruth and Naomi* in Oxford (fig. 33c).[8] The faces in the two compositions—the shapes of the noses, mouths, and eyes—present obvious parallels. Traditionally, *The Angel Departing from the Family of Tobit* was held to be by Rembrandt, and only relatively recently was it attributed to Drost.[9] This is a good illustration of how well a pupil could imitate his teacher's use of line and hatching during the early 1650s, but without achieving the master's endless variety. —**HB**

1 Saxl 1939.
2 The drawings *Minerva in Her Study* and *Homer Dictating Verses* in the *liber amicorum* of Jan Six, dated 1652, provide good stylistic comparisons; Benesch 913 and 914.
3 Benesch 895, 974, 975, and 976. All these sheets that Benesch published as by Rembrandt were done by pupils.
4 See Rotermund ca. 1960; Tümpel and Schatborn 1987; Held 1991, pp. 118–43.
5 B. 43.
6 Valentiner 1939, p. 308; Sumowski, *Paintings*, 609.
7 Sumowski, *Drawings*, 546; Bremen 2000–01, no. 10.
8 Sumowski, *Paintings*, 311; Bikker 2005, no. 1.
9 Schatborn in Berlin, Amsterdam, and London 1991–92, p. 144, no. 46.

Rembrandt

Cain Slaying Abel

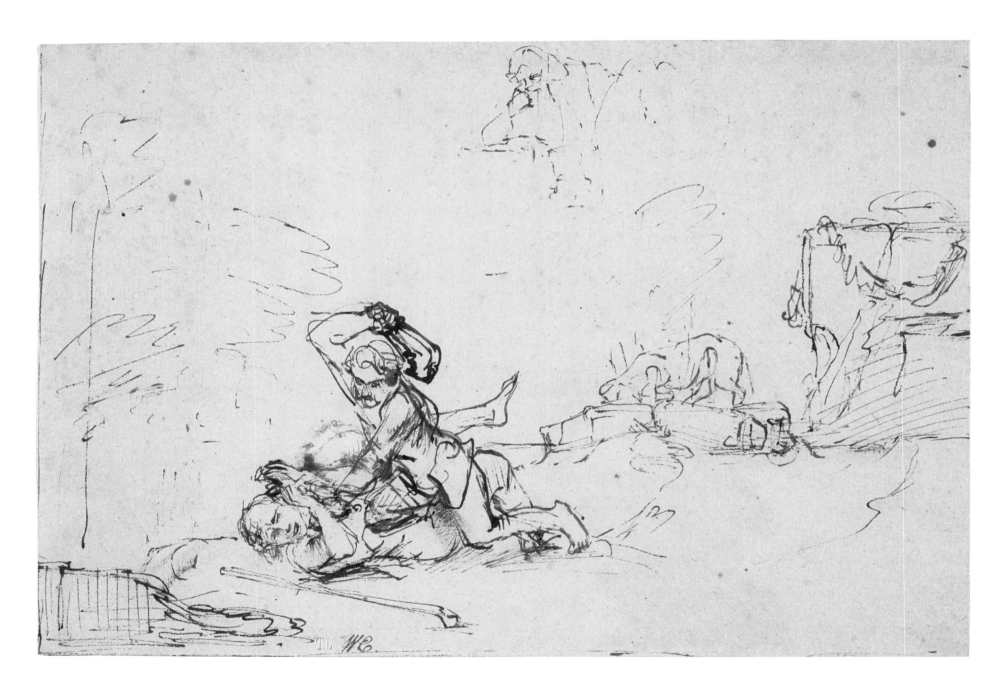

Willem Drost

Lamentation on the Death of Abel

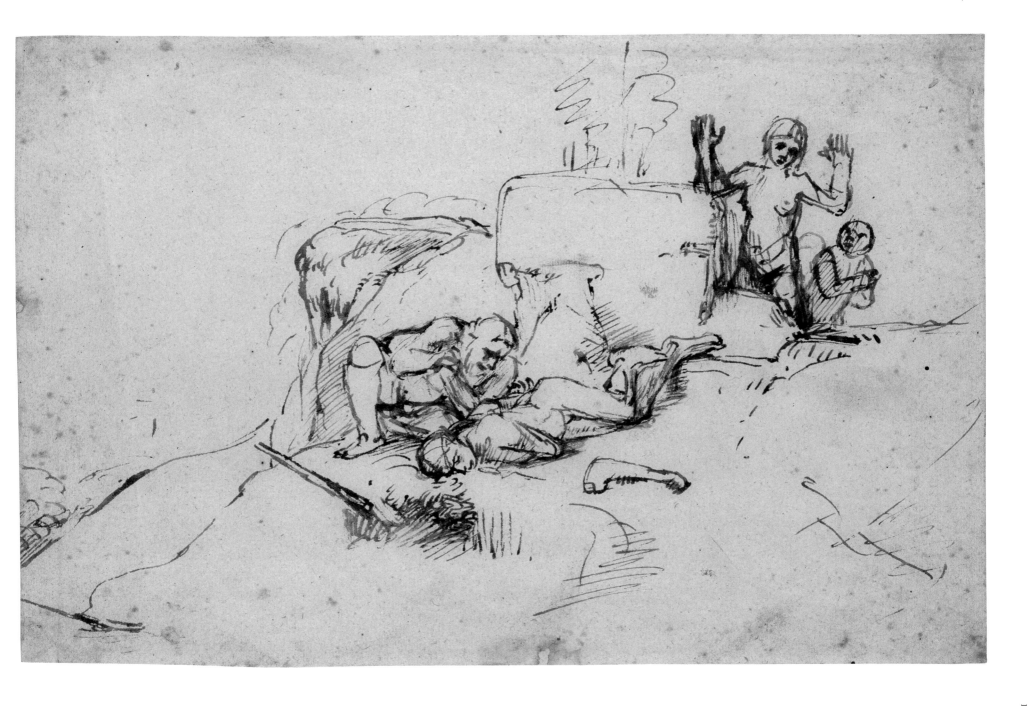

34.1 Rembrandt

Cain Slaying Abel, ca. 1652

Pen and brown ink, the ink smudged in places with a finger or a dry brush, with lead white, 16.8 × 24.7 cm (6⅝ × 9¾ in.)
Copenhagen, Statens Museum for Kunst, KKS 10097

34.2 Willem Drost

Lamentation on the Death of Abel, ca. 1652

Pen and brown ink with lead white, 19.4 × 28.7 cm (7⅝ × 11⁵⁄₁₆ in.)
Berlin, Staatliche Museen, Kupferstichkabinett, KdZ 1115 recto

Specific biblical subjects were treated repeatedly by Rembrandt and his pupils and in his workshop, as seen in this exhibition. For example, there are six sheets devoted to the story of Adam and Eve and their sons Cain and Abel.[1] Only the drawing *Cain Slaying Abel* is the work of Rembrandt; the others, including the *Lamentation on the Death of Abel* by Willem Drost, are the work of pupils. To judge from their style, all of these drawings were produced in the early 1650s.

In Rembrandt's drawing, Cain presses Abel to the ground with his right knee and left arm, brandishing the ass's jawbone in his raised right hand. Abel tries to protect himself from the blow by holding his hands in front of his face. His flailing left leg is an indication of his desperation. His left arm was initially placed higher, but Rembrandt covered that first version with lead white and redrew the arm closer to his chest. His pen strokes are extremely varied. Abel, the victim, is sketched with thin lines; his brother, the assailant, with thicker ones. Rembrandt accented the underside of Cain's right knee with a few broad parallel strokes, vividly emphasizing the brutality of his attack. He also rendered the jawbone with broad, dark outlines to suggest the weight of the fateful weapon. The movement of Cain's arm is emphasized by a thin line, curved along the top, following the contour of his elbow. Abel's fingers are also outlined in broader strokes that emphasize his attempt to defend himself. A bit of delicate hatch-ing under Cain's leg indicates the shadow he casts on the ground. A denser tangle of lines renders the shadow of Abel's right arm and also marks the boundary between his body and the ground. To the left of Cain's left thigh, Rembrandt smudged a little ink to suggest shadow and to clearly distinguish Cain's leg from the body of his brother. The lines on the illuminated side are somewhat thinner than those on the shaded one, as is clearly visible in Cain's left arm.

Drost's drawing captures the moment that followed, which is not recorded in the Bible. Adam, followed by Eve and Cain, discovers Abel's slain body and mourns him. As in Rembrandt's drawing, Abel's shepherd's crook lies in the foreground on the left, and on the right is the jawbone with which he was killed. Adam kneels next to him with folded hands. Drost sketched a study for the figure of Abel on the verso, making minimal changes to the placement of his head and arm (fig. 34a). The compositions of the works by Rembrandt and Drost are similar, and the main groupings have much in common. They occupy a comparable amount of the surface area in both drawings, and in both, the head of Abel lies on the ground, toward the foreground. Their summary, broken lines are similar as well. One can see that the pupil's drawing style is largely imitative of Rembrandt's. It is therefore not surprising that *Lamentation on the Death of Abel* was long held to be a Rembrandt original.[2] It is only through closer comparison that one comes to recognize how different their pen strokes actually are.

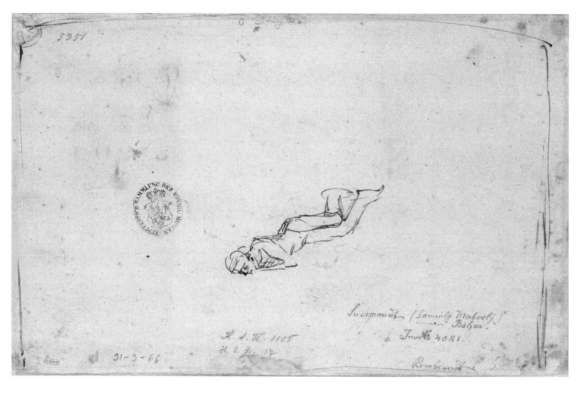

Figure 34a. Willem Drost
Study for the Figure of Abel, ca. 1652
(verso of cat. no. 34.2)
Pen and brown ink, 19.4 × 28.7 cm
(7⅝ × 11⁵⁄₁₆ in.)
Berlin, Staatliche Museen,
Kupferstichkabinett, KdZ 1115 verso

Figure 34b. Willem Drost
Self-Portrait as a Draftsman, 1652
Etching, 6.4 × 5.2 cm (2½ × 2¹⁄₁₆ in.)
Amsterdam, Rijksmuseum,
Rijksprentenkabinet, RP-P-1907-2834

The contours of the figures in Drost's drawing are heavier, somewhat rounder, and also more continuous than those in Rembrandt's drawing. Because the lines are so uniform, there is virtually no distinction between illuminated and shaded sides, and Drost's hatching is more schematic than Rembrandt's. In both drawings, the central figure group is placed in a landscape. In Rembrandt's drawing there is a tree on the left, and on the right are depictions of the two brothers' altars: on the left is Abel's, with an animal sacrifice, on the right is Cain's, heaped with fruits of the field. What appears to be Cain's dog sniffs at the remains of Abel's offering. With a few delicate, broken lines near the top edge, Rembrandt sketched the figure of God, his head resting on his hand as he observes and ponders the heinous deed. These elements of the drawing are executed in very fine lines, which convincingly set them off in a space distant from the foreground. In Drost's sheet there are rocks in the middle distance, behind which one sees Eve and Cain. A small tree or shrub in the center is suggested with looping lines very similar to those in the tree on the left in Rembrandt's drawing and the flame above Abel's altar. There is a consistency in the handling of the linework in the background and the foreground; for example, the thick strokes delineating the figures of Eve and Cain undermine the convincing creation of recession. The patches of hatching are dense and uniform, occasionaly even extending beyond the outlines, as in the figure of Cain. Uniform strokes and the abundant hatching are characteristic features of Drost's drawing style. The artist's self-portrait etching, signed and dated 1652 (fig. 34b), presents a similar use of line.[3]

Rembrandt's *Cain Slaying Abel* conforms in style to other drawings of his from circa 1652, for example, his *Return from Egypt* (cat. no. 31.1).[4] Drost emerges as a good, but somewhat stiff, imitator of Rembrandt's drawing style from that period, one who tried to capture the main figures' emotions but was unable to do so as vividly as his teacher. This is apparent from their somewhat doll-like, schematic faces. In Rembrandt's drawing, Abel's pained expression is forcefully captured with only a few varied strokes indicating his mouth, nose, eyes, brows, and furrowed forehead. A small patch of gently smudged ink beneath the bridge of his nose suggests a shadow on his right cheek. In the pupil's drawing, the rendering of Abel's features is cruder, with none of the delicacy seen in Rembrandt's figure. —**HB**

1 For the other sheets of the series, see Bevers 2006, p. 209, note 115.
2 Benesch 955. However, in his notes on Rembrandt drawings now in the Rijksbureau voor Kunsthistorische Documentatie in The Hague, Frits Lugt already doubted that this was the master's own work. See also Lugt 1931, p. 56, where it is listed as being by a Rembrandt pupil. Sumowski finally ascribed it to Willem Drost; Sumowski, *Drawings*, 553ˣ.
3 Hollstein 1.
4 Also quite comparable is the drawing *The Angel Appearing to Hagar in the Wilderness* of circa 1652 in the Hamburger Kunsthalle, 22411. Benesch 904; Bremen 2000–01, no. 69.

Rembrandt

A Thatched Cottage by a Large Tree

Willem Drost

A Thatched Cottage by a Large Tree

35.1 Rembrandt

A Thatched Cottage by a Large Tree, ca. 1650

Pen and brown ink, rubbed in spots, 17.5 × 26.7 cm (6⅞ × 10½ in.)
Chatsworth, The Duke of Devonshire and the Trustees of the
Chatsworth Settlement, 1046

35.2 Willem Drost

A Thatched Cottage by a Large Tree, ca. 1650

Pen and brown ink, rubbed in spots, 15.5 × 26.1 cm (6⅛ × 10¼ in.)
Wroclaw, Museum of the Lubomirski Princes, The Ossoliński National Institute,
8725

A mong Rembrandt's landscape drawings, which were mainly produced around 1650, there are numerous depictions of farmhouses. Houses surrounded by towering trees were a favorite motif. The Chatsworth drawing shown here depicts a thatched wooden *langhuis* (long house), a type of dwelling found south of the Ij River and Amsterdam in the seventeenth century.[1] It depicts the front end of the house, the living quarters. There would have been animal stalls at the back. The front door is visible on the gable end, and a second door that extends up into the area of the roof can be seen on the side facing outward. Looking closely, one sees that the house is inhabited. Laundry has been hung out on a wooden pole to dry, and a woman is seated next to the front of the house in the shade.

A drawing in Wroclaw depicts the same house from almost the same vantage point and includes the other motifs: the large tree, the bushes on the right, and the fence in the foreground. Given the great similarities in motif and style, one might suspect that both sheets were the work of Rembrandt.[2] However, the Wroclaw drawing is not a repetition by Rembrandt himself and can be attributed to Willem Drost, his pupil.[3] In it the farmhouse is portrayed from a bit farther to the right and from a greater distance than in Rembrandt's drawing, which suggests that this is not merely a copy. The slightly different vantage point could indicate that Rembrandt and Drost sketched the scene together, standing at some distance from each other.

Rembrandt's version presents a great variety of strokes intended to capture the play of light and shadow. The branches of the tree and its foliage, indicated by tiny loops, are executed in great detail with a fine pen. One even senses that the leaves are slightly stirred by the wind. Shaded portions in the top of the tree are represented by intricate, dense layers of lines and parallel hatching, while those most brightly lit are only loosely outlined, allowing the light color of the paper to shine through. The thatched roof, with the sun shining on it, was drawn with a broad pen and lighter ink, and is effectively set off by the darker tree. Rembrandt rubbed the ink between his strokes, suggesting with a softer area of color the dappled shadows of the moving foliage. The darkest areas at the base of the tree contrast sharply with the pieces of laundry hanging in the light. The gable end of the house and the woman seated in its shadow are rendered with thin, parallel strokes of differing density. The plants in the left foreground and the fence on the opposite side are sketched more freely and convincingly evoke a sense of spatial recession. A landscape drawing by Rembrandt in the Ashmolean Museum, Oxford,[4] which is related to his etching *Landscape with Fisherman* from roughly 1650, presents a similar use of line.[5]

The pen strokes in Drost's drawing are similar to those in Rembrandt's sheet but are not nearly so subtle. The foreground and background are not as clearly distinguished, either. In the Rembrandt, the

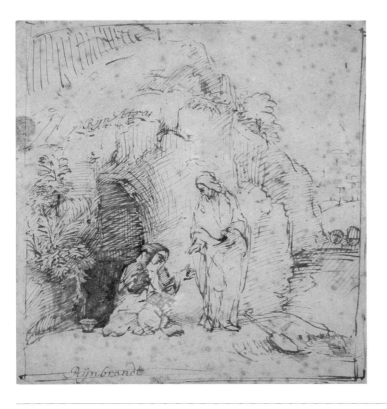

Figure 35a. Willem Drost
Noli me Tangere, ca. 1650–52
Pen and brown ink, lead white,
19.7 × 18.5 cm (7¾ × 7⁵⁄₁₆ in.)
Copenhagen, Statens Museum for Kunst,
Den kongelige Kobberstiksamling,
KKS 7049

ground in front of the tree and the house is largely composed of the blank reserve of the paper, structured here and there with minimal strokes. In the Drost, this area is completely covered with hatching. Drost renders the tree's foliage with groups of slightly curving, parallel strokes running in different directions, and the roof area and sides of the house with quite uniform parallel and cross-hatching. Thus, in contrast to Rembrandt's drawing, their materiality and textures are undifferentiated. Also, the figure walking along the path in Drost's drawing is rendered more clumsily and with less precision than Rembrandt's woman seated in front of the house. Finally, the light-colored wash is absent, which in combination with the dark background would have created a sense of space. Instead, a birdcage, a quotidian detail, hangs from the left end of the pole.

Willem Drost has heretofore been credited mainly with drawings of biblical subjects, as well as a few genre scenes and figure studies, but no landscapes.[6] Yet the landscape study in Wroclaw fits easily with drawings that have been identified so far by this gifted Rembrandt pupil. The extensive and regular parallel and cross-hatching here is a characteristic feature of Drost's drawing style. In addition, the splotchy overlay of strokes beneath the crown of the tree and in the cottage's side door reveal his hand. Comparable hatching and splotchy areas occur in the drawing *Noli me Tangere* (fig. 35a) in Copenhagen,[7] certainly by Drost since he used it as a study for the signed painting

in Kassel from the first half of the 1650s.[8] Also, the shape of the light branch of the tree that stands out from the dark hatching of the roof in the landscape drawing is quite similar to that of the foliage to the left of the cave in the Copenhagen sheet. —**HB**

1 Bakker in Washington 1990, pp. 37–43; Schmitz in Amsterdam and Paris 1998–99, pp. 56–58.
2 Benesch 1282 and 1283.
3 The attribution was proposed by Sumowski and Schatborn; Wroclaw 1998, no. 11.
4 Benesch 1227.
5 B. 213. See Washington 1990, nos. 22–23.
6 Sumowski, *Drawings*, 546–69ˣˣ; Schatborn 1985B, pp. 100–103.
7 Sumowski, *Drawings*, 547ˣ; Copenhagen 1996, no. 12.
8 Sumowski, *Paintings*, 315; Bikker 2005, no. 5.

Rembrandt

Rembrandt
pupil

Dutch, active 1650s

36.1

Rembrandt

The Mocking of Christ

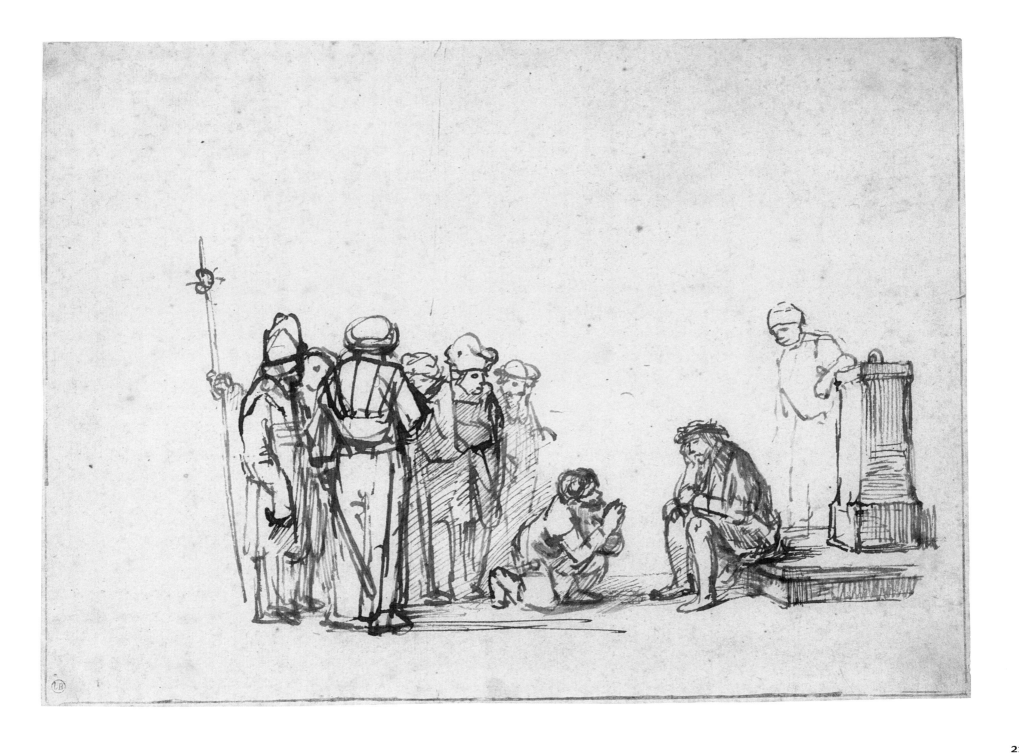

36.1 Rembrandt

The Mocking of Christ, ca. 1650–55

Pen and brown ink, 15.6 × 21.7 cm (6³⁄₁₆ × 8⁹⁄₁₆ in.)
New York, Gift of J. P. Morgan, Jr., 1924, The Pierpont Morgan Library, I, 189

36.2 Rembrandt pupil

The Mocking of Christ, ca. 1650–55

Pen and brown ink, 18.1 × 24.6 cm (7¹⁄₈ × 9¹¹⁄₁₆ in.)
Los Angeles, The J. Paul Getty Museum, 83.GA.358

Around the time of his preoccupation with the epochal etchings *The Three Crosses* and *Christ Presented to the People* (1653 and 1655, respectively), Rembrandt explored the Passion and life of Christ in drawings. Until recently, both of the above drawings were accepted as by Rembrandt, with the Getty sheet considered to be less developed in relation to the one at the Morgan.[1] As seen widely throughout this catalogue, multiple versions of a subject are now regarded skeptically, which is warranted in this case. The Morgan *Mocking of Christ* (cat. no. 36.1) is drawn with a dryish pen, frequently seen in Rembrandt's later drawings, which produces evanescent, scumbled marks that skip across the page, simultaneously creating form and surrounding atmosphere. The version in the collection of the Getty (cat. no. 36.2), on the other hand, is drawn with a thicker nib and wetter ink, which produces marks that are coarser, less varied and nuanced, and lacking atmosphere. Whereas the Morgan sheet is full of exploratory pentimenti, such as the multiple marks positioning Christ's left foot, and more detail, including the looming architecture and variously placed onlookers, the Getty example seems comparatively resolved and simplified. Certain areas clearly repeat the Morgan example but in a stiffer, more schematic form, such as the pillar behind Christ, the figure of Christ himself, and the kneeling man with folded hands who tauntingly entreats Christ.

The Rembrandt pupil who drew the Getty sheet appears to have based it upon the one in the Morgan collection but made changes of his own. Most notably, Christ wears the "scarlet robe" described in Matthew 27:27–29, the biblical source for the subject. In the Morgan drawing it is draped on the pillar, where Christ is shown disrobed according to the iconographic tradition of "Christ on the Cold Stone."[2] He holds a scepter and slumps forward, his mouth slightly agape in an expression combining both physical and psychological agony. In the Getty version, he rests his head in his hands and closes his eyes in an expression of tortured resignation. The vast spatiality of cat. no. 36.1, with the layers of onlookers, soaring architecture, and looming lion sculpture serves to underscore Christ's utter spiritual isolation. Indeed, one can put a slightly finer point on the iconography as blending elements of the Mocking with a slightly later moment in which Christ succumbs to the reality of his cosmic abandonment and isolation called "The Repose of the Lord."[3] The Rembrandt pupil also uses space—this time empty space—to create this effect. He compresses the figures and thus increases compositional tension, adding the smiling female onlooker beside the column to balance the group of male onlookers at left.

The Getty drawing can probably be added to a group of three in the Rijksmuseum by an anonymous Rembrandt pupil of the 1650s comprising *Ecce Homo* (fig. 36a), *Jonathan Saying Farewell to David,* and *Jacob Being Shown Joseph's Bloodstained Coat*.[4] A striking feature of this

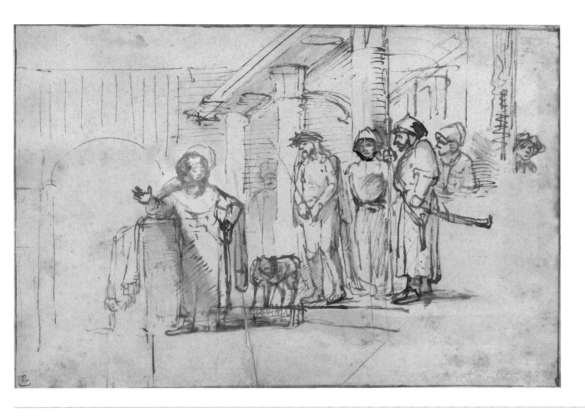

Figure 36a. Rembrandt pupil
Ecce Homo, ca. 1653
Pen and brown ink, brush and brown wash,
corrections in white gouache, gray washes
by a later hand, 16.8 × 24.4 cm
(6⅝ × 9⅝ in.)
Amsterdam, Rijksmuseum,
Rijksprentenkabinet, RP-T-1961-84

artist's style is the use of dark accents and lines applied over lighter
lines. He also tends to compress the composition and enframe it in
empty space. Various other sheets may be by this same artist.[5] —**LH**

1. Paris, London, and New York 1979–80,
 under no. 73; Goldner 1988, no. 95.
2. Paris, London, and New York 1979–80,
 under no. 73; Turner 2006, no. 223.
3. *Herrgottsruh*. See Schiller 1970-71,
 vol. 2, pp. 73–74. Thanks to Victoria
 Sancho Lobis for iconographical
 research.
4. Benesch 971; Benesch 927 and
 Sumowski, *Drawings*, 1210* (as Hoog-
 straten, beginning of the 1650s);
 Benesch 1025, Schatborn 1985A,
 pp. 154–59, nos. 70–72.
5. See *Christ and the Adulteress*, Stock-
 holm, Nationalmuseum, 1998/1863, cf.
 Benesch 1038, and Stockholm 1992–93,
 no. 154; *Christ Mocked*, Chatsworth,
 1017; see Jaffé 2002, vol. 3, no. 1468;
 Susanna Brought to Judgment, Oxford,
 The Ashmolean Museum, WA1855.7,
 Benesch 942, cf. Benesch 1025 and
 1322.

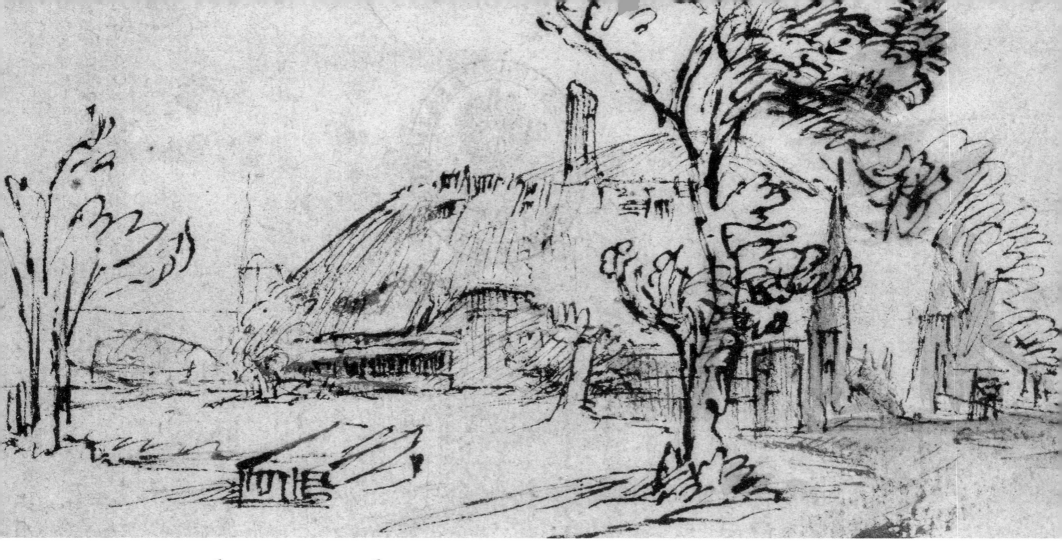

Rembrandt

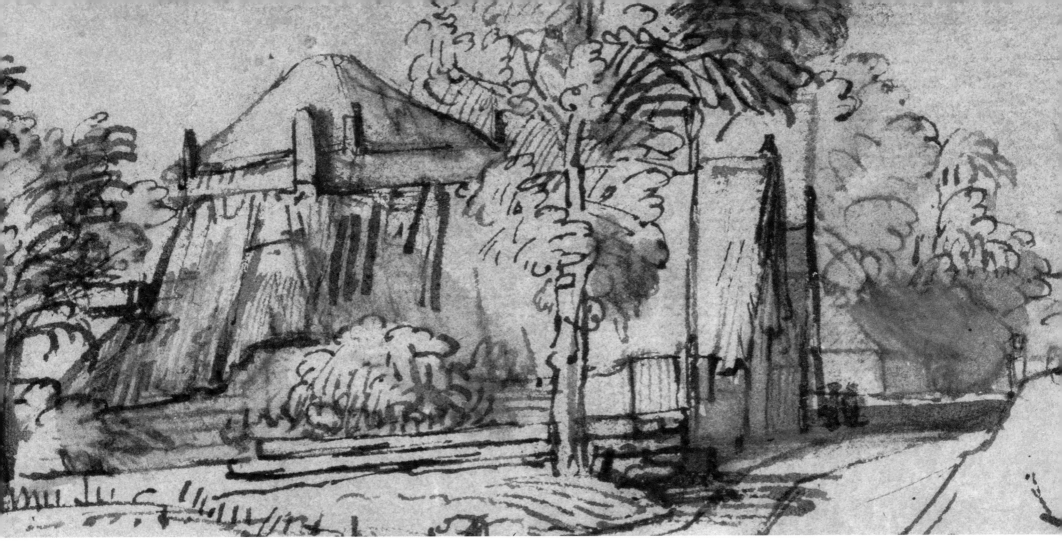

Pieter de With

Dutch, active second half of seventeenth century–after 1689

Although there is no record that De With ever worked in Rembrandt's studio, he was probably apprenticed to the master in the early 1650s, since an etching by Rembrandt of 1652, *Clump of Trees with a Vista*,[1] displays a boathouse among trees that also appears—seen from a slightly different viewpoint—in a drawing attributed to De With.[2] The drawings ascribed to De With that appear in this catalogue likewise display subjects that were also drawn by Rembrandt. No paintings by De With have survived, although two are documented.[3] Several of his nine etchings bear his monogram, *PDW*, and two are dated 1659.[4] De With usually depicted Dutch scenery and fantasy landscapes, though he also drew Italianate landscapes. Sumowski published a catalogue

of De With's drawings in 1992,[5] and a few Rembrandtesque drawings were attributed to him as recently as 2005 and 2008.[6]

1 B. 222.
2 Berlin, Staatliche Museen, Kupfer-
 stichkabinett, 5265; Benesch 1273;
 Bevers 2006, pp. 204–5.
3 Sumowski, *Drawings*, p. 5415.
4 Hollstein 7 and 8.
5 Sumowski, *Drawings*, 2390–2453xx.
6 Schatborn 2005 and Schatborn 2008.

Rembrandt

Farmhouse and a Haystack

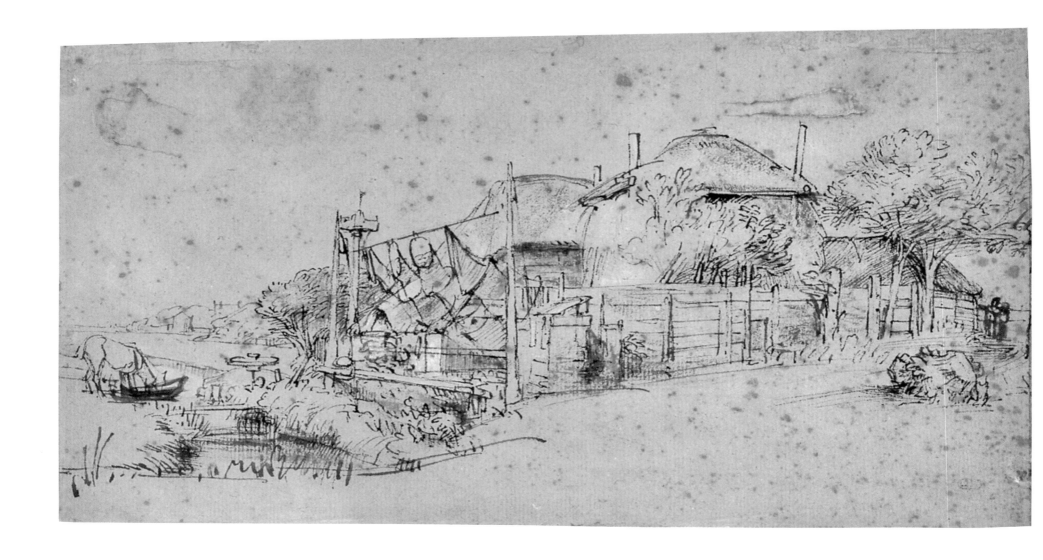

Pieter de With

Farmhouse and a Haystack

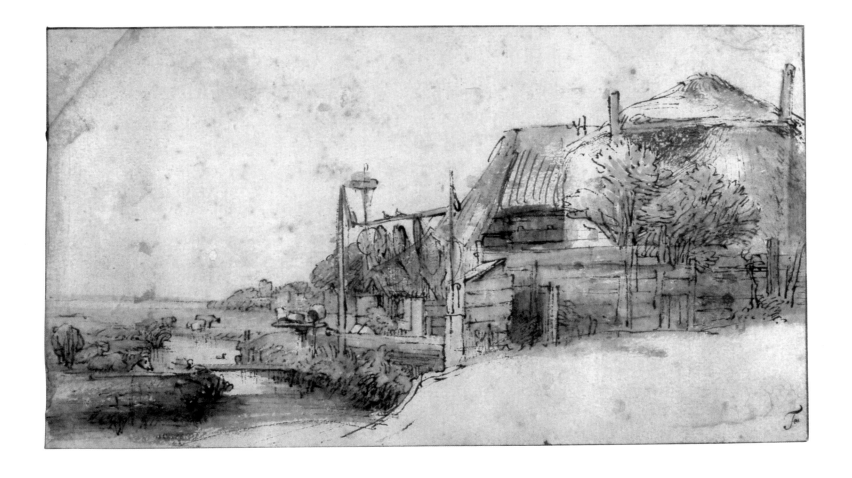

37.1 Rembrandt

Farmhouse and a Haystack, ca. 1652

Pen and brown ink, brush and brown wash, with white heightening
on gray-brown paper, 14.3 × 27 cm (5⅝ × 10⅝ in.)
Paris, Frits Lugt Collection, Institut Néerlandais, 302

37.2 Pieter de With

Farmhouse and a Haystack, ca. 1652

Pen and brown ink, brush and brown wash, some gouache white heightening
(oxidized), 11.6 × 20.2 cm (4⁹⁄₁₆ × 7¹⁵⁄₁₆ in.)
Chatsworth, The Duke of Devonshire and the Trustees of the
Chatsworth Settlement, 1041A

These two drawings depict the same farmhouse from a slightly different angle, and even though both were once thought to be by Rembrandt, the differences in execution clearly show that they are not by the same hand. The images on both the recto and verso of the Chatsworth sheet are attributed to De With mainly on the basis of the stylistic similarity of the verso depiction (fig. 37a) to a signed drawing by De With, *Landscape with Fishermen* (fig. 37c), in the Frits Lugt Collection in Paris.[1]

In Rembrandt's *Farmhouse and a Haystack* (cat. no. 37.1), the tall barn next to the farmhouse is partly hidden by the haystack. Next to the ditch on the left, a cartwheel perched on a pole serves as a rack for pots and pans, which can also be seen in the drawing by De With (cat. no. 37.2). Closer to the barn, fishing nets have been hung up to dry. To the right of these stands a privy next to a wooden fence, on either side of which are trees.[2]

Rembrandt depicted the scene with care and precision, creating a harmonious balance between light and shade. The consistently rendered fall of light contributes substantially to the spatial harmony of the farmhouse and its landscape setting. The shadows were drawn with little ink and a nearly dry brush, then fine lines were added, as seen in the reflection on the bank of the water-filled ditch. The houses and trees in the distance were executed in light tones with faint ink, which enhances the impression of recession into the distance.

De With's drawing (cat. no. 37.2) was made from a slightly higher vantage point more to the right and shows less of the farmyard on that side. The draftsman has looked closely at Rembrandt's example and imitated him in many respects. This drawing was also executed with a fine pen but in a number of places lacks Rembrandt's precision and clarity. The wooden fence, for example, cuts through the haystack, and it is not clear whether the trees are inside or outside the fence. The lines on the roof of the barn are heavily drawn, in contrast to Rembrandt's more delicate shades. The master's subtle shadows, applied with a half-dry brush, do not occur in the pupil's work. De With generally made more liberal use of the brush, so that the light effects are less subtle. The banks of the ditch were drawn with less care, and the shadows on the trees behind the shed and in the distance are flatter, resulting in a diminished sense of depth. The presence of the farm animals discernible on the left shows that the two drawings were not made at the same time.

On the verso of De With's drawing is *A Tree near the Entrance of a House* (fig. 37a). The foliage on the left, which was executed in a looser style, resembles the foliage in a signed fantasy landscape in Besançon (fig. 38a).[3] The style of *A Tree near the Entrance of a House* is perfectly in keeping with that of a drawing in Berlin, *Boathouse between Trees* (fig. 37b),[4] also recently attributed to De With. There is a close correspondence between the rendering of the trees in both drawings.

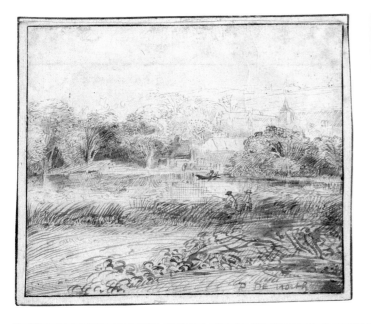

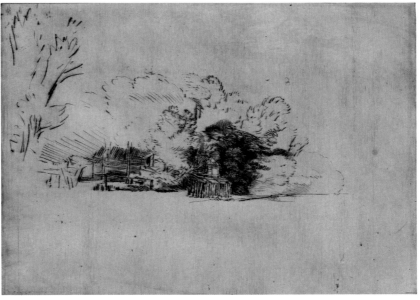

The draftsman drew groups of short hatched lines running in various directions, sometimes placing them tightly together, and elsewhere loosely clustered, as in the contours of the leaves. He also placed dots and dark accents in the foliage to suggest depth and left blank spaces among the leaves to depict light. This manner of depiction is also in evidence in the background of a drawing signed by De With, *Landscape with Fishermen* in the Frits Lugt Collection in Paris (fig. 37c), though the trees in the latter drawing are somewhat sketchier.

The boathouse between the trees was depicted by Rembrandt in the drypoint etching *Clump of Trees with a Vista*, which is dated 1652 (fig. 37d).[5] In the present drawing (fig. 37b)—wrongly considered a preparatory study for that print, which reproduces the site in reverse—the boathouse is seen from a different angle. In the drawing, one side of the boathouse is wider than the other, whereas both sides are the same width in the print. It can be assumed that Rembrandt drew the first state of the print onto the copper plate, out of doors, in a very cursory sketch of the composition. Later, in his studio, he worked up the plate to completion. It is possible that Pieter de With was sitting next to him in the meadow, drawing his own *Boathouse Between Trees* (fig. 37b).

Rembrandt drew the *Farmhouse with a Haystack* two more times, from different viewpoints,[6] but that is not unusual, for there are other examples of farmhouses that Rembrandt and his pupils drew from various angles. A recently discovered drawing attributed to Pieter de With displays the same farmhouse from yet another angle. This drawing reveals the existence, next to the farmhouse, of a house with a sign—the inn where draftsmen went to quench their thirst after a drawing session.[7] —**PS**

1 Sumowski, *Drawings*, 2390.
2 The location was provisionally identified in Amsterdam and Paris 1998–99, pp. 290–97, as near the River Amstel. The drawing mentioned in note 7 makes this identification unlikely.
3 Sumowski, *Drawings*, 2392.
4 Benesch 1273; Bevers 2006, pp. 204–6.
5 B. 222.
6 Benesch 1295 and 1297.
7 Sale, New York, Christie's, January 29, 2009, no. 41.

38.1

Rembrandt

*Farmhouse on the Schinkel Road,
Looking toward Amsterdam*

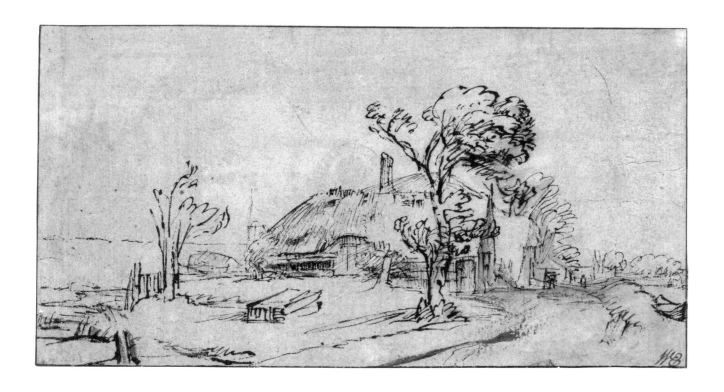

Pieter de With

Farmhouse on the Schinkel Road,
Looking toward Amsterdam

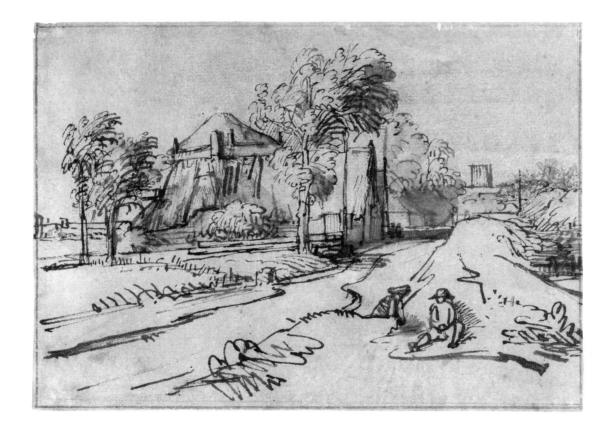

38.1 Rembrandt

Farmhouse on the Schinkel Road,
Looking toward Amsterdam, ca. 1650

Pen and brown ink, brush and dark brown wash and light brown wash (probably
applied later) on light brown prepared paper, 9.4 × 17.2 cm (3¹¹⁄₁₆ × 6¾ in.)
Berlin, Staatliche Museen, Kupferstichkabinett, KdZ 3116

38.2 Pieter de With

Farmhouse on the Schinkel Road,
Looking toward Amsterdam, ca. 1650

Pen and brown ink, brush and brown wash on brownish prepared paper,
10.7 × 14.4 cm (4⁹⁄₁₆ × 5¹¹⁄₁₆ in.)
Berlin, Staatliche Museen, Kupferstichkabinett, KdZ 1137

These two drawings show the same road running alongside the Schinkel River to the southwest of Amsterdam, but they differ in their details.[1] While both were once thought to be by Rembrandt, the more coarsely executed drawing was recently attributed to De With (cat. no. 38.2).[2] This attribution is based on its similarity to a signed drawing in Besançon, *Landscape with Ruins and Shepherds* (fig. 38a), even though the latter was more sketchily executed.[3] Common to both drawings are lines with little tonal variation, uniform hatching, and, above all, the woodenness of the little figures. The Berlin drawing depicts an existing location, whereas the drawing in Besançon, which displays more smoothness of line, was done from the imagination.

Rembrandt drew the same farmhouse with subtle nuances, using little ink in some places while accentuating others, such as the area below the eaves (cat. no. 38.1). Behind this house with its tall chimney stands another farmhouse, which he depicted with a finer pen to create a sense of depth. The houses and trees behind that farmhouse, as well as the windmill on the left in the distance and the boat lying on its side, likewise display finer lines that increase the sense of recession. By contrast, the motifs closer to the viewer were drawn with a heavier hand, such as the boat at the far right, moored in the Schinkel River, the large tree in the middle, and the wooden rabbit hutch in the grass. Their darker lines convey their proximity to the viewer. Such calculated nuances are characteristic of Rembrandt's way of working.

Moreover, the outlines of the tree in the middle display great variation in intensity, a variation that also occurs in the foliage. In the crown of the tree, Rembrandt left a blank patch to indicate the light striking it. The undulating lines make it seem as though the leaves and branches are moving in the wind, which appears to be bending the other trees to the left as well. The light brown wash visible on the front of the farmhouse and the road was applied by a later hand. The tracks in the road in the foreground were also drawn in later with the same ink.

The drawing attributed to De With (cat. no. 38.2) has a different character. When it was still considered the work of Rembrandt, the differences between it and the Berlin drawing were explained by a different dating. This more coarsely executed drawing, however, displays similarities with other drawings by Pieter de With, including the above-mentioned drawing in Besançon and also *Farmhouse and a Haystack* (cat. no. 37.2).

De With's penwork is more powerful and more angular, particularly in the foreground, and in any case, produces lines that are less subtle and detailed. The contours of the tree trunks are less diversified, even though De With was apparently striving for variation. The small, heavily outlined figures are likewise rather angularly rendered. The less varied pen strokes lend the whole drawing a more uniform character, diminishing the spatial effects and the sense of depth.

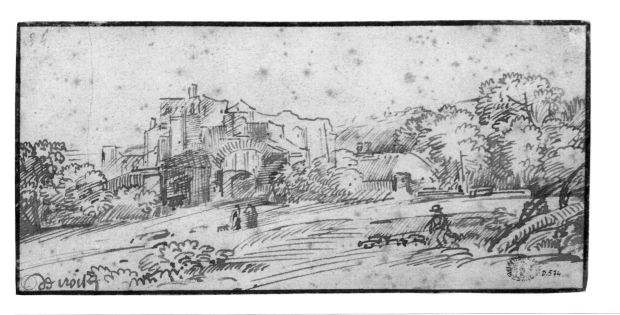

Figure 38a. Pieter de With
Landscape with Ruins and Shepherds,
ca. 1652
Pen and brown ink, 10.2 × 20.5 cm
(4 × 8⅛ in.)
Besançon, Musée des Beaux-Arts
et d'Archéologie, D. 574

As in the Chatsworth drawing (cat. no. 37.2), De With here made more use of the brush than Rembrandt did. The wash was applied somewhat patchily, especially to the houses farther down the road, though the draftsman managed, like Rembrandt, to render the light in the treetop. This wash seems to be the same color as the pen lines, so it must have been applied when the drawing was first made and not at a later date.

There are notable differences in the compositions of the two drawings. The tall roof behind the foremost farmhouse in Rembrandt's drawing becomes a haystack in De With's depiction, and in the distance a tower stands in front of a tall building, which in actuality did not exist on the Schinkel Road. On the left, De With drew two trees and worked them up in some detail; in the same place, Rembrandt sketchily suggested a small tree. In De With's drawing, moreover, the dike on the right seems higher and displays a low opening in the foreground. If we assume that Rembrandt made a faithful depiction of the site, then De With simply drew that site differently. The question is whether De With and Rembrandt made these drawings simultaneously, on the spot, or whether De With took Rembrandt's drawing as an example and made a variant of Rembrandt's composition with some changes. This enterprise would have been in keeping with the pupil's task of emulating the work of the master but at the same time creating a work with something of his own input. In any case, these differences confirm that the two drawings were not made by the same hand.

The drawings by Rembrandt in Paris and Berlin—*Farmhouse and a Haystack* (cat. no. 37.1) and *Farmhouse on the Schinkel Road, Looking Toward Amsterdam* (cat. no. 38.1)—resemble one another in the precision of their execution and in the dappled effect of the light, while De With's drawings in Chatsworth (cat. no. 37.2) and Berlin (cat. no. 38.2) represent coarser variants of the same subjects. Both of De With's drawings, moreover, create a more limited atmospheric effect through their heavier linework and more extensive shading in wash. —PS

1 Regarding the topography, see Amsterdam and Paris 1998–99, pp. 332–34, figs. 5–6.
2 Schatborn 2005, pp. 11–12.
3 Sumowski, *Drawings*, 2390.

DE WITH

225

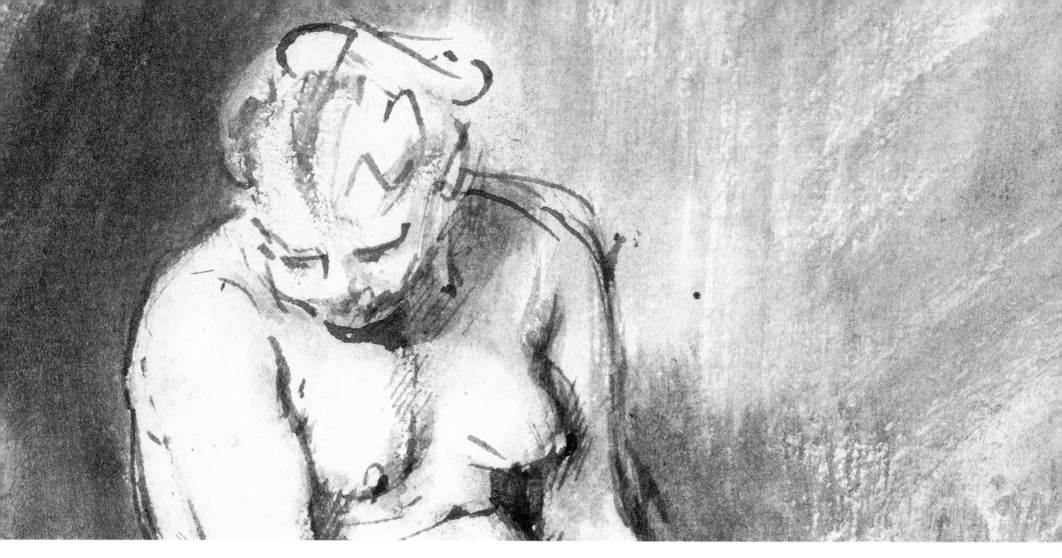

Rembrandt

Arent de Gelder began his artistic training in the late 1650s in his native Dordrecht, where Samuel van Hoogstraten taught him "the fundamentals of art."[1] A former Rembrandt pupil, Van Hoogstraten must have encouraged the youth to complete his education in Rembrandt's workshop. Accordingly, De Gelder studied for two years— probably between 1661 and 1663—with Rembrandt before settling permanently in Dordrecht.[2] Thanks to the wealth his father had accumulated as a politician, merchant, and treasurer of the West India Company, Arent could devote himself to his art and never had to earn a living from it. From the mid-1660s into the 1720s, he painted biblical and literary subjects, portraits, and a couple of genre scenes in an

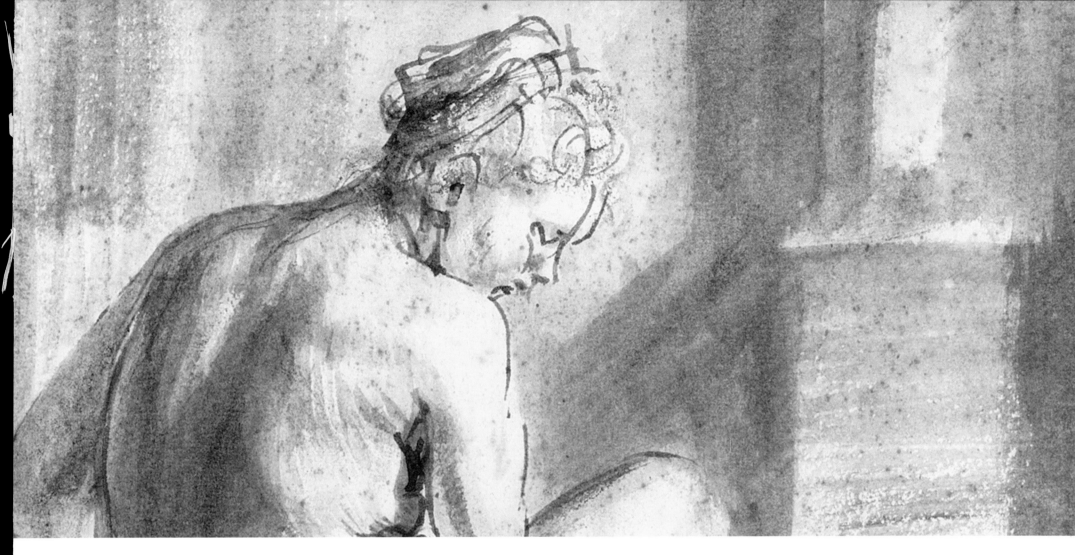

Arent de Gelder

Dordrecht, 1645–Dordrecht, 1727

idiosyncratic manner that combined Rembrandt's late brushwork and compositional models with elements of color and figure style informed by Dutch painting of the late seventeenth and early eighteenth centuries. His contemporaries noted his remarkable allegiance to Rembrandt's style decades after it had passed out of fashion.[3]

That De Gelder was not a prolific draftsman is attested to by the documentary evidence and the modest oeuvre of drawings attributed to him today.[4] His estate inventory lists "4 albums with a few drawings in them," and not many are recorded in eighteenth- and nineteenth-century sale catalogues.[5] Since the artist had no pupils and did not routinely make preparatory studies for his paintings, he probably

had little reason to draw after completing his training in Rembrandt's workshop.

1 Houbraken 1718–21, vol. 3, p. 206. See also Dordrecht and Cologne 1998–99, pp. 11, 45.
2 Dordrecht and Cologne 1998–99, pp. 12–13.
3 Houbraken 1718–21, vol. 3, pp. 206–7; Dordrecht and Cologne 1998–99, pp. 16–17.
4 Sumowski, *Drawings*, 1052–98ˣˣ. Dordrecht and Cologne 1998–99, p. 121.
5 Dordrecht and Cologne 1998–99, p. 112. Sumowski, *Drawings*, pp. 2336–37.

Rembrandt

Isaac and Rebecca Spied Upon by Abimelech

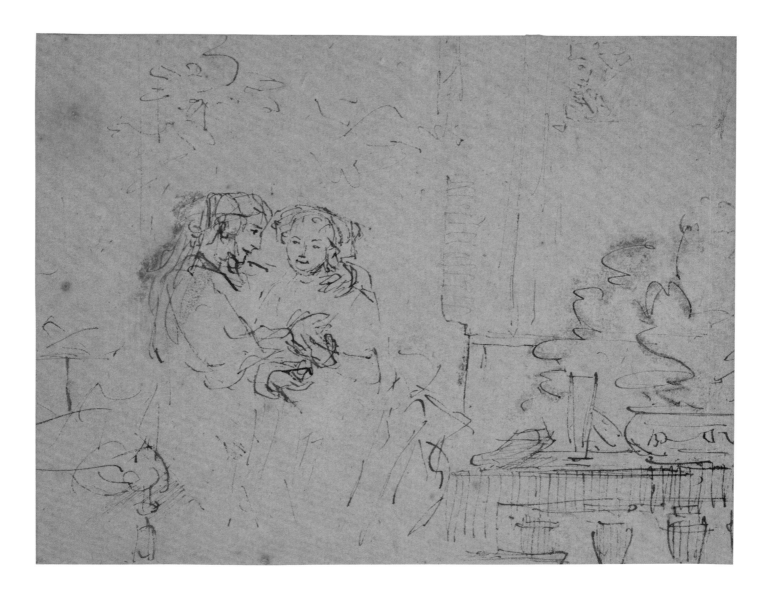

Arent de Gelder

Men in Middle Eastern Costume

39.1 Rembrandt
Isaac and Rebecca Spied Upon by Abimelech, ca. 1662

Pen and brown ink with white gouache heightening,
14.5 × 18.5 cm (5⁵/₁₆ × 7⁵/₁₆ in.)
Collection of Sarah-Ann and Werner H. Kramarsky

39.2 Arent de Gelder
Men in Middle Eastern Costume, ca. 1660–62

Pen and brown ink, brush and brown wash with touches of white gouache
heightening, 15.1 × 19.5 cm (5¹⁵/₁₆ × 7¹¹/₁₆ in.)
The Maida and George Abrams Collection, Boston, on loan to the
Harvard Art Museum/Fogg Museum, Cambridge, 25.1998.123

Isaac and Rebecca Spied Upon by Abimelech (cat. no. 39.1) is a rare working sketch related to a painting by Rembrandt of the 1660s (fig. 39a).[1] It illustrates a passage from the book of Genesis. During a famine, Isaac and Rebecca settled in Gerar. Rebecca was beautiful, and Isaac feared he would be murdered because other men desired her, so he put out word that she was his sister, not his wife. The truth emerged when Abimilech, king of the Philistines, looked out his window and saw "Isaac was sporting with Rebecca his wife."[2]

Rembrandt based his composition on an engraving by Sisto Badalocchio that reproduced a Vatican fresco by a follower of Raphael.[3] The print shows the couple in an intimate embrace, with one of Rebecca's legs slung over Isaac's knee. Rembrandt, too, focused on the erotic play sanctioned by the text. In his drawing, Rebecca sits on Isaac's lap. Abimilech watches furtively from a high window in both the drawing and the print. With a few light, delicate pen strokes Rembrandt summarily sketched the setting and the contours of the figures. Only the table at the lower right and the heads and hands of Isaac and Rebecca were worked up. Rembrandt covered the first draft of Isaac's head with white gouache and moved it closer to his wife's face. Wrapping his arm around her shoulder, Isaac looks directly at her with a joyful expression, while Rebecca smiles and turns her head slightly toward him. Rembrandt initially placed Isaac's other hand at her waist, then redrew it so that it touches her breast, and she places her hand over his.

After his initial training under Samuel van Hoogstraten in Dordrecht, Arent de Gelder spent "two full years" with Rembrandt.[4] We do not know the precise dates of De Gelder's stay in Rembrandt's workshop, but it probably took place between 1661 and 1663.[5] *Men in Middle Eastern Costume* (cat. no. 39.2) is the only drawing securely attributed to De Gelder and, as such, provides the point of departure for the reconstruction of his oeuvre.[6] He adapted the study to compose the two groups of conversing figures at the lower left of his signed and dated painting *The Forecourt of a Temple* of 1679 (detail, fig. 39b).[7] While working on the canvas, he reduced the height of the turbaned figure in the center and enriched the costumes, giving the tall man at left a cloak and a feather in his turban and the one at the far right a miter and embroidered caftan. Despite these changes, one cannot mistake the derivation of the figures in the picture from those in the drawing.

Men in Middle Eastern Costume (cat. no. 39.2) and *Jacob Shown Joseph's Bloody Coat* (fig. 39c),[8] a drawing executed in the same technique, probably date from the period when De Gelder was Rembrandt's pupil.[9] If so, the exhibited work preceded the related painting by some seventeen years. Thus it cannot be categorized as a direct preparatory study for *Forecourt of a Temple* but rather as a drawing made for another purpose, which the artist adapted to the requirements of a

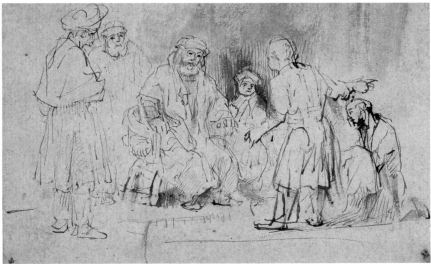

Figure 39a. Rembrandt
Isaac and Rebecca ("The Jewish Bride"),
ca. 1662
Oil on canvas, 121.5 × 166.5 cm
(47^{13}/₁₆ × 65^{9}/₁₆ in.)
Amsterdam, Rijksmuseum (on loan
from the City of Amsterdam since 1885),
SK-C-216

Figure 39b. Arent de Gelder
The Forecourt of a Temple (detail of
lower left group of figures), 1679
Oil on canvas, 70.7 × 91 cm
(27^{13}/₁₆ × 35^{13}/₁₆ in.) (whole composition)
The Hague, Royal Cabinet of Paintings,
Mauritshuis, 737

Figure 39c. Arent de Gelder
Jacob Shown Joseph's Bloody Coat,
ca. 1660–62
Pen and brown ink, brush and brown wash,
12 × 18 cm (4¾ × 7⅛ in.)
The Art Institute of Chicago, The Charles
Dering Collection, 1927.5189

new composition. The technique of the two drawings derives from works by Rembrandt of the late 1650s and early 1660s.[10] De Gelder's handling of the pen is characterized by the spare, delicate lines, lightly sketched contours, some reinforced by darker strokes, refined vertical and diagonal hatchings, and dark dots or short dashes for the eyes.

Even in the summary sketch of Isaac and Rebecca, Rembrandt devised the graphic means to represent faces and gestures that express the emotions invoked in the text. In the biblical narrative of Joseph's coat (fig. 39c), facial expressions repeat the shorthand conventions De Gelder used for faces in other contexts, and his repertoire of gestures—most conspicuously those of the hands—is limited. Although he adopted the later Rembrandt's spare, lightly sketched contours, De Gelder did not emulate the economy of line that so effectively concentrates the composition of *Isaac and Rebecca Spied Upon by Abimelech* on the interaction of the amorous couple. His contours and hatchings can be fussy and mannered, and when he reinforces an outline, he does not always succeed in clarifying the figure or the narrative. Like the contours, the diagonal and vertical hatchings in De Gelder's drawings often serve to embellish, rather than model, the form. —**WWR**

1 Bredius 1971, no. 416.
2 Genesis 26:1–8.
3 New York 1988, no. 35.
4 Houbraken 1718–21, vol. 3, p. 207.
5 Dordrecht and Cologne 1998–99, pp. 12–13.
6 Sumowski, *Drawings,* 1052; Dordrecht and Cologne 1998–99, pp. 113, 255, no. 58.
7 Sumowski, *Paintings,* 724. The painting presumably depicts a biblical theme, but its specific subject—if it has one—has not been satisfactorily explained. Dordrecht and Cologne 1998–99, p. 36.
8 Sumowski, *Drawings,* 1068x.
9 Dordrecht and Cologne 1998–99, pp. 121, 255, nos. 58 and 59.
10 Dordrecht and Cologne 1998–99, pp. 113–14.

40.1

Rembrandt

Simeon and the Christ Child,
from the Heyblocq Album

40.2

Arent de Gelder

Simeon and the Christ Child

40.1 Rembrandt

Simeon and the Christ Child,
from the Heyblocq Album, 1661

Pen and brown ink, brush and brown wash, original arched-top frame,
12 × 8.9 cm (4¾ × 3½ in.)
The Hague, Koninklijke Bibliotheek, shelf mark 131 H26, p. 61

40.2 Arent de Gelder

Simeon and the Christ Child, ca. 1661–62

Pen and brown ink, brush and brown and grayish brown washes,
white gouache corrections, 16.4 × 18.9 cm (6⁷⁄₁₆ × 7⁷⁄₁₆ in.)
Private Collection

Rembrandt contributed *Simeon and the Christ Child* (cat. no. 40.1)[1] to an *album amicorum*, a type of autograph album that might contain poems, aphorisms, mottos, coats of arms, or drawings dedicated to its owner by his friends, acquaintances, and famous contemporaries. The volume belonged to the Amsterdam schoolmaster Jacob Heyblocq.[2] Rembrandt's drawing bears the artist's autograph signature and the date 1661. Since it is mentioned in a poem on the facing page, and the poem was entered into the album on March 30, 1661, the drawing must date between January 1 and March 30 of that year.[3]

Simeon and the Christ Child is one of Rembrandt's most painterly drawings. After sketching a few contours and facial features, he covered most of the small sheet with ink and wash applied with a brush.[4] The media range in tone from a light grayish brown to the dark brown of the deepest shadows and long diagonal strokes that invoke the rays of supernatural light that, as in other versions of this subject by Rembrandt, shines on Simeon.[5] The shadow cast by the celestial light blankets the head of the Christ Child.[6] Reserves of white paper amid the wash highlight Simeon's beard, the heads of Joseph and Mary, and the halolike illumination that hovers over them. In a departure from his earlier depictions of this subject, Rembrandt stripped away the narrative context, leaving a kind of devotional image. As such, the drawing resembles his painting *Simeon and the Christ Child* in

Stockholm, a work begun in the late 1660s and left unfinished at his death.[7]

Rembrandt drew the outer framing lines with a straight edge at the bottom and sides and perhaps with a compass for the arched top. He added freehand the upper border of the field where he placed his signature and, just inside the outer lines, sketchy vertical strokes that complete the illusion of a frame or window. A shadow cast by the figure of the Virgin falls across the frame, partially covering Rembrandt's signature.

Taking Rembrandt's earlier representations of the subject as his models, Arent de Gelder composed a narrative that includes, in addition to the Virgin and Joseph, the prophetess Anna and her young attendant (cat. no. 40.2).[8] The technique of De Gelder's *Simeon and the Christ Child* seems far removed from that of *Men in Middle Eastern Costume* (cat. no. 39.2), the only drawing securely attributed to him. However, De Gelder also drew in the painterly manner of the work exhibited here. *Saint Thomas on His Knees before Christ* (fig. 40a)[9] and *Christ with Nine of the Disciples* (fig. 40b)[10] exhibit the facial types, fleeting contours, and delicate, diagonal strokes of *Men in Middle Eastern Costume* and *Jacob Shown Joseph's Bloody Coat* (fig. 39c). Additionally, both drawings show the more forceful hatchings and, in *Christ with Nine of the Disciples,* the combination of parallel shading lines and wash that De Gelder deployed in the darker shadows in *Simeon and*

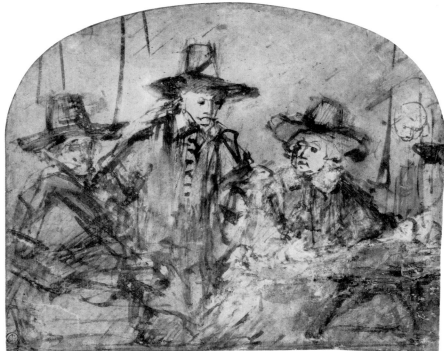

Figure 40a. Arent de Gelder
Saint Thomas on His Knees before Christ,
ca. 1660–62
Pen and brown ink, white gouache
corrections, 16.6 × 23.7 cm (6⁹/₁₆ × 9⁵/₁₆ in.)
Paris, Musée du Louvre, Département des
Arts graphiques, RF 38384

Figure 40b. Arent de Gelder
Christ with Nine of the Disciples,
ca. 1660–62
Pen and brown ink, brush and brown and
gray washes, white gouache corrections,
and scratchwork, 20.5 × 29.8 cm
(8⅛ × 11¾ in.)
Berlin, Staatliche Museen,
Kupferstichkabinett, KdZ 5279

Figure 40c. Rembrandt
*Study for the Syndics of the Cloth Drapers'
Guild ("De Staalmeesters")*, 1662
Pen and brown ink, brush and brown wash,
white gouache corrections, 17.3 × 20.5 cm
(6¹³/₁₆ × 8⅛ in.)
Berlin, Staatliche Museen,
Kupferstichkabinett, KdZ 5270

the Christ Child. The boy standing behind Simeon displays the facial features, lightly sketched contours, and diagonal hatchings characteristic of De Gelder's technique. In its painterly execution, as well as in the use of diagonal hatchings that range from refined to coarse, De Gelder's *Simeon and the Christ Child* emulates the handling of drawings by Rembrandt of the early 1660s, such as the *Study for The Syndics of the Cloth Drapers' Guild ("De Staalmeesters")* of 1662 (fig. 40c).[11]

De Gelder assimilated Rembrandt's technique, but only superficially. He could not marshal his teacher's austere contours, painterly washes, and varied hatchings to bring narrative clarity and meaningful emotional expression to his own drawings. De Gelder evoked the dim interior of the temple by covering most of the sheet with wash and, following Rembrandt's model (cat. no. 40.1), left a large reserve to conjure the powerful light that shines on Simeon's face. Yet he undermined its dramatic impact by scattering additional reserves over the principal figures. Dissatisfied with the inconspicuous presence of Anna in his first draft, De Gelder deleted the head with white gouache and redrew it in a higher position, adding the raised hands. However, the revised Anna is too tall and destabilizes the scale of the composition. De Gelder belabored his drawing, adding superfluous washes and hatchings that, in the central group, obscure the contours and spaces between the figures. Consequently, Simeon merges with the boy behind him and, because of De Gelder's fussy handling, the

Virgin's body is limp and formless. Rembrandt's figures, even those in the heavily reworked composition study for *The Syndics*, retain their structure and discrete identity. —**WWR**

1 For the subject (Luke 2:22–38), see cat. no. 26.1. For Rembrandt's depictions of this theme, see Haverkamp-Begemann 1992–93, and Schwartz 2006, pp. 365–66.
2 Thomassen and Gruys 1998, pp. 7–35.
3 Schwartz 2006, pp. 365–66.
4 Earlier cataloguers mistakenly described the medium of the dark brown marks as white gouache that had discolored due to oxidation. Schwartz 2007, pp. 170–71.
5 See, for example, the etching B. 49, and the painting Bredius 1971, no. 543.
6 See Schwartz 2007, pp. 171–72, for his hypothetical interpretation of the significance of the dark Christ Child in cat. nos. 40.1 and 40.2.
7 Bredius 1971, no. 600. Haverkamp-Begemann 1992–93, pp. 31–40.
8 See cat. no. 26.
9 Dordrecht and Cologne 1998–99, no. 61.
10 Sumowski, *Drawings*, 1075bˣˣ.
11 Bevers 2006, no. 55.

41.1

Rembrandt

Seated Female Nude

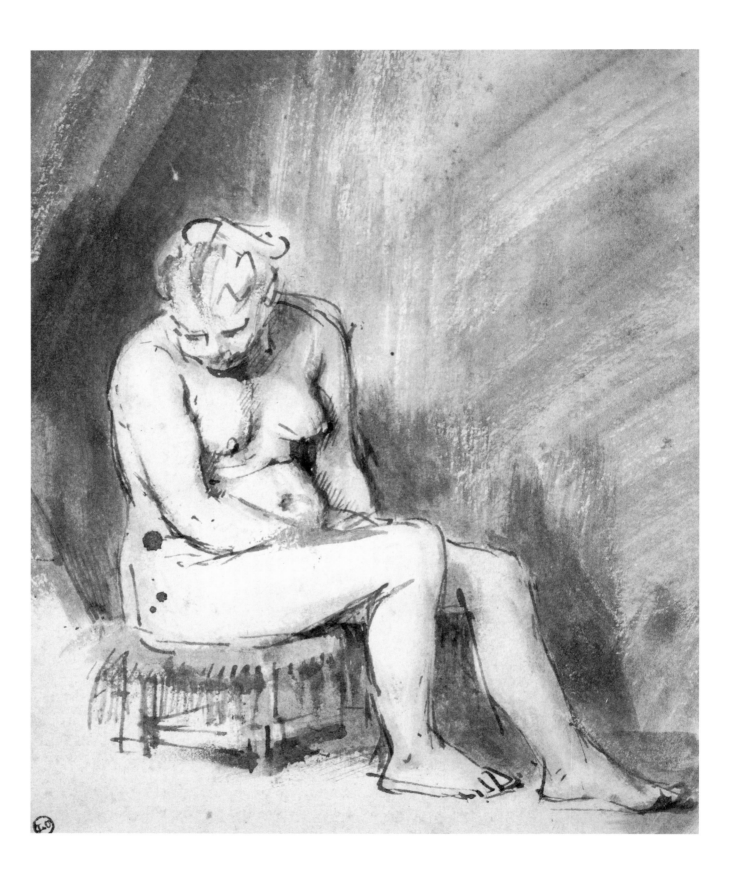

41.2

Arent de Gelder

Seated Female Nude

41.1 Rembrandt
Seated Female Nude, ca. 1660

Pen and brown ink, brush and brown wash, corrected with white gouache,
21.1 × 17.7 cm (8�5/₁₆ × 6¹⁵/₁₆ in.)
The Art Institute of Chicago, Clarence Buckingham Collection, 1953.38

41.2 Arent de Gelder
Seated Female Nude, ca. 1660–62

Pen and brown ink, brush and brown wash, corrected with white gouache,
29.2 × 19.5 cm (11½ × 7¹¹/₁₆ in.)
Rotterdam, Museum Boijmans Van Beuningen, Koenigs Collection, R 1 recto

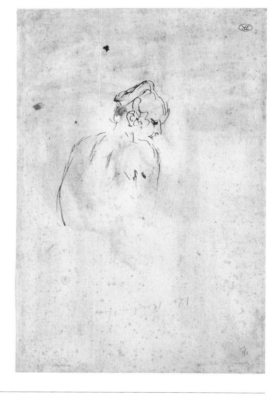

There are various drawings from various periods by Rembrandt and his pupils that demonstrate that they drew the same model together in life-drawing sessions. On some of these occasions Rembrandt drew directly onto the etching plate (see cat. no. 42.1). Rembrandt sketched *Seated Female Nude* (cat. no. 41.1)[1] together with his pupil Arent de Gelder, who drew the model from another vantage point,[2] while also using Rembrandt's drawing as a basis for his own (cat. no. 41.2). Both sheets were formerly attributed to Rembrandt, but the stylistic differences between them are particularly significant. Above all, it is highly improbable that one artist would draw the same model from the same pose twice.

The style of De Gelder's nude can be compared to that of the only securely attributed drawing by him, *Men in Middle Eastern Costume* (cat. no. 39.2), which is connected to his painting *The Forecourt of a Temple* (fig. 39b), in which the figures exhibit similar poses and expressions. It is primarily through the handling of light that the plasticity and rendering of form in De Gelder's drawing and in Rembrandt's can be seen to diverge.

Rembrandt leaves the foreground open so that the stool is placed at the boundary where light and shadow meet. De Gelder's stool is drawn in far greater detail, but it is less sturdy and is surrounded by a great deal of uneven brush wash. The shadows of the brushstrokes laid in by Rembrandt behind the nude in varying tones and different directions create a strong sense of space around the figure, while the nude of De Gelder protrudes less from the background, an effect also resulting from her being more heavily shadowed, especially on her back. The brushstrokes in the background of De Gelder's nude, which render the tiled heating stove at the right, contribute little to creating a sense of space surrounding the model. Rembrandt rendered the head of the model and above all her little cap with a few lines, using wash shadows to describe her head advancing forward in space. Above all, the little cap has been given a precise form with just a couple of pen strokes. The head of De Gelder's nude has a flatter effect, while the little cap, rendered with short small lines and shadows, yields a formless impression. The body of Rembrandt's nude is rendered with pen lines placed next to each other, crossing over and overlapping one another. Some of these lines serve a corrective function and also improve the sense of form, such as the line through the calf of her left leg and the line within the contour of her posterior and the bottom of her back. The dark accents around the figure made with the brush—between her arms and her body and between her legs—accentuate the illuminated parts of her form. By contrast, De Gelder's nude is more shadowed, whereby the darker accents under her posterior and beside her breast are less effective. Rembrandt's nude possesses a greater suggested strength, while the nude of De Gelder is weaker with respect to illumination and the rendering of form.

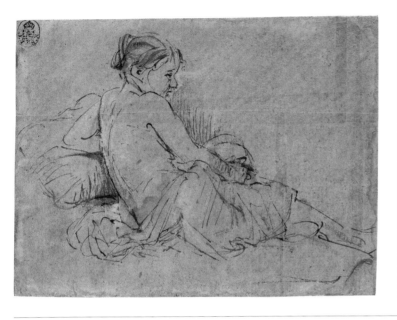

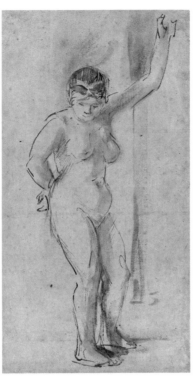

Figure 41a. Arent de Gelder
Bust of a Seated Female Nude, ca. 1660–62
(verso of cat. no. 41.2)
Pen and brown ink, 29.2 × 19.5 cm
(11½ × 7¹¹⁄₁₆ in.)
Rotterdam, Museum Boijmans Van Beuningen, Koenigs Collection, R 1 verso

Figure 41b. Arent de Gelder
Reclining Female Nude, ca. 1660–62
Pen and brown ink, brush and brown wash, corrections with white gouache on brownish paper, 14.2 × 17.5 cm (5⁹⁄₁₆ × 6¹⁵⁄₁₆ in.)
Dresden, Staatliche Kunstsammlungen, Kupferstich-Kabinett, C 1344

Figure 41c. Arent de Gelder
Standing Female Nude with Raised Arm,
ca. 1660–62
Pen and brown ink, brush and brown wash on brownish paper, 27 × 14.1 cm
(10⁵⁄₈ × 5⁹⁄₁₆ in.)
Amsterdam, Rijksmuseum,
Rijksprentenkabinet, RP-T-1901-A-4519

De Gelder began to draw his nude on the verso (fig. 41a) but, dissatisfied with the result, turned his sheet over and began anew. De Gelder has drawn the ear in a peculiar manner, with a little circle within which is a dark spot. One encounters a similar manner of execution in *Reclining Female Nude*, which was formerly regarded as by Rembrandt but is now attributed to De Gelder (fig. 41b).[3] Compared to the seated nude, this drawing uses less wash, but the finely drawn pen lines that exhibit some swelling here and there have a similar character. A similar but sketchier changeability in the handling of line is encountered in *Men in Middle Eastern Costume* (cat. no. 39.2). As mentioned, this drawing forms the starting point for all further attributions. The differences between *Men in Middle Eastern Costume* and the *Reclining Female Nude* can be explained through the fact that the nude was made from life after the model and *Men in Middle Eastern Costume* from the imagination. The result is that in the latter, there are short, loose, and animated little lines with a somewhat more sketchy character and with less precision in the rendering of form.

While there are few known female nudes among Rembrandt's late drawings (cat. no. 41.1 and 43.1), from De Gelder there is a group of nudes, formerly given to Rembrandt, that exhibit a close stylistic connection to the two nudes by De Gelder discussed above. One in this group, *Standing Female Nude with Raised Arm* (fig. 41c),[4] exhibits the same characteristics and above all is comparable to *Reclining*

Female Nude (fig. 41b). While De Gelder here draws looser, more open contours, the fine pen lines and delicate washes are quite comparable. It is not known whether Rembrandt also made drawings of these and other models depicted by De Gelder—this is the only certain one. Indeed, there survives another drawing of a nude model by Rembrandt from around this period made in the same session as one by Johannes Raven (cat. no. 43). —**PS**

1 Benesch 1122.
2 Benesch 1121.
3 Benesch 1109; Berlin, Amsterdam, and London 1991–92, no. 48; Dresden 2004, no. 83 (for full bibliography).
4 Benesch 1118; Dordrecht and Cologne 1998–99, no. 65.

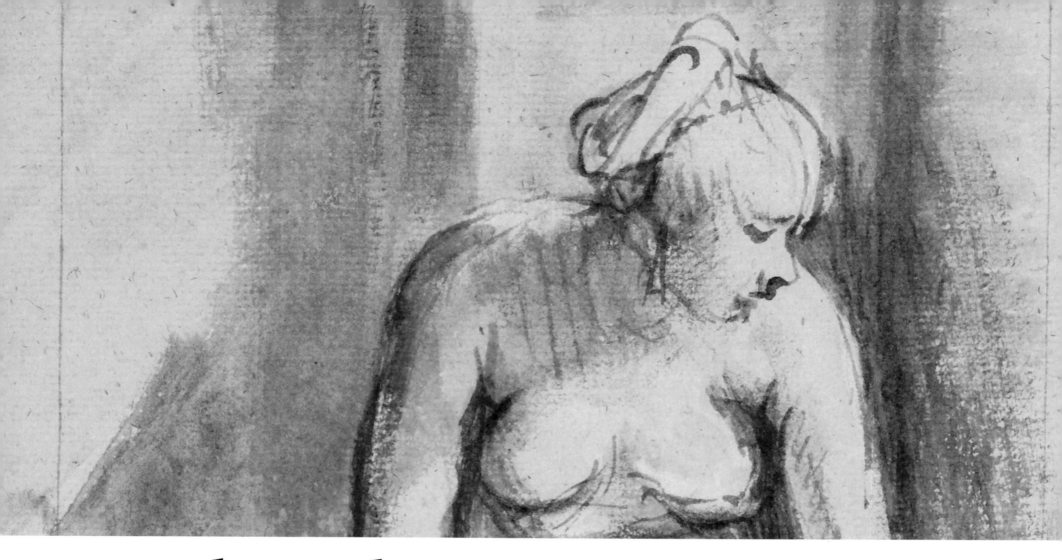

Rembrandt

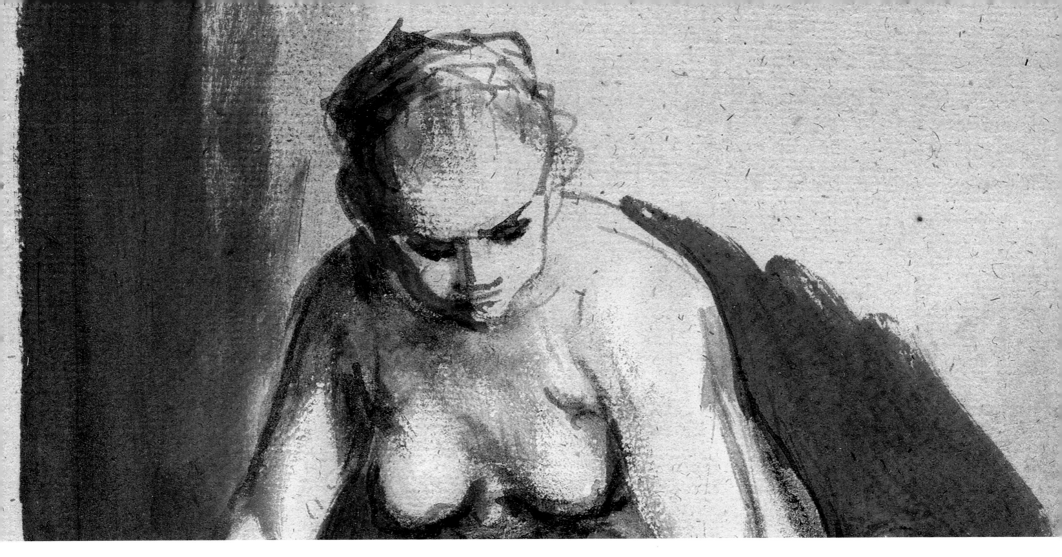

Johannes Raven

Amsterdam (?), 1634–Amsterdam, 1662

On September 20, 1659, when Raven's marriage was announced in Amsterdam, he was recorded as a twenty-five-year-old painter. Two drawings reveal that around 1661–62 he and Rembrandt depicted the same model. Raven had probably been a pupil and possibly an assistant of Rembrandt before his marriage in 1659.

There is only one drawing by Raven that bears his name (on the back), thus forming the basis for assembling his drawn oeuvre.[1] No paintings by Raven are known.

1 Sumowski, *Drawings*, pp. 4807–10.

42.1

Rembrandt

The Woman with the Arrow

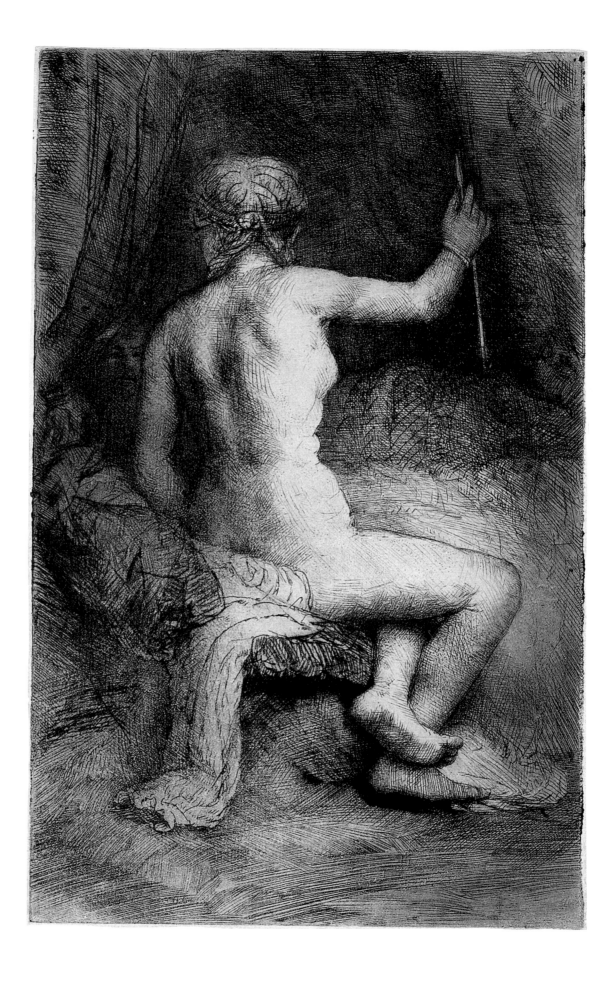

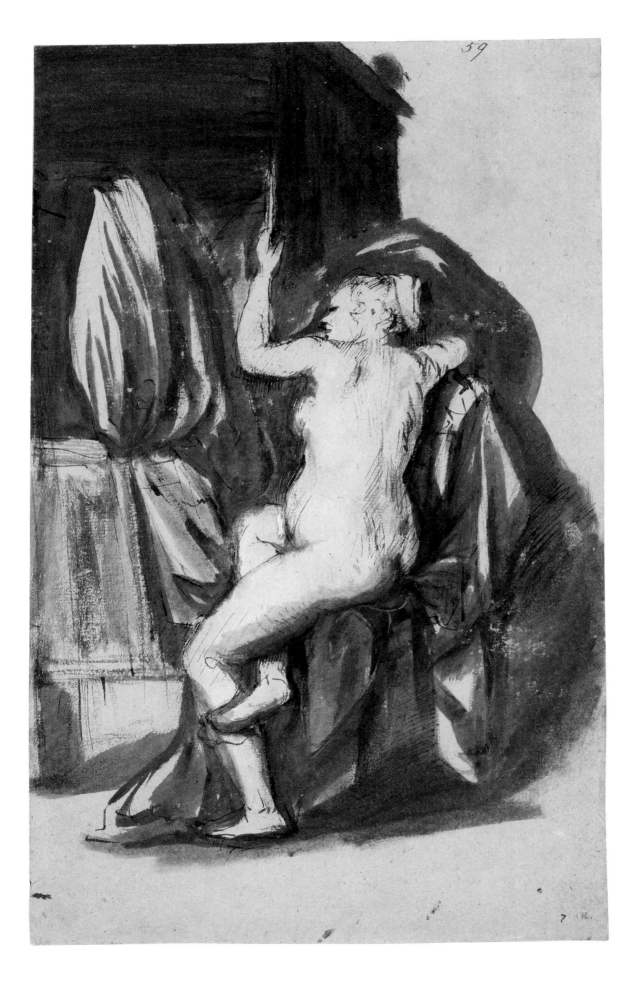

42.2

Johannes Raven

Seated Female Nude,
Surrounded by Drapery

42.1 Rembrandt
The Woman with the Arrow, 1661

Etching, drypoint and burin, second state, 20.5 × 14.8 cm (8¹⁄₁₆ × 5¹³⁄₁₆ in.)
Pasadena, Norton Simon Art Foundation, M.1977.32.115G

42.2 Johannes Raven
Seated Female Nude, Surrounded by Drapery, 1661

Pen and brown ink, brush and brownish gray wash, light gray wash,
and brown wash, with white heightening, 29.7 × 18.5 cm (11¹¹⁄₁₆ × 7⁵⁄₁₆ in.)
London, The British Museum, 1859,0806.85

When Rembrandt and his pupils sketched together, he sometimes worked directly on a copper plate. In these cases, the printed impression shows the composition in reverse. This etching of a nude woman on a bed (cat. no. 42.1) was drawn with a stylus on the wax-covered plate at the same time Johannes Raven was drawing this same model from a slightly different angle (cat. no. 42.2). Raven's drawing was previously taken to be a preparatory study by Rembrandt for the etching,[1] despite the differences between the etching and the subject as Raven depicted it.

In Raven's drawing, the woman is seated next to a canopied bed on a chair draped with bedclothes. Her right arm rests on the back of the chair, and with her left hand she holds the cord used to open and close the bed-curtains. The woman's right leg is raised slightly and tucked under her left leg. In the Rembrandt etching the woman's pose is different: instead of sitting on a chair, she sits on the edge of the bed, with one arm hanging loosely by her side and her head turned toward the bed. This change of pose results in her head appearing rather large and broad, with a scarf tied around it. In contrast to Raven's drawing, in which the woman's right knee is visible, the knee of the tucked-under leg is not visible in Rembrandt's etching, and the foot of that leg is anchored lower down, against the ankle of the other leg. Rembrandt changed the curtain cord into an arrow, and he depicted a face, possibly that of a child, in the bed to the left of the woman. The arrow and the child might refer to a representation of Venus and Cupid, but this remains conjecture.[2] Despite these differences, Rembrandt certainly used the same model as Raven, who probably drew the woman directly as she posed. Another drawing by Raven in Amsterdam shows the model in a similar pose but seen from a different angle, holding the cord with both hands (fig. 42a).

The attribution to Raven of this and other nude studies is based on their similarity to a drawing of a *Seated Half-Nude Youth with Clasped Hands* in Munich (fig. 42b), on the verso of which is written in a seventeenth-century hand, possibly that of Raven himself, *Johannes de Jonge = Raven*.[3] The most striking similarities between this study and Raven's female nudes are the loose and rather scratchy pen strokes, the little contour lines that sometimes overlap, and the use of hatching for the shaded areas on and around the figure. Raven also used a brush to apply delicate shading to the bodies, while placing broader, heavier brushstrokes along the contours and in the folds of the drapery. This wash was probably not added later by Raven, as previously assumed.[4] In the other drawing Rembrandt made at the same time with this pupil (cat. no. 43.1), he, too, used a brush, which Raven here imitated. The wash in the London and Amsterdam drawings displays a heavier handling of the brush than that seen in the signed drawing in Munich.

It can be assumed that the drawings originated as follows: a first

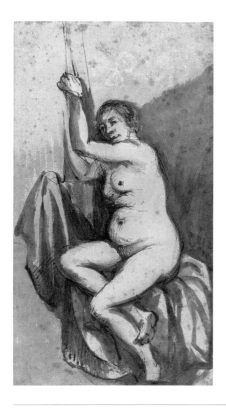

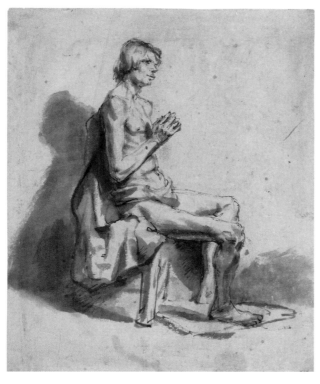

Figure 42a. Johannes Raven
Seated Woman Holding a Sling, ca. 1661
Pen and dark brown ink, brush and
brown and gray washes, 29.1 × 15.5 cm
(11½ × 6⅛ in.)
Amsterdam, Rijksmuseum,
Rijksprentenkabinet, RP-T-1930-57

Figure 42b. Johannes Raven
Seated Half-Nude Youth with Clasped Hands,
ca. 1661
Pen and brown ink, brush and brown
and white washes, 19.8 × 16 cm
(7¹³⁄₁₆ × 6⁵⁄₁₆ in.)
Munich, Staatliche Graphische
Sammlung, 4912

version, the *Seated Half-Nude Youth with Clasped Hands,* was made with
the pen, the wash was applied with the brush, and then the forms
were worked up in more detail again with the pen. The nudes in London
and Amsterdam (cat. no. 42.2 and fig. 42a), however, display delicate
strokes made with a half-dry brush, so it is conceivable that here a
brush was used to make the initial drawing. After this, the forms were
roughly indicated with the pen and a wash was applied, over which
pen and dark ink were used to give the figures their final form. —**PS**

1 B. 202; Benesch 1147; Royalton-Kisch
 1992, no. 106.
2 For opinions on the subject-matter,
 see Hinterding 2008, no. 159.
3 Other nude studies by Raven are
 Benesch 1143 (cat. no. 43.2) and
 1144–46 (fig. 43b).
4 Royalton-Kisch 1992, under no. 106.

43.1

Rembrandt

Seated Female Nude

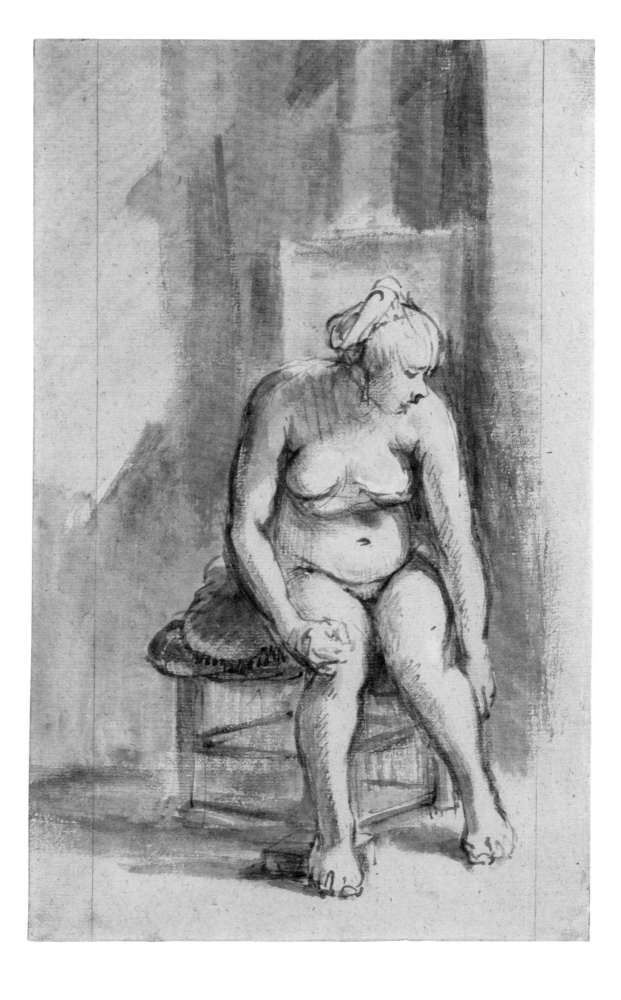

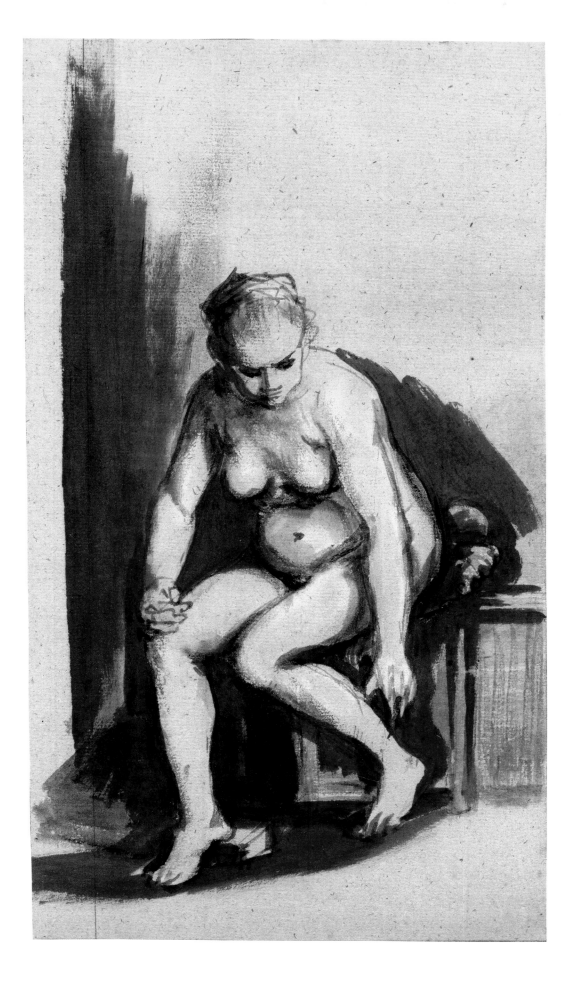

43.2

Johannes Raven

Seated Female Nude

43.1 Rembrandt
Seated Female Nude, ca. 1661

Pen and brown ink, brush and brown wash, black chalk (?), corrected
and heightened with white, on ledger paper, 29.2 × 17.5 cm (11½ × 6⅞ in.)
Amsterdam, Rijksmuseum, Rijksprentenkabinet, RP-T-00-227

43.2 Johannes Raven
Seated Female Nude, ca. 1661

Pen and brown ink, brush and gray-brown and brown washes, black chalk (?),
corrected and heightened with white (oxidized), 28.6 × 16.2 cm (11¼ × 6⅜ in.)
London, The British Museum, 1895,1214.102

Rembrandt was accustomed to working with his pupils and assistants from the same models, just as they sat together drawing the same landscapes and other compositions (fig. 43a).

In one of the master's etchings from the years around 1660, a female model sits before a stove similar to, or perhaps identical with, the one depicted in the background of the present drawing (cat. no. 43.1).[1] In those days there were "Drawing Schools or Academies" (*Teykenscholen of Academien*), where, according to Samuel van Hoogstraten's 1678 book on the art of painting, "male or female nudes [were drawn] from life [posing] by the warm stoves" (*mans- of vrouwenaeckten nae 't leven in de warme stooven*).[2] Artists also went to the "College of Painters" (*Collegie van schilders*), where they could draw together from a live model.[3] Rembrandt's model was depicted at the same time by Johannes Raven, who also used Rembrandt's drawing as an example (cat. no. 43.2).[4]

Rembrandt sits directly across from the model, who has turned her head to her left, so that he sees the right side of her face in profile. Raven, who is sitting to the right of Rembrandt, sees her face more from the front. Characteristically, Rembrandt uses only a few deft lines to depict the cap on her head, which he renders in a similar manner in the Chicago drawing (cat. no. 41.1). The woman's profile is drawn with lines of varying thicknesses, while the contour of her forehead

is reinforced with a pen line. This is also true of some of the body's contours, which appear to have been gone over with black chalk and in some places toned down again with white. The fingers of the right hand—which rests on the knee, with thumb and fingers forming an O—are merely suggested, rather than precisely depicted; the toes are also indicated only cursorily with looping lines. Perhaps because the brush created too strong a contrast with the unshaded areas on the arms and legs, Rembrandt drew zigzag lines over these places to reduce the contrast a little. Other areas of hatching create shadows and contribute to the image's plasticity.

The space in the background where the stove stands is indicated solely with the brush and with extremely transparent wash, with deliberate strokes in various directions to create an impression of light and space. This use of wash to evoke light and space is extremely characteristic of Rembrandt. It also occurs in the drawing of a female nude in Chicago, which Rembrandt drew at the same time as another pupil, Arent de Gelder (see cat. no. 41).

Rembrandt executed this nude on ledger paper, as is apparent from the vertical lines on the left and right. He used the same kind of paper for two figure studies made as preliminary drawings for the 1662 painting *The Syndics* in the Rijksmuseum in Amsterdam.[5] Raven, who was sitting with Rembrandt and also drawing on ledger paper, must have observed not only the model but also Rembrandt's drawing

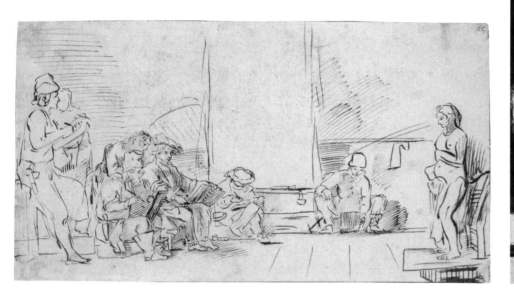

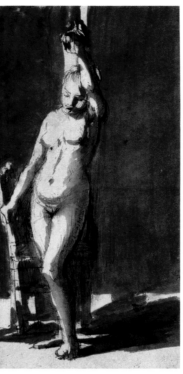

itself. He depicts the woman's cap much more cautiously, however, using very short lines, and draws only three of her fingers, in a rather awkward manner that fails to lend volume to the entire hand. A remarkable aspect is the application of a heavy brown wash, which, in contrast to Rembrandt's brushwork, is opaque and envelops the figure so tightly that it distorts the shape of the body in several places. The application of this dark wash prevented Raven from evoking space and atmosphere to the extent that Rembrandt did in his drawing.

It is assumed that Raven added the gray-brown wash only at a later stage, and that the brown wash was not applied by him at all, but by a later hand (see cat. no. 42.2).[6] It has also been conjectured that Rembrandt's drawing is actually the work of Raven, but its stylistic differences from Raven's drawings (cat. nos. 42.2 and 43.2, fig. 43b) and its resemblance to other drawings by Rembrandt, such as the female nude in Chicago (cat. no. 41.1), make this theory highly unlikely. —**PS**

1 B. 179; Benesch 1142.
2 Van Hoogstraten 1678, p. 294.
3 Amsterdam and Washington 1981–82, p. 21.
4 Benesch 1143; Royalton-Kisch 1992, no. 107.
5 Benesch 1179–80.
6 Royalton-Kisch 1992, no. 107.

Checklist of the Exhibition

Prepared by Laura Patrizi

Exhibited works that appear as figures in Holm Bevers's introductory essay "Drawing in Rembrandt's Workshop"

i **Samuel van Hoogstraten**
Artist in His Studio Painting a Double Portrait, ca. 1640–45

Pen and brown ink, brush and brown wash, 17.5 × 23.4 cm (6⁷⁄₈ × 9³⁄₁₆ in.)
Paris, Musée du Louvre, Département des Arts graphiques, RF 690

MARKS AND INSCRIPTIONS: None.

SELECTED BIBLIOGRAPHY: Sumowski, *Drawings*, 1167aˣ (for full bibliography); Paris 1988–89, no. 107.

ii **Rembrandt**
An Artist in His Studio, ca. 1630

Pen and brown ink, 20.5 × 17 cm (8¹⁄₁₆ × 6¹¹⁄₁₆ in.)
Los Angeles, The J. Paul Getty Museum, 86.GA.675

MARKS AND INSCRIPTIONS: In the bottom left corner, collection mark of Edward Bouverie (L. 325); in the bottom right corner, inscribed in brown ink in an old hand, *R* or *Rᵉ*

SELECTED BIBLIOGRAPHY: Benesch 390; Goldner and Hendrix 1992, no. 103 (for full bibliography); Boston and Chicago 2003–04, no. 19; Schwartz 2006, p. 68.

iii **Constantijn Daniel van Renesse**
Rembrandt and His Pupils Drawing from a Nude Model, ca. 1650

Black chalk, brush and brown wash, heightened with white, 18 × 26.6 cm (7¹⁄₈ × 10½ in.)
Darmstadt, Hessisches Landesmuseum, AE 665

MARKS AND INSCRIPTIONS: None.

SELECTED BIBLIOGRAPHY: Märker and Bergsträsser 1998, no. 32 (for full bibliography); Schwartz 2006, p. 69.

iv **Rembrandt**
A Pupil Drawing from a Plaster Cast, ca. 1641

Etching, state 1, 9.2 × 6.3 cm (3⁵⁄₈ × 2½ in.)
Paris, Frits Lugt Collection, Institut Néerlandais, 727

MARKS AND INSCRIPTIONS: None.

SELECTED BIBLIOGRAPHY: B. 130; Hinterding 2008, no. 110 (for full bibliography).

vi **Rembrandt**
Male Nudes Seated and Standing ("The Walking Trainer"), ca. 1646

Etching, state 1, on Japanese paper, lightly retouched by a later hand in grayish brown ink, 18.9 × 12.8 cm (7⁵⁄₈ × 5¹⁄₁₆ in.)
Paris, Frits Lugt Collection, Institut Néerlandais, 2486

MARKS AND INSCRIPTIONS: None.

SELECTED BIBLIOGRAPHY: B. 194; Hinterding 2008, no. 151 (for full bibliography).

vii **Carel Fabritius**
Standing Male Nude, ca. 1646

Pen and brown ink, brush and brown wash, white gouache heightening, 19.8 × 13.3 cm (7¹³⁄₁₆ × 5¼ in.)
Vienna, Albertina, 8827

MARKS AND INSCRIPTIONS: In the bottom left corner, collection mark of Albert von Sachsen Teschen (L. 174); in the bottom right corner, unidentified collection mark (star).

SELECTED BIBLIOGRAPHY: Benesch 709; Vienna 2004, no. 62 (for full bibliography); Schatborn 2006, pp. 136–37.

viii **Samuel van Hoogstraten**
Standing Male Nude, ca. 1646

Pen and brown ink, brush and brown wash, white gouache heightening, 24.7 × 15.5 cm (9¾ × 6¹⁄₈ in.)
Paris, Musée du Louvre, Département des Arts graphiques, RF 4713

MARKS AND INSCRIPTIONS: In the top right corner, 71; in the bottom right corner, collection mark of Léon Bonnat (L. 1714); in the bottom left corner, collection mark of the Musée du Louvre (L. 1886).

SELECTED BIBLIOGRAPHY: Benesch A55; Sumowski, *Drawings*, 1253* (for full bibliography); Paris 1988–89, no. 109.

x **Rembrandt**
Artist Drawing from the Model, ca. 1639

Etching, drypoint and burin, 23.4 × 18.3 cm (9¼ × 7¼ in.)
Washington, D.C., National Gallery of Art, Print Purchase Fund (Rosenwald Collection), 1968.4.1

MARKS AND INSCRIPTIONS: None.

SELECTED BIBLIOGRAPHY: B. 192; Hinterding 2008, no. 149 (for full bibliography).

xi **Rembrandt**
Cottage and Farm Buildings with a Man Sketching, ca. 1641

Etching, 13.5 × 21 cm (5⁵⁄₁₆ × 8¼ in.)
Pasadena, Norton Simon Art Foundation, M.1977.32.069G

MARKS AND INSCRIPTIONS: None.

SELECTED BIBLIOGRAPHY: B. 219; Hinterding 2008, no. 171 (for full bibliography).

xii **Constantijn Daniel van Renesse and Rembrandt**
The Annunciation, ca. 1650–52

Black and red chalk, pen and brown ink, brush and brown wash, heightened with white, 17.4 × 23.1 cm (6¹³⁄₁₆ × 9¹⁄₈ in.)
Berlin, Staatliche Museen, Kupferstichkabinett, KdZ 2313

MARKS AND INSCRIPTIONS: In the bottom left corner, collection mark of Thomas Lawrence (L. 2445); in the bottom right corner, collection marks of Jonathan Richardson Senior (L. 2184), Thomas Hudson (L. 2432), Sir Joshua Reynolds (L. 2364), and collection inscription of William Esdaile (L. 2617).

SELECTED BIBLIOGRAPHY: Benesch 1372; Bevers 2006, no. 47 (for full bibliography).

xiii Anonymous Rembrandt pupil and Rembrandt
Standing Female Nude, ca. 1637

Black chalk, pen and brown ink, heightened with white,
25.3 × 16.2 cm (9 15/16 × 6 3/8 in.)
Budapest, Szépmüvészeti Múzeum, 1575

MARKS AND INSCRIPTIONS: Inscription at lower right in brown
ink, *Rembrandt*, and unidentified pen strokes; in the bottom left
corner, collection mark of Prince Nikolaus Esterházy (L. 1965); in
the bottom right corner collection mark of Antonio Cesare Poggi
(L. 617).

SELECTED BIBLIOGRAPHY: Benesch 713; Gerszi 2005, no. 208
(for full bibliography).

Exhibited works that appear in the catalogue

Jan Lievens

1.1 Rembrandt
Study of an Old Man with an Open Book,
ca. 1627–28

Red and black chalk, white chalk heightening, pale yellow
prepared paper; vertical strip at right a later addition,
29.6 × 21.1 cm (11 11/16 × 8 5/16 in.)
Berlin, Staatliche Museen, Kupferstichkabinett, KdZ 5284

MARKS AND INSCRIPTIONS: Watermark of a crowned coat of
arms, similar to Churchill 289 (Neuchatel, ca. 1626).

SELECTED BIBLIOGRAPHY: Benesch 7; Amsterdam 1988–89,
pp. 11, 16, pl. III; Royalton-Kisch 1991, p. 410, fig. 3; Bevers 2006,
pp. 24–26, no. 1 (for full bibliography).

1.2 Rembrandt, also attributed to Jan Lievens
Bust of an Old Man Looking Left, ca. 1629–30
Verso: *Drapery Study, a Mantle*, ca. 1629–30

Red and black chalk (recto), red chalk on pale yellow prepared
paper (verso); piece at bottom right a later addition, 13.7 × 11.6 cm
(5 3/8 × 4 9/16 in.)
The Hague, Private Collection

MARKS AND INSCRIPTIONS: On the verso in pencil at the lower
left, *No. 31* and *I*; collection mark of Christiaan van Eeghen at
lower right.

SELECTED BIBLIOGRAPHY: Bauch 1960, pp. 176–77, fig. 161 on
p. 179; Amsterdam and Washington 1981–82, p. 50, fig. 1;
Amsterdam 1988–89, p. 36, no. 12; Royalton-Kisch 1990, p. 134;
Royalton-Kisch 1991, pp. 413–14, fig. 5; Leiden 1991–92, p. 66,
fig. 20; Kassel and Amsterdam 2001–02, pp. 176–77, no. 18;
Washington, Milwaukee, and Amsterdam 2008–09, no. 95, note 5.

1.3 Jan Lievens
Bust of an Old Woman, ca. 1628–30

Red and black chalk on pale yellow prepared paper, 10.8 × 8.3 cm
(4 1/4 × 3 1/4 in.)
New York, Private Collection

MARKS AND INSCRIPTIONS: Collection mark *P.H.* (L. 1272) in
the lower left; collection mark of Jacobus Klaver (not in Lugt) on
the mount.

SELECTED BIBLIOGRAPHY: Sumowski, *Drawings*, 539ˣ (as Gerrit
Dou); Amsterdam 1988–89, no. 11; Washington, Milwaukee, and
Amsterdam 2008–09, under no. 95.

2.1 Rembrandt
Bust of an Old Man Looking Right, ca. 1629/30

Red and black chalk, white gouache heightening (oxidized) on
pale yellow prepared paper, 11.4 × 9.1 cm (4 1/2 × 3 9/16 in.)
Paris, Musée du Louvre, Département des Arts graphiques, 22581

MARKS AND INSCRIPTIONS: Collection marks of the Louvre
(L. 2207 and L. 1886) in the upper right and at lower left,
respectively.

SELECTED BIBLIOGRAPHY: Benesch 39; Paris 1988–89, no. 5;
Kassel and Amsterdam 2001–02, pp. 172–73, no. 16; Paris
2006–07, pp. 38–39, no. 4 (for full bibliography).

2.2 Rembrandt
Bust of an Old Man with Folded Arms, ca. 1629/30

Red and black chalk, 14.7 × 14.5 cm (5 3/4 × 5 11/16 in.)
Stockholm, Nationalmuseum, NMH 2651/1863

MARKS AND INSCRIPTIONS: Inscribed in the upper right, *2546*;
inscribed *2651* and *69* in the lower right.

SELECTED BIBLIOGRAPHY: Benesch 38; Amsterdam and
Washington 1981–82, p. 50, fig. 2; Amsterdam 1988–89, p. 37,
no. 13; Royalton-Kisch 1991, pp. 413–14, fig. 6; Leiden 1991–92,
p. 66, fig. 19; Stockholm 1992–93, no. 131 (for full bibliography);
Kassel and Amsterdam 2001–02, pp. 174–75, no. 17.

2.3 Rembrandt
Bearded Old Man Seated in an Armchair, 1631

Red and black chalk on pale yellow prepared paper, 22.9 × 15.9 cm
(9 × 6 1/4 in.)
Private Collection

MARKS AND INSCRIPTIONS: Signed and dated in red chalk at the
bottom, *RHL 1631*.

SELECTED BIBLIOGRAPHY: Benesch 20; Berlin, Amsterdam, and
London 1991–92, vol. 2, no. 2; Amsterdam and London 2000–01,
p. 160, no. 31, fig. a; Boston and Chicago 2003–04, pp. 118–22,
no. 50; Bevers 2006, under no. 4.

2.4 Jan Lievens
Bearded Old Man in Profile, ca. 1631
Verso: *Drapery Study: A Sleeve (?)*, ca. 1631

Red chalk with touches of black chalk (recto), red chalk (verso),
13.7 × 13.8 cm (5 3/8 × 5 7/16 in.)
Washington, D.C., National Gallery of Art, Gift of Mrs. Lessing J.
Rosenwald, 1987.20.11

MARKS AND INSCRIPTIONS: Inscribed in graphite at upper left,
HH690; and in the center, *2* (in a circle); in the center on the verso,
the collection mark of William Bateson (L. Supplément 2604a).

SELECTED BIBLIOGRAPHY: Benesch 42; Amsterdam 1988–89,
pp. 12, 17, plates IV and V; Leiden 1991–92, pp. 70–71, fig. 25;
Washington, Milwaukee, and Amsterdam 2008–09, no. 98 (for
full bibliography).

2.5 **Jan Lievens**
Bust of a Man with Abundant Curly Hair, ca. 1650

Black chalk, 19.5 × 21.2 cm (7¹¹⁄₁₆ × 8⅜ in.)
Paris, Musée du Louvre, Département des Arts graphiques, 22394

MARKS AND INSCRIPTIONS: Collection mark of the Louvre
(L. 1886) in the lower left corner; unidentified collection mark
(L. 2842).

SELECTED BIBLIOGRAPHY: Sumowski, *Drawings*, 1661ˣ;
Braunschweig 1979, p. 149, no. 58 (for further bibliography).

Govert Flinck

3.1 **Rembrandt**
Nude Woman with a Snake, ca. 1637

Red chalk, white gouache heightening,
24.7 × 13.7 cm (9¹¹⁄₁₆ × 5⁷⁄₁₆ in.)
Los Angeles, The J. Paul Getty Museum, 81.GB.27

MARKS AND INSCRIPTIONS: None.

SELECTED BIBLIOGRAPHY: Benesch 137; Goldner 1988, no. 114
(for full bibliography).

3.2 **Govert Flinck**
*Nude Woman as Bathsheba with King David's
Letter*, ca. 1637–38

Red chalk, 34.2 × 23.2 cm (13⁷⁄₁₆ × 9⅛ in.)
Paris, École nationale supérieure des Beaux-Arts, 390

MARKS AND INSCRIPTIONS: Signed and dated in red chalk in the
lower right, *G.Flinck / f. 16...* (cut off).

SELECTED BIBLIOGRAPHY: Sumowski, *Drawings*, 895 (for full
bibliography).

4.1 **Rembrandt**
Lot and His Daughters, ca. 1638

Pen and brown ink, 15.2 × 19.1 cm (6 × 7½ in.)
Weimar, Klassik Stiftung, Graphische Sammlungen, Sch. I,
874/0001

MARKS AND INSCRIPTIONS: None.

SELECTED BIBLIOGRAPHY: Benesch 128; Amsterdam 1999,
pp. 77–78 (for full bibliography).

4.2 **Govert Flinck**
Joseph Interpreting the Prisoners' Dreams, ca. 1638

Pen and brown ink, brush and brown wash, 17.4 × 20.6 cm
(6⅞ × 8⅛ in.)
The Art Institute of Chicago, Clarence Buckingham Collection,
1967.144

MARKS AND INSCRIPTIONS: Collection mark of E. J. Poynter
(L. 874) in the lower left.

SELECTED BIBLIOGRAPHY: Chicago, Minneapolis, and Detroit
1969–70, no. 103 (for full bibliography); Benesch 80; Plomp 1997,
p. 293, under no. 322.

5.1 **Rembrandt**
Three Studies of the Prodigal Son and a Woman,
ca. 1635–36
Recto: *The Lamentation of Christ at the Foot of the
Cross*, ca. 1635–36 [not exhibited]

Pen and brown ink (recto and verso), 17.3 × 15.5 cm (6¾ × 6¹⁄₁₆ in.)
Berlin, Staatliche Museen, Kupferstichkabinett, KdZ 2312

MARKS AND INSCRIPTIONS: Watermark of a fragment of a
Strassburg lily (cf. Hinterding 2006, vol. 2, p. 208, C'b).

SELECTED BIBLIOGRAPHY: Benesch 100; Bevers 2006, no. 9 (for
full bibliography).

5.2 **Govert Flinck**
The Departure of the Prodigal Son, ca. 1635–36

Pen and brown ink, 19.3 × 27.5 cm (7⅝ × 10¹³⁄₁₆ in.)
Dresden, Staatliche Kunstsammlungen,
Kupferstich-Kabinett, C 1309

MARKS AND INSCRIPTIONS: Watermark of the letter *D* [C?];
collection mark of the Kupferstich-Kabinett Dresden (L. 1647) in
the lower right.

SELECTED BIBLIOGRAPHY: Benesch 81; Dresden 2004, no. 67
(for full bibliography).

6.1 **Rembrandt**
The Actor Willem Ruyter as Saint Augustine,
ca. 1638

Pen and brown ink with some corrections in white, 18.3 × 15 cm
(7³⁄₁₆ × 5⅞ in.)
Chatsworth, The Duke of Devonshire and the Trustees of the
Chatsworth Settlement, 1018

MARKS AND INSCRIPTIONS: Collection mark of N. A. Flinck
(L. 959) in the lower right.

SELECTED BIBLIOGRAPHY: Benesch 120; Chicago, Minneapolis,
and Detroit 1969–70, no. 113; Schatborn and de Winkel 1996, p.
388, fig. 4; Jaffé 2002, no. 1463 (for full bibliography).

6.2 **Govert Flinck**
*Putting a Bishop's Costume on the Actor Willem
Ruyter*, ca. 1638

Pen and brown ink and white heightening on light brown prepared
paper, 21.2 × 18 cm (8⅜ × 7⅛ in.)
Dresden, Staatliche Kunstsammlungen, Kupferstich-Kabinett,
C 1388

MARKS AND INSCRIPTIONS: Collection mark of the Kupferstich-
Kabinett Dresden (L. 1647) in the lower right.

SELECTED BIBLIOGRAPHY: Benesch 121; Dresden 2004, no. 104
(for full bibliography).

7.1 Rembrandt
Joseph in Prison Interpreting the Dreams of Pharaoh's Baker and Butler, ca. 1639
Verso: *The Artist Drawing from a Model*, ca. 1639
[not exhibited]

Pen and brown ink on light brown prepared paper (recto), pen and brown ink, brush and brown wash on light brown prepared paper (verso), 18.8 × 16.4 cm (7⁷⁄₁₆ × 6½ in.)
London, The British Museum, Gg,2.248

MARKS AND INSCRIPTIONS: Inscription on the verso in the lower left in pen and black ink, *248* (the inventory number).

SELECTED BIBLIOGRAPHY: Benesch 423; Royalton-Kisch 1992, no. 27 (for full bibliography).

7.2 Govert Flinck
Joseph in Prison Interpreting the Dreams of Pharaoh's Baker and Butler, ca. 1639

Pen and brown ink, traces of black chalk, 11.4 × 13.5 cm (4½ × 5⁵⁄₁₆ in.)
Los Angeles, The J. Paul Getty Museum, 2007.5

MARKS AND INSCRIPTIONS: None.

SELECTED BIBLIOGRAPHY: Sumowski, *Drawings*, 948bˣ.

7d Rembrandt
Joseph in Prison Interpreting the Dreams of Pharaoh's Baker and Butler, ca. 1639

Pen and brown ink on light brown prepared paper; the figure of Joseph is on a separate, irregularly cut sheet, 20 × 18.7 cm (7⁷⁄₈ × 7³⁄₈ in.)
Los Angeles, The J. Paul Getty Museum, 95.GA.18

MARKS AND INSCRIPTIONS: Inscription in the lower right corner in brown ink in an old hand, *R* or *Rᵉ*; inscribed in graphite above the initial, *55*.

SELECTED BIBLIOGRAPHY: Royalton-Kisch 1992, p. 82, under no. 27; Turner and Hendrix 2001, no. 48.

Ferdinand Bol

8.1 Rembrandt
The Annunciation, ca. 1635

Pen and brown ink, white gouache corrections, 14.4 × 12.4 cm (5¹¹⁄₁₆ × 4⁷⁄₈ in.)
Besançon, Musée des Beaux-Arts et d'Archéologie, D. 2618

MARKS AND INSCRIPTIONS: Collection mark of Jean-François Gigoux (L. 1164) in the lower left; collection mark of the Musée des Beaux-Arts et d'Archéologie, Besançon (L. Supplément 238c) in the lower left.

SELECTED BIBLIOGRAPHY: Benesch 99; Royalton-Kisch 1992, under no. 7, note 2; Bevers 2006, under no. 47; Schwartz 2006, p. 347; Paris 2006–07, no. 11.

8.2 Ferdinand Bol
The Annunciation, ca. 1636–40

Pen and brown ink, brush and brown wash, 19.4 × 16.5 cm (7⅝ × 6½ in.)
Oslo, Nasjonalmuseet for kunst, arkitektur og design, NG.K&H.B. 15591

MARKS AND INSCRIPTIONS: None.

SELECTED BIBLIOGRAPHY: Sumowski, *Drawings*, 180ˣ.

9.1 Rembrandt
Seated Woman with an Open Book on Her Lap, ca. 1635–40

Pen and brown ink, brush and brown wash, 12.6 × 11 cm (4¹⁵⁄₁₆ × 4⁵⁄₁₆ in.)
Rotterdam, Museum Boijmans Van Beuningen, Koenigs Collection, R 10

MARKS AND INSCRIPTIONS: Collection marks of Sir Joshua Reynolds (L. 2364), Sir Thomas Lawrence (L. 2445), and William Esdaile (L. 2617) in the lower left; collection mark of Jonathan Richardson (L. 2183) in the lower right.

SELECTED BIBLIOGRAPHY: Benesch 757; Giltaij 1988, no. 15 (with earlier bibliography); Edinburgh and London 2001, no. 86; Rotterdam 2005–06, no. 12.

9.2 Ferdinand Bol
Seated Woman in an Interior, ca. 1637–40
Verso: *Head of a Woman in Profile*, ca. 1637–40
[not exhibited]

Pen and brown ink, brush and brown wash (recto); pen and brown ink (verso), 16.2 × 12.8 cm (6³⁄₈ × 5¹⁄₁₆ in.)
Berlin, Staatliche Museen, Kupferstichkabinett, KdZ 18533

MARKS AND INSCRIPTIONS: Inscription on the verso in brown ink, *ende soo ghy wylt / weten soo . . . ght / ghy . . . gg.*

SELECTED BIBLIOGRAPHY: Sumowski, *Drawings*, 168ˣ.

10.1 Rembrandt
Three Studies of a Bearded Man on Crutches and a Woman, 1636–40

Pen and brown ink, 15.2 × 18.5 cm (6 × 7⁵⁄₁₆ in.)
London, The British Museum, Gg,2.252

MARKS AND INSCRIPTIONS: An unrecognizable mark or number in brown ink in the lower left; initials of Rev. C. M. Cracherode in the lower right; on the verso in the lower right in graphite, *43* (in a circle).

SELECTED BIBLIOGRAPHY: Benesch 327; Royalton-Kisch 1992, no. 8 (for full bibliography); Schatborn 1994, p. 22.

10.2 Ferdinand Bol
Three Studies of an Old Man in a High Fur Cap, 1636–40

Pen and brown ink, brush with gray-brown wash added by a later hand, 15.1 × 18.5 cm (5¹⁵⁄₁₆ × 7⁵⁄₁₆ in.)
London, The British Museum, Gg,2.251

MARKS AND INSCRIPTIONS: Inscription in brown ink in the lower left, *no 201*; inscriptions on the verso in graphite, *42* (in a circle), and in the lower left in brown ink, *321*(?).

SELECTED BIBLIOGRAPHY: Benesch 688; Royalton-Kisch 1992, no. 36 (for full bibliography); Schatborn 1994, p. 22.

11.1 Rembrandt
Esau Selling His Birthright to Jacob, ca. 1640

Pen and brown ink, touched with brush and brown-gray wash,
20 × 17.3 cm (7⁷⁄₈ × 6¹³⁄₁₆ in.)
London, The British Museum, Gg,2.250

MARKS AND INSCRIPTIONS: Inscription on the verso in brown
ink in the upper left, *38*; inscription on a fragment of an old mat
in pen by John Barnard, *F. 59[?58]/.P./JB.* [in monogram] –
No: 1067./7³⁄₄ by 6³⁄₄ / Engraved by S: Watts for Mr: Rogers; modern
inscription in graphite, *48* (in a circle).

SELECTED BIBLIOGRAPHY: Benesch 606; Royalton-Kisch 1992,
no. 37 (for full bibliography); Vienna 2004, no. 104.

11.2 Ferdinand Bol
Esau Selling His Birthright to Jacob, ca. 1640

Pen and brown ink, corrections with white gouache,
15.5 × 14.8 cm (6¹⁄₈ × 5¹³⁄₁₆ in.)
Amsterdam, Historisch Museum, Bequest of C. J. Fodor, TA 10285

MARKS AND INSCRIPTIONS: Collection mark of Thomas
Lawrence in the lower left (L. 2445); inscription in the lower
right in pen, *WE* (William Esdaile) (L. 2717); on the verso on an
additional piece of paper in pencil, *42* (in a circle), *III,* and *169*;
collection mark of Carel Joseph Fodor (L. 1036) in the lower left,
and inscription in the lower left in pen, *1835 WE* and *Rembrandt*;
inscription in the lower right in pencil, *paste some paper on the hole
and 5*.

SELECTED BIBLIOGRAPHY: Benesch 564; Broos 1981, no. 12;
Schatborn 1982, pp. 254–55; Royalton-Kisch 1992, under no. 37,
note 3.

12.1 Rembrandt
Christ as a Gardener Appearing to Mary Magdalene,
ca. 1640

Pen and brown ink, corrections with white gouache, indented
for transfer, 15.4 × 14.6 cm (6¹⁄₁₆ × 5³⁄₄ in.)
Amsterdam, Rijksmuseum, Rijksprentenkabinet,
Gift of Mr. and Mrs. De Bruijn-Van der Leeuw, 1949, RP-T-1961-80

MARKS AND INSCRIPTIONS: Inscriptions on the lower verso in
pen, *Claude Aug. Mariette 1700* (L. 1786) and unreadable numbers;
collection mark of the Rijksprentenkabinet (L. 2228).

SELECTED BIBLIOGRAPHY: Benesch 538; Schatborn 1981, pp.
13–14; Schatborn 1985A, no. 22 (for full bibliography); Schatborn
1985B, pp. 94–95; Vienna 2004, no. 103; Schapelhouman 2006,
p. 89.

12.2 Ferdinand Bol
Christ as a Gardener Appearing to Mary Magdalene,
ca. 1640

Pen and brown ink, 15.4 × 19.1 cm (6¹⁄₁₆ × 7⁹⁄₁₆ in.)
Amsterdam, Rijksmuseum, Rijksprentenkabinet,
Gift of Mr. Cornelius Hofstede de Groot, 1930, RP-T-1930-29

MARKS AND INSCRIPTIONS: None.

SELECTED BIBLIOGRAPHY: Benesch 537; Schatborn 1985A, under
no. 22; Schatborn 1985B, pp. 94–95; Schapelhouman 2006, p. 91.

Gerbrand van den Eeckhout

13.1 Rembrandt
Christ Carrying the Cross, ca. 1635

Pen and brown ink, brush and brown wash, 14.4 × 26 cm
(5⁵⁄₈ × 10¹⁄₄ in.)
Berlin, Staatliche Museen, Kupferstichkabinett, KdZ 1554

MARKS AND INSCRIPTIONS: Inscription by a later hand in brown
ink in the bottom left, *Rembrant*; collection inscription of
Sir John Charles Robinson (L. 1433) in the bottom right corner.

SELECTED BIBLIOGRAPHY: Benesch 97; Berlin, Amsterdam, and
London 1991–92, vol. 2, p. 35, no. 5; Boston and Chicago 2003–04,
no. 40; Bevers 2006, no. 8 (for full bibliography).

13.2 Gerbrand van den Eeckhout
The Crucifixion, ca. 1640

Pen and brown ink, brush and gray-brown wash, with some lead
white; sheet patched together at right edge, 21.8 × 17.9 cm
(8⁹⁄₁₆ × 7¹⁄₁₆ in.)
Berlin, Staatliche Museen, Kupferstichkabinett, KdZ 12954

MARKS AND INSCRIPTIONS: None.

SELECTED BIBLIOGRAPHY: Benesch 108; Boston and Chicago
2003–04, no. 41; Bevers 2006, pp. 192–193.

14.1 Rembrandt
Listeners for Saint John the Baptist Preaching,
ca. 1634–35

Pen and brown ink, touched with brush and brown wash,
with some lead white, 18.9 × 12.5 cm (7⁷⁄₁₆ × 4⁷⁄₈ in.)
Berlin, Staatliche Museen, Kupferstichkabinett, KdZ 5243

MARKS AND INSCRIPTIONS: None.

SELECTED BIBLIOGRAPHY: Benesch 140; Bevers 2006, no. 12
(for full bibliography); Schwartz 2006, p. 106.

14.2 Gerbrand van den Eeckhout
Saint Paul Preaching in Athens, ca. 1635–40

Pen and brown ink, brush and brown and reddish brown washes,
lead white heightening, touched with red chalk, 18 × 20.7 cm
(7¹⁄₈ × 8³⁄₁₆ in.)
London, The British Museum, T,14.7

MARKS AND INSCRIPTIONS: Inscription at lower right by a later
hand in brown ink, *Remt:*

SELECTED BIBLIOGRAPHY: Benesch 138; Royalton-Kisch 1992,
no. 97 (for full bibliography); Bevers 2005, p. 468; Royalton-Kisch
2008–09, no. 1.

15.1 Rembrandt
A Quack and His Public, ca. 1635–37

Pen and brown ink, corrections in lead white, 20 × 14.7 cm
(7⅞ × 5¹³⁄₁₆ in.)
Berlin, Staatliche Museen, Kupferstichkabinett, KdZ 5268

MARKS AND INSCRIPTIONS: None.

SELECTED BIBLIOGRAPHY: Benesch 416; Bevers 2006, no. 19
(for full bibliography).

15.2 Gerbrand van den Eeckhout
A Quack and His Public, ca. 1637–40

Pen and brown ink, brush and brown wash with corrections
in lead white, 18.8 × 16.6 cm (7⁷⁄₁₆ × 6⁹⁄₁₆ in.)
London, The Samuel Courtauld Trust, The Courtauld Gallery,
D.1978.PG.186

MARKS AND INSCRIPTIONS: None.

SELECTED BIBLIOGRAPHY: Benesch 417; London 1983, no. 11
(for selected bibliography); Bevers 2005, p. 469.

16.1 Rembrandt
*Study of a Woman in an Elaborate Costume Seen
from the Back*, ca. 1638

Pen and brown ink, brush and brown wash on reddish prepared
paper, 19.8 × 13.1 cm (7¹³⁄₁₆ × 5⅛ in.)
Leipzig, Museum der Bildenden Künste, NI.470

MARKS AND INSCRIPTIONS: None.

SELECTED BIBLIOGRAPHY: Benesch 321; Gleisberg and Mehnert
1990, no. 43 (for full bibliography).

16.2 Gerbrand van den Eeckhout
*Study of a Woman in an Elaborate Costume Seen
from the Front*, ca. 1638

Pen and brown ink, brush and brown wash, with traces of lead
white, 18.4 × 13.9 cm (7¼ × 5½ in.)
Berlin, Staatliche Museen, Kupferstichkabinett, KdZ 3115

MARKS AND INSCRIPTIONS: Inscription in the lower right corner
by a later hand in black pencil, *Rembrand*.

SELECTED BIBLIOGRAPHY: Benesch 316; Bevers 2006,
pp. 196–97.

17.1 Rembrandt
Study of Hendrickje Sleeping, ca. 1654–55

Brush and brown wash, with some white gouache mixed in places
with the wash, 24.6 × 20.3 cm (9¹¹⁄₁₆ × 8 in.)
London, The British Museum, 1895,0915.1279

MARKS AND INSCRIPTIONS: None.

SELECTED BIBLIOGRAPHY: Benesch 1103; Royalton-Kisch
1992, no. 58 (for full bibliography); Edinburgh and London 2001,
no. 118; Schwartz 2006, p. 295; Royalton-Kisch 2008–09, no. 51.

17.2 Gerbrand van den Eeckhout
Reclining Young Man, ca. 1670

Brush and brown ink, 20 × 30.6 cm (7⅞ × 12¹⁄₁₆ in.)
Amsterdam, Rijksmuseum, Rijksprentenkabinet, RP-T-1948-401

MARKS AND INSCRIPTIONS: None.

SELECTED BIBLIOGRAPHY: Sumowski, *Drawings*, 789ˣ (for full
bibliography); Amsterdam and Washington 1981–82, no. 47.

Jan Victors

18.1 Rembrandt
The Angel Departs from Manoah and His Wife,
ca. 1635–38

Pen and brown ink, 17.4 × 19 cm (6⅞ × 7½ in.)
Berlin, Staatliche Museen, Kupferstichkabinett, KdZ 3774

MARKS AND INSCRIPTIONS: Collection mark in the bottom left
corner of Sir Thomas Lawrence (L. 2445) and collection inscription
by William Esdaile (L. 2617).

SELECTED BIBLIOGRAPHY: Benesch 180; Bevers 2006, no. 15
(for full bibliography).

18.2 Jan Victors
Haman Begs Esther for Mercy, ca. 1638
Verso: *Haman Begs Esther for Mercy*, ca. 1638
[not exhibited]

Pen and brown ink, isolated strokes of red chalk unrelated to the
composition (recto), pen and brown ink, brush and brown wash,
black chalk, white gouache heightening (verso), 14.9 × 17 cm
(5⅞ × 6¹¹⁄₁₆ in.)
Kunsthalle, Kupferstichkabinett, Der Kunstverein in Bremen,
09/730

MARKS AND INSCRIPTIONS: None.

SELECTED BIBLIOGRAPHY: Sumowski, *Drawings*, 2336ˣˣ; Bremen
2000–01, no. 94 (for full bibliography); Bevers 2007, pp. 42–46.

19.1 Rembrandt
Ruth and Naomi, ca. 1638–39
Verso: *Joseph Relating His Dreams*, ca. 1638
[not exhibited]

Pen and brown ink on light brown prepared paper (recto),
red chalk (verso), 18 × 12.5 cm (7¹⁄₁₆ × 4¹⁵⁄₁₆ in.)
Rotterdam, Museum Boijmans Van Beuningen, MB 1958/T32

MARKS AND INSCRIPTIONS: None.

SELECTED BIBLIOGRAPHY: Benesch 161; Giltaij 1988, no. 13
(for full bibliography); Rotterdam 2005–06, no. 8.

19.2 Jan Victors
Lot and His Family Departing from Sodom,
ca. 1638–39
Verso: *Abraham's Sacrifice*, ca. 1638–39
[not exhibited]

Pen and brown ink, brush and brown wash (recto), black chalk,
pen and brown ink, brush and brown wash, with lead white
heightening (oxidized) (verso), 22.6 × 23.5 cm (8¹⁵⁄₁₆ × 9¼ in.)
Vienna, Albertina, 8767

MARKS AND INSCRIPTIONS: Collection mark of Albert von
Sachsen Teschen (L. 174) in the bottom left corner.

SELECTED BIBLIOGRAPHY: Benesch 129; Sumowski, *Drawings*,
2329ˣˣ (verso only); Bevers 2007, pp. 52–54.

Carel Fabritius

20.1 Rembrandt
The Return of the Prodigal Son, ca. 1642

Pen and brown ink, brush and brown wash, white heightening,
19.1 × 22.7 cm (7⁹⁄₁₆ × 8¹⁵⁄₁₆ in.)
Haarlem, Teylers Museum, O*48

MARKS AND INSCRIPTIONS: Inscription on the verso in the
upper right in pencil (?), *28-f – I st*; inscription in the middle
left in graphite, *108*; collection mark of J. de Vos Jbz. (L. 1450);
watermark of a cockatrice (cf. Churchill, nos. 286, 575 and
Heawood, no. 845).

SELECTED BIBLIOGRAPHY: Benesch 519; Plomp 1997, no. 326
(for full bibliography); Schatborn 2006, pp. 131–32.

20.2 Carel Fabritius
The Liberation of Saint Peter, mid-1640s

Pen and brown ink, brush and blue-gray wash,
16.7 × 15.6 cm (6⁹⁄₁₆ × 6¹⁄₈ in.)
Amsterdam, Rijksmuseum, Rijksprentenkabinet,
Gift of Mr. Cornelius Hofstede de Groot, 1906, RP-T-1930-31

MARKS AND INSCRIPTIONS: Inscription on the verso in the
lower left in pencil, *18, 44*, in the upper left in pencil, *Gelder*,
in the middle, in violet pencil, *127*; collection mark of the
Rijksprentenkabinet (L. 2228); watermark of a wreath of laurels
and tower gate (?).

SELECTED BIBLIOGRAPHY: Sumowski, *Drawings*, 220ˣ (as Bol);
Schatborn 1985A, no. 63 (for full bibliography); Schatborn 2006,
pp. 130–31.

21.1 Rembrandt
Two Men in Oriental Dress in Discussion, 1641

Pen and brown ink, with corrections in white,
22.8 × 18.4 cm (9 × 7¼ in.)
London, The Samuel Courtauld Trust, The Courtauld Gallery,
D.1978.PG.190

MARKS AND INSCRIPTIONS: Signed and dated in the lower right,
Rembrandt f. 1641.

SELECTED BIBLIOGRAPHY: Benesch 500a.

21.2 Carel Fabritius
The Messenger Presenting Saul's Crown to David,
mid-1640s

Pen and brown ink, brush and brown and gray washes,
16.9 × 19.3 cm (6⅝ × 7⅝ in.)
Amsterdam, Rijksmuseum, Rijksprentenkabinet,
Gift of Mr. Cornelius Hofstede de Groot, 1906, RP-T-1930-15

MARKS AND INSCRIPTIONS: Collection mark in the lower left
of Thomas Lawrence (L. 2445) and William Esdaile (L. 2617);
on the verso in the middle, the collection mark of the
Rijksprentenkabinet (L. 2228); inscription on the verso in pen,
1835 WE (L. 1617) and *Rembrandt.*

SELECTED BIBLIOGRAPHY: Benesch 506; Schatborn 1985A, no. 61
(for full bibliography); Schatborn 2006, pp. 130–31.

Samuel van Hoogstraten

22.1 Rembrandt
The Holy Family in the Carpenter's Workshop,
ca. 1645

Pen and brown ink, brush and grayish brown wash, touches
of red chalk and white gouache corrections, 18.4 × 24.6 cm
(7¼ × 9¹¹⁄₁₆ in.)
London, The British Museum, 1900,0824.144

MARKS AND INSCRIPTIONS: None.

SELECTED BIBLIOGRAPHY: Benesch 516; Royalton-Kisch 1992,
no. 43 (for additional bibliography); Royalton-Kisch 2008–09,
Rembrandt, no. 39.

22.2 Samuel van Hoogstraten
The Adoration of the Shepherds, ca. 1646–47

Pen and brown ink, brush and brown wash over sketch in
black chalk, some red chalk and white gouache heightening,
15.3 × 20.4 cm (6 × 8¹⁄₁₆ in.)
Hamburg, Kunsthalle, 22050

MARKS AND INSCRIPTIONS: Signed in the lower right in brown
ink, *S v Hoogstraten*; collection mark of William Esdaile (L. 2617)
in the lower right.

SELECTED BIBLIOGRAPHY: Sumowski, *Drawings*, 1102;
Sumowski, *Paintings*, under 823; Bremen 2000–01, no. 33 (for full
bibliography).

23.1 Rembrandt
Peter's Vision of the Unclean Beasts, ca. 1645–47

Pen and brown ink with white gouache corrections; a strip
of paper 5 mm wide attached to left side of sheet, additions in
gray ink by later hand at left edge, lower left, and bottom,
17.9 × 19.3 cm (7¹⁄₁₆ × 7⅝ in.)
Munich, Staatliche Graphische Sammlung, 1392

MARKS AND INSCRIPTIONS: Collection mark of Counts Palatine
(L. 620) and associated number in brown ink, *5151*, in the lower
left; in the lower right, blind stamp of Bavarian electoral collection
(L. 2723) and associated number in blue ink, *70*.

SELECTED BIBLIOGRAPHY: Benesch 1039; Sumowski, *Drawings*,
under 1127ˣ; Munich and Amsterdam 2001–02, no. 66 (for full
bibliography).

23.2 Samuel van Hoogstraten
Peter's Vision of the Unclean Beasts, ca. 1646–47

Pen and brown and gray ink, brush and brown and gray washes,
red and black chalk with white gouache heightening and
corrections; original framing line in brown ink, 25 × 15.8 cm
(9¹³⁄₁₆ × 6¼ in.)
Stockholm, Nationalmuseum, NMH 1986/1863

MARKS AND INSCRIPTIONS: Inscribed in brown ink in the
lower right, *33*, inventory no. of C. G. Tessin, *85* (crossed out),
inventory no. of the Kungliga Biblioteket, *1793*, inventory no.
of the Nationalmuseum, Stockholm, *1986*, mark of the Kungliga
Museum (L. 1638).

SELECTED BIBLIOGRAPHY: Sumowski, *Drawings*, 1127ˣ;
Stockholm 1992–93, no. 181; Munich and Amsterdam 2001–02,
under nos. 66, 67 (for full bibliography).

24.1 Rembrandt
The Baptism of the Eunuch, ca. 1650–52

Pen and brown ink, partially incised, 18.2 × 21.1 cm
(7³⁄₁₆ × 8⁵⁄₁₆ in.)
Ottawa, National Gallery of Canada, 18909

MARKS AND INSCRIPTIONS: Collection mark of Henri Dumesnil
(L. 739) in the lower left.

SELECTED BIBLIOGRAPHY: Benesch 909; Sumowski, *Drawings,*
under 1244ˣ; Ottawa, Cambridge, and Fredericton 2003–05,
no. 44 (for full bibliography).

24.2 Samuel van Hoogstraten
The Baptism of the Eunuch, ca. 1656–60

Pen and brown ink, 15.1 × 21.8 cm (5¹⁵⁄₁₆ × 8⁹⁄₁₆ in.)
Ottawa, National Gallery of Canada, Gift of Marianne Seger,
42006

MARKS AND INSCRIPTIONS: None.

SELECTED BIBLIOGRAPHY: Sumowski, *Drawings,* 1244ˣ;
Ottawa, Cambridge, and Fredericton 2003–05, no. 45 (for full
bibliography).

Abraham Furnerius

25.1 Rembrandt
Houses on the Bulwark "The Rose," Amsterdam,
ca. 1645–50

Pen and brown ink, brush and brown wash on brown tinted paper,
13.5 × 21.1 cm (5⁵⁄₁₆ × 8⁵⁄₁₆ in.)
Budapest, Szépművészeti Múzeum, 1578

MARKS AND INSCRIPTIONS: Framing lines in brown ink;
collection marks of A. C. Poggi (L. 617) in the lower right, Nicholas
Esterházy (L. 1965) in the lower left, and Országos Képtár
(L. 2000) on the verso.

SELECTED BIBLIOGRAPHY: Lugt 1920, p. 79, fig. 38; Benesch
1264; Washington 1990, pp. 222–23, no. 66; Amsterdam and
Paris 1998–99, pp. 196–200; Gerszi 2005, no. 205 (for further
bibliography); Budapest 2006, no. 103.

25.2 Abraham Furnerius
A House on the Bulwark "The Rose," Amsterdam,
ca. 1645–50

Pen and brown ink, brush and brown, red, and gray-blue washes,
16.5 × 23.1 cm (6½ × 9⅛ in.)
Haarlem, Teylers Museum, P*65

MARKS AND INSCRIPTIONS: Framing line in pen and gray ink
along the bottom; watermark of a foolscap (cf. Churchill, nos.
339, 344); inscribed on the verso in the upper center in red chalk,
fürnerüs f 1-10, perhaps in 17th-century handwriting; inscription
in pencil at lower left, *p* 94;* collection marks of Teylers Museum
(L. 2392) in the lower left on the verso.

SELECTED BIBLIOGRAPHY: Scholten 1904, p. 179; Lugt 1920,
p. 79, fig. 40; Sumowski, *Drawings,* 1022ˣˣ; Plomp 1997, vol. 2,
no. 157 (for full bibliography).

Nicolaes Maes

26.1 Rembrandt
Simeon and the Christ Child, ca. 1640

Black chalk, white gouache heightening, 14.4 × 15.3 cm
(5¹¹⁄₁₆ × 6 in.)
Berlin, Staatliche Museen, Kupferstichkabinett, KdZ 4269

MARKS AND INSCRIPTIONS: Collection mark of William Bates
(L. 2604) in the lower right.

SELECTED BIBLIOGRAPHY: Benesch 575; Munich and Amsterdam
2001–02, pp. 37–38, and under no. 54; Bevers 2006, pp. 102–4,
no. 25 (for full bibliography).

26.2 Nicolaes Maes
The Adoration of the Shepherds, ca. 1658
Recto: *Isaac Blessing Jacob,* ca. 1658
[not exhibited]

Red chalk (verso), pen and brown ink, brush and brown wash
(recto), 15.8 × 13.6 cm (6¼ × 5⅜ in.)
Rotterdam, Museum Boijmans Van Beuningen, Koenigs
Collection, R. 54

MARKS AND INSCRIPTIONS: Inscribed in the center in graphite,
JG (L. 1460d), in the upper left in graphite, *54;* collection mark of
Franz Koenigs (L. 1023a) in the upper right.

SELECTED BIBLIOGRAPHY: Sumowski, *Drawings,* 1765;
Sumowski, *Paintings,* under 1318; Giltaij 1988, no. 113 verso
(for full bibliography); Robinson 1996, pp. 161–62 and 239–40,
no. A-4b.

27.1 Rembrandt
Old Woman with a Large Headdress, ca. 1640–43

Black chalk, 13.8 × 10.9 cm (5⁷⁄₁₆ × 4⁵⁄₁₆ in.)
London, The Samuel Courtauld Trust, The Courtauld Gallery,
D.1978.PG.191

MARKS AND INSCRIPTIONS: Collection mark of Friedrich
August II (L. 971) in the lower right.

SELECTED BIBLIOGRAPHY: Benesch 684; Edinburgh and London
2001, no. 89 (for full bibliography).

27.2 Rembrandt
Old Woman Seated, ca. 1647

Red chalk, 23.7 × 15.7 cm (9⁵⁄₁₆ × 6³⁄₁₆ in.)
Paris, Musée du Louvre, Département des Arts graphiques,
193 D.R.

MARKS AND INSCRIPTIONS: An illegible mark in the lower left,
possibly the mark of Paul Sandby (L. 2112).

SELECTED BIBLIOGRAPHY: Benesch 310; Paris 1988–89,
no. 14; Edinburgh and London 2001, under nos. 89 and 121;
Leiden 2005–06, under no. 30; Paris 2006–07, no. 15 (for full
bibliography).

27.3 Nicolaes Maes
Old Woman Asleep, ca. 1655

Red chalk, 17.8 × 15.1 cm (7 × 5¹⁵⁄₁₆ in.)
Paris, Frits Lugt Collection, Institut Néerlandais, 588

MARKS AND INSCRIPTIONS: None.

SELECTED BIBLIOGRAPHY: Sumowski, *Drawings,* 1811ˣ
(for full bibliography).

28.1 Rembrandt
Joseph Sold into Slavery by His Brothers, ca. 1652

Pen and brown ink, smudged in places, with white gouache corrections, 15.6 × 20.5 cm (6⅛ × 8¹/₁₆ in.)
Berlin, Staatliche Museen, Kupferstichkabinett, KdZ 1119

MARKS AND INSCRIPTIONS: Collection mark of Barthold Suermondt (L. 415) in the lower right.

SELECTED BIBLIOGRAPHY: Benesch 876; Melbourne and Canberra 1997–98, no. 92; Boston and Chicago 2003–04, no. 175; Bevers 2006, no. 46 (for full bibliography).

28.2 Nicolaes Maes
Sheet of Studies of Eavesdroppers, ca. 1655
Verso: *Studies of Abraham*, ca. 1655 [not exhibited]

Pen and brown ink, brush and brown wash (recto), red chalk (verso), 9.8 × 19 cm (3⅞ × 7½ in.)
Rotterdam, Museum Boijmans Van Beuningen, Koenigs Collection, R. 63

MARKS AND INSCRIPTIONS: Collection mark of the Earl of Dalhousie (L. 717a) in the lower left.

SELECTED BIBLIOGRAPHY: Sumowski, *Drawings*, 1770; Sumowski, *Paintings*, under 1349, 1354, 1355; Giltaij 1988, no. 116 (for full bibliography); Robinson 1996, pp. 122, 243, no. A12b.

29.1 Rembrandt
Landscape with the House with the Little Tower, ca. 1651

Pen and brown ink, brush and brown wash, 9.7 × 21.5 cm (3¹³/₁₆ × 8⁷/₁₆ in.)
Los Angeles, The J. Paul Getty Museum, 83.GA.363

MARKS AND INSCRIPTIONS: None.

SELECTED BIBLIOGRAPHY: Benesch 1267; Goldner 1988, no. 118 (for full bibliography); Amsterdam and Paris 1998–99, no. V-3.5; Boston and Chicago 2003–04, no. 186; Schwartz 2006, p. 261.

29.2 Nicolaes Maes
View of Dordrecht, ca. 1653

Pen and brown ink, brush and brown wash, touches of white gouache heightening, 12.3 × 25.7 cm (4¹³/₁₆ × 10⅛ in.)
Cambridge, Harvard Art Museum/Fogg Museum, Bequest of Frances L. Hofer, 1979.210

MARKS AND INSCRIPTIONS: Inscribed in brown ink, *Dordregt* in the lower center; collection mark of E. V. Utterson (L. 909) in the lower right.

SELECTED BIBLIOGRAPHY: Robinson 1989, pp. 159–60 (for full bibliography).

Constantijn Daniel van Renesse

30.1 Rembrandt
Daniel in the Lions' Den, 1649

Pen and brown ink, brush and brown wash, with some lead white heightening (partly oxidized), 22.2 × 18.5 cm (8¾ × 7⁵/₁₆ in.)
Amsterdam, Rijksmuseum, Rijksprentenkabinet, Gift of Mr. Cornelius Hofstede de Groot, 1906, RP-T-1930-17

MARKS AND INSCRIPTIONS: None.

SELECTED BIBLIOGRAPHY: Benesch 887; Schatborn 1985A, no. 24 (for full bibliography); Schapelhouman 2006, pp. 96–97; Schwartz 2006, p. 124.

30.2 Constantijn Daniel van Renesse
Daniel in the Lions' Den, 1649–52
Verso: *Inscription* [not exhibited]

Black chalk, pen and brown ink, brush and brown wash, heightened with white (recto); pen and brown ink (verso), 20.6 × 32 cm (8⅛ × 12⅝ in.)
Rotterdam, Museum Boijmans Van Beuningen, MB 200

MARKS AND INSCRIPTIONS: Inscription in the bottom right in Van Renesse's hand in brown ink, *CARenesse inventor / et fecit 1652*; inscription on the verso in Van Renesse's hand in brown ink, *CARenesse / de eerste tijckening getoont Bij RemBramt in Jaer 1649 den 1 october / het waert voor de tweede mael dat ick bij Rembrant geweest ben.*

SELECTED BIBLIOGRAPHY: Sumowski, *Drawings*, 2145; Giltaij 1988, no. 130 (for full bibliography); Rotterdam 2005–06, no. 87; Schwartz 2006, pp. 125–26.

31.1 Rembrandt
The Return from Egypt, ca. 1652

Pen and brown ink, slightly washed, corrections in white gouache, 19.3 × 24.1 cm (7⅝ × 9½ in.)
Berlin, Staatliche Museen, Kupferstichkabinett, KdZ 5262

MARKS AND INSCRIPTIONS: None.

SELECTED BIBLIOGRAPHY: Benesch 902; Bevers 2006, no. 45 (for full bibliography).

31.2 Constantijn Daniel van Renesse
The Return from Egypt, ca. 1652
Verso: *Inscription* [not exhibited]

Black chalk, pen and brown and gray ink, brush and gray wash, red chalk, with white heightening (recto), pen and brown ink (verso), 19.5 × 22.3 cm (7¹¹/₁₆ × 8¾ in.)
Dresden, Staatliche Kunstsammlungen, Kupferstich-Kabinett, C 1443

MARKS AND INSCRIPTIONS: Inscription in brown ink in the bottom right corner, *25*; inscription in brown ink on the verso in an anonymous hand or in Van Renesse's hand, *Beeter waert dat (om de veranderin) / den eesel van achteren was / dan dat al de / hoofden iuist uit het stuck sien / dat oock omtrent die boom wat meerder / groente was / . . . 1 josep heft alte swaer en te onbesuist / 2 maria most het kindeken wat meerder vieren / want een teeder kint magh sulck duwen niet ve[len?] // josep alte kort en dick / syn hoofd wast hem wt de [borst, romp?] / sij hebben alle beide al te groote koppen.*

SELECTED BIBLIOGRAPHY: Dresden 2004, no. 14 (for full bibliography); Bevers 2006, no. 45; Schwartz 2006, p. 126.

32.1 Rembrandt
Road with Trees and a Bridge Leading to a House,
ca. 1660

Pen and brown ink, brush and gray-brown wash on light brown cartridge paper, 13.5 × 20.4 cm (5⁵⁄₁₆ × 8¹⁄₁₆ in.)
Amsterdam, Rijksmuseum, Rijksprentenkabinet,
Gift of Mr. and Mrs. De Bruijn-Van der Leeuw, 1949, RP-T-1961-85

MARKS AND INSCRIPTIONS: None.

SELECTED BIBLIOGRAPHY: Benesch 1368; Schatborn 1985A,
no. 51 (for full bibliography); Schapelhouman 2006, pp. 67–68.

32.2 Constantijn Daniel van Renesse
Cottages beneath High Trees in Bright Sunlight,
ca. 1660
Verso: *Studies of Three Heads,* ca. 1660
[not exhibited]

Pen and brown ink, brush and brown wash (recto), black chalk (verso), 19.6 × 31.1 cm (7³⁄₄ × 12¹⁄₄ in.)
Berlin, Staatliche Museen, Kupferstichkabinett, KdZ 2694

MARKS AND INSCRIPTIONS: None.

SELECTED BIBLIOGRAPHY: Benesch 1367; Royalton-Kisch 2000,
pp. 162–63; Bevers 2006, pp. 202–3 (for full bibliography).

Willem Drost

33.1 Rembrandt
Manoah's Offering, ca. 1652

Pen and brown ink, partially rubbed with a finger or a dry brush,
20.8 × 18 cm (8³⁄₁₆ × 7¹⁄₈ in.)
Paris, Frits Lugt Collection, Institut Néerlandais, 5803

MARKS AND INSCRIPTIONS: In the bottom right corner,
collection mark of Jonathan Richardson Senior (L. 2184) and
collection inscription of Charles Rogers (L. 624).

SELECTED BIBLIOGRAPHY: Benesch 980; Paris and Haarlem
1997–98, no. 15 (for full bibliography).

33.2 Willem Drost
The Angel Departing from the Family of Tobit,
ca. 1652

Pen and brown ink, partially rubbed with a finger or a dry brush,
19.3 × 24.5 cm (7⁵⁄₈ × 9⁵⁄₈ in.)
New York, The Pierpont Morgan Library, I, 197

MARKS AND INSCRIPTIONS: In the bottom right, collection
marks of Jonathan Richardson Senior (L. 2184) and Henry Reveley
(L. 1356).

SELECTED BIBLIOGRAPHY: Benesch 893; Berlin, Amsterdam, and
London 1991–92, vol. 2, p. 144, no. 46; Turner 2006, vol. 1, p. 57,
no. 62 (for full bibliography).

34.1 Rembrandt
Cain Slaying Abel, ca. 1652

Pen and brown ink, the ink smudged in places with a finger
or a dry brush, with lead white, 16.8 × 24.7 cm (6⁵⁄₈ × 9³⁄₄ in.)
Copenhagen, Statens Museum for Kunst, KKS 10097

MARKS AND INSCRIPTIONS: In the bottom left, collection mark
of Sir Thomas Lawrence (L. 2445) and collection inscription of
William Esdaile (L. 2617).

SELECTED BIBLIOGRAPHY: Benesch 860; Copenhagen 1996,
no. 2 (for full bibliography); Boston and Chicago 2003–04, no. 177.

34.2 Willem Drost
Lamentation on the Death of Abel, ca. 1652
Verso: *Study for the Figure of Abel,* ca. 1652
[not exhibited]

Pen and brown ink with lead white (recto), pen and brown ink
(verso), 19.4 × 28.7 cm (7⁵⁄₈ × 11⁵⁄₁₆ in.)
Berlin, Staatliche Museen, Kupferstichkabinett, KdZ 1115

MARKS AND INSCRIPTIONS: None.

SELECTED BIBLIOGRAPHY: Benesch 955; Sumowski, *Drawings,*
553ˣ; Bevers 2006, pp. 209–10.

35.1 Rembrandt
A Thatched Cottage by a Large Tree, ca. 1650

Pen and brown ink, rubbed in spots, 17.5 × 26.7 cm (6⁷⁄₈ × 10¹⁄₂ in.)
Chatsworth, The Duke of Devonshire and the Trustees of the
Chatsworth Settlement, 1046

MARKS AND INSCRIPTIONS: In the bottom left corner, collection
mark of Nicolaes Anthoni Flinck (L. 959).

SELECTED BIBLIOGRAPHY: Benesch 1282; Jaffé 2002, vol. 3,
no. 1482 (for full bibliography); Schwartz 2006, pp. 257–58.

35.2 Willem Drost
A Thatched Cottage by a Large Tree, ca. 1650

Pen and brown ink, rubbed in spots, 15.5 × 26.1 cm (6¹⁄₈ × 10¹⁄₄ in.)
Wroclaw, Museum of the Lubomirski Princes, The Ossoliński
National Institute, 8725

MARKS AND INSCRIPTIONS: None.

SELECTED BIBLIOGRAPHY: Benesch 1283; Wroclaw 1998, no. 11;
Schwartz 2006, pp. 257–58.

Rembrandt pupil

36.1 Rembrandt
The Mocking of Christ, ca. 1650–55

Pen and brown ink, 15.6 × 21.7 cm (6³⁄₁₆ × 8⁹⁄₁₆ in.)
New York, Gift of J. P. Morgan, Jr., 1924,
The Pierpont Morgan Library and Museum, I, 189

MARKS AND INSCRIPTIONS: Faint traces of an inscription (now
erased) in the lower right, in brown ink ... 3(?); inscribed on verso
of lining, in the center, in graphite (nearly erased), *Roscoes Collⁿ /
nr. 607.*

SELECTED BIBLIOGRAPHY: Benesch 920; Turner 2006, vol. 1,
p. 151, no. 223 (for full bibliography).

36.2 Rembrandt pupil
The Mocking of Christ, ca. 1650–55

Pen and brown ink, 18.1 × 24.6 cm (7⅛ × 9¹¹⁄₁₆ in.)
Los Angeles, The J. Paul Getty Museum, 83.GA.358

MARKS AND INSCRIPTIONS: In the bottom left, collection mark of Léon Bonnat (L. 1714).

SELECTED BIBLIOGRAPHY: Benesch 1024; Goldner 1988, pp. 268–69, no. 120 (for full bibliography).

Pieter de With

37.1 Rembrandt
Farmhouse and a Haystack, ca. 1652

Pen and brown ink, brush and brown wash, with white heightening on gray-brown paper, 14.3 × 27 cm (5⅝ × 10⅝ in.)
Paris, Frits Lugt Collection, Institut Néerlandais, 302

MARKS AND INSCRIPTIONS: Watermark of a Latin cross in a shield with a crown and the letters *DP* below (cf. Heawood 962).

SELECTED BIBLIOGRAPHY: Benesch 1296; Paris and Haarlem 1997–98, no. 17 (for full bibliography).

37.2 Pieter de With
Farmhouse and a Haystack, ca. 1652
Verso: *A Tree near the Entrance of a House*, ca. 1652

Pen and brown ink, brush and brown wash, some gouache white heightening (oxidized) (recto), pen and dark brown ink (verso), 11.6 × 20.2 cm (4⁹⁄₁₆ × 7¹⁵⁄₁₆ in.)
Chatsworth, The Duke of Devonshire and the Trustees of the Chatsworth Settlement, 1041AB

MARKS AND INSCRIPTIONS: Collection mark of Nicolaes Anthoni Flinck (L. 959) in the lower right.

SELECTED BIBLIOGRAPHY: Benesch 1294; Amsterdam and Paris 1998–99, p. 295; Jaffé 2002, no. 1486; Schatborn 2005, p. 7.

38.1 Rembrandt
Farmhouse on the Schinkel Road, Looking toward Amsterdam, ca. 1650

Pen and brown ink, brush and dark brown wash and light brown wash (probably applied later) on light brown prepared paper, 9.4 × 17.2 cm (3¹¹⁄₁₆ × 6¾ in.)
Berlin, Staatliche Museen, Kupferstichkabinett, KdZ 3116

MARKS AND INSCRIPTIONS: None.

SELECTED BIBLIOGRAPHY: Benesch 835; Bevers 2006, no. 41 (for full bibliography).

38.2 Pieter de With
Farmhouse on the Schinkel Road, Looking toward Amsterdam, ca. 1650

Pen and brown ink, brush and brown wash on brownish prepared paper, 10.7 × 14.4 cm (4³⁄₁₆ × 5¹¹⁄₁₆ in.)
Berlin, Staatliche Museen, Kupferstichkabinett, KdZ 1137

MARKS AND INSCRIPTIONS: None.

SELECTED BIBLIOGRAPHY: Benesch 1293; Schatborn 2005, pp. 8 and 12; Bevers 2006, p. 204.

Arent de Gelder

39.1 Rembrandt
Isaac and Rebecca Spied Upon by Abimelech, ca. 1662

Pen and brown ink with white gouache corrections, 14.5 × 18.5 cm (5⁵⁄₁₆ × 7⁵⁄₁₆ in.)
Collection of Sarah-Ann and Werner H. Kramarsky

MARKS AND INSCRIPTIONS: None.

SELECTED BIBLIOGRAPHY: Benesch 988; New York 1988, no. 35; Royalton-Kisch 1992, under nos. 62 and 107, note 2; Dordrecht and Cologne 1998–99, p. 114; Royalton-Kisch 2008–09, under Rembrandt, no. 56.

39.2 Arent de Gelder
Men in Middle Eastern Costume, ca. 1660–62

Pen and brown ink, brush and brown wash with touches of white gouache heightening, 15.1 × 19.5 cm (5¹⁵⁄₁₆ × 7¹¹⁄₁₆ in.)
The Maida and George Abrams Collection, Boston, on loan to the Harvard Art Museum/Fogg Museum, Cambridge, 25.1998.123

MARKS AND INSCRIPTIONS: None.

SELECTED BIBLIOGRAPHY: Sumowski, *Drawings*, 1052; Schatborn 1985A, under nos. 67–68; Berlin, Amsterdam, and London 1991–92, vol. 2, no. 47; Royalton-Kisch 1992, under nos. 62 and 105; Dordrecht and Cologne 1998–99, no. 58; London, Paris, and Cambridge 2002–03, no. 54; Bevers 2006, p. 214; Royalton-Kisch 2008–09, under Rembrandt, no. 56, and under Arent de Gelder (attributed to), nos. 1 and 2.

40.1 Rembrandt
Simeon and the Christ Child, from the Heyblocq Album, 1661

Pen and brown ink, brush and brown wash, original arched-top frame, 12 × 8.9 cm (4¾ × 3½ in.)
The Hague, Koninklijke Bibliotheek, shelf mark 131 H26, p. 61

MARKS AND INSCRIPTIONS: Signed in the lower center in brown ink, *Rembrandt f. 1661*.

SELECTED BIBLIOGRAPHY: Benesch 1057; Sumowski, *Drawings*, under 1078ˣˣ; Schwartz 2006, p. 366; Schwartz 2007, pp. 170–72; Royalton-Kisch 2008–09, no. 56.

40.2 Arent de Gelder
Simeon and the Christ Child, ca. 1661–62

Pen and brown ink, brush and brown and grayish brown washes, white gouache corrections, 16.4 × 18.9 cm (6⁷⁄₁₆ × 7⁷⁄₁₆ in.)
Private Collection

MARKS AND INSCRIPTIONS: Inscribed in black chalk in the lower right, *Rembran*; collection mark of William Esdaile (L. 2617) in the lower right.

SELECTED BIBLIOGRAPHY: Sumowski, *Drawings*, 1078ˣˣ; Bolten and Folmer-von Oven 1989, no. 69; Dordrecht and Cologne 1998–99, no. 66; Schwartz 2007, p. 171.

41.1 Rembrandt
Seated Female Nude, ca. 1660

Pen and brown ink, brush and brown wash, corrected with white gouache, 21.1 × 17.7 cm (8 5/16 × 6 15/16 in.)
The Art Institute of Chicago, Clarence Buckingham Collection, 1953.38

MARKS AND INSCRIPTIONS: Collection mark of J. Corot (L. 1718) in the lower left.

SELECTED BIBLIOGRAPHY: Benesch 1122; Berlin, Amsterdam, and London 1991–92, vol. 2, no. 38; Boston and Chicago 2003–04, no. 200.

41.2 Arent de Gelder
Seated Female Nude, ca. 1660–62
Verso: *Bust of a Seated Female Nude*, ca. 1660–62 [not exhibited]

Pen and brown ink, brush and brown wash, corrected with white gouache (recto), pen and brown ink (verso), 29.2 × 19.5 cm (11 1/2 × 7 11/16 in.)
Rotterdam, Museum Boijmans Van Beuningen, Koenigs Collection, R 1

MARKS AND INSCRIPTIONS: Collection marks in the lower right of E. Rodrigues (L. 997) and Baron R. Portalis (L. 2232); inscribed on the verso in pencil, *12 Rembrandt* and *41*; collection mark in the lower left on the verso of F. Koenigs (L. 1023a).

SELECTED BIBLIOGRAPHY: Benesch 1121; Giltaij 1988, no. 185 (for full biliography); Berlin, Amsterdam, and London 1991–92, vol. 2, no. 49; Dordrecht and Cologne 1998–99, p. 117, no. 64; Boston and Chicago 2003–04, p. 290.

Johannes Raven

42.1 Rembrandt
The Woman with the Arrow, 1661

Etching, drypoint and burin, second state,
20.5 × 14.8 cm (8 1/16 × 5 13/16 in.)
Pasadena, Norton Simon Art Foundation, M.1977.32.115G

MARKS AND INSCRIPTIONS: Signed and dated, *Rembrndt f. 1661* (the d reversed) in the lower left.

SELECTED BIBLIOGRAPHY: B. 202 and Hollstein 202; Hinterding 2008, no. 159 (for full bibliography).

42.2 Johannes Raven
Seated Female Nude, Surrounded by Drapery, 1661

Pen and brown ink, brush and brownish gray wash, light gray wash, and brown wash, with white heightening, 29.7 × 18.5 cm (11 11/16 × 7 5/16 in.)
London, The British Museum, 1859,0806.85

MARKS AND INSCRIPTIONS: Inscription at the top right in pen and brown ink, *59*, and at the lower right, collection mark of Richard Houlditch (L. 2214) and his inscription.

SELECTED BIBLIOGRAPHY: Benesch 1147; Royalton-Kisch 1992, no. 106 (for full bibliography); Hinterding 2008, under no. 159.

43.1 Rembrandt
Seated Female Nude, ca. 1661

Pen and brown ink, brush and brown wash, black chalk (?), corrected and heightened with white, on ledger paper, 29.2 × 17.5 cm (11 1/2 × 6 7/8 in.)
Amsterdam, Rijksmuseum, Rijksprentenkabinet, RP-T-00-227

MARKS AND INSCRIPTIONS: Inscribed on the verso in the lower left, *Leiden*; watermark of Fisch in a double circle and *CARTUS MARIA PARAD*.

SELECTED BIBLIOGRAPHY: Benesch 1142; Schatborn 1985A, no. 55 (for full bibliography); Royalton-Kisch 1992, under no. 107 (not Rembrandt); Munich and Amsterdam 2001–02, no. 11; Schapelhouman 2006, p. 29.

43.2 Johannes Raven
Seated Female Nude, ca. 1661

Pen and brown ink, brush and gray-brown and brown washes, black chalk (?), corrected and heightened with white (oxidized), 28.6 × 16.2 cm (11 1/4 × 6 3/8 in.)
London, The British Museum, 1895,1214.102

MARKS AND INSCRIPTIONS: None.

SELECTED BIBLIOGRAPHY: Benesch 1143; Royalton-Kisch 1992, no. 107 (for full bibliography).

Works Cited

Prepared by V. S. Lobis

Exhibition Catalogues (listed by city)

AMSTERDAM 1973
Hollandse genre-tekeningen uit de 17de eeuw. Amsterdam, Rijksmuseum, Rijksprentenkabinet, 1973. Catalogue by Peter Schatborn.

AMSTERDAM 1984–85
Bij Rembrandt in de leer. Amsterdam, Museum het Rembrandthuis, 1984–85. Catalogue by Eva Ornstein-van Slooten; introduction by Peter Schatborn.

AMSTERDAM 1987–88
Dossier Rembrandt: Documenten, tekeningen en prenten. Amsterdam, Museum het Rembrandthuis, 1987–88. Catalogue by S. A. C. Dudok van Heel, Peter Schatborn, and Eva Ornstein-van Slooten.

AMSTERDAM 1988–89
Jan Lievens: Prenten en Tekeningen. Amsterdam, Museum het Rembrandt-huis, 1988–89. Catalogue by Eva Ornstein-van Slooten; introduction by Peter Schatborn.

AMSTERDAM 1991–92
Pieter Lastman: Leermeester Van Rembrandt. Amsterdam, Museum het Rembrandthuis, 1991–92. Catalogue by Astrid Tümpel and Peter Schatborn.

AMSTERDAM 1996
Rembrandt and Van Vliet: A Collaboration on Copper. Amsterdam Museum het Rembrandthuis, 1996. Catalogue by Christiaan Schuckman, Martin Royalton-Kisch, and Erik Hinterding.

AMSTERDAM 1999
Goethe en Rembrandt: Tekeningen uit Weimar. Amsterdam, Museum het Rembrandthuis, 1999. Catalogue by Bob van den Boogert, Charles Dumas, Leonoor van Oosterzee, and Peter Schatborn.

AMSTERDAM AND BERLIN 2006
Rembrandt: Quest of a Genius. Amsterdam, Museum het Rembrandthuis, and Berlin, Staatliche Museen, Gemäldegalerie, 2006. Catalogue by Ernst van de Wetering; with contributions by Michiel Franken, Jan Kelch, Bernd Lindemann, Volker Manuth, and Christian Tümpel. Edited by Bob van den Boogert.

AMSTERDAM AND LONDON 2000–01
Rembrandt the Printmaker. Amsterdam, Rijksmuseum, Rijksprenten-kabinet, and London, British Museum, 2000–01. Catalogue by Erik Hinterding, Ger Luijten, and Martin Royalton-Kisch; with contributions by Marijn Schapelhouman, Peter Schatborn, and Ernst van de Wetering.

AMSTERDAM AND PARIS 1998–99
Landscapes of Rembrandt: His Favourite Walks. Amsterdam, Gemeentearchief, and Paris, Institut Néerlandais, 1998–99. Catalogue by Boudewijn Bakker, Mària van Berge-Gerbaud, Erik Schmitz, and Jan Peeters.

AMSTERDAM AND WASHINGTON 1981–82
Dutch Figure Drawings from the Seventeenth Century. Amsterdam, Rijksmuseum, Rijksprentenkabinet, and Washington, D.C., National Gallery of Art, 1981–82. Catalogue by Peter Schatborn.

AMSTERDAM, VIENNA, NEW YORK, AND CAMBRIDGE 1991–92
Seventeenth-Century Dutch Drawings: A Selection from the Maida and George Abrams Collection. Amsterdam, Rijksmuseum, Rijksprentenkabinet; Vienna, Graphische Sammlung Albertina; New York, Pierpont Morgan Library; and Cambridge, Mass., Fogg Art Museum, 1991–92. Catalogue by William W. Robinson; introduction by Peter Schatborn.

BERLIN 2007–08
Disegno: Der Zeichner im Bild der Frühen Neuzeit. Berlin, Staatliche Museen, Kupferstichkabinett, 2007–08. Catalogue by Hein-Th. Schulze Altcappenberg and Michael Thimann; with Heiko Damm and Ulf Sölter.

BERLIN, AMSTERDAM, AND LONDON 1991–92
Rembrandt: Der Meister und seine Werkstatt. 2 vols. Berlin, Gemäldegalerie and Kupferstichkabinett in Alten Museum; Amsterdam, Rijksmuseum; and London, National Gallery, 1991–92. Catalogue by Christopher Brown, Jan Kelch, Pieter van Thiel, Holm Bevers, Peter Schatborn, and Barbara Welzel. See also English edition.

BOSTON AND CHICAGO 2003–04
Rembrandt's Journey: Painter, Draftsman, Etcher. Boston, Museum of Fine Arts, and Art Institute of Chicago, 2003–04. Catalogue by Clifford S. Ackley, Ronni Baer, Thomas E. Rassieur, and William W. Robinson.

BRAUNSCHWEIG 1979
Jan Lievens: Ein Maler im Schatten Rembrandts. Braunschweig, Herzog Anton Ulrich-Museum, 1979. Catalogue by Rüdiger Klessmann, Sabine Jacob, and Rudolf E. O. Ekkart.

BRAUNSCHWEIG 2006
Aus Rembrandts Kreis: Die Zeichnungen des Braunschweiger Kupferstich-kabinetts. Braunschweig, 2006. Braunschweig, Herzog Anton Ulrich-Museum. Catalogue by Thomas Döring; with the assistance of Gisela Bungarten and Christiane Pagel.

BREMEN 2000–01
Rembrandt, oder nicht? Zeichnungen von Rembrandt und seinem Kreis aus den Hamburger und Bremer Kupferstichkabinetten. Bremen, Kunsthalle, 2000–01. Catalogue by Anne Röver-Kann.

BUDAPEST 2006
Rembrandt 400: Etchings and Drawings. Budapest, Szépművészeti Múzeum, 2006. Catalogue by Teréz Gerszi.

CHICAGO, MINNEAPOLIS, AND DETROIT 1969–70
Rembrandt after Three Hundred Years. Art Institute of Chicago, Minneapolis Institute of Art, and Detroit Institute of Arts, 1969–70. Catalogue by J. Richard Judson, E. Haverkamp-Begemann, and Anne-Marie Logan.

COPENHAGEN 1996
Drawings by Rembrandt and Other 17th Century Dutch Artists in the Department of Prints and Drawings. Copenhagen, Royal Museum of Fine Arts, 1996. Catalogue by Jan Garff.

DORDRECHT 1992–93
De Zichtbare Werelt: Schilderkunst uit de Gouden Eeuw in Hollands oudste stad. Dordrechts Museum, 1992–93. Catalogue by Celeste Brusati, Alan Chong, John Loughman, and Marjorie E. Wieseman. Edited by Peter Marijnissen et al.

DORDRECHT AND COLOGNE 1998–99
Arent de Gelder (1645–1727): Rembrandt's Laatste Leerling. Dordrechts Museum, and Cologne, Wallraf-Richartz-Museum, 1998–99. Catalogue by Dirk Bijker et al.

DRESDEN 2004
Rembrandt: Die Dresdener Zeichnungen. Dresden, Kupferstich-Kabinett, 2004. Catalogue by Christian Dittrich and Thomas Ketelsen; with the collaboration of Katrin Bielmeier and Christien Melzer.

EDINBURGH AND LONDON 2001
Rembrandt's Women. Edinburgh, National Gallery of Scotland, and London, Royal Academy of Arts, 2001. Catalogue by Julia Lloyd Williams; with contributions from S. A. C. Dudok van Heel, E. de Jongh, Volker Manuth, Eric Jan Sluijter, and Marieke de Winkel.

FRANKFURT 2000
'Nach dem Leben und aus der Phantasie:' Niederländische Zeichnungen vom 15. bis 18. Jahrhundert aus dem Städelschen Kunstinstitut. Frankfurt, Städelsches Kunstinstitut, 2000. Catalogue by Annette Strech.

THE HAGUE AND SCHWERIN 2004–05
Carel Fabritius, 1622–1654. The Hague, Mauritshuis, and Schwerin, Staatliches Museum, 2004–05. Catalogue by Frederik J. Duparc, Gero Seelig, and Ariane van Suchtelen.

KASSEL AND AMSTERDAM 2001–02
The Mystery of the Young Rembrandt. Kassel, Gemäldegalerie Alte Meister, and Amsterdam, Museum het Rembrandthuis, 2001–02. Catalogue by Ernst van de Wetering, Bernhard Schnackenburg, Gerbrand Korevaar, and Dagmar Hirschfelder.

KOBLENZ, GÖTTINGEN, AND OLDENBURG 2000
Zeichnungen von Meisterhand: Die Sammlung Uffenbach aus der Kunstsammlung der Universität Göttingen. Koblenz, Mittelrhein Museum; Göttingen, Kunstsammlung der Universität; and Oldenburg, Landesmuseum für Kunst und Kulturgeschichte, 2000. Catalogue by Gerd Unverfehrt; with the collaboration of Nils Büttner, Georg Girgensohn, Dietrich Meyerhöfer, Tobias Möller, Matthias Ohm, and Meike Rotermund.

LEIDEN 1976–77
Geschildert tot Leyden anno 1626. Leiden, Stedelijk Museum de Lakenhal, 1976–77. Catalogue by Ingrid W. L. Moermann, Ernst van de Wetering, Rudi E. O. Ekkart, and Maarten L. Wurfbain.

LEIDEN 1991–92
Rembrandt en Lievens in Leiden: 'een jong en edel schildersduo.' Leiden, Stedelijk Museum de Lakenhal, 1991–92. Catalogue by Christiaan Vogelaar, P. J. M. de Baar, Ingrid W. L. Moerman, Ernst van de Wetering, Rudolf E. O. Ekkart, and Peter Schatborn.

LEIDEN 2005–06
Rembrandt's Mother: Myth and Reality. Leiden, Stedelijk Museum de Lakenhal, 2005–06. Catalogue by Christiaan Vogelaar and Gerbrand Korevaar, et al.

LONDON 1983
Drawings by Rembrandt in the Princes Gate Collection. University of London, Courtauld Institute Galleries, 1983. Catalogue by Helen Braham; introduction by Michael Kitson.

LONDON 1988–89
Art in the Making: Rembrandt. London, National Gallery, 1988–89. Catalogue by David Bomford, Christopher Brown, and Ashok Roy.

LONDON AND AMSTERDAM 2006
Uylenburgh and Son: Art and Commerce from Rembrandt to De Lairesse 1625–1675. London, Dulwich Picture Gallery; and Amsterdam, Museum het Rembrandhuis, 2006. Catalogue by Friso Lammertse and Jaap van der Veen.

LONDON, PARIS, AND CAMBRIDGE 2002–03
Bruegel to Rembrandt: Dutch and Flemish Drawings form the Maida and George Abrams Collection. London, British Museum; Paris, Insitut Néerlandais; and Cambridge, Mass., Fogg Art Museum, 2002–03. Catalogue by William W. Robinson; introduction by Martin Royalton-Kisch.

MANTUA 1996
Domenico Fetti, 1588/89–1623. Mantua, Palazzo Te, 1996. Catalogue by Eduard Šafařík.

MELBOURNE AND CANBERRA 1997–98
Rembrandt: A Genius and His Impact. Melbourne, National Gallery of Victoria, and Canberra, National Gallery of Australia, 1997–98. Catalogue by Albert Blankert et al.

MUNICH AND AMSTERDAM 2001–02
Rembrandt auf Papier: Werk und Wirkung. Munich, Staatliche Graphische Sammlung, and Amsterdam, Museum het Rembrandthuis, 2001–02. Catalogue by Thea Vignau-Wilberg; introduction by Peter Schatborn.

MÜNSTER 1994
Im Lichte Rembrandts: Das Alte Testament im Goldenen Zeitalter der niederländischen Kunst. Münster, Westfälisches Landesmuseum, 1994. Edited by Christian Tümpel.

NEW YORK 1988
Creative Copies: Interpretative Drawings from Michelangelo to Picasso. New York, The Drawing Center, 1988. Catalogue by Egbert Haverkamp-Begemann and Carolyn Logan.

OTTAWA, CAMBRIDGE, AND FREDERICTON 2003–05
Dutch and Flemish Drawings from the National Gallery of Canada. Ottawa, National Gallery of Canada; Cambridge, Mass., Arthur M. Sackler Museum, and Fredericton, New Brunswick, Beaverbrook Art Gallery, 2003–05. Catalogue by Joaneath Spicer, Odilia Bonebakker, and David Franklin.

PARIS 1988–89
Rembrandt et son école, dessins du Musée du Louvre. Paris, Musée du Louvre, 1988–89. Catalogue by Menehould de Bazelaire and E. Starcky.

PARIS 2006–07
Rembrandt dessinateur: Chefs-d'oeuvre des collections en France. Paris, Musée du Louvre, 2006–07. Catalogue by Hélène Grollemond, Peter Schatborn, and Carel van Tuyll van Serooskerken.

PARIS AND HAARLEM 1997–98
Rembrandt et son école: Dessins de la collection Frits Lugt. Paris, Institut Néerlandais, and Haarlem, Teylers Museum 1997–98. Catalogue by Maria van Berge-Gerbaud; introduction by Peter Schatborn. See also Dutch edition.

PARIS, LONDON, AND NEW YORK 1979–80
Rubens and Rembrandt in Their Century: Flemish and Dutch Drawings of the 17th Century from the Pierpont Morgan Library. Paris, Institut Néerlandais; London, British Museum; and New York, Pierpont Morgan Library, 1979–80. Catalogue by Felice Stampfle.

ROTTERDAM 2005–06
Rembrandt in Rotterdam: Tekeningen van Rembrandt en zijn kring in het Museum Boijmans Van Beuningen. Rotterdam, Museum Boijmans Van Beuningen, 2005–06. Catalogue by Albert Elen.

STOCKHOLM 1992–93
Rembrandt och hans tid. Stockholm, Nationalmuseum, 1992–93. Catalogue by Görel Cavalli-Björkman, Egbert Haverkamp-Begemann, Albert Blankert, Peter C. Sutton, Walter Liedtke, and Börje Magnusson.

STUTTGART 1984
Meisterwerke aus der Graphischen Sammlung Zeichnungen des 15. bis 18. Jahrhunderts. Stuttgart, Staatsgalerie, Graphische Sammlung, 1984. Catalogue by Heinrich Geissler, Otto Pannewitz, and Thorsten Rodiek.

VIENNA 2004
Rembrandt. Vienna, Albertina, 2004. Catalogue by Marian Bisanz-Prakken; with the collaboration of S. A. C. Dudok van Heel, Ger Luijten, Peter Schatborn, Martina Sitt, and Ernst van de Wetering.

WASHINGTON 1990
Rembrandt's Landscapes: Drawings and Prints. Washington, D.C., National Gallery of Art, 1990. Catalogue by Cynthia Schneider, Boudewijn Bakker, Nancy Ash, and Shelley Fletcher.

WASHINGTON, MILWAUKEE, AND AMSTERDAM 2008–09
Jan Lievens: A Dutch Master Rediscovered. Washington, D.C., National Gallery of Art; Milwaukee Art Museum; and Amsterdam, Museum het Rembrandthuis, 2008–09. Catalogue by Arthur K. Wheelock Jr.; with Stephanie S. Dickey, E. Melanie Gifford, Gregory Rubinstein, Jaap van der Veen, and Lloyd DeWitt.

WROCLAW 1998
Rembrandt i niderlandzcy mistrzowie rysunku (XV–XVII w.) (Rembrandt and the Masters of 15th–17th Century Netherlandish Drawing). Wroclaw, Poland, Ossoliński National Institute–Museum of the Princes Lubomirski, 1998. Catalogue by Stanislaw Kozak. [See also website catalogue: http://www.oss.wroc.pl/rembrandt/ryc11-eng.html.]

Books and Articles

ALBACH 1972
Albach, Ben. "Een tekening van het Amsterdamse toneel in 1638." *De Kroniek van het Rembrandthuis* 26, no. 4 (1972), pp. 111–25.

ALBACH 1979
Albach, Ben. "Rembrandt en het toneel." *De Kroniek van het Rembrandthuis* 31, no. 2 (1979), pp. 2–32.

B.
Bartsch, Adam. *Le Peintre-Graveur*, 21 vols. Vienna, 1803–21. Adam Bartsch, *Catalogue raisonné de toutes les estampes qui forment l'oeuvre de Rembrandt, et ceux de ses principaux imitateurs, composé par les sieurs Gersaint, Helle, Glomy et P. Yver*, 2 vols. Vienna, 1797.

BAUCH 1926
Bauch, Kurt. *Jacob Adriaensz. Backer, ein Rembrandtschüler aus Friesland*. Grote'sche Sammlung von Monographien zur Kunstgeschichte 5. Berlin, 1926.

BAUCH 1960
Bauch, Kurt. *Der frühe Rembrandt und seine Zeit: Studien zur geschichtlichen Bedeutung seines Frühstils*. Berlin, 1960.

BENESCH
Benesch, Otto. *The Drawings of Rembrandt*. 6 vols. London, 1954–57. 2nd edition, enlarged and edited by Eva Benesch, 1973.

BENESCH 1922
Benesch, Otto. "E. W. Bredt. Rembrandt-Bibel, München 1921." *Mitteilungen der Gesellschaft für Vervielfältigende Kunst* 45 (1922), pp. 35–36.

BENESCH 1935
Benesch, Otto. *Rembrandt: Werk und Forschung*. Vienna, 1935. Edited by Eva Benesch, 1970.

BENESCH 1947
Benesch, Otto. *A Catalogue of Rembrandt's Selected Drawings*. 2 vols. London and New York, 1947.

BENESCH 1970
Benesch, Otto. *Collected Writings*. Vol. 1, *Rembrandt*. Edited by Eva Benesch. London, 1970.

BEVERS 2005
Bevers, Holm. "Ausstellungen zu Rembrandt im Rückblick." *Kunstchronik* 58 (2005), pp. 463–82.

BEVERS 2006
Bevers, Holm. *Rembrandt: Die Zeichnungen im Berliner Kupferstichkabinett; Kritischer Katalog*. Staatliche Museen zu Berlin: Die Zeichnungen alter Meister im Berliner Kupferstichkabinett. Ostfildern, 2006.

BEVERS 2007
Bevers, Holm. "Federzeichnungen bei Jan Victors: Einige Überlegungen und Neuzuschreibungen." *De Kroniek van het Rembrandthuis* (2007), pp. 42–59.

BIESBOER 2001
Biesboer, Pieter. "Documents for the History of Collecting: Netherlandish Inventories I." In *Collections of Paintings in Haarlem 1572–1745*. Los Angeles, 2001.

BIKKER 2005
Bikker, Jonathan. *Willem Drost (1633–1659): A Rembrandt Pupil in Amsterdam and Venice*. New Haven and London, 2005.

BLANC 2006
Blanc, Jan. *Dans l'atelier de Rembrandt: Le maître et ses élèves*. Paris, 2006.

BLANKERT 1982
Blankert, Albert. *Ferdinand Bol (1616–1680): Rembrandt's Pupil*. Doornspijk, 1982.

BOCK AND ROSENBERG 1930
Bock, Elfried, and Jacob Rosenberg. *Die Zeichnungen alter Meister im Kupferstichkabinett*. Staatliche Museen zu Berlin: Die niederländischen Meister; beschreibendes Verzeichnis sämtlicher Zeichnungen. 2 vols. Berlin, 1930.

BOLTON AND FOLMER-VON OVEN 1989
Bolton, J., and A. T. Folmer-von Oven. *Catalogue of Drawings [of a private collection]*, 1989.

BONEBAKKER 1998
Bonebakker, Odilia. "The *Baptism of the Eunuch* in Netherlandish Art c. 1523–1750: Depictions of the Biblical Subject and the Question of Denominational Significance." MA thesis, Queen's University, Kingston, Ontario, 1998.

BONEBAKKER 2003
Bonebakker, Odilia. "Rembrandt's Drawing of *The Baptism of the Eunuch* in Munich: Style and Iconography." In *Rembrandt-Zeichnungen in München: Beiträge zur Ausstellung Rembrandt auf Papier—Werk und Wirkung*, edited by Thea Vignau-Wilberg, pp. 28–43. Munich, Staatliche Graphische Sammlung, 2003.

BREDIUS 1915–22
Bredius, Abraham. *Künstler-Inventare: Urkunden zur Geschichte der holländischen Kunst des XVIten, XVIIten und XVIIIten Jahrhunderts*. 8 vols. The Hague, 1915–22.

BREDIUS 1971
Bredius, Abraham. *Rembrandt: The Complete Edition of the Paintings*. 4th ed. London, 1971.

BROOS 1981
Broos, Ben. *Oude tekeningen in het bezit van de Gemeentemusea in Amsterdam, waaronder de collectie Fodor*, vol. 3, *Rembrandt en tekenaars uit zijn omgeving*. Amsterdam, 1981.

BROOS 1981–82
Broos, Ben. "Walter L. Strauss and Marjon van der Meulen, The Rembrandt Documents, New York 1979." *Simiolus* 12 (1981–82), pp. 245–62.

BROOS 1983
Broos, Ben. "Fame shared is fame doubled." In *The Impact of a Genius: Rembrandt, His Pupils and His Followers in the Seventeenth Century*, pp. 35–58. Exh. cat. Amsterdam, Waterman Gallery, and Groningen, Groninger Museum, 1983.

BRUSATI 1995
Brusati, Celeste. *Artifice and Illusion: The Art and Writing of Samuel van Hoogstraten*. Chicago and London, 1995.

BRUYN 1983
Bruyn, Josua. "On Rembrandt's Use of Studio-Props and Model Drawings during the 1630s." In *Essays in Northern European Art Presented to Egbert Haverkamp-Begemann on His Sixtieth Birthday*, pp. 52–60. Doornspijk, 1983.

BRUYN 1984
Bruyn, Joshua. "W. Sumowski, *Gemälde der Rembrandt-Schüler*, I (J.A. Backer – A. van Dijck). Landau/Pfalz (Edition PVA) 1983." *Oud Holland* 98 (1984), pp. 146–62.

BÜRGER 1857
Bürger, Wilhelm (E. J. T. Thoré). *Trésors d'art en Angleterre*. Paris, 1857.

BÜRGER 1858
Bürger, Wilhelm (E. J. T. Thoré). "Les Dessins de Rembrandt au British Museum." *Revue Germanique* 3 (1858), pp. 392–403.

CHURCHILL
Churchill, W. A. *Watermarks in Paper in Holland, England, France, etc. in the XVII and XVIII Centuries and Their Interconnection*. Amsterdam, 1935.

CORPUS
A Corpus of Rembrandt Paintings. Stichting Foundation Rembrandt Research Project. Vols. I–III by Josua Bruyn, Bob Haak, Simon H. Levie, Pieter J. J. van Thiel, and Ernst van de Wetering. The Hague, Boston, and London, 1982, 1986, and 1989. Vol. IV by Ernst van de Wetering; with contributions by Karin Groen, Peter Klein, Jaap van der Veen, and Marieke de Winkel. Dordrecht, 2005.

D'ARGENVILLE 1745–52
d'Argenville, Antoine-Joseph Dézallier. *Abrégé de la vie des plus fameux peintres*, preceded by a *Discours sur la connaissance des desseins et des tableaux*. 4 vols. Paris, 1745–52. 2nd edition, 1762.

DEKIERT 2004
Dekiert, Markus. *Rembrandt: Die Opferung Isaaks*. Munich, 2004.

DEMPSEY 1986–87
Dempsey, Charles. "The Carracci Academy." In *Academies of Art between Renaissance and Romanticism*, pp. 33–43. *Leids Kunsthistorisch Jaarboek* 5–6 (1986–87). The Hague, 1989.

DÖRING 2007
Döring, Thomas. "Von Rembrandt zeichnen lernen…." In *Beyond the Line: Ein künstlerisches Forschungsprojekt zur Zeichnung diesseits und jenseits der Linie*, pp. 25–31. Braunschweig, 2007.

DUDOK VAN HEEL 1979
Dudok van Heel, S. A. C. "Willem Bartel(omeu)sz Ruyters (1587–1639): Rembrandt's Bisschop Gosewijn." *Amstelodamum* 66, no. 4 (1979), pp. 83–87.

DUDOK VAN HEEL 2006
Dudok van Heel, S. A. C. *De jonge Rembrandt onder tijdgenoten: Godsdienst en schilderkunst in Leiden en Amsteram*. PhD. diss., Radboud Universiteit Nijmegen, 2006.

EMMENS 1968
Emmens, Jan A. *Rembrandt en de regels van de kunst*. Utrecht, 1968.

FALCK 1927
Falck, Gustav. "Einige Bemerkungen über Ph. Konincks Tätigkeit als Zeichner. Ein Beitrag zur Echtheitskritik der Handzeichnungen Rembrandts." In *Festschrift für Max J. Friedländer zum 60. Geburtstage*, pp. 168–80. Leipzig, 1927.

FEIGENBAUM 1993
Feigenbaum, Gail. "Practice in the Carracci Academy." In *The Artist's Workshop*, pp. 58–76. *Studies in the History of Art* 38. Washington, D.C., 1993.

FRIEDLÄNDER 1915
Friedländer, Max J. "Rembrandt's Zeichnungen." *Zeitschrift für Bildende Kunst* 26 (1915), pp. 213–16.

GERSAINT 1751
Gersaint, Edme-François. *Catalogue raisonné de toutes les pièces qui forment l'œuvre de Rembrandt, composé par feu M.Gersaint, & mis au jour, avec les Augmentations nécessaires, par les sieurs Helle & Glomy*. Paris, 1751.

GERSZI 2005
Gerszi, Teréz. *Seventeenth-Century Dutch and Flemish Drawings in the Budapest Musuem of Fine Arts: A Complete Catalogue*. Budapest, 2005.

GILTAIJ 1977
Giltaij, Jeroen. "Een onbekende schets van Rembrandt." *De Kroniek van het Rembrandthuis* 29, no. 1 (1977), pp. 1–9.

GILTAIJ 1983
Giltaij, Jeroen. "Abraham Furnerius en Gerrit van Battem." In *Essays in Northern European Art Presented to Egbert Haverkamp-Begemann on His Sixtieth Birthday*, pp. 97–101. Doornspijk, 1983.

GILTAIJ 1988
Giltaij, Jeroen. *De tekeningen van Rembrandt en zijn school in het Museum Boymans-van Beuningen*. Rotterdam, 1988.

GILTAIJ 1989
Giltaij, Jeroen. "The Function of Rembrandt Drawings." *Master Drawings* 27 (1989), pp. 111–17.

GLEISBERG AND MEHNERT 1990
Gleisberg, Dieter, and Karl-Heinz Mehnert. *Meisterzeichnungen: Museum der bildenden Künste Leipzig*. Leipzig, 1990.

GLORIEUX 2002
Glorieux, Guillaume. *A l'Enseigne de Gersaint: Edme-François Gersaint, Marchant d'Art sur le Pont Notre-Dame*. Seyssel, 2002.

GOEREE 1668
Goeree, Willem. *Inleydinge tot de Alghemeene Teycken-Konst*. 1668. Edited by Michael Kwakkelstein. Leiden, 1998.

GOLDNER 1988
Goldner, George, with the assistance of Lee Hendrix and Gloria Williams. *European Drawings 1: Catalogue of the Collections* (The J. Paul Getty Museum). Malibu, Calif., 1988.

GOLDNER AND HENDRIX 1992
Goldner, George and Lee Hendrix, with the assistance of Kelly Pask. *European Drawings 2: Catalogue of the Collections* (The J. Paul Getty Museum). Malibu, Calif., 1992.

HAMANN 1936
Hamann, Richard. "Hagars Abschied bei Rembrandt und im Rembrandt-Kreise." *Marburger Jahrbuch für Kunstwissenschaft* 8/9 (1936), pp. 1–110.

HAVERKAMP-BEGEMANN 1961
Haverkamp-Begemann, Egbert. "Review of Benesch, 1954–57." *Kunstchronik* 14 (1961), pp. 10–28, 50–57, and 85–91.

HAVERKAMP-BEGEMANN 1972
Haverkamp-Begemann, Egbert. "Rembrandt as Teacher." In *Actes du XXIIe congrès international d'histoire de l'Art, Budapest 1969*, vol. 2, *Évolution générale et développements régionaux en histoire de l'art*, pp. 105–13. Budapest, 1972.

HAVERKAMP-BEGEMANN 1992–93
Haverkamp-Begemann, Egbert. "Rembrandts Simeon och Jesusbarnet/Simeon and the Christ Child." In *Rembrandt och hans tid*. Exh. cat. Stockholm, Nationalmuseum, 1992–93.

HEAWOOD
Heawood, H. *Watermarks, Mainly of the 17th and 18th Centuries*. Monumenta Chartae Papyraceae 1. Hilversum, 1950.

HELD 1964
Held, Julius. *Rembrandt and the Book of Tobit*. Northhampton, Mass., 1964.

HELD 1991
Held, Julius. *Rembrandt Studies*. Princeton, N.J., 1991.

HENKEL 1942
Henkel, M. D. *Catalogus van de Nederlandsche Teekeningen in het Rijksmuseum te Amsterdam*, vol. 1, *Teekeningen van Rembrandt en zijn school*. The Hague, 1942.

HIND 1915
Hind, A. M. *Catalogue of Drawings by Dutch and Flemish Artists Preserved in the Department of Prints and Drawings in the British Museum*, vol. 1, *Drawings by Rembrandt and His School*. London, 1915.

HINTERDING 2006
Hinterding, Erik. *Rembrandt as an Etcher: The Practice of Production and Distribution*. 3 vols. *Studies in Prints and Printmaking* 6. Ouderkerk aan de IJssel, 2006.

HINTERDING 2008
Hinterding, Erik. *Rembrandt Etchings from the Frits Lugt Collection: Catalogue Raisonné*. 2 vols. Bussum and Paris, 2008.

HOFSTEDE DE GROOT 1906
Hofstede de Groot, Cornelis. *Die Handzeichnungen Rembrandts: Versuch eines beschreibenden und kritischen Katalogs.* Haarlem, 1906.

HOFSTEDE DE GROOT 1915
Hofstede de Groot, Cornelis. "Rembrandts onderwijs aan zijne leerlingen." In *Feest-Bundel Dr. Abraham Bredius aangeboden den achttienden April 1915,* pp. 79–94. Amsterdam, 1915.

HOFSTEDE DE GROOT 1927
Hofstede de Groot, Cornelis. *Kunstkennis: Herinneringen van een kunstcriticus.* The Hague, 1927.

HOLLSTEIN
Hollstein, F. W. H. *Dutch and Flemish Etchings, Engravings and Woodcuts, ca. 1450–1700.* 30 vols. Amsterdam, 1949–87, Roosendaal, 1988–94, Rotterdam, 1995–2004; *The New Hollstein: Dutch and Flemish Etchings, Engravings and Woodcuts, 1450–1700.* Roosendaal, 1993–95, Rotterdam, 1996–.

VAN HOOGSTRATEN 1678
Van Hoogstraten, Samuel. *Inleyding tot de Hooge Schoole der Schilderkonst; anders de zichtbare werelt.* Rotterdam, 1678.

HOUBRAKEN 1718–21
Houbraken, Arnold. *De groote schouburgh der Nederlantsche konstschilders en schilderessen.* 3 vols. Amsterdam, 1718–21.

JAFFÉ 1994
Jaffé, Michael. *The Devonshire Collection of Italian Drawings.* 4 vols. London, 1994.

JAFFÉ 2002
Jaffé, Michael. *The Devonshire Collection of Northern European Drawings.* 5 vols. Turin, London, and Venice, 2002.

KETELSEN 2006
Ketelsen, Thomas. "Stil als Erbschaft? Rembrandt und seine Schüler." In *Rembrandt-Bilder: Die historische Sammlung der Kasseler Gemäldegalerie,* pp. 8–26. Exh. cat. Kassel, Staatliche Museen, 2006.

KREMPEL 2000
Krempel, Léon. *Studien zu den datierten Gemälden des Nicolaes Maes (1634–1693).* Petersberg, 2000.

L. AND L. SUPPLÉMENT
Lugt, Frits. *Les Marques de collections de dessins et d'estampes.* Amsterdam, 1921; and *Supplément.* The Hague, 1956.

LIEDTKE 2004
Liedtke, Walter. "Rembrandt's 'Workshop' Revisited." *Oud Holland* 117 (2004), pp. 48–73.

LIPPMANN–HOFSTEDE DE GROOT 1888–1911
Lippmann, F. *Original Drawings by Rembrandt Harmensz, van Rijn Reproduced in Phototype.* Four series, edited from the 2nd edition by C. Hofstede de Groot. London, Paris, and The Hague, 1888–1911.

LOCHNAN 2008
Lochnan, Katharine. *Drawing Attention: Selected Works on Paper from the Renaissance to Modernism: Art Gallery of Ontario.* London and New York, 2008.

LOGAN 1979
Logan, Anne-Marie. *The 'Cabinet' of the Brothers Gerard and Jan Reynst.* Amsterdam, 1979.

LUGT 1920
Lugt, Frits. *Mit Rembrandt in Amsterdam: Die Darstellungen Rembrandts vom Amsterdamer Stadtbilde und von der unmittelbaren landschaftlichen Umgebung.* Berlin, 1920.

LUGT 1931
Lugt, Frits. "Beiträge zu dem Katalog der niederländischen Handzeichnungen in Berlin." *Jahrbuch der Preußischen Kunstsammlungen* 52 (1931), pp. 36–80.

LUGT 1933
Lugt, Frits. *Musée du Louvre: Inventaire général des dessins des écoles du Nord; École hollandaise,* vol. 3, *Rembrandt, ses élèves, ses imitateurs, ses copistes.* Paris, 1933.

LUGT 1938
Lugt, Frits. *Répertoire des catalogues de ventes publiques,* vol. 1. The Hague, 1938.

MAGNUSSON 1992–93
Magnusson, Börje. "Rembrandts teckningar." In *Rembrandt och hans tid,* pp. 323–96. Exh. cat. Stockholm, Nationalmuseum 1992–93.

MANUTH 1987
Manuth, Volker. "Ikonographische Studien zu den Historien des Alten Testaments bei Rembrandt und seiner frühen Amsterdamer Schule." PhD. diss., Berlin, Freie Universität, 1987.

MÄRKER AND BERGSTRÄSSER 1998
Märker, Peter, and Gisela Bergsträsser. *Hundert Zeichnungen alter Meister aus dem Hessischen Landesmuseum Darmstadt.* Leipzig, 1998.

MEDER 1919
Joseph Meder. *Die Handzeichnung: Ihre Technik und Entwicklung.* Vienna, 1919.

ORLERS 1641
Orlers, Jan Jansz. *Beschrijvinge der stadt Leiden.* 2nd ed. Leiden, 1641.

PASSAVANT 1839–58
Passavant, John David. *Rafael von Urbino und sein Vater Giovanni Santi.* 3 vols. Leipzig, 1839 (vols. 1 and 2), 1858 (vol. 3).

VAN DE PASSE 1643
Van de Passe, Crispijn. *'t Light der teken en schilderkonst.* Amsterdam, 1643.

DE PILES 1699
De Piles, Roger. *Abrégé de la vie des peintres, avec des réflections sur leurs oeuvrages, et une traité du Peintre parfait, de la connoissance des Dessins, & de l'utilité des estampes.* Paris, 1699.

PLOMP 1997
Plomp, Michiel. *The Dutch Drawings in the Teyler Museum. Artists Born between 1575 and 1630,* vol. 2. Ghent and Doornspijk, 1997.

PLOMP 2001
Plomp, Michiel. *Hartstochtelijk verzameld. 18de-eeuwse Hollandse verzamelaars van tekeningen en hun collecties,* vol. 1. Paris and Bussum, 2001.

PLOMP 2006
Plomp, Michiel. "Rembrandt and His Circle. Drawings and Prints." *Metropolitan Museum of Art Bulletin* 64, no. 1 (Summer 2006), pp. 3–48.

PONT 1960
Pont, D. "De compositis 'Ruth en Naomi' te Bremen en te Oxford. Toeschrijvingen aan Willem Drost." *Oud Holland* 75 (1960), pp. 205–21.

QUATREMÈRE DE QUINCY 1824
Quatremère de Quincy, Antoine-Chrysostome. *Histoire de la vie et des ouvrages de Rafaël.* Paris, 1824.

REINHARD-FELICE 2003
Reinhard-Felice, Mariantonia. *Sammlung Oskar Reinhart 'Am Römerholz' Winterthur: Gesamtkatalog.* Basel, 2003.

ROBINSON 1987
Robinson, William W. "Rembrandt's Sketches of Historical Subjects." In *Drawings Defined,* preface by Konrad Oberhuber, edited by Walter Strauss and Tracie Felker, pp. 241–57. New York, 1987.

ROBINSON 1989
Robinson, William W. "Nicolaes Maes as a Draughtsman." *Master Drawings* 27, no. 2 (Summer 1989), pp. 146–62.

ROBINSON 1996
Robinson, William W. "The Early Works of Nicolaes Maes, 1653–1661." Ph.D. diss., Harvard University, 1996.

ROSCAM ABBING 1993
Roscam Abbing, Michiel, with the collaboration of Peter Tissen. *De Schilder en Schrijver Samuel van Hoogstraten. 1627–1678. Eigentijdse Bronnen en Oeuvre van gesigneerde Schilderijen*. Leiden, 1993.

ROSCAM ABBING 1999
Roscam Abbing, Michiel. *Rembrandt toont zijn kunst*. Leiden, 1999.

ROSCAM ABBING 2006
Roscam Abbing, Michiel. *Rembrandt 2006: New Rembrandt Documents*. Leiden, 2006.

ROSENBERG 1956
Rosenberg, Jacob. "Review of Benesch, 1954–57, I–II." *Art Bulletin* 38 (1956), pp. 63–70.

ROSENBERG 1959
Rosenberg, Jacob. "Review of Benesch, 1954–57, III–IV." *Art Bulletin* 41 (1959), pp. 108–19.

ROTERMUND CA. 1960
Rotermund, Hans–Martin. *Das Buch Tobias: Erzählt und ausgelegt durch Zeichnungen und Radierungen Rembrandts*. Stuttgart, ca. 1960.

ROYALTON-KISCH 1990
Royalton-Kisch, Martin. "The Drawings by Rembrandt and His School in the Museum Boymans-van Beuningen." *Burlington Magazine* 132, no. 1043 (February 1990), pp. 131–36.

ROYALTON-KISCH 1991
Royalton-Kisch, Martin. "An Early Drawing by Jan Lievens." *Master Drawings* 29, no. 4 (Winter 1991), pp. 410–15.

ROYALTON-KISCH 1992
Royalton-Kisch, Martin. *Drawings by Rembrandt and His Circle in the British Museum*. London, 1992.

ROYALTON-KISCH 2000
Royalton-Kisch, Martin. "From Rembrandt to Van Renesse." *Burlington Magazine* 142 (2000), pp. 157–64.

ROYALTON-KISCH 2008-09
Royalton-Kisch, Martin. *Drawings by Rembrandt and His School in the British Museum*. Available online: www.britishmuseum.org/research/search_the_collection_database/publication_reference_search.aspx (version 2008–09).

ROYALTON-KISCH AND EKSERDJIAN 2000
Royalton-Kisch, Martin, and David Ekserdjian. "*The Entombment of Christ*: A Lost Mantegna Owned by Rembrandt?" *Apollo* 151, no. 457 (2000), pp. 52–56.

SADKOV 2001
Sadkov, Vadim. *Netherlandish, Flemish, and Dutch Drawings of the XVI–XVIII Centuries, Belgian and Dutch Drawings of the XIX–XX Centuries*. Moscow, 2001.

ŠAFAŘÍK 1990
Šafařík, Eduard. *Fetti*. Milan, 1990.

SANDRART 1675 AND 1679
Sandrart, Joachim van. *Teutsche Academie der Edlen Bau- Bild- und Mahlerey-Künste*. Nuremberg, 1675 and 1679.

SAXL 1939
Saxl, Fritz. *Rembrandt's Sacrifice of Manoah. Studies of the Warburg Institute* 9. London, 1939.

SCHAPELHOUMAN 2006
Schapelhouman, Marijn. *Rembrandt and the Art of Drawing: Rijksmuseum dossier*. Zwolle and Amsterdam, 2006.

SCHATBORN 1975-76
Schatborn, Peter. "Review of Otto Benesch, *The Drawings of Rembrandt*, 6 vols., London, 1973." *Simiolus* 8 (1975–76), pp. 34–39.

SCHATBORN 1981
Schatborn, Peter. "Van Rembrandt tot Crozat. Vroege verzamelingen met tekeningen van Rembrandt." *Nederlands Kunsthistorisch Jaarboek* 32 (1981), pp. 1–54

SCHATBORN 1982
Schatborn, Peter. "Review of Broos 1981." *Oud Holland* 96, no. 1 (1982), pp. 251–58.

SCHATBORN 1985A
Schatborn, Peter. *Tekeningen van Rembrandt. Zijn onbekende leerlingen en navolgers / Drawings by Rembrandt. His Anonymous Pupils and Followers*. Catalogus van de Nederlandse tekeningen in het Rijkprentenkabinet, Rijksmuseum, Amsterdam 4. The Hague, 1985.

SCHATBORN 1985B
Schatborn, Peter. "Tekeningen van Rembrandts leerlingen." *Bulletin van het Rijksmuseum* 33 (1985), pp. 93–109.

SCHATBORN 1986
Schatborn, Peter. "Tekeningen van Rembrandt in verband met zijn etsen." *De Kroniek van het Rembrandthuis* 38, no. 1 (1986), pp. 1–38.

SCHATBORN 1993
Schatborn, Peter. "Rembrandt: On the Method of the Authentication of the Drawings." In *Künstlerischer Austausch. Akten des XXVIII. Internationalen Kongress für Kunstgeschichte, Berlin, 15–20 Juli 1992*, pp. 621–26. Berlin, 1993.

SCHATBORN 1994
Schatborn, Peter. "Review of Martin Royalton-Kisch, *Drawings by Rembrandt and His Circle in the British Museum*, London, 1992." *Oud Holland* 108, no. 1 (1994), pp. 20–24.

SCHATBORN 2005
Schatborn, Peter. "Tekeningen van Rembrandt en Pieter de With." *De Kroniek van het Rembrandthuis* 1–2 (2005), pp. 2–13.

SCHATBORN 2006
Schatborn, Peter. "Drawings Attributed to Carel Fabritius." *Oud Holland* 119, no. 2/3 (2006), pp. 130–38.

SCHATBORN 2007
Schatborn, Peter. "De Parijse kunsthandelaar Edme-François Gersaint: de problematiek van de eigenhandigheid van Rembrandts etsen." *De Kroniek van het Rembrandthuis* (2007), pp. 60–68.

SCHATBORN 2008
Schatborn, Peter. "Getekende landschappen van Pieter de With." In *De Verbeelde Wereld: Liber Amicorum voor Boudewijn Bakker*, pp. 76–81. Bussum, 2008.

SCHATBORN AND DE WINKEL 1996
Schatborn, Peter, and Marieke de Winkel. "Rembrands portret van de acteur Willem Ruyter." *Bulletin van het Rijksmuseum* 44 (1996), pp. 382–93.

SCHILLER 1971-72
Schiller, Gertrud. *Iconography of Christian Art*, vol. 2. Greenwich, Conn., 1971–72.

SCHNEIDER 1932
Schneider, Hans. *Jan Lievens: Sein Leben und seine Werke*. Haarlem, 1932.

SCHNEIDER AND EKKART 1973
Schneider, Hans. *Jan Lievens: Sein Leben und seine Werke*. With a supplement by Rudolf E. O. Ekkart. 1932. Reprint, Amsterdam, 1973.

SCHOLTEN 1904
Scholten, H. J. *Musée Teyler à Haarlem: Catalogue raisonné des dessins des écoles françaises et hollandaises*. Haarlem, 1904.

SCHWARTZ 2006
Schwartz, Gary. *The Rembrandt Book*. New York, 2006.

SCHWARTZ 2007
Schwartz, Gary. "Rembrandt Harmensz. van Rijn, 'Simeon with the Christ Child in His Arms, with Mary and Joseph, 1661.' In *In Arte Venustas: Studies on Drawings in Honour of Teréz Gerszi; Presented on Her Eightieth Birthday*, edited by Andrea Czére et al., pp. 170–72. Budapest, 2007.

VON SEIDLITZ 1894
Von Seidlitz, Woldemar. "Review of F. Lippmann and C. Hofstede de Groot, *Original Drawings by Rembrandt Harmensz. van Rijn Reproduced in Photo-type*, London, Paris, and The Hague, 1889–1911." *Repertorium für Kunstwissenschaft* 17 (1894), pp. 116–27.

SEILERN 1961
Seilern, Antoine Graf. *Paintings and Drawings of Continental Schools other than Flemish and Italian at 56 Princes Gate London SW7*. London, 1961.

SLIVE 1953
Slive, Seymour. *Rembrandt and His Critics 1630–1730*. The Hague, 1953.

STARCKY 1985
Starcky, Emmanuel. "Quelques dessins de Rembrandt dans les collections du Louvre: problèmes de chronologie." *Revue du Louvre* 35 (1985), pp. 255–64.

STARCKY 1993
Starcky, Emmanuel. "Essai sur le goût pour les dessins de Rembrandt en France au XVIIIe siècle." In *Rembrandt and His Pupils: Papers Given at a Symposium in the National Museum Stockholm, 2–3 October 1992*, pp. 193–222. Stockholm, 1993.

STECHOW 1940
Stechow, Wolfgang. "Rembrandt's *Presentation in the Dark Manner*." *Print Collector's Quarterly* 27 (1940), pp. 364–79.

VAN STRATEN 2005
Van Straten, Roelof. *Rembrandts Leidse Tijd, 1606–1632*. Leiden, 2005.

STRATTON 1986
Stratton, S. "Rembrandt's Beggars: Satire and Sympathy." *Print Collector's Newsletter* 17 (1986), pp. 77–82.

STRAUSS AND VAN DER MEULEN 1979
Strauss, Walter, and Marjon van der Meulen. *The Rembrandt Documents*. New York, 1979.

SUMOWSKI 1956–57
Sumowski, Werner. "Bemerkungen zu Otto Benesch, Corpus der Rembrandt-Zeichnungen, I'." *Wissenschaftliche Zeitschrift der Humboldt-Universität zu Berlin, Gesellschafts- und sprachwissenschaftliche Reihe* 6 (1956–57), pp. 255–81.

SUMOWSKI 1961
Sumowski, Werner. *Bemerkungen zu Otto Beneschs Corpus der Rembrandt-zeichnungen*, II. Bad Pyrmont, 1961.

SUMOWSKI 1983
Sumowski, Werner. "Rembrandt als Lehrer." In *Gemälde der Rembrandt-Schüler*, vol. I, pp. 9–81 Landau, 1983.

SUMOWSKI, *DRAWINGS*
Sumowski, Werner. *Drawings of the Rembrandt School*. 10 vols. New York, 1979–92.

SUMOWSKI, *PAINTINGS*
Sumowski, Werner. *Gemälde der Rembrandt Schüler*. 6 vols. Landau, 1983–95.

THOMASSEN AND GRUYS 1998
Thomassen, Kees, and J. A. Gruys. *The Album Amicorum of Jacob Heyblocq*. Zwolle, 1998.

TÜMPEL 1970
Tümpel, Christian, with Astrid Tümpel. *Rembrandt legt die Bibel aus: Zeichnungen und Radierungen aus dem Kupferstichkabinett der Staatlichen Museen Preußischer Kulturbesitz Berlin*. Berlin, 1970.

TÜMPEL AND SCHATBORN 1987
Tumpel, Christian, with the contribution of Peter Schatborn. *Het boek Tobias: Met etsen en tekeningen van Rembrandt en zijn leerlingen*. Zeist, 1987.

TURNER 2006
Turner, Jane. *Dutch Drawings in The Pierpont Morgan Library: Seventeenth to Nineteenth Centuries*. 2 vols. New York, 2006.

TURNER AND HENDRIX 2001
Turner, Nicholas, and Lee Hendrix. *European Drawings 4: Catalogue of the Collections* (The J. Paul Getty Museum). Los Angeles, 2001.

VALENTINER 1925 AND 1934
Valentiner, Wilhelm Reinhold. *Rembrandt: Des Meisters Handzeichnungen*. 2 vols. Stuttgart, Berlin, and Leipzig, n.d. [1925 and 1934].

VALENTINER 1939
Valentiner, Wilhelm Reinhold. "Willem Drost, Pupil of Rembrandt." *Art Quarterly* 2 (1939), pp. 295–325.

VERMEEREN 1978–79
Vermeeren, Karel. "Constantijn Daniel van Renesse, zijn leven en zijn werken." *De Kroniek van het Rembrandthuis* 30, no. 1 (1978), pp. 3–23, and 31, no. 1 (1979), pp. 27–32.

VOSMAER 1868
Vosmaer, Carel. *Rembrandt Harmensz.van Rijn, sa vie et ses oeuvres*. The Hague, 1868. 2nd edition, 1877.

VAN DE WAAL 1969
Van de Waal, H. "Rembrandt at Vondel's tragedy *Gysbrecht van Amstel*." In *Miscellanea I.Q. van Regteren Altena*, pp. 145–49. Amsterdam, 1969.

WALSH 1996
Walsh, John. *Jan Steen: The Drawing Lesson*. Malibu, Calif., 1996.

WEGNER 1973
Wegner, Wolfgang. *Die niederländischen Handzeichnungen des 15.–18. Jahrhunderts*. 2 vols. Kataloge der Staatlichen Graphischen Sammlung München 1. Berlin, 1973.

VAN DE WETERING 1983
Van de Wetering, Ernst. "Isaac Jouderville, a Pupil of Rembrandt." In *The Impact of a Genius: Rembrandt, His Pupils, and His Followers in the Seventeenth Century*, pp. 59–69. Exh. cat. Amsterdam, Waterman Gallery, and Groningen, Groninger Museum, 1983.

VAN DE WETERING 1986
Van de Wetering, Ernst. *Problems of apprenticeship and studio collaboration*. In *Corpus*, vol. II, pp. 45–90, 1986.

WHITE 1999
White, Chistopher. *Rembrandt as an Etcher: A Study of the Artist at Work*. New Haven and London, 1999.

DE WINKEL 2006
De Winkel, Marieke. *Fashion and Fancy. Dress and Meaning in Rembrandt's Paintings*. Amsterdam, 2006.

ZAFRAN 1977
Zafran, Eric. "Jan Victors and the Bible." *Israel Museum News* 12 (1977), pp. 92–120.

Photography Credits

Most of the photographs in this book were provided by the institutions cited in the captions. Additonal photograph credits are below. Every effort has been made to contact holders of copyright for all images reproduced in this book. Anyone having further information concerning copyright holders is asked to contact the publisher so that this information can be included in future printings.

Amsterdam, Jan Six Collection, "Pandora" Album. Collectie Six, Amsterdam: fig. 24b

Amsterdam, P. & N. de Boer Foundation: fig. 29b

Amsterdam, Private Collection. Image courtesy of Douwes Fine Art, Amsterdam: fig. 7b

Bayonne, Musée Bonnat. © René-Gabriel Ojéda / Réunion des musées nationaux / Art Resource, New York: fig. 26c

Beasançon, © Musée des beaux-arts et d'archéologie. Photo: Pierre Guenat: cat. no. 8.1; figs. 8b, 38a

Berlin, Staatliche Museen zu Berlin, Kupferstichkabinett. © Bildarchiv Preussischer Kulturbesitz / Art Resource, New York: cat. nos. 1.1, 5.1

Berlin, Staatliche Museen zu Berlin, Kupferstichkabinett, © Jörg P. Anders / Bildarchiv Preussischer Kulturbesitz / Art Resource, New York: cat. nos. 13.1, 13.2, 14.1, 15.1, 16.2, 18.1, 26.1, 28.1, 31.1, 32.2, 34.2, 38.1, 38.2; figs. xii, 5a, 14a, 34a, 37b,40c

Berlin,Staatliche Museen zu Berlin, Kupferstichkabinett. © Volker-H. Schneider / Bildarchiv Preussischer Kulturbesitz / Art Resource, New York: cat. no. 9.2; figs. 32c, 40b

Boston, Museum of Fine Arts. Photo © 2009 Museum of Fine Arts, Boston: fig. 28a

Bremen, Kunsthalle Bremen. © Kunsthalle Bremen-Der Kunstverein in Bremen: cat. no. 18.2; figs. 18b, 33b; formerly Bremen, Kunstalle, © Kunsthalle Bremen-Der Kunstverein in Bremen: fig. 9b

Budapest, Szépmüvészeti Múzeum. © Dénes Fózsa / Szépmüvészeti Múzeum, Budapest: fig. xii; © András Rázsó / Szépmüvészeti Múzeum, Budapest: cat. no. 25.1

Chicago, The Art Institute of Chicago. Photo © The Art Institute of Chicago: cat. nos. 4.2, 41.1; fig. 39c

Cambridge, Harvard Art Museum / Fogg Museum. Photo Katya Kallsen, © President and Fellows of Harvard College: cat. no. 39.2; figs. xvi, 3a

Cambridge, Harvard Art Museum / Fogg Museum. Photo Allan Macintyre, © President and Fellows of Harvard College: cat. no. 29.2

Cologne, Wallraf-Richartz-Museum. Stadt Köln, Rheinisches Bildarchiv: fig. 18a

Copenhagen, Statens Museum for Kunst. ©SMK Foto: cat. no. 34.1; fig. 35a

Dresden, Staatliche Kunstsammlungen Dresden, Kupferstich-Kabinett: cat. nos. 5.2, 6.2, 31.2; fig. 31a, 41b. Photo by Herbert Boswank: fig. 31b

Hamburg, Kunsthalle, © Hamburger Kunsthalle / bpk. Photograph: Cristoph Irrgang: cat. no. 22.2; fig 11a

Leipzig, Museum der Bildenden Künste. © Ursula Gerstenberger / Bildarchiv Preussischer Kulturbesitz / Art Resource, New York: cat. no. 16.1

Lille, Palais des beaux-arts, Pluchart. © Thierry Le Mage / Réunion des musées nationaux / Art Resource, New York: fig. 29c

London, The British Museum. © The Trustees of the British Museum: cat. nos. 7.1, 10.1, 10.2, 11.1, 14.2, 17.1, 22.1, 42.2, 43.2; figs. ix, 2a, 7a, 22a, 24a, 25a, 43b

Montreal, The Montreal Museum of Fine Arts. Photo: The Montreal Museum of Fine Arts, Photographer: Brian Merrett: fig. 26b

Munich, Staatliche Graphische Sammlung. © Staatliche Graphische Sammlung München: cat. no. 23.1; figs. 23c, 42b

New York, Private Collection. Image. ICRAT 2006 LLC: cat. no. 1.3

New York, The Metropolitan Museum of Art. Image, © The Metropolitan Museum of Art: fig. 22b

New York, The Pierpont Morgan Library and Museum. © The Pierpont Morgan Library, New York. 2009: cat. nos. 33.2, 36.1

Oslo, Nasjonalmuseet for kunst, arkitektur og design. Photo: J. Lathion, © Nasjonalmuseet 2009: cat. no. 8.2

Ottawa, National Gallery of Canada. © Musée des beaux-arts du Canada: cat. nos. 24.1, 24.2; fig. 27c

Oxford, Ashmolean Museum, University of Oxford. figs. v, 33c

Paris, Institut Néerlandais. Fondation Custodia, Collection Frits Lugt: cat. nos. 27.3, 33.1, 37.1; figs. iv, vi, 16b, 24c, 25b, 37c, 37d

Paris, Musée du Louvre. © Gérard Glot / Réunion des musées nationaux /Art Resource, New York: cat. no. 27.2

Paris, Musée du Louvre. © Jean-Gilles Berizzi / Réunion des musées nationaux / Art Resource, New York: cat. no. 2.5; fig. i

Paris, Musée du Louvre. © Michèle Bellot / Réunion des musées nationaux / Art Resource, New York: fig. viii, 9a

Paris, Musée du Louvre. © Thierry Le Mage / Réunion des musées nationaux / Art Resource, New York: cat. no. 2.1; figs. 29c, 40a

Private Collection. Photo by Robert Lorenzson: cat. 2.3

Rouen, The Museum of Fine Arts. © Musées de la Ville de Rouen: fig. 6a

Schwerin, Staatliches Museum Schwerin. Photo: Elke Walford: fig. 20c

St. Petersburg, Hermitage. Photo © The State Hermitage Museum: fig. 27a

Stockholm, Nationalmuseum. © The National Museum of Fine Arts: cat. nos. 2.2, 23.2; figs. 3b, 17a

Stuttgart, Staatsgalerie Stuttgart, Graphische Sammlung, on loan from the Friends of the Staatsgalerie Stuttgart, Stuttgart Galerieverein. Photo © Staatsgalerie Stuttgart: fig. xiv

Stuttgart, Private Collection. Photo by Kaufmann Prepress: fig. xvii

Washington, D.C., National Gallery of Art. Image courtesy of the Board of Trustees, National Gallery of Art, Washington, D.C.: cat. no. 2.4 recto, verso; fig. x

Wroclaw, The Ossoliński National Institute. © Museum of the Lubomirski Princes. Ossoliński National Institute: cat. no. 35.2

Formerly Dusseldorf, C. G. Boerner (present location of drawing unknown). From Werner Sumowski, *Drawings of the Rembrandt School* (New York, 1979), vol. 1, no. 90, p. 205: fig 8a

Private Collection. From Otto Benesch, *The Drawings of Rembrandt*, enlarged by Eva Benesch (London, 1973), vol. 2 fig. 500: fig 15a

Index

Page numbers in **bold** indicate illustrations. All works of art mentioned are drawings unless otherwise indicated.

This volume accompanies the exhibition *Drawings by Rembrandt and His Pupils: Telling the Difference,* on view at the J. Paul Getty Museum, Los Angeles, December 8, 2009–February 28, 2010.

© 2009 J. Paul Getty Trust

Published by the J. Paul Getty Museum

Getty Publications
1200 Getty Center Drive, Suite 500
Los Angeles, California 90049-1682
www.getty.edu/publications

Gregory M. Britton, *Publisher*

John Harris, *Editor*
Cynthia Newman Bohn, *Manuscript Editor*
Jeffrey Cohen, *Designer*
Elizabeth Burke Kahn, *Production Coordinator*
Susan Amorde, *Photo Researcher*
Kimberly Wilkinson, *Editorial Staff Assistant*

Typesetting by Diane Franco
Color separations by Professional Graphics, Inc.
Rockford, Illinois
Printed by CS Graphics Pte, Singapore

Library of Congress Cataloging-in-Publication Data

Rembrandt Harmenszoon van Rijn, 1606–1669.
 Drawings by Rembrandt and his pupils : telling the difference / Holm Bevers...[et al.].
 p. cm
 Published to accompany an exhibition held at the J. Paul Getty Museum, Los Angeles, Dec. 8, 2009–Feb. 28, 2010.
 Includes index.
 ISBN 978-0-89236-978-2 (hardcover) —
 ISBN 978-0-89236-979-9 (pbk.)
 1. Rembrandt Harmenszoon van Rijn, 1606–1669—Exhibitions.
 2. Rembrandt School—Exhibitions. 3. Drawing, Dutch—
17th century—Exhibitions. 4. Drawing—Expertising—Exhibitions.
I. Bevers, Holm. II. J. Paul Getty
Museum. III. Title.
 NC263.R4A4 2009
 741.9492—dc22

 2009014471

FRONT COVER:
Rembrandt, *Seated Female Nude* (detail). See cat. no. 41.1, p. 236.
BACK COVER:
Arent de Gelder, *Seated Female Nude* (detail). See cat. no. 41.2, p. 237.
HALF-TITLE PAGE:
(Left) Rembrandt, *The Annunciation* (detail). See cat. no. 8.1, p. 82.
(Right) Ferdinand Bol, *The Annunciation* (detail). See cat. no. 8.2, p. 83.
OPPOSITE TITLE PAGE:
(Left) Rembrandt, *Study of a Woman* (detail). See cat. no 16.1, p. 116.
(Right) Gerbrand van den Eeckhout, *Study of a Woman* (detail). See cat. no. 16.2, p 117.
OPPOSITE P. 1:
Rembrandt, *The Angel Departs from Manoah and His Wife* (detail). See cat no. 18.1, p. 126.
P. 30:
Rembrandt, *Listeners for Saint John the Baptist Preaching* (detail). See cat. no. 14.1, p. 108.
BELOW LEFT:
Rembrandt, *The Actor William Ruyter as Saint Augustine* (detail). See cat. no. 6.1, p. 72.
BELOW RIGHT:
Govert Flink, *Putting a Bishop's Costume on the Actor William Ruyter* (detail). See cat. no. 6.2, p. 73.

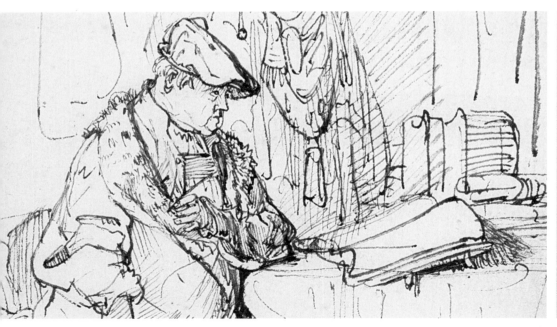

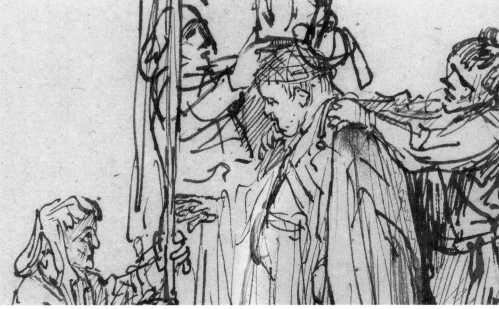